HITLER'S FLYING SAUCERS

The **New Science Series**:
- •THE TIME TRAVEL HANDBOOK
- •THE FREE ENERGY DEVICE HANDBOOK
- •THE FANTASTIC INVENTIONS OF NIKOLA TESLA
- •THE ANTI-GRAVITY HANDBOOK
- •ANTI-GRAVITY & THE WORLD GRID
- •ANTI-GRAVITY & THE UNIFIED FIELD
- •ETHER TECHNOLOGY
- •THE ENERGY GRID
- •THE BRIDGE TO INFINITY
- •THE HARMONIC CONQUEST OF SPACE
- •VIMANA AIRCRAFT OF ANCIENT INDIA & ATLANTIS
- •UFOS & ANTI-GRAVITY: Piece For a Jig-Saw
- •THE COSMIC MATRIX: Piece For a Jig-Saw, Part II
- •TAPPING THE ZERO-POINT ENERGY
- •QUEST FOR ZERO-POINT ENERGY

The **Mystic Traveller Series**:
- •IN SECRET TIBET by Theodore Illion (1937)
- •DARKNESS OVER TIBET by Theodore Illion (1938)
- •IN SECRET MONGOLIA by Henning Haslund (1934)
- •MEN AND GODS IN MONGOLIA by Henning Haslund (1935)
- •MYSTERY CITIES OF THE MAYA by Thomas Gann (1925)
- •THE MYSTERY OF EASTER ISLAND by Katherine Routledge (1919)
- •SECRET CITIES OF OLD SOUTH AMERICA by Harold Wilkins (1952)

The **Lost Cities Series**:
- •LOST CITIES OF ATLANTIS, ANCIENT EUROPE
 & THE MEDITERRANEAN
- •LOST CITIES OF NORTH & CENTRAL AMERICA
- •LOST CITIES & ANCIENT MYSTERIES OF SOUTH AMERICA
- •LOST CITIES OF ANCIENT LEMURIA & THE PACIFIC
- •LOST CITIES & ANCIENT MYSTERIES OF AFRICA & ARABIA
- •LOST CITIES OF CHINA, CENTRAL ASIA & INDIA

The **Atlantis Reprint Series**:
- •THE HISTORY OF ATLANTIS by Lewis Spence (1926)
- •ATLANTIS IN SPAIN by Elena Whishaw (1929)
- •RIDDLE OF THE PACIFIC by John MacMillan Brown (1924)
- •THE SHADOW OF ATLANTIS by Col. A. Braghine (1940)
- •ATLANTIS MOTHER OF EMPIRES by R. Stacy-Judd (1939)

HITLER'S FLYING SAUCERS

A Guide to German Flying Discs of the Second World War

by Henry Stevens

Adventures Unlimited Press

Hitler's Flying Saucers:
A Guide to German Flying Discs of the Second World War
by Henry Stevens

Copyright 2003 Henry Stevens

ISBN: 1-931882-13-4

Published by:

Adventures Unlimited Press
One Adventure Place
Kempton, Illinois 60946

aup@frontiernet.net

Printed in the United States of America

www.adventuresunlimitedpress.com
www.adventuresunlimited.nl

TABLE OF CONTENTS

PREFACE

This book is a guide into the world of German flying discs. You may have picked up this guide because you are unfamiliar with the German production of flying saucers during World War Two. The basics of this production will be revealed to you in the following pages. An adventure awaits you.

On the other hand, you may be looking for nothing more than a rational explanation of the UFO phenomenon. The UFO phenomenon involves sightings of unidentified flying objects. This means that any unidentified flying object is a UFO, regardless of its alleged source. Because the object is unidentified, the object's source is also undetermined. Only a leap of faith can connect UFOs to an extraterrestrial course without first introducing proof. A radical hypothesis such as an extraterrestrial origin of UFOs requires overwhelming proof in order to be generally accepted. No such overwhelming extraterrestrial proof has ever been offered which has stood up to scrutiny. No crashed alien craft have ever been produced by anyone, inside or outside government. Likewise, no alien bodies have ever been found. No extraterrestrial culture, or alien technology has ever been uncovered by anyone. There is simply no actual evidence at all linking UFOs with an extraterrestrial source. Therefore, no such leap of faith should be made. We need to start all over again. All rational earthly explanations need to be exhausted before any extraterrestrial theories are even put forth.

Unfortunately, the simple truth is that, for the most part, UFO research has done a leap-frog to the extraterrestrial explanation without ever adequately exploring and exhausting a terrestrial origin. This statement is inclusive of everyone regardless of background or education. It applies to the charlatan UFO attention-getters as well as to former NASA scientists with Ph.D.s. This is the condition of our current state of affairs in the UFO world.

Let me expound on this. For over fifty years, the UFO research paradigm has been fundamentally wrong. A proper attempt to explain the UFO phenomenon would involve a gathering of the evidence and then explanation by proceeding from simple solutions involving known facts and conditions and totally exhausting these as possibilities before postulating explanations, conditions, or entities not represented by fact. Only after known facts fail us can we move on to postulate explanations beyond our realm of experience.

1

Even then, an idea which may fit the observed facts but which is not in evidence itself cannot be accepted as fact until it is tested. This is nothing new. This is simply the way logic and science test new explanations of reality. This method is the foundation of our modern western technological culture.

Unfortunately, research in the field of flying saucer phenomena has never been undertaken with this principle in mind. More and more frequently, UFOs are attributed to an extraterrestrial source by the media, or the "witnesses", as a sort of knee-jerk reaction. It seems if one sees something for which he has no prior reference, then it must be extraterrestrial as a matter of course. Over the years sightings have become "encounters," then "abductions." Such reports are increasing even as the use of regression hypnosis replaces the scientific method for finding the truth. The same individuals often have repeated "experiences" each of which becomes stranger than the last.

If no real research has ever been done on the UFO phenomena, then how has thesis extraterrestrial theory crept into popular culture? One simple answer is the media. The media loves extraterrestrials. Why? It is because the extraterrestrial hypothesis is marketable. It sells copy. Just look at the number of books, magazines, movies and television programs devoted to this explanation. Look at your check-out counter in the supermarket.

The government itself is another answer. The word "government" from here on will basically mean the government of the United States of America but will sometimes include other governments, as specified. The government has used "flying saucers" to cover its own testing of secret aircraft. It uses the UFO-extraterrestrial ploy superbly. When a UFO is seen by civilians, a controlled procedure is enacted. This procedure plants or encourages witnesses who expound an extraterrestrial origin in a given sighting. The government may even go so far as to fund television programming and magazines devoted to this explanation. After all, a huge part of the C.I.A.'s budget goes into such covert conditioning of the American people. However, Americans are not the first to be fooled, as we shall see.

In most cases, any extraterrestrial hypothesis is acceptable to government manipulators, especially if it is so ridiculous that the witnesses end up discrediting themselves. The government is so successful at this that the entire topic of UFOs has become somewhat of a joke. This is done deliberately. Thus, serious people with "something to lose" are afraid to stake their reputations on a public announcement of their UFO experience, no matter how real it

may have been. At this point the government has achieved its purpose which is to discredit and suppress all serious inquiry into the UFO question.

Supposedly, UFO research has been left to large, well-financed UFO "research organizations". The largest of these is MUFON (Mutual UFO Network). This organization "trains" people to report sightings, then collects the data and organizes it using some sort of multi-variant analysis into something meaningful. Over the years MUFON has had the opportunity to collect and "organize" thousands of sightings into something meaningful.

In reality, the information is organized into gibberish. After a body of knowledge has been studied and organized, usually, certain facts or at least generalizations can be gleaned form this kind of work. In its fifty years of existence can anyone name one new fundamental fact that MUFON has provided us? They have provided us with nothing. Someone once said that MUFON is really a black hole into which information is attracted and does not have the power to escape on its own. We will return to MUFON and explain this reasoning at a later point.

If we are to seek any real explanation of the UFO phenomenon, we must make a clean break with the past. We must go back to the basics of simplicity and logic. One basic question is this: could we humans be capable of making the unidentified flying machines which have been seen in abundance in the sky since the Second World War? Until we answer that question in the negative, there is no reason to postulate an alien origin for UFOs.

One purpose of this book is to give an individual new to this subject an overview into the study of German flying discs. Never fear, this is not a disjointed spook-hunt, chasing sightings and abductions. There are real facts in this field. There are real people with real names and histories and there are real saucer designs.

Another purpose is to give the reader references, upon which statements in this book are based. Given these references, the reader may then research the topics of particular interest in more detail.

The research methodology is straightforward. We will listen to what is claimed about German saucers by Germans of those times or from other individuals who are in a position to know something about this topic. We then attempt to verify it using an independent historical source. Corroboration from other independent sources, especially from witnesses, is also acceptable and important. Photographs are important but nowadays pictures can be manufactured on a computer. Well-documented pictures which

appeared before the modern computer age are perhaps best. Also, pictures accompanied with negatives may be considered better documents than those without negatives.

Government documents can be great sources of confirmation. Unfortunately, governments cannot be trusted and have historically attempted to manipulate UFO research. Therefore, these sources are best not used to formulate ideas but to confirm ideas first developed through independent sources.

Politically, time is on our side. Since the Berlin Wall fell, more and more German researchers are going public with their findings. There is more freedom to research this subject now than at any time in the past sixty years. As each piece fits into the puzzle, a consensus of public acceptance acknowledging the reality of German flying discs grows. All we really have to do is find the pieces, confirm them and keep putting them together. The truth will emerge by itself and in the end nobody, no special interest of any sort, will be able to deny this basic truth.

The writer of this book is not an authority to be believed upon face-value alone. New assertions made in this book about German saucers will be accompanied with documentation. Assertions made by others will be accompanied with their references. This book will briefly touch upon most of the facts, ideas, writers and researchers in this field. With the sources given, the reader will be able to confirm the veracity of the position put forth independently.

In an attempt to explain the field of German saucers to someone new to it some background is necessary. First, we will discuss the situation within wartime Germany. Then, there will follow a discussion concerning reliable sources in this field. An overview of German flying discs will follow. Finally, various trains of thought or schools of thought in this field will be presented in a discussion section along with some odds and ends which do not fit into any neat pattern. At that point, the post-war disposition of German saucer technology will be discussed before concluding with some thoughts on the topic.

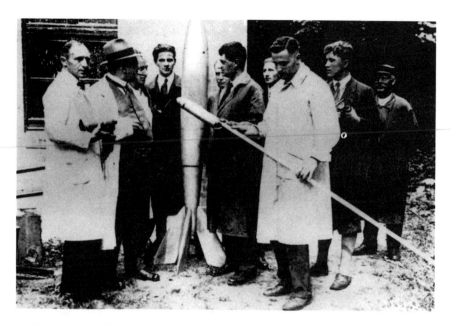

A meeting of Germany's early rocket pioneers, including Rudolph Nebel at left, Hermann Oberth, to the right of the rocket, Klaus Riedel, holding the small rocket, and behind him the dapper young Wernher von Braun.

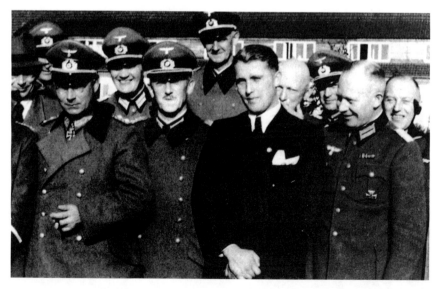

After the rise of Hitler, von Braun found himself with a new circle of acquaintances, as well as a new research facility at Peenemünde.

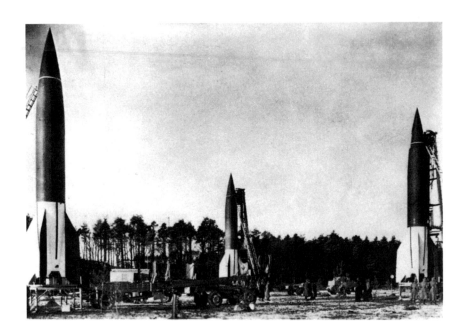

As the A-4 neared completion, the SS maneuvered to take control of the weapon from the German Army. Below, an obviously impressed Heinrich Himmler, standing next to Walter Dornberger, makes his first visit to Peenemünde in April 1943.

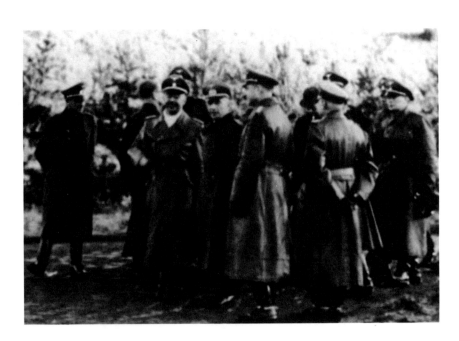

A vast factory complex called the Mittelwerk was constructed in the Harz Mountains to conceal and protect rocket production from Allied bombers. Below, a view of one of the underground galleries.

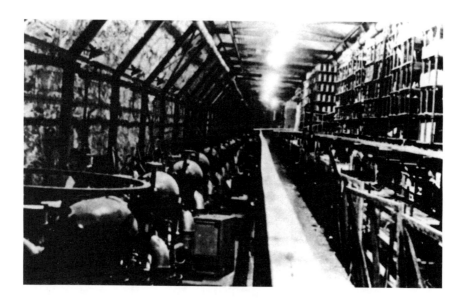

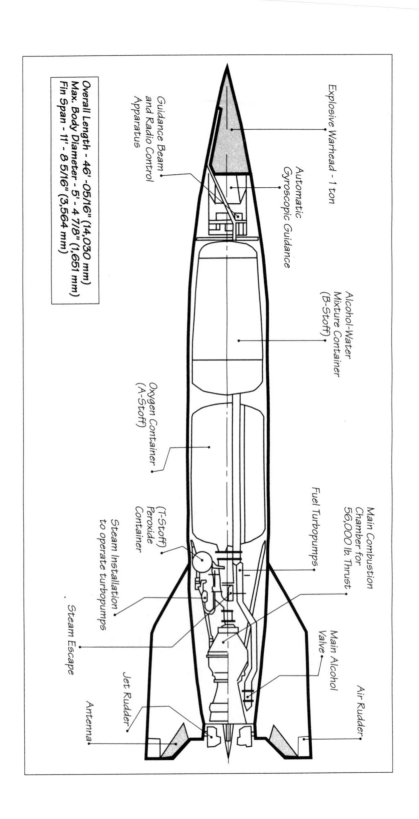

Explosive Warhead - 1 ton

Automatic
Gyroscopic Guidance

Guidance Beam
and Radio Control
Apparatus

Alcohol-Water
Mixture Container
(B-Stoff)

Oxygen Container
(A-Stoff)

(T-Stoff)
Peroxide
Container

Steam Installation
to operate turbopumps

Steam Escape

Fuel Turbopumps

Main Combustion
Chamber for
56,000 lb. Thrust

Main Alcohol
Valve

Air Rudder

Jet Rudder

Antenna

Overall Length - 46' - 05/16" (14,030 mm)
Max. Body Diameter - 5' - 4 7/8" (1,651 mm)
Fin Span - 11' - 8 5/16" (3,564 mm)

Allied intelligence was able to identify the "ski sites" originally designed to launch the V-1. While Operation Crossbow unleashed thousands of bombers against the sites, the Germans meanwhile switched to more flexible, and inconspicuous, launch methods.

The gigantic V-2 storage bunker at Wizernes, France after absorbing 14 Allied air attacks. Today the bunker is a museum run by the French government called La Coupole. It contains originals of the V-1 and V-2 and also celebrates space travel.

Carefully considered German camouflage schemes were designed to conceal the weapons among trees.

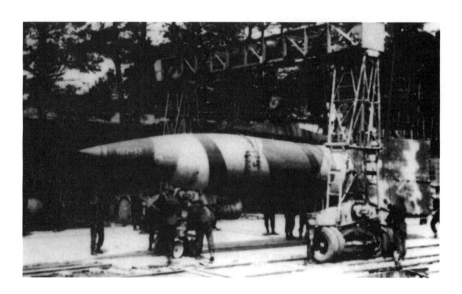

CHAPTER ONE:

THE SITUATION
WITHIN NAZI GERMANY

CHAPTER ONE

The Situation Within Nazi Germany

Thanks to the American media and what passes for history, most Americans have no idea of wartime conditions within Germany. The topics most germane to this discussion are the means of wartime industrial production and transportation within Germany.

After the Battle of Britain, Germany's air domination over Europe began to decline, sliding down a slippery slope which ultimately resulted in one major reason for its defeat. German means of industrial, arms, and energy production became increasing venerable to attack by Allied bombers. The munitions plants needed to produce the arms to maintain the war effort, such as tanks, airplanes and cannons were all targets of Allied air bombardment. Likewise, high priority targets included oil production and refining facilities which produced the fuel and lubricants needed to make the war effort possible.

One way Germany responded to air attacks was by moving munitions facilities and high-value industrial plants underground (1). Some of these facilities were vast, encompassing miles of underground tunnels. They housed both the industrial means of war production and the workers themselves. The facilities at Nordhausen in Thuringia are well known as the site of production for the V-1 and V-2, but there were others. The newly discovered underground complexes of the Jonas Valley south of Nordhausen in Thuringia constitute another vast complex (2)(3). This facility was to serve as a center of government and most probably a research center for advanced weaponry. This is also true for the many underground complexes in what is now Poland. Notable among these is a facility called "Der Riese" (The Giant). Der Riese served as a uranium mine, uranium processing facility, and research and development facility for secret weapons (4). Underground facilities for weapons production were found throughout Germany, Austria, Czechoslovakia and Poland. Underground production facilities were also set up to refine synthetic petroleum products from coal and to generate electricity.

In addition to underground facilities, camouflage was used to hide numerous smaller facilities. These many camouflaged and underground plants formed a web of sub-assembly producers. Each sub-assembly facility sent their product to a larger or a more centrally located facility for further work. From there it might be transported again for final assembly. As an example, type XX1 U-boats were modular, being produced in pipe-like sections throughout Germany. They were transported by rail to sites near the North Sea and only finally assembled at water's edge. Likewise, some types of aircraft were only finally assembled near the runway.

13

Further confusing Allied air intelligence, the plants were constantly moving. Eventually everything of value was to be moved underground, to bomb-proof shelters. Facilities were kept on the move until space was available for this underground re-location. These tactics worked for the Germans. There were simply too many moving targets for the Allies to completely stop German war production.

Of course the weak link in this scheme was transportation. The railroad system was the only practical and most energy efficient method of moving all these sub-assemblies. Trucking material was done but in a petroleum-starved Third Reich, it was not possible to sustain a truck-based transportation system necessary to meet all the requirements of wartime Germany. Recognizing this, the Allies bombed railroad centers using the heavy, four-engine B-17 bombers.

By mid-1943 the American P-51 Mustang was introduced into the field of play. This aircraft could be thought of as a Spitfire which could fly for eight hours. Its range allowed it to escort Allied bombers to their targets throughout the Reich. After escorting the bombers to their targets the P-51s were released to attack "targets of opportunity". A P-51 can fly close to the ground and attack individual trains, which they did. Perhaps you will recall the many wartime film clips showing these P-51s destroying German trains as they traveled. By mid-1944, it is a wonder that any trains within Germany could move at all. Some were forced to hide in mountain tunnels, as they did near the Jonas Valley, running at night or when there were no enemy aircraft reported.

As a result of these day and night air attacks, Germany found itself increasingly the victim of shortages of material and fuel, limiting its ability to make war.

Though Germany's air defence system was the best of any warring nation, it was clear that if Germany was to survive, improvement was imperative. Germany experimented with radically new types of air defense systems. Anti-aircraft rockets, guided both from the ground and by infra-red homing devices were invented. Vortex cannons, sun cannons, air-explosive turbulence bombs, rockets trailing long wire to ensnare enemy propellers, numerous electronic jamming devices, electronic devices designed to stop ignition-based engines, magnetically repulsed projectiles and long-range x-ray "death rays" were all under development as the conflict ended (5) (6). Among these exotic solutions were saucer-shaped interceptor aircraft.

The Germans already had jet and rocket interceptors as well as jet and rocket attack vehicles. German skies were full of these and other exotic aircraft so this new saucer shape was not considered as important then as we do today looking back upon it from a UFO perspective. To the German military and civilians alike these were just more new weapons.

14

The "Alpenfestung"

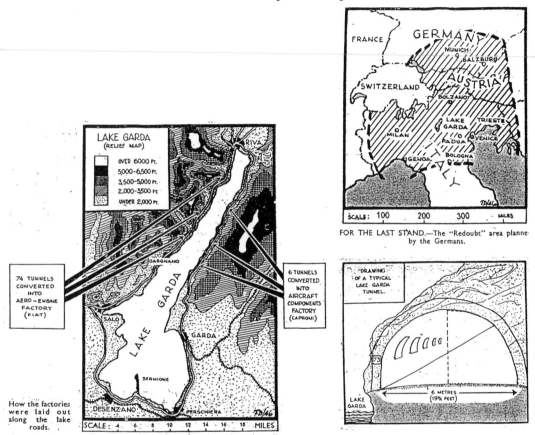

FOR THE LAST STAND.—The "Redoubt" area planne
by the Germans.

From top to bottom, right to left are: The "Alpenfestung"
which was the southernmost island of defense planned by the
Germans; Diagram of the Fiat underground facility at Lake
Garda in Northern Italy which worked under direction of the
Germans; A cross section of the tunnel. It was in this
facility where Renato Vesco worked during the Second World
War.

As the conflict drew to its conclusion, military planners in Germany considered the idea of concentrating their ground and air defenses into specific fortresses for a last stand. This would buy them time. They needed time to perfect new "Siegerswaffen", super-weapons so powerful that they could turn the course of the war for Germany by themselves.

A mountain fortress or "Alpenfestung" was to be set up in the German held areas of Northern Italy, Austria and Germany in roughly the areas in which these countries converged with each other and Switzerland (7). A fortress was to be set up in the Harz Mountains of Thruingia including several large underground complexes. This would extend from Nordhausen in the north down through Kahla and into the Jonas Valley. Another similar fortress complex was scheduled for the Owl Mountains separating Poland from Czechoslovakia including "Der Riese" mentioned earlier (8). Another fortress was to be set up in the Black Forest of Southern Germany. Other minor islands of resistance were to be set up in Norway, the Bohemian forest and the Bavarian forest (9).

These fortifications were to house soldiers, mostly SS units. They would also provide underground hangers and bomb-proof overhangs for aircraft take-offs and landings. Missiles, such as the V-1 and V-2, and other weapons were to be mass produced there and fired automatically, right off the automated assembly line. The exotic weaponry mentioned above was to be employed, along with especially trained mountain troops, defending the mountain passes into these fortresses (10).

History tells us the Alpenfestung never actually happened. It did not happen because German construction was simply not able to make these places ready in time. What is important for us to realize is that the weaponry for these fortresses was being developed as the Second World War drew to a close. Few of these weapons reached the operational stage but many were in various stages of development.

When Hitler took power in 1933 one of his first decisions was to rebuild the German Air Force, the Luftwaffe. This new organization was to make a clean break with the old and this reasoning was reflected in its research and development facilities, the RLM, which were the finest of any branch of the German military. Two brilliant research facilities were also in the possession of the Luftwaffe, the Lilenthalgesellschaft and the Academy of Air Research. Besides the Luftwaffe, there was the Army which did develop such things as the V-1 cruise missile. There was the Speer Ministry of Arms which did research. In addition, a system of research and development facilities was set up headed by a research council, the "Reichsforschungrat". Their job was to coordinate the technical schools and universities, the military and governmental research groups, and the research and development facilities into a concerted effort (11).

16

The Underground Complex "Der Riese"

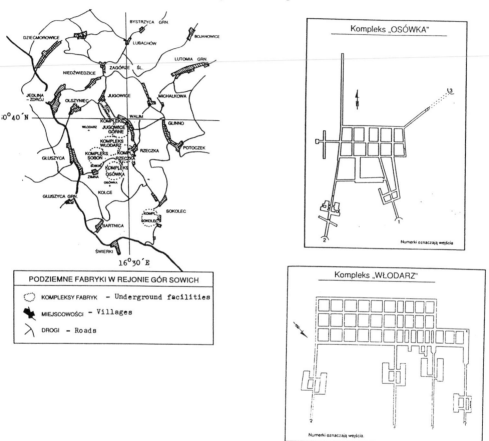

Kompleks „OSÓWKA"

Numerki oznaczają wejścia

Kompleks „WŁODARZ"

Numerki oznaczają wejścia

PODZIEMNE FABRYKI W REJONIE GÓR SOWICH

KOMPLEKSY FABRYK — Underground facilities

MIEJSCOWOŚCI — Villages

DROGI — Roads

"Der Riese", ("The Giant" in English), is located in the "Gory Sowie" or Owl Mountains of modern-day Poland. It consisted of seven undergound complexes which concerned themselves with the mining, refining, research and development of uranium both for energy producing machines and weapons of war. The tunnels of the larger complexes are almost two miles in length. Courtesy of Robert Lesniakiewicz. Mr. Lesniakiewicz is a Polish engineer and a member of the research group responsible for opening, exploring and maping of "Der Riese".

Another fact that influences our story was the ascendance of the SS (Schutz Staffel). The SS began simply as Hitler's body guard. From humble beginnings it was transformed into the most powerful entity within the Third Reich after Hitler himself. The military arm of the SS, the Waffen SS, became the most elite military force in Germany. The SS also took over many research, development and production facilities from the Army and Air Force. The SS took over control of civilian research and development facilities. The SS began taking facilities and power away from Albert Speer's Ministry of Arms and the RLM headed by Hermann Goering. As the war progressed, the SS organized, built and ran many underground manufacturing facilities (12). They even appropriated the huge industrial firm, the Skoda Works, its subsidiaries and related firms, centered near Prague, for their in-house projects (13). The SS became an empire within an empire answerable only to Adolf Hitler.

The SS also set up special research facilities for politically unreliable scientists. Research projects arose within these facilities which were in part staffed by technical people drawn from the prisoner pool. Such facilities were set up at Oraneinburg, Nordhausen, Mechlenburg and Mathausen (14).

As the SS rose within Germany, so did the fortunes of Doctor of Engineering, General Hans Kammler. Kammler seems to come into prominence through his talent at designing and building massive underground facilities (15). Soon Kammler was placed, by Hitler, in charge of V-weapons (Vergeltungswaffen). This means Kammler was in charge of the facilities at Peenemuende and Nordhausen. He was Dr. and General Walhter Dornberger's boss who, in turn was Dr. Wernher von Braun's boss. Further, Kammler headed up an advanced research and development group, associated with the Skoda Works, called the Kammler Group (16). This group held the most advanced technical secrets of the Third Reich.

During post-war questioning, when asked for details concerning V-weaponry, Albert Speer told Allied interrogators to ask Kammler these questions (17). They never did, however, because the 42 year old General Kammler had disappeared. Kammler was no fool. Wherever he went he undoubtedly took copies of the most advanced German technology. Numerous countries would have dealt with Kammler, regardless of his past. This includes the U.S.A. Couple this with the fact that no search was ever made for General Kammler in spite of the fact that he extensively employed slave-labor in his projects.

Did Kammler do a secret deal with an Allied government, exchanging information for a new identity? Or did Kammler escape Allied clutches to some safe haven such as South America? It is known that the Nazis set up shop in large, secure tracts of land between Chile and Argentina. It is also known that UFOs were seen earlier in that region than in the USA after the war. Many post-war stories involve German scientists relocating in South American countries formerly friendly to the

18

Nazis and there building and flying German saucers.

CHAPTER ONE

The Situation Within Nazi Germany

Sources and References

1. Vesco, Renato, 1976, <u>Intercept UFO</u>, pages 90-110, Pinnacle Books, 275 Madison Ave, N.Y., NY. 10016 Reissued as <u>Man-Made UFOs 1944-1994</u> by Adventures Unlimited Publishing, P.O. Box 74, Kempton, Illinois 60946

2. Zunneck, Karl-Heinz, 1998, <u>Geheimtechnologien, Wunderwaffen Und Irdischen Facetten Des UFO-Phaenomens 50 Jahre Desinformation und die Folgen</u>, CTT-Verlag, Suhl, Germany

3. Faeth, Harald, 1998, <u>1945 - Thueringens Manhattan Project Auf der Spuerensuche nach der verlorenen V-Waffen-Fabrik in Deutschlands Untergrund</u>, CTT-Verlag, Heinrich-Jung-Verlagsgesellschaft mbH, Suhl, Germany

4. Jesensky, Milos, Ph.D. and Robert Lesniakiewicz, 1998, <u>"Wunderland" Mimozemske Technologie Treti Rise</u>, AOS Publishing, 1 Vydani

5. Lusar, Rudolf, 1960, <u>German Secret Weapons Of The Second World War</u>, Neville Spearman, London, England

6. German Research Project, 1999, "German Death Rays Part Two: The German And American Governmental Evidence", German Research Project, P.O. Box 7, Gorman, CA. 93243-0007, USA

7. Vesco, Renato, 1976, pages 95-98

8. Jesensky, Milos, Ph.D. and Robert Lesniakiewicz, 1998, page 37

9. Vesco, Renato, 1976, page 106

10. ibid, pages 90-111

11. Combined Intelligence Objectives Subcommittee Evaluation Report 20, Planning Board Of Reich Research Council

12. Vesco, Renato, 1976, pages 90-93

13. Agoston, Tom, 1985, <u>Blunder! How the U.S. Gave Away Nazi Supersecrets To Russia</u> , pages 12-15, Dodd, Mead & Company, New York

14. British Intelligence Objectives Sub-Committee, Report Number

142, Information Obtained From Targets Of Opportunity In The Sonthofen Area, pages 1 and 3

15. Vesco, Renato, 1976, pages 93-95

16. Agoston, Tom, 1985, page 13

17. Combined Intelligence Objectives Subcommittee Evaluation Report Number 53(b), Interrogation of Albert Speer, Former Reich Minister of Armaments, page 3

Some of the earliest forms of UFOs, reported during the 1940s, were the ball of light phenomena known as 'foo fighters,' as depicted here.

Walter
Dornberger,
Wernher von
Braun (in cast)
and other scien-
tists after surren-
dering to the U.S.
Seventh Army in
May 1945.

Below, in
May 1946, the
Americans fire off
a captured V-2 at
the White Sands
proving ground in
New Mexico.

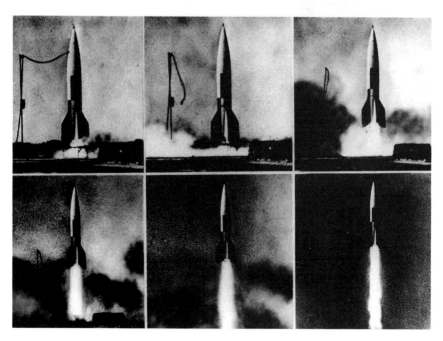

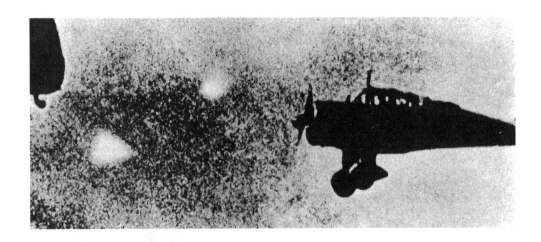

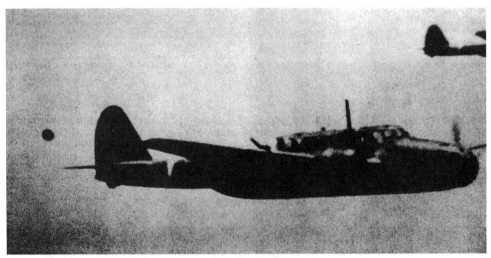

Above: Few photos of foo fighters are currently known. The top photo is one of the most famous, taken over Europe; the bottom was taken over the Sea of Japan between Japan and Korea in 1943.

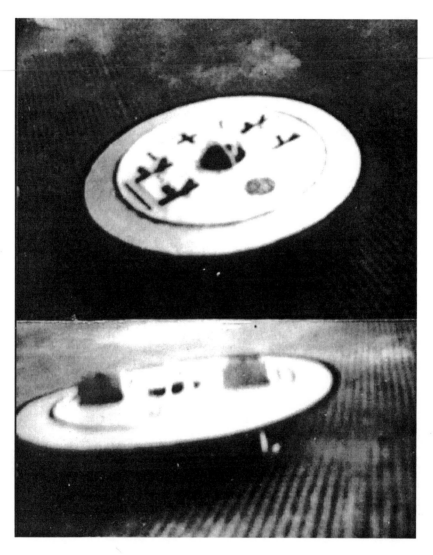

Above: Rare photos allegedly of an early experimental saucer at the Peenemuende Space Center.

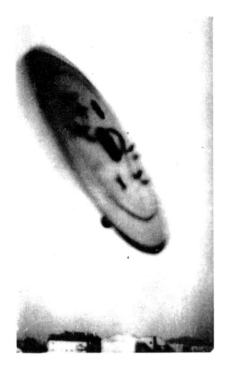

Left: Rare photo allegedly of an early experimental saucer at the Peenemuende Space Center in flight.

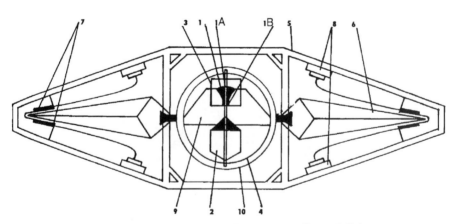

Above: Internal plans for a "Vril-1" saucer, according to Polish historian Igor Witkowski.

binding soldered & bound binding
Note: Paper insulation between magnet
and coil.

Rys.1

Rys.2

Rys.3

Rys.4

Patent for the Coler Converter, a free energy device designed by Hans Coler
in 1937.

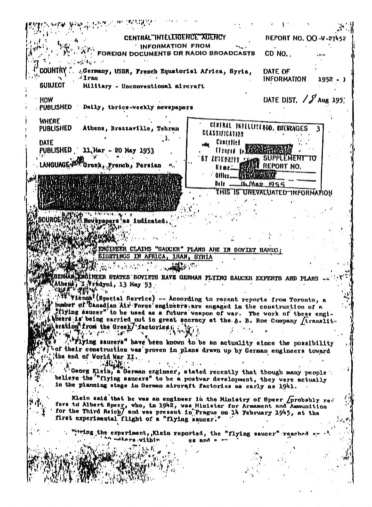

SOURCE Newspapers as indicated.

ENGINEER CLAIMS "SAUCER" PLANS ARE IN SOVIET HANDS;
SIGHTINGS IN AFRICA, IRAN, SYRIA

GERMAN ENGINEER STATES SOVIETS HAVE GERMAN FLYING SAUCER EXPERTS AND PLANS --
(Athens) I Vradyni, 13 May 53

Vienna (Special Service) -- According to recent reports from Toronto, a
number of Canadian Air Force engineers are engaged in the construction of a
"flying saucer" to be used as a future weapon of war. The work of these engi-
neers is being carried out in great secrecy at the A. B. Roe Company [translit-
eration from the Greek] factories.

"Flying saucers" have been known to be an actuality since the possibility
of their construction was proven in plans drawn up by German engineers toward
the end of World War II.

Georg Klein, a German engineer, stated recently that though many people
believe the "flying saucers" to be a postwar development, they were actually
in the planning stage in German aircraft factories as early as 1941.

Klein said that he was an engineer in the Ministry of Speer [probably re-
fers to Albert Speer, who, in 1942, was Minister for Armament and Ammunition
for the Third Reich] and was present in Prague on 14 February 1945, at the
first experimental flight of a "flying saucer."

During the experiment, Klein reported, the "flying saucer" reached
meters within es and

A C.I.A. document dated August 18, 1952 mentioning that the Germans were building "flying saucers" as early as 1941. From the German book *Die Dunkle Seite Des Mondes (The Dark Side of the Moon)* by Brad Harris (1996, Pandora Books, Germany).

CHAPTER TWO:

RELIABLE SOURCES

CHAPTER TWO

Reliable Sources

Much has recently been written concerning German flying discs. To the best of my knowledge, no single source has all the answers. To piece this puzzle together information from various sources must be used. Of course, some sources are better than others. Categories of sources, in a somewhat descending order of reliability are:

1. Those actually involved with these projects.

2. Witnesses of flying saucers who had prior knowledge that the sighting was of a German saucer as opposed to an unidentified flying object.

3. Those who at the time had good reason to know of German saucers.

4. Third-party intelligence sources which verify claims made by the higher categories above.

5. Researchers who have interviewed principals involved in German saucer research.

6. Studies or scientific papers published by individuals identified as participants in these projects.

Sources without names are not as good as sources with names. Information, data, or pictures without a "chain of evidence" linking them to the event are not as good as those with proper documentation.

After almost sixty years, nothing is going to be perfect. These categories are not meant to be absolute. Some sources fit into multiple categories. Some reports have value even though they are not rigorous simply because they were later corroborated by other sources.

When reading allegedly factual statements, the reader should always be looking for the source documentation for these statements. A writer's opinion or interpretation may be valuable but it should always be made clear which is who.

Examples of the first category are those who worked on German saucer projects:

Among these is Rudolf Schriever. Schriever was involved in a German saucers project which sometimes bears his name. As a source of information, he wrote an article on German saucers for the very respected Der Spiegel magazine (1).

Likewise, Joseph Andreas Epp was a self-admitted consultant for both the Schriever-Habermohl project at Prag and the Miethe project in Dresden and Breslau. Mr. Epp wrote to me personally (2) and has written several articles and a book about German saucers before he died in 1997 (3).

An example of a witness who had prior knowledge of German saucers would be Georg Klein. Klein was an engineer, an eyewitness to a saucer lift-off on February 14, 1945. He was also Special Commissioner in the Ministry of Arms Production who oversaw both the Schriever-Habermohl and Miethe-Belluzzo projects for Albert Speer. Mr. Klein has written some newspaper articles about these facts such as his article in Welt am Stonntag, titled "Erste "Flugscheibe" flog 1945 in Prag" (The First Flying Disc flew in Prag in 1945)(4). Other newspaper references of Mr. Klein will be mentioned. He has also written under the pen-name of Georg Sautier.

Another example would be the unnamed eyewitness provided by researcher Horst Schuppmann and first reported in Karl-Heinz Zunneck's book <u>Geheimtechnologien, Wunderwaffen Und Irdischen Facetten Des UFO-Phaenomens</u> (Secret Technology, Wonder-weapons and the Terrestrial Facts of the UFO Phenomenon). In this report the informant relates a wartime experience in which he witnessed several small flying saucers in a hangar (5).

George Lusar is an example of a source falling under category three. Lusar worked for the German Patent Office during World War Two. He saw many secret patents as they came into his office. After the War he wrote a book and some articles concerning this technology which was taken by the Allies (6).

Likewise, Italian engineer Renato Vesco worked with Germans while at a secret division of Fiat housed in an underground facility on Lake Garda, right in the middle of the proposed Alpenfestung. After the war, Vesco also researched British Intelligence data. This data was volumnous. Of course, Vesco knew what to look for based upon what he had learned while working in a secret Axis underground facility. Vesco is an example of category three and the next one, category four.

Category four involves intelligence information obtained from governmental sources. This information mostly comes from the very entities who are trying to suppress this information. It should always be suspect. It should be used only to verify information obtained from higher sources (categories 1 through 3) or from governmental sources of another government. For instance, information concerning flying objects which Renato Vesco called "Fireballs" was verified using information obtained from the U.S. government under laws forcing it to divulge some types of information (Freedom Of Information Act) (7).

Category five would include, for instance, Callum Coats whom spent three years with mathematician and physicist, Walter

Schauberger, son of Viktor Schauberger. Mr. Coats consequently learned a great deal of information concerning the ideas of Viktor Schauberger. Mr. Coats is a scientist and architect. Coats wrote <u>Living Energies</u> about the ideas of Schauberger and his saucer models (8).

In the same category we find Michael X. Barton, who, through a translator, Carl F. Mayer, received information from an informant in German, Hermann Klaas, who claimed to have actually been involved with some of the German saucer projects. Klaas's peripheral knowledge (category three) also seems to have extended into other aspects of secret German research and technology. Barton wrote one of the earliest books on this topic, <u>The German Saucer Story</u> in 1968 (9).

One unique source is Wilhelm Landig. Landig wrote three novels dealing with the Second World War. Following the title of each novel, Landig tells the reader that this is a "novel based on realities". The reader is given to understand that the technology described was based on hard fact. Landig's works contain more than cold facts, however. Landig deals with a large variety of topics in his books. Sometimes facts or opinions are stated or "stories behind the story" are told. He writes, unashamedly, from the National Socialist perspective. Landig was obviously a Nazi and an intellectual insider. His history always remained unclear, at least to this writer, until his recent death. Because of his unclear background and the fact that he wrote in novel form, there has been a reluctance to ascribe full creditability to the statements he makes regarding the technology of the Third Reich.

This all changed in 1999 as a result of research done by Margret Chatwin with an organization called "Informations diesnst gegen Rechtsextremismus" (Information service against the extreme right) (10). Coming in from this perspective, they, certainly, would not be accused of aggrandizing Landig's career. Some details of Landig's biography are now filled in. In that article we learn that Landig, an Austrian, took part in the unsuccessful Vienna Putsch of 1934. Thereafter, he fled to Germany and was inducted into the SD, the SS and the Waffen SS. There he rose to the rank of "Oberschafueher". Eventually, Landig was detailed to oversee government security concerns and given a position in the Reichs Security Department. Landig, in this position, was assigned to cover the security for the development of "UFOs" (11). It turns out that Landig was not only a source but a great source concerning the development of German saucers.

Returning to unnamed sources, they should never be given the weight as named sources are given. Many times writers use unnamed sources to advance a radically new and fantastic hypothesis in the UFO world. This type of source may sound convincing, given the "secret" nature of the message, but they should only be accepted if they yield new information which can be verified independently. This goes double for unnamed

31

government sources. Government has a history of manipulation of information concerning UFOs and UFO origin theories. One of the most famous was the Majestic 12 or MJ 12 affair which was based on unnamed government sources. This house of card finally fell apart but the real issue before us is why this house of cards, the MJ-12 affair, was ever allowed so much attention in the first place.

Government information should, therefore, never be used as the primary basis for a UFO hypothesis. It should only be used to verify a hypothesis developed, ideally, from multiple, independent sources. Concerning German saucers, this means that information or ideas from German sources might be checked using U.S. or British governmental archives, but not the reverse. Similar assertions given by official records of two different countries is notable. If both United States and British or German governmental sources agree upon something, then something might be said of the assertion. Of course there are those that say this only points to a conspiracy between the two governments to conceal a deeper truth. This may be true in some cases. These are all really judgment calls which the reader will have to make for himself, in the end.

Regarding individual sources cited, an effort will be made to describe the type of evidence each cited reference uses when that information is available.

CHAPTER TWO

Reliable Sources

Sources and References

1. Der Spiegel, March 30, 1959, Article and interview of Rudolf Schriever

2. Epp, Joseph Andreas, telephone communication and personal letters

3. Epp, Joseph Andreas, 1994, Die Realitaet der Flugscheiben Ein Leben fuer eine Idee, EFODON e. V., c/o Gernot L. Geise, Zoepfstrasse 8, D-82405 Wessobrunn, Germany

4. Klein, Georg, in Welt Am Sontag, 4/26/53, "Erste Flugscheibe Flog 1945 in Prag

5. Zunneck, Karl-Heinz, 1998, pages 120-122

6. Lusar, Rudolf, 1960, German Secret Weapons Of The Second World War, Neville Spearman, London

7. Headquarters, United States Strategic Air Forces In Europe,

Office Of The Director Of Intelligence, 1944, report titled:
"An Evaluation Of German Capabilities In 1945"

8. Coats, Callum, 1996, <u>Living Energies</u>, National Book Network,
 4720 Boston Way, Lanham, MD. 20706

9. Barton, Michael X., 1968, <u>The German Saucer Story</u>, Futura
 Press, 5949 Gregory Ave., Los Angeles, CA. 90038

10. Chatwin, Margret, 1999, page 1, Ahnenerbe, Ufos, Neonazis:
 Wilhelm Landig, Informationsdienst gegen Rechtsextremismus,
 http://www.idgr.de/texte-1/esoterik/landig/landig.html

11. ibid

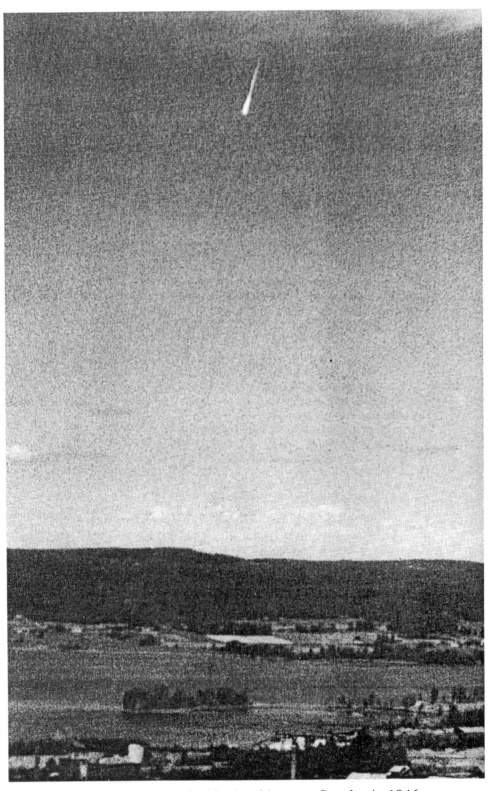

A Ghost Rocket photographed in the skies over Sweden in 1946.

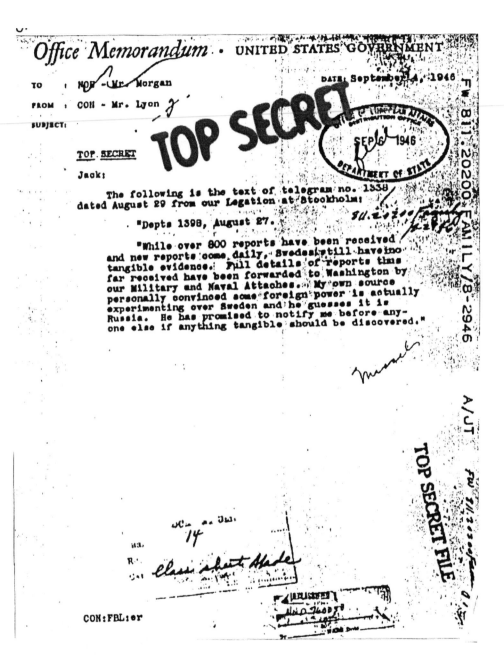

Office Memorandum • UNITED STATES GOVERNMENT

TO : NOF - Mr. Morgan DATE: September 4, 1946

FROM : COH - Mr. Lyon

SUBJECT:

TOP SECRET

TOP SECRET

Jack:

 The following is the text of telegram no. 1338 dated August 29 from our Legation at Stockholm:

 "Depts 1398, August 27.

 "While over 800 reports have been received and new reports come daily, Swedes still have no tangible evidence. Full details of reports thus far received have been forwarded to Washington by our Military and Naval Attaches. My own source personally convinced some foreign power is actually experimenting over Sweden and he guesses it is Russia. He has promised to notify me before anyone else if anything tangible should be discovered."

TOP SECRET FILE

CON:FBL:er

A September, 1946 Top Secret Memorandum on Ghost Rockets.

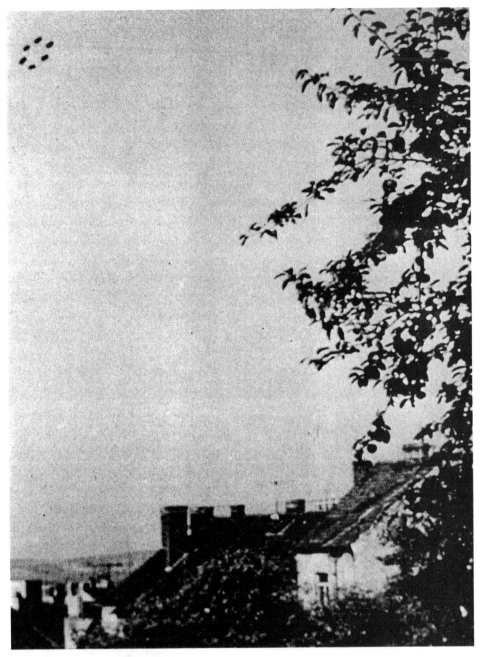

The above photo, showing six saucers in formation, was given to Dr. J. Allen Hynek in the early 1950s by the director of the Ondrejov Observatory in Czechoslovakia. No details of the sighting are available, but the photo is thought to have been taken near Prague, perhaps during WWII.

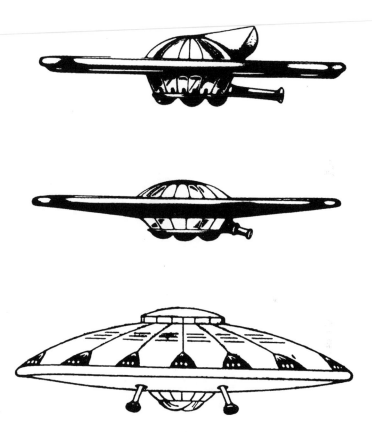

Above: Drawings of the Project Saucer craft designed in 1941 by Rudolf Schriever, a Luftwaffe aeronautical engineer, and his three colleagues, Habermohl, Miethe and Bellonzo. The first prototype was flown in June 1942 and larger versions were apparently designed and manufactured at the BMW factory near Prague, Czech Republic.

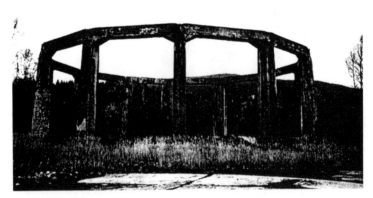

Above: The circular "Mucholapka" building in Poland. According to Polish Military Historian Igor Witkowski it was used for testing saucer-type craft.

CHAPTER THREE:

AN OVERVIEW OF THE GERMAN CONVENTIONAL SAUCER PROJECTS

THE SCHREIVER-HABERMOHL PROJECT(S)

THE MIETHE-BELLUZZO PROJECT

FOO FIGHTERS

THE PEENEMUENDE SAUCER PROJECT

CHAPTER SUMMARY

CHAPTER THREE

An Overview of the German Conventional Saucer Projects

In this section we will progress from saucer projects with are absolutely factual and of which detail is known and proceed to projects which are less known.

Several types of flying craft we would call flying saucers were built by the Germans during the Second World War. The exact number is still open for debate but it certainly must vary from between three to seven or possibly eight different types. These different types do not mean experimental models or variants of which there were many. What is meant here is that there were very different lines of flying machines being built in wartime Germany at different places by different groups of people. Since more than one saucer-type may have been produced by a single group, we will review this data group by group. We will progress from saucer projects which are factually better known and which deal in conventional propulsion methods and then move to lesser known projects which deal in more exotic propulsion methods which are less well documented and so more controversial.

The Schriever-Habermohl Project(s)

The best known of these projects is usually referred to as the Schriever-Habermohl project although it is by no means clear that these were the individuals in charge of the project. Rudolf Schriever was an engineer and test pilot. Less is known about Otto Habermohl but certainly he was an engineer. This project was centered in Prag, at the Prag-Gbell airport (1)(2). Actual construction work began somewhere between 1941 and 1943 (3)(4). This was originally a Luftwaffe project which received technical assistance from the Skoda Works at Prag and at a Skoda division at Letov (5) and perhaps elsewhere (6). Other firms participating in the project according to Epp were the Junkers firm at Oscheben and Bemburg, the Wilhelm Gustloff firm at Weimar and the Kieler Leichtbau at Neubrandenburg (7). This project started as a project of the Luftwaffe, sponsored by second-in-command, Ernst Udet. It then fell under the control of Speer's Armament Ministry at which time it was administered by engineer Georg Klein. Finally, probably sometime in 1944, this project came under the control of the SS, specifically under the purview of General Hans Kammler (8).

According to his own words, Georg Klein saw this device fly on February 14, 1945 (9). This may have been the first official flight, but it was not the first flight made by this device. According to one witness, a saucer flight occurred as early as August or September of 1943 at this facility. The eyewitness was in flight-training at the Prag-Gbell facility when he saw a short test flight of such a device. He states that the saucer was 5 to 6 meters in diameter (about 15 to 18 feet in diameter) and about as tall as a man, with an outer border of 30-40 centimeters. It was "aluminum" in color and rested on four thin, long legs. The flight distance observed was about 300 meters at low level of one meter in altitude. The witness was 200 meters from the event and one of many students there at the time (10).

Joseph Andreas Epp, an engineer who served as a consultant to both the Schriever-Habermohl and the Miethe-Belluzzo projects, states that fifteen prototypes were built in all (11) (12). The final device associated with Schriever-Habermohl is described by engineer Rudolf Lusar who worked in the German Patent Office, as a central cockpit surrounded by rotating adjustable wing-vanes forming a circle. The vanes were held together by a band at the outer edge of the wheel-like device. The pitch of the vanes could be adjusted so that during take off more lift was generated by increasing their angle from a more horizontal setting. In level flight the angle would be adjusted to a smaller angle. This is similar to the way helicopter rotors operate. The wing-vanes were to be set in rotation by small rockets placed around the rim like a pinwheel. Once rotational speed was sufficient, lift-off was achieved. After the craft had risen to some height the horizontal jets or rockets were ignited and the small rockets shut off (13). After this the wing-blades would be allowed to

42

The Airport at Prag-Gbell

Site of the Schriever and Habermohl Flying Saucer Projects

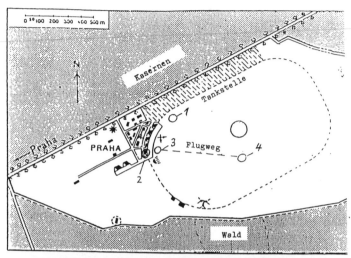

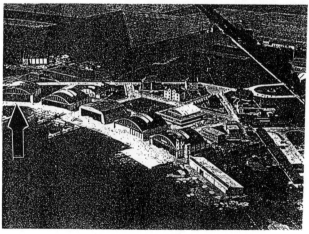

In the top diagram the hanger which was the site of the research is marked as number 2. The same hanger is indicated in the picture below with an arrow.

43

The Habermohl Saucer In Flight

To the left is the closest shot of the two taken by Joseph
Andreas Epp as he drove to the Prag airport in 1944. To
the right is a blow up (400 times) of that same saucer.
Epp remembers a date of November, 1944 but the foliage on
the trees argues for a date earlier in the year.

rotate freely as the saucer moved forward as in an auto-gyrocopter. In all probability, the wing-blades speed, and so their lifting value, could also be increased by directing the adjustable horizontal jets slightly upwards to engage the blades, thus spinning them faster at the digression of the pilot.

Rapid horizontal flight was possible with these jet or rocket engines. Probable candidates were the Junkers Jumo 004 jet engines such as were used on the famous German jet fighter, the Messerschmitt 262. A possible substitute would have been the somewhat less powerful BMW 003 engines. The rocket engine would have been the Walter HWK109 which powered the Messerschmitt 163 rocket interceptor (14). If all had been plentiful, the Junkers Jumo 004 probably would have been the first choice. Epp reports Jumo 211/b engines were used (15). Klaas reports the Argus pulse jet (Schmidt-duct), used on the V-1, was also considered (16). All of these types of engines were difficult to obtain at the time because they were needed for high priority fighters and bombers, the V-1 and the rocket interceptor aircraft.

Joseph Andreas Epp reports in his book <u>Die Realitaet der Flugscheiben</u> (The Reality of the Flying Discs) that an official test flight occurred in February of 1945. Epp managed to take two still pictures of the saucer in flight which appear in his book and are reproduced here. There is some confusion about the date of these pictures. In the video film "UFOs Secrets of the 3rd Reich", Epp states these pictures were taken in the Fall of 1944. In his book the date is given as the official date of February 14, 1945. In personal correspondence to me of December, 30, 1991, he indicated the date of the pictures as August, 1944. In that correspondence he further revealed that the official flight had been February 14, 1945 but an earlier lift-off had taken place in August of 1944. The pictures show a small disc-like object in the distance at some altitude posed above a landscape. The saucer is at too great a distance and altitude to show any mechanical detail. As Klaus-Peter Rothkugel points out, the foliage on the trees indicates the August date as being the most accurate.

Very high performance flight characteristics are attributed to this design. Georg Klein says it climbed to 12,400 meters (over 37,000 feet) in three minutes (17) and attaining a speed around that of the sound barrier (18). Epp says that it achieved a speed of Mach 1 (about 1200 kilometers per hour or about 750 miles per hour) (19). From his discussion, it appears that Epp is describing the unofficial lift-off in August, 1944 at this point. He goes on to say that on the next night, the sound barrier was broken in manned flight but that the pilot was frightened by the vibrations encountered at that time (20). On the official test flight, Epp reports a top speed of 2200 kilometers per hour (21). Lusar reports a top speed of 2000 kilometers per hour (22). Many other writers cite the same or similar top speed. There is no doubt of two facts. The first is that these are supersonic speeds which are being discussed.

45

Second, it is a manned flight which is under discussion.

But at least one writer has discounted such high performance (23). It is argued that the large frontal area of one of the possible designs in question makes Mach 2 flight impossible. The argument seems to be that given the possible power plants the atmospheric resistance caused by this frontal area would slow the craft to a point below the figures stated earlier.

Some new information has come to light regarding the propulsion system which supports the original assessment. Although actual construction had not started, wind-tunnel and design studies confirmed the feasibility of building a research aircraft which was designated Project 8-346. This aircraft was not a saucer but a modern looking swept-back wing design. According this post-war Allied intelligence report, the Germans designed the 8-346 to fly in the range of 2000 kilometers per hour to Mach 2. (24). Interestingly enough, it was to use two Walther HWK109 rocket engines. This is one of the engine configurations under consideration for the Schriever-Habermohl saucer project.

As an aside, it should be noted that there are those who will resist at any attempt to impugn the official breaking of the sound barrier by Chuck Yeager in 1947 in the Bell X-1 rocket aircraft. They had better brace themselves. This record has also been challenged from another direction. This challenge was reported in February, 2001, by the Associated Press, Berlin. It seems that a certain Hans Guido Mutke claims he pushed his Messerschmitt jet fighter, the Me-262, through the sound barrier in 1945. This occurred during an emergency dive to help another German flyer during air combat. At that time he experienced vibrations and shaking of the aircraft. According to the report, a Hamburg Professor is working on a computer simulation in order to check the validity of this claim.

Returning to the topic at hand, Schriever continued to work on the project until April 15, 1945. About this time Prag was threatened by the Soviet Army. The Czech technicians working on this project were reported to have gone amuck, looting the facility as the Russians approached. The saucer prototype(s) at Prag-Gbell were pushed out onto the tarmac and burnt. Habermohl disappeared and presumably ended up in the hands of the Soviets. Schriever, according to his own statements, packed the saucer plans in the trunk of his BMW and with his family drove into Southern Germany. After cessation of hostilities Schriever worked his way north to his parents house in Bremerhaven-Lehe. There Schriever set up an inventor-workshop. On August 4, 1948 there was a break in to the workshop in which Schriever's plans and saucer model were stolen (25). Schriever was approached by agents of "foreign powers" concerning his knowledge of German saucers. He declined their offers, preferring rather menial work driving a truck for the U.S. Army (25).

Schriever is reported to have died shortly thereafter in 1953.

There is a report, however, that his death was reported prematurely and that he was identified by a witness who knew him in Bavaria in 1964 or 1965 (26). The publisher of this book, Thomas Mehner, was so kind as to send me a copy of the statement by a Bavarian woman who knew Schriever and made this claim (27). This means that there is a possibility that Schriever did do post-war work on flying saucers.

Interestingly enough, Schriever never claimed that his saucer ever flew at all! If this true, Schriever's saucer was still in the pre-flight stage at the time of the Russian advance and its ultimate destruction on the Prag-Gbell tarmac. This is in direct contradiction to the sources cited above and the photographic evidence. How can this seeming inconsistency be explained?

J. Andeas Epp has always maintained that it was he who originated the type of design used in the Schriever-Habermohl project (28). He states in his book that the imbalance in the ring of wing-vanes which plagued the early Schriever-Habermohl prototypes was a deviation from his original design in which the wing-vanes were lengthened. He states that when they returned to his original design, the saucer was able to take off (29) (30). He referred to the saucer used in the August, 1944 unofficial lift-off, the saucer whose wing-vanes had been altered and then corrected through his intervention, as the "Habermohlischen Version", the Habermohl version (31).

Could the discrepancy referred to above be accounted for if there were actually two lines of saucers built by Schriever and Habermohl? In other words, could the Schriever-Habermohl project have actually been a Schriever project and a Habermohl project, two separate designs within the team? Georg Klein seems to answer this question, stating that "three constructions" which were finished at Prag by the end of 1944. One of these, he says, was a design by Dr. Miethe (32). The best interpretation of the words of both Epp and Klein would indicate that both Schriever and Habermohl each produced their own design. Schriever made no claim that his design flew. Epp claims the Habermohl design did fly in August, 1944 and again in February 14, 1945. This was the saucer witnessed by both Klein and Epp in flight.

Therefore, the history of the Schriever-Habermohl project in Prag can be summarized in a nutshell as follows: Epp's statement is that it was his design and model which formed the basis for this project. This model was given to General Erst Udet which was then forwarded to Dr. Walter Dornberger at Peenemuende. Dr. Dornberger tested and recommended the design (33) which was confirmed by Dornberger to Epp after the war (34). A facility was set up in Prag for further development and the Schriever-Habermohl team was assigned to work on it there. At first this project was under the auspices of Hermann Goering and the Luftwaffe (35). Sometime later the Speer Ministry took over the running of this project with chief engineer Georg Klein in charge (36). Finally, the project was usurped by the SS in 1944, along

47

A Comparison of the Schriever and Habermohl Designs

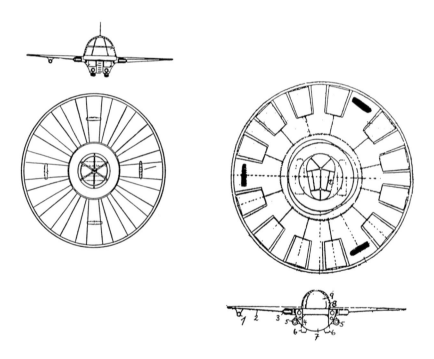

On the left is the Schriever design while on the right is
the Habermohl design. Please note the differing dimensions
of the vane blades. This difference caused instability in
the Schriever design. Drawings adapted from the work of
Klaus-Peter Rothkugel.

with other saucer projects, and fell under the purview of Dr. Hans Kammler (37). Schriever altered the length of the wing-vanes from their original design. This alteration caused the instability. Schriever was still trying to work out this problem in his version of the saucer as the Russians overran Prag. Habermohl, according to Epp, went back to his original specifications, with two or three successful flights for his version.

While speaking of flight success, two more pieces of important evidence exists which were supplied by Andreas Epp. One comes in the form of a statement by a German test pilot, Otto Lange, given years after the war to Andreas Epp. In that statement, signed by Lange, Epp is credited with the idea behind the invention of the flying saucer and states that none other than Dr. Walter Dornberger had a hand in its development. He also makes the astonishing claim that he, personally, test flew this flying saucer for 500 kilometers in the course of testing (38) (39).

Otto Lange is a person who is known historically and independently of any connection to Epp. Lange is mentioned in U.S. intelligence documents as a member of the "Rustungsstab" (Armament Staff), for aircraft (40). This is some confusion on this issue since a German researcher, Klaus-Peter Rothkugel, has found evidence for three individuals with this name serving in the German military at this time. Mr. Rothkugel, has suggested that the statement by Lange, discussed above, was, in fact, written by Epp based on known examples of Epp's hand writing. It was signed by another hand, so perhaps Epp and Lange had a chance meeting in 1965 wherein the letter was drafted by Epp in an effort to further document his, at that time, little-acknowledged involvement in the German saucer projects.

The second piece of evidence, also supplied by Epp, is a wartime letter from Prag, dated March, 1944. It speaks to the conditions behind German lines with its opening greeting, simply "Still Alive!". It follows in a cryptic style describing historically well known political and military people who apparently knew or had something to do with the saucer project at Prag. The letter also describes some early prototype saucer models and their shortcomings. Interestingly enough figures on thrust are given (40) (41).

Three pictures appear at the bottom of the letter. One definitely shows a saucer in flight. There is no mention of these pictures in the text of the letter. Because they are not referenced and from their placement on the face of the letter it is possible that these pictures may have been a later addition to that letter. There are some other reasons why these pictures may not have been connected to the Schriever-Habermohl project or the Miethe-Belluzzo project. We shall return to these pictures at a later time.

An interesting fact elucidated by Epp is that the senior experts

Cryptic And Enigmatic Letter Describes Flying Disc Development

An K. Rüdiger LZA, III Finow Prag, März 1944

An K. Rüdiger LZA, III Finow Prag, März 1944

Noch am Leben. 3 Tage Pulverturm (*shelter in Prag*)Verlusst 3 Zähne – Schwiel
Karl. Sofort nach Berlin. Zu von Melldorf + Göring: Achte auf SS A. Müller,
Dönitz, Keitel, von Greim, H. Reitsch (von Below) (Sepp Dietrich Chance für un
Nach Prager Liste. Canaris. Witzleben, Oster, von Melldorf, Göring, Gierdeler, ◄
Moltke. Delp. Lange, Nebe. Liste an Nebe (*Leader of Criminal Investigati*
Department. as I know) nach Berlin. Durch Prager Mann. Fr. Leip
benachrichtigen. Noch am Leben. Komm nach Weimar NORA. Mutzenbrunn
00214.

Fliege mit V3 (Scheibe). VI(*rank?*) sofort V I und V II stoppen. Motoren
schwach. V5 ???? Motoren mit Hochdruck (?). 3. BAA.

Versuche sehr gut. Senkrecht Start mit 9 x Torpedo 2 x 500 HO?.B. Fast bis 30
M(*eter*). Einschwenken der Motoren störungsfrei. Auch mit Asbest Motoren. 10
Aufnehmen von Lastensegler – 2 To.(*1*) LKW. Sehr gut. Halte die Luft an! Reise
2 To. in 6000 M. = 860-880 Km (*km per hour*). Komm mit Nacht (Sömmer
Fliege Weimar-NORA (Göring Ratsfeld). Barbarossa-Höhle (282) mitbing
Vorsicht, Himmler im Schloß. ????????Stoppmist!. B.R. für WSA wie Blitz. Wein
SAW o-o an alle in Berlin. Wer ist Diplm. Achenbach? Zu Canaris + Goerdel
Meine Sachen mit nach Baron!.

Achte auf Schlachtberg.

SS. H. Müller

K. Dönitz

Keitel

v. Creim mit Reitsch

v. Below (Dietrich Sepp Chance für uns)

??? Dein Wusnch.

Es lebe Deutschland!!!

On the left is the orignal letter sent to the author by
Andreas Epp. On the right is a typed version done by
Kadmon. Notes in English are directed to the author. The
letter starts without any formal or informal greeting,
stating only "Still alive". Flying disc research "sehr
gut" with vertical take-off at speeds of 860-880 per hour
(525-550 milesper hour).

Leider spät aber nicht zu spät!
Habe ich den Flugscheibenerfinder Epp nach 21 Jahren wiedergefunden.

Als Ingenieurpilot der im Kriege gebauten Flugscheiben VI VII und VIII möchte ich vor aller Welt dokumentieren das Herr Joseph Andreas Epp der Urheber der Flugscheiben Idee und Konstruktionen ist!

Das Konstrukteur Epp 25 Jahre hindurch trotz aller Schwierigkeiten diese Idee zum Prototyp entwickelt hat. Mir als Chefpilot, der die ersten Flugscheiben Eppsinen Idee fluggetestet und über 500 km geflogen habe ist es unverständlich, das man die Realisierung der Eppsinen Flugscheibenkonstruktion ignoriert. Namhafte Wissenschaftler und Techniker haben ausser mir dem Konstrukteur Epp die Richtigkeit seiner Flugscheibenkonstruktion wie dessen Realisierung sinnschriftlich bestätigt.

Unter Ihnen Dr. W. R. Dornberger. Sinniever als Mitkonstrukter. Dipl. Ing. Langendorf Snecma Frankreich, Dipl. Ing. Flamai Bertin Frankreich Ing. Alex Consinet Paris. Dipl. Rolf Engel Rom Italien u.s.w.

Ich werde von jetzt ab die Sache Epps zu meiner eigen machen und wünsche das alle Interessierten sich für eine Realisierung einsetzen möchten.

München den 10 Juli 1965.

Fl. Oberstabsing. A. D.

Otto Lange

Unfortunately late, but not too late!
After 21 years, I have once more found the flying disc inventor, Epp.

As an engineer-pilot who in wartime-built flying discs V-I, VII and VII, I would like to document before the whole world that Mr. Joseph Andreas Epp was the originator of the idea and designs of the flying discs! The designer Epp developed this idea to prototype for 25 years inspire of hinderance and difficulties. To me, as chief pilot, who flight tested the first flying discs of Epp's idea, and have flown for over 500 kilometers, it is incomprehensible that the realization of Epps flying disc designs have been ignored. Well known scientists and technicians have confirmed to me in writing the correctness of designer Epps flying discs designs.

Among these, Dr. W.R. Dornberger, Schriever as co-designer, certified engineer Langendorf, Sinecnia, France, certified engineer Flanian Bertin, France, engineer Alex Consinet, Paris, certified Rolf Engel, Rome, Italy and so forth.

From now on I will take Epps cause and make it my own and wish that all those who are interested be permitted a realization.

Munich, July 10, 1965

Flight Chief Headquarters Engineer, Retired

Otto Lange

Translator's note: the "V" designation in VI, VII, VII do not mean "Vergeltung" or vengeance but more likely "Versuchs", test, or "Varante", variant. Epp states that 15 designs were known to him to have been built.

Original and author's translation of letter signed by Lange acknowledging Epp's role in flying disc history

and advisors for both the Schriever-Habermohl project and the next project to be discussed, the Miethe-Belluzzo project, were exactly the same individuals (43).

The Schriever-Habermohl Project(s)

Sources and References

1. Meier, Hans Justus, 1999, page 24, "Zum Thema "Fliegende Untertassen" Der Habermohlsche Flugkreisel", reprinted in Fliegerkalender 1999, Internationales Jahrbuch de Luft-und Raumfahrt, Publisher: Hans M. Namislo, ISBN 3-8132-0553-3

2. Lusar, Rudolf, 1964, page 220, <u>Die Deutschen Waffen und Geheimwaffen des 2. Weltkrieges und ihre Weiterentwicklung</u>, J.F. Lemanns Verlag, Munich

3. Lusar, 1964, ibid

4. Epp, Joseph Andreas, 1994, page 28, <u>Die Realitaet der Flugscheiben</u>, Efodon e.V., c/o Gernot L. Geise, Zoepfstrasse 8, D-82495

5. Epp, 1994, ibid

6. Rothkugel, Klaus-Peter, in personal letters a witness has reported to Mr. Rothkugel the sites of Prag-Rusin, Letov-Werke (Lettow), the Skoda Works at Pressburg/Trentschin

7. Epp, 1994, pages 30-31

8. Epp, 1994, pages 28-33

9. Keller, Werner, Dr., April 25, 1953, Welt am Sonntag, "Erste "Flugscheibe" flog 1945 in Prag enthuellt Speers Beauftrager", an interview of Georg Klein

10. Meier, 1999, page 23

11. Personal letter from J. Andreas Epp dated 12/30/91

12. Epp, 1994, page 27, 30

13. Lusar, 1964, 220

14. Holberg, Jan, 8/20/54, page 4, "UFOs gibt es nicht! Wohl aber: Flugscheiben am laufenden Band!" Das Neue Zeitalter

15. Epp, 1994, page 31

16. Barton, Michael X., 1968, page 38, <u>The German Saucer Story</u>, Futura Press, Los Angeles (based upon Hermann Klaas)

17. Zwicky, Viktor, September 19, 1954, page 4, Tages-Anzeiger

fuer Stadt und Kanton Zuerich, "Das Raetsel der Fliegenden Teller Ein Interview mit Oberingenieur Georg Klein, der unseren Lesern Ursprung und Konstruktion dieser Flugkoerper erklaert"

18. Klein, Georg, October 16, 1954, page 5, "Die Fliegenden Teller", Tages-Anzeiger fuer Stadt und Kanton Zuerich

19. Epp, 1994, page 31

20. ibid

21. Epp, 1994, page 34

22. Lusar, 1964, page 220

23. Meier, Hans Justus, 1999, page 10, "Zum Thema "Fleigende Untertassen" Der Habermohlsche Flugkreisel", Fliegerkalender Internationales Jahrbuch der Luft-und Raumfahrt

24. Combined Intelligence Committee Evaluation Reports, Combined Intelligence Objectives Subcommittee, Evaluation Report 149, page 8

25. Der Spiegel, March 30, 1959, "Untertassen Sie fliegen aber doch" Article about and interview of Rudolf Schriever

26. Zunneck, 1998, page 119

27. This written statement, translated from Bavarian dialect to High German was provided courtesy of publisher Thomas Mehner

28. Epp, 1994, page 30

29. Epp, 1994, page 31

30. Personal letter from J. Andreas Epp dated 12/30/91

31. ibid

32. Klein, Georg, October 16, 1954, page 5, "Die "Fliegenden Teller", Tages-Anzeiger fuer Stadt und Kanton Zuerich

33. Epp, 1994, page 26

34. ibid

35. Epp, 1994, page 27

36. Epp, 1994, page 33

37. ibid

38. Kadmon, 2000, Ahnstern 1X, "Andreas Epp", Aorta c/o Petak,

Postfach 778, A-1011, Wien, Austria

39. Personal letter from Andreas Epp, dated 12/30/91

40. Combined Intelligence Objectives Sub-Committee Evaluation Report, Report Number 40 "Sonderausschuss"

41. Kadmon, 2000, Ahnstern 1X, "Andreas Epp"

42. Personal letter from Andreas Epp, dated 12/30/91

43. Epp, 1994, page 31

The Miethe-Belluzzo Project

This saucer project may have been an outgrowth of flying wing research. It was begun in 1942, and was under the on-site authority of Dr. Richard Miethe, sometimes called Dr. Heinrich Richard Miethe. Not much is known about Dr. Miethe before the war. After the war Dr. Miethe is rumored to have worked on the Anglo-American saucer project at the firm of Avro Aircraft Limited of Canada. Such is stated Klein (1), Epp (2), Barton (3), Lusar (4), as well as a myriad of other sources. We will return to the Avro projects later.

Working with Dr. Miethe was an Italian engineer, Professor Guiseppe Belluzzo. Belluzzo was the Deputy, Senator and Minister of National Economy under Mussolini. He had written several books on technical matters including Steam Turbines in 1926 and Calculations and Installations of Modern Turbine Hydrolics in 1922 (names are English translations of Italian titles). Belluzzo was considered to be an expert in steam turbines. Dr. Belluzzo was not a junior scientist and he was not Dr. Miethe's assistant. He was a senior scientist whose expertise was somehow invaluable on the saucer devices or planned further developments of them.

After the war Belluzzo seems to have led a quiet life in Italy until his death on 5/22/52. Unlike Miethe, however, Belluzzo went on record about German flying discs after the war. He is quoted on the subject in The Mirror, a major Los Angeles newspaper in 1950. This may be the first mention of the subject in the American press. In his obituary in the New York Times his work on the German saucer program is mentioned. (Please refer to copies of these articles).

This team worked in facilities in, Dresden, Breslau and Letow/Prag according to Epp (5). Both this project and the Schriever and Habermohl projects were directed by the same experts and advisors (6). From Epp's discussion, it is clear that Dr. Walter Dornberger first evaluated and recommended his saucer model for further development (7). Miethe is described by Epp in translation as a "known V-weapons designer"(8). The association of both projects to Peenemuende is clear. Both were sanctioned and set up by officials there, probably by Dr. Walter Dornberger himself. Miethe and Belluzzo worked primarily in Dresden and Breslau but for a brief time they may have actually joined forces with Schriever and Habermohl in Prag, as evidenced by Klein's statement that three saucer models were destroyed on the Prag tarmac (9). One saucer, which Klein he describes as Miethe's was among these. Klein acknowledges that Peenemuende, and its nearby test facility at Stettin, retained and developed the Miethe design as an unmanned vehicle (10)(11).

Epp tells us that the Miethe-Belluzzo project was organized under exactly the same authority as the Schriever-Habermohl project and

Giuseppe Belluzzo

Flying Discs 'Old Story,' Says Italian

ROME, March 24 (Æ)—An Italian scientist said today that types of flying discs were designed and studied in Germany and Italy as early as 1942.

Adolph Hitler and Benito Mussolini, he added, were interested in the instruments, and the idea was developed concurrently both in Italy and Germany.

Flying discs or saucers have been reported sighted recently in many parts of the world. There has been no scientific confirmation of the existence of such things, nor any universally accepted explanation of what their purpose might be.

The Italian scientist, Giuseppe Belluzzo, noted Italian authority on projectiles and cannons and builder in 1905 of the first steam turbine in Italy, made his declarations in Rome's independent Giornale d'Italia.

Frequent Reports

"There is nothing supernatural or Martian about flying discs," he said; "but they are simply rational application of recent technique."

Prof. Belluzzo expressed the opinion "some great power is launching discs to study them."

Reports of flying discs in Italian skies have been frequent. The latest report came last night from Northern Turin, where several persons said they saw a saucer speeding across the moonlit sky leaving a fiery trail.

GIUSEPPE BELLUZZO, SCIENTIST, ECONOMIST

ROME, May 22 (Æ) — Giuseppe Belluzzo, Italian scientist and former Cabinet Minister, died here today at the age of 76.

An authority on projectiles and cannons, he reportedly drew up plans for a flying disc which were shown to Adolf Hitler.

Professor Belluzzo, a former Deputy, Senator and Minister of National Economy under Mussolini, said in a newspaper article in March, 1950, "there is nothing supernatural or Martian about flying discs. They are simply rational application of recent technique." He expressed a belief then that "some great power now is launching discs to study them."

In 1905, he built the first steam turbine in Italy.

As Minister of National Economy, Professor Belluzzo told the Italian Chamber in 1927 that Italian industrialists should adopt American industrial organization as their aim. He admitted, however, that Italy could not hope to reach the "rhythm of production and wages existing in America."

He said that Italian manufacturers should reduce the cost of production through technical improvement rather than lowered wages.

In the same year, he noted the tendency of farm youth to migrate toward urban areas and characterized this before the Senate as "pernicious, pathological, anti-social and uneconomic." Signor Belluzzo urged that youths be judged fit or unfit for city life, and that life on farms be made more attractive by grants for agriculture and free education.

On the left, a column from The Mirror, dated March 24, 1950. This is one of the earliest English references to German flying discs. On the right is Dr. Belluzzo's obituary, dated May 22, 1952 from the New York Times which again mentions German flying discs.

he further identifies the very same industrial firms which supported Schriever-Habermohl as supporting this project (12). In reality, both should be viewed as one project with different aspects.

The designs envisioned by Dr. Miethe and Professor Belluzzo were quite different from those of Schriever and Habermohl. Designs of this project consisted of a discus-shaped craft whose outer periphery did not rotate. Two designs have positively been attributed to Miethe and Belluzzo although three designs exist as part of their legacy.

The first design is made known to us from Georg Klein's article in the October 16, 1954 edition of the Swiss newspaper, Tages-Anzeiger fuer Stadt und Kanton Zuerich, mentioned above. The same design is reproduced in the book by J. Andreas Epp. This saucer was not intended to take-off vertically but at an angle as does a conventional airplane. In this design twelve jet engines are shown to be mounted "outboard" to power the craft. The cockpit was mounted at the rear of the vehicle and a periscope used to monitor directions visually impaired. Notably, a large gyroscope mounted internally at the center of the craft provided stability. This and other Miethe-Belluzzo designs were said to be 42 meters or 138 feet in diameter.

Aeronautical writer Hans Justus Meier has challenged this design on a number of grounds (13). It is certainly possible, if not probable, that the outboard jet-turbine arrangement is incorrect. One might ask, if this was an outboard jet-turbine design, then what purpose did the bloated central body serve? In reality the twelve jets may simply have been jet nozzles of one engine. Certainly the large central body had a function, it must have housed the engine.

But how could the authenticity of this design come under question when Georg Klein is vouching for it in his article? The answer may be that Klein never saw this design himself and he simply is relying on the descriptions of those that did. If one reads the works of Klein carefully, he never claims to have seen this model in flight. As a matter of fact, he never claims to have actually seen this design at all. We will return to the flaws with Klein's description momentarily.

The second Miethe design seems to have originated with a 1975 German magazine article (14). This version shows a cockpit above and below the center of the craft. Four jet engines lying behind the cockpits are shown as the powerplants. No real detail is supplied in this article. This design is not ever discussed in the text which deals primarily with the Schriever-Habermohl Project. Some writers have speculated on this particular design, supplying detail (15). For now, however, no named source seems to be able to link this design with the Miethe-Belluzzo Project. Therefore, at least for the time being, we must put this design in suspense and focus on the first and next design in discussing

The Miethe-Belluzzo Disc--Design One

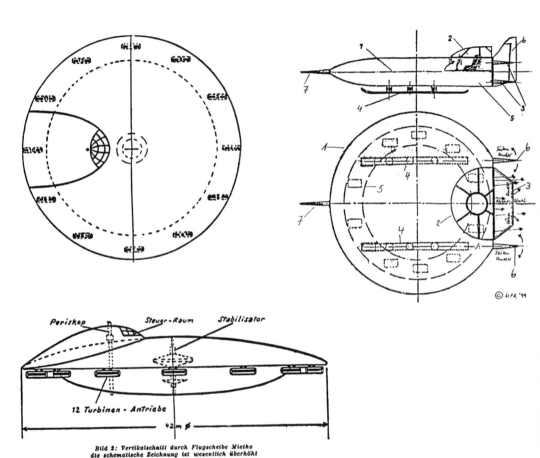

Bild 2: Vertikalschnitt durch Flugscheibe Miethe
die schematische Zeichnung ist wesentlich überhöht

On the left is a reconstruction by Georg Klein, 10/16/54,
from the Swiss newswaper Tages-Anzeiger. Note the small
"Stabisator" and the outboard jet engines. On the right
is Klaus-Peter Rothkugel's more probable reconstruction
incorporating fins, skids, and the inner-lying Rene Leduc
engine.

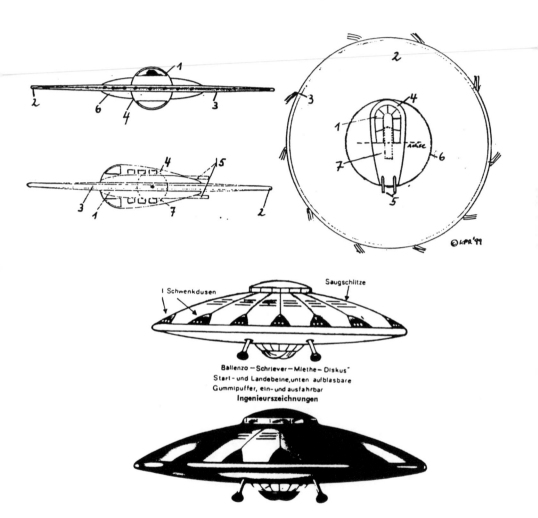

On the top is Miethe-Belluzzo design two. Note rotating disc (2) and stabilizing wheel (7) acting as a gyroscope. (Courtesy of Klaus-Peter Rothkugel) It is the author's opinion that this design was never built. On the bottom is Miethe-Belluzzo design three, capable of vertical take-off.

the aforementioned saucer project.

The third design attributed to the Miethe-Belluzzo Project comes to us from and article by Jan Holberg in an August 20, 1966 article in Das Neue Zeitalter and also from Michael X. Barton-Carl F. Mayer-Hermann Klaas connection (16) (17). This design was capable of vertical take-off. Klaas provides internal detail which has been reproduced here.

At first, this appears to be a push-pull propeller system driven by a single engine. It is not. Neither are the twelve jet nozzles unsupported in any way as depicted. The real answer to this mystery is that this drawing is incomplete. With the completed parts depicted, a radial turbojet engine of special type would appear. Design one differs from design three in that the latter, with its centrally located cabin and symmetrical arrangement of twelve adjustable jet nozzles, is controlled by selectively shutting off various jets through the use of a surrounding ring. This allows the saucer to make turns and to take off vertically.

Recently, a German researcher, Klaus-Peter Rothkugel using Vesco as his source (18), has proposed an engine which links the designs one and three, and possibly even design two, while supplying the missing pieces needed to make the engine depicted air-worthy and resolves other problems. This engine was invented by a French engineer, Rene Leduc and probably acquired by the Germans during their occupation of France.

If a flying saucer equipped with this engine were viewed from the outside, no rotating parts would be visible. This is because the engine was totally contained within the metal skin of the saucer. It did rotate but this rotation was within the saucer itself and not viable from the outside. An air space existed all around the spinning engine, between it and the non-rotating outer skin. This engine was a type of radial-flow jet engine. It was this type of engine which probably powered all of Dr. Miethe's saucer designs. It is also the prime candidate for the post-war design of John Frost, the "Flying Manta."

The Flying Manta actually did fly. Pictures of it during a test flight are unmistakable. They were taken on July 7, 1947 by William A. Rhodes over Phoenix, Arizona. It almost goes without saying that the time frame, July of 1947, as well as the geographical location, the American Southwest, as well as the description of the flying object itself, beg comparisons to the saucer which crashed at Rosewell, New Mexico, earlier that same month.

If one looks at what is known of Dr. Miethe's saucer design, the Leduc engine, and the Frost Manta, it must be acknowledged that a connection between these three not only explains apparent inconsistencies in the existing Miethe designs but also links them to the post-war American Southwest, the precise spot where

The Rene Leduc Engine

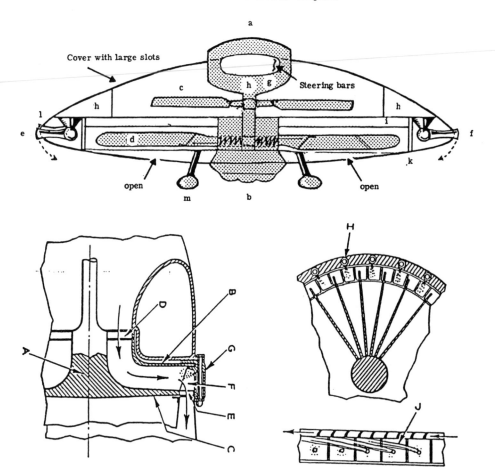

Top: Hermann Klaas' diagram of the workings of the Miethe-Belluzzo Disc. Note: intake screw (c) Carrying wing blade (d)affixed to a piston engine, jets nozzles (e) with no apparent engines. Close but not exactly right. Bottom: Leduc design. A-Rotor B-Front Bulk-head C-Rear Bulk-head D-Intake Vane E-Compressor Vane F-Combustion Chamber G-Bulk-head H-Fuel Injection Jets J-Fixed Flame Ring From I Velivoli Del Mistero I segreti technici dei dischi volanti by Renato Vesco

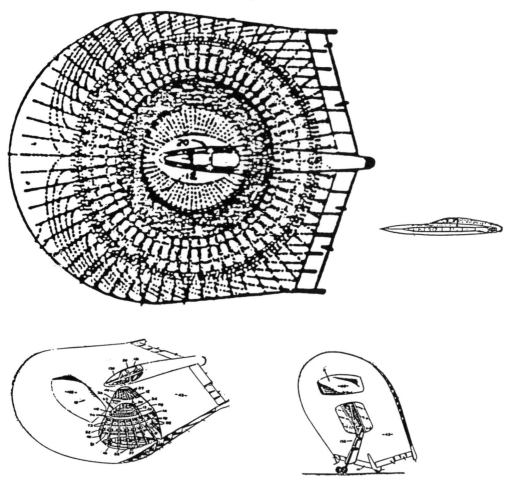

This is the mounting of the Leduc engine as illustrated by the later Avro diagram (Canada-USA). The outer hull is fixed. The inner rotating engine draws in the air from between it and the hull and exhausts through rear or sides as needed for steering. Compare this design to Miethe-Belluzzo designs, especially to the first design.

captured German World War Two technology was being tested and evaluated.

There is considerable confusion as to where the first test flight of the Miethe-Belluzzo saucer occurred. Epp tells us that models made by this team were flight tested since 1943. Georg Klein, as well as Andreas Epp, state that a test model of this craft took off from Stettin, in northern Germany, near Peenemuende, roughly where the Oder River meets the Baltic, and crashed in Spitsbergen which are the islands to the north of Norway.

A manned test flight in December, 1944 has been mentioned by Norbert Juergen-Ratthofer and Ralf Ettl in one of the films on which they worked. The pilot named was Joachim Roehlicke or perhaps Hans-Joachim Roehlicke (19). Klaus-Peter Rothkugel reports that Roehlicke was under the direction of none other than Dr. Hans Kammler himself and was stationed at the Gotha Wagonfabrik company (20). The Gotha Wagonfabrik company is in the Jonas Valley in Thuringia. This valley was packed full of high-tech underground facilities which included nuclear research. Roehlicke confided to his daughter after the war, according to Mr. Rothkugel, that he "had seen the earth from above" (21).

Confusion over the test details of the Miethe-Belluzzo saucer start as early as the whole German flying disc controversy itself in the 1950s. In the English translation of his book, titled <u>Brighter than a Thousand Suns A Personal History Of The Atomic Scientists</u>, a footnote appeared which deviated from the discussion of atomic weaponry. This 1958 description is one of the first in English and may illustrate some of the difficulties in sorting out this information:

" *The only exception to the lack of interest shown by authority was constituted by the Air Ministry. The Air Force research workers were in a peculiar position. The produced interesting new types of aircraft such as the Delta (triangular) and "flying discs." The first of these "flying saucers," as they were later called--circular in shape, with a diameter of some 45 yards--were built by the specialists Schriever, Habermohl and Miethe. They were first airborne on February 14, 1945, over Prague and reached in three minutes a height of nearly eight miles. They had a flying speed of 1250 m.p.h. which was doubled in subsequent tests. It is believed that after the war Habermohl fell into the hands of the Russians. Miethe developed at a later date similar "flying saucers" at A. V. Roe and Company for the United States." (22).

One big difference between the Miethe-Belluzzo design and the Schriever-Habermohl designs is that the former craft was alleged to have, or be designed to have, a longer flight range. This point is reinforced by the Spitzbergen flight mentioned above. Klein states that the Germans considered long range, remote controlled attack from Germany to New York using this craft.

Miethe-Belluzzo Saucer In Flight

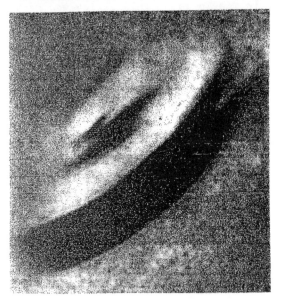

Top picture is of a September 6, 1952 article in the
Italian newspaper "Tempo". This article deals with the
work of Dr. Miethe and features a photograph of his saucer
allegedly dated April 17, 1944, taken over the Baltic.
Bottom is an enlargement of the photograph. It seems to be
a Miethe-Belluzzo type 1 but could also be a type 3.
Courtesy of Klaus-Peter Rothkugel.

As stated earlier, both projects were under the same authority. Experts and advisors included, according to Epp, among others, head-designer Kalkert of the Gotha Waggonfabrik, head-designer Guenther of Heinkel, engineer Wulf of Arado, engineer Otto Lange of the RLM, and engineer Alexander Lippish of Messerschmitt. Pilots were Holm, Irmler, Kaiser and Lange. The test pilot was Rudolf Schriever.

There does exist two alleged still pictures of the Miethe craft in flight. One is reproduced here. It may be the first design. A picture claiming to be of what is called here the third design can be found in W. Mattern's book, UFO's Unbekanntes Flugobjekt? Letzte Geheimwaffe Des Dritten Reiches? (23). Efforts have been made to acquire the picture for this book but the inquiry went unanswered by the book's publisher.

Politically, in 1944, Heinrich Himmler, head of the SS, replaced Albert Speer's appointee, Georg Klein, with Dr. Hans Kammler as overseer of this combined saucer project (24). This is a little confusing, however, since Kammler retained Klein as his employee. Perhaps a more practical way to look at this is that Kammler, Himmler's employee, replaced Speer while Klein did what he always did. The result was that the SS took direct and absolute control over these projects from this point until the end of the war.

Prior to this happening, news of these designs or application itself was made to the German Patent Office. All German wartime patents were carried off as booty by the Allies. This amounted to truckloads of information. Fortunately, Rudolf Lusar, an engineer who worked in the German Patent Office during this time period, wrote a book in the 1950s listing and describing some of the more interesting patents and processes based upon his memory of them (25). They are surprisingly detailed. Included is the Schriever saucer design with detail. Also discussed is the Miethe project.

The significance of these two teams can not be minimized in the history of flying saucers or UFOs. Already in this brief discussion, the evidence, taken as a whole, is overwhelming. Please compare this to any and all extraterrestrial explanations of flying saucers. Here we have Germans who claim to have invented the idea of the flying saucer. We have Germans who claim to have designed flying saucers. We have Germans who claim to have built flying saucers. We have Germans who claim to have flown flying saucers. We have Germans who claim to be witnesses to flying saucers known beforehand to be of German construction. We have German construction details. And finally, we have a man who took pictures of a known German flying saucer in flight. The facts speak for themselves. During the Second World War the Germans built devices we would all call today "flying saucers". No other UFO explanation can even approach this in terms of level of proof.

Miethe-Belluzzo Saucer In America?

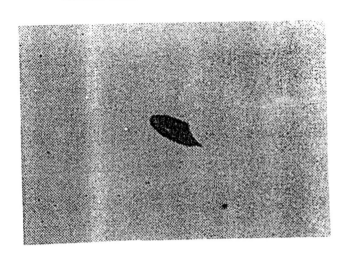

Top: a picture from the July 9, 1947 edition of the Arizona Republic taken by William A. Rhodes as it flew over his home in Phoenix. Lower Left: a drawing of the craft by Klaus-Peter Rothkugel. Lower Right: one view of the Avro Frost-Manta design, predating the Silver Bug Project. Was this a captured Miethe-Belluzzo-Leduc saucer?

Sources and References

1. Klein, Georg, 10/16/54, page 5, "Die "Fliegenden Teller"", Tages-Anzeiger fuer Stadt und Kanton Zuerich

2. Epp, J. Andreas, 1994, page 34

3. Barton, Michael X., 1968, page 58, <u>The German Saucer Story</u>, Futura Press, 5949 Gregory Avenue, Los Angeles, CA. 90038

4. Lusar, Rudolf, 1964, page 220, <u>Die deutschen Waffen und Geheimwaffen des 2. Weltkrieges und ihre Weiterentwicklung</u>, J.F. Lehmanns Verlang, Munich

5. Epp, J. Andreas, 1994, pages 30-31

6. ibid

7. Epp, J. Andreas, 1994, pages 26-27

8. Epp, J. Andreas, 1994, page 30

9. Klein, Georg, 10/16/54, page 5

10. Zwicky, Viktor, 9/18/54, page 4, "Das Raetsel der Fliegenden Teller", Tages-Anzeiger fuer Stadt und Kanton Zuerich

11. Klein, Georg, 10/16/54, page 5

12. Epp, J. Andreas, 1994, pages 30 and 31

13. Meier, Hans Justus, 1995, "Die Miethe-Flugscheibe-eine reichlich nebuloese Erfindung", Flieger-Kalender 1995, E.S. Mettler & Sohn, text editing: Hans M. Namislo, Celsius-Str. 56, 53125 Bonn, Germany

14. Luftfahrt International, May-June, 1975, "Deutsche Flugkreisel Gab's die?"

15. J. Miranda and P. Mercado, 1998, Flugzeug Profile, page 25-27

16. Holberg, Jan, 8/20/54, "UFOs gibt es nicht! Wohl aber: Flugscheiben am laufenden Band!", Das Neue Zeitalter

17. Barton, Michael X., 1968, pages 42, 63, 64

18. Vesco, Renato, 1974, from photos and diagrams begining on page 392, <u>I Velivoli Del Mistero I segreti tecnici dei dischi volanti</u>, U Mursia editore, Via Tadiuo 29, Milan, Italy

19. Video film, "UFOs Das Dritte Reich Schlaegt Zurueck?", 1988, Tempelhof Gesellschaft, Wien, Available through Dr. Michael Damboeck Verlag, Markt 86, A-3321, Ardaggr, Austria

20. Rothkugel, Klaus-Peter, 2000, page 4, "Baute Peenemuende
 ueberschallschnelle Flugscheiben?", four page information
 sheet concerning supersonic and high altitude saucer
 construction at Peenemuende, Bad Nauheim, Germany

21. ibid

22. Jungk, Robert, 1958, page 87, <u>Brighter than a Thousand Suns A
 Personal History Of The Atomic Scientists</u>, Harcourt, Brace
 and Company, New York, translated by James Cleugh from <u>Heller
 als tausend Sonnen</u>, 1956, Alfred Scherz Verlag, Bern

23. Mattern, W., date unknown, page 34, <u>UFO's Unbekanntes
 Flugobjekt? Letzte Geheimwaffe Des Dritten Reiches?</u>, Samisdat
 Publishers LTD, 206 Carlton Street, Toronto, Canada M5A 2LI

24. Epp, J. Andreas, 1997. page 33

25. Lusar, Rudolf, 1960, (English version) <u>German Secret Weapons
 of the Second World War</u>, Neville Spearman Limited, 112
 Whitfield St., London W.1, England

Foo Fighters

"Foo fighter" is a name given to a small, round flying object which followed Allied bombers over Germany during the latter phases of the air war. There are also some reports of foo fighters in the Pacific theater of the war. Sometimes they would appear singularly but more often in groups, sometimes flying in formation. By day they appeared to be small metallic globes. By night they glowed with various colors. These object attempted to approach Allied bombers closely which scared the bomber crews who assumed they were hostile and might explode. Upon taking evasive maneuvers they found the foo fighters would keep pace with them in some instances. Besides the name foo fighter this device is sometimes called "Feuerball", its German name or its English translation, fireball. More about names later.

For those readers who have not been exposed to foo fighters before, following is an American flight account found in Intercept UFO by Renato Vesco:

"At 0600 (on December 22) near Hagenau, at 10,000 feet altitude, two very bright lights climbed toward us from the ground. The leveled off and stayed on the tail of our plane. They were huge bright orange lights. They stayed there for two minutes. On my tail all the time. They were under perfect control (by operators of the ground). They turned away from us, and the fire seemed to go out".

Vesco goes on to say:

"The rest of the report was censored. Apparently it went on to mention the plan's radar and its sudden malfunctioning" (1).

Flying saucer books of the 1950s usually mentioned foo fighters and recounted the sightings of Allied servicemen. Later, due to the extraterrestrial hysteria, publications tended to omit descriptions of foo fighters, preferring to begin the tale of flying saucers with Kenneth Arnold in 1947.

In modern times, if they are mentioned at all by mainstream UFO magazines or books, an attempt is sometimes made to confuse the issue of the origin of foo fighters in one of three ways. First, they say or imply that both sides in World War Two thought foo fighters were a weapon belonging to the opposite side. They may cite as a source some German pilot obviously "out of the loop" who claims the Germans did not know their origin. Second, they attempt to advance the idea that foo fighters are still unknown and a mystery or possibly a naturally occurring phenomenon. Third, they advance an extraterrestrial origin.

It is difficult to imagine a vast bad faith plot, extending over years, which attempts to discredit or confuse the issue of foo fighters. Perhaps the authors of these UFO magazines and books

69

SUPREME HEADQUARTERS, Dec. 13 (Reuter)—The Germans have produced a "secret" weapon in keeping with the Christmas season.

The new device, apparently an air defense weapon, resembles the huge glass balls that adorn Christmas trees.

There was no information available as to what holds them up like stars in the sky, what is in them, or what their purpose is supposed to be.

Floating Mystery Ball Is New Nazi Air Weapon

SUPREME HEADQUARTERS, Allied Expeditionary Force, Dec. 13—A new German weapon has made its appearance on the western air front. It was disclosed today.

Airmen of the American Air Force report that they are encountering silver colored spheres in the air over German territory. The spheres are encountered either singly or in clusters. Sometimes they are semi-translucent.

Top: A Reuters report from December 13, 1944
Bottom: The New York Times, December 14, 1944

70

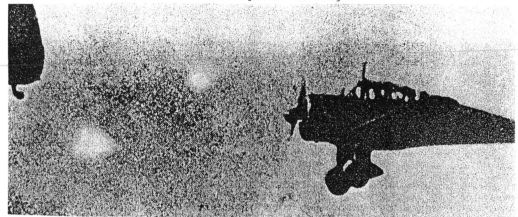

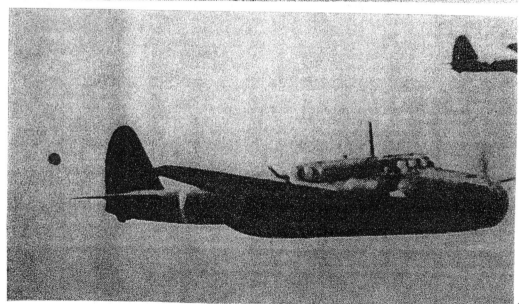

Top: At night or in dim light foo fighters appeared luminescent. Bottom: In strong light foo fighters appeared as silvery balls. This picture was taken over the Pacific in 1943. There are many stories speaking of small, round flying balls sent to Japan by the Germans via submarine.

are truly without a clue and simply perpetuating old and bad information as a convenient explanation. In any event, it is now clear they utterly failed to do their homework on foo fighters before writing about them.

The U.S. military, too, has always denied knowledge of foo fighters. Numerous Freedom Of Information Act (FOIA) requests have been filed, for instance, by this writer as well as other researchers asking for information on foo fighters. A "no record" response always followed. All U.S. governmental agencies queried claimed that they had never heard of foo fighters. This happened in spite of the fact that all known alternate names for foo fighters were submitted as well as a detailed description of the device itself. This was the situation until the late 1990s.

Vesco is by far the best source concerning the foo fighter which he calls "Feuerball". He describes it as a radio controlled missile, built at an aeronautical establishment at Wiener Neustadt (Austria) with assistance of the Flugfunk Forschungsanstalt (Radio-Flight Research Installation) of Oberpfaffenhoffen. The project was under the control of an SS technical division. It was armored, circular in shape, resembling the shell of a tortoise. The device was powered by special flat, circular a turbojet engine. After being guided to the proximity of the target from the ground, an automatic infra-red tracking device took over control. The circular spinning turbojet exhaust created a visual effect of a bright, fiery ball in the nighttime sky. Within the craft itself a klystron tube pulsated at the frequency of Allied radar making it almost invisible to those remote eyes. A thin sheet of aluminum encircled the device immediately under the layer of protective armor but was electrically insulated from the armor. Once a bullet pierced the armor and the thin aluminum sheet, a circuit was formed which had the effect of triggering the Feuerball to climb out of danger at full speed (2).

Once within range, special chemical additives were added to the fuel mixture which caused the air in the vicinity of the device to become ionized. This meant that electricity could be conducted directly through the air itself (3). Any ignition-based engine coming into range of the ionized region would become useless, misfiring, stalling and eventually crashing.

Vesco goes on to say that with the advance of the Soviets into Austria the production facilities for the Feuerball were moved to a number of underground plants in the Black Forest run by the Zeppelin Works (4).

Recently an Austrian researcher, Kadmon, who specializes in uncovering the esoteric, sent to me a copy of a letter describing details of the foo fighter from the German perspective. This letter is reproduced here for those who read German language. It is a letter from physicist Friedrich Lachner to Professor, Dr. Alois Fritsch. The letter tells Dr. Fritsch that in an aircraft

72

plant which was a branch of Messerschmitt at Weiner-Neustadt, Austria, a test model of a flying craft was built with a diameter of five meters which presumably made a test flight to Vienna. "His Martha", his wife, saw the outline of an exactly elliptical flying object in the twilight which appeared to her to be operating by some other means of flight that was normally the case because of its sudden directional changes. Her reaction was that it was an enemy flying object and it scared her. After the bomber attack on the plant, a doctor, "Oskar L." saw a model of this frightful thing in the plant also and had no idea of what it was. The astronomer Waehnl was, during the war, employed calculating construction costs at this aircraft facility where she had earlier in life learned something of aircraft technology from her father. She confirmed it also. Lachner briefly spoke with an engineer named Kuehnelt who worked as in flight technology for the German Army. He explained to Lachner that he saw such a device with a diameter of fifteen meters. Lachner says that he had known for some years about a machine with a thirty meter diameter. He also says that he had gotten to know a flight engineer named Klein when he was active near the flight testing of the supreme chief General Udet. Lachner claims that "Klein had something to do with these things". One or more unmanned and remote controlled of this sort of spinning-top-like flying objects are mentioned by Lachner in connection with the massive Allied bomber raids on the ball-bearing plant at Wuerzburg. Finally, Lachner goes on to say that a Professor Richter built these devices for Peron in Argentina. A long distance test-flight was actually flown to the United States. There the device was intercepted and an American pilot was shot down. The remainder of the letter concerns nuclear developments in Austria and the USA before and after the Second World War and misunderstandings by Lusar in his book.

This letter was written in 1975. Details concerning Klein and the larger flying objects were in print by that time. There are important confirmations within this letter. These are revelations concerning Lachner's wife as an eyewitness to the object in twilight flight, the medical witness who saw the object within the plant at Wiener-Neustadt, and the confirmation of the astronomer, Waehnl. Unfortunately, Kadmon advises that Dr. Waehnl is now deceased. The important point is that these are real people with real names. Most of whom were alive at the time of this letter. Further, some of these people were scientists with a reputation at stake yet they did not disavow the substance of this letter in any way.

In the closing months of the last millennium witnessed a breakthrough regarding foo fighters. The break came by accident and from the government of the United States. Remember, Freedom Of Information Act requests regarding foo fighters had been filed with many branches of the U.S. military and intelligence services as well as with their repository, the National Archives. Even though all known alternative names were included, as well as a detailed description of the device in question was provided, a

Austrian Atomic Scientist Professor Friedrich Lachner's Letter

Sehr geehrter Herr Dr. Fritsch!

Besten Dank für Ihren Brief mit den Flugkreisel-Ablichtungen. Im Kriege hörte ich davon in Fachkreisen. In der Wiener Neustädter Flugzeugfabrik die ein Filialbetrieb der Messerschmitt-Werke war, wurde ein Versuchsmodell von 5 m Durchmesser hergestellt, das vermutlich auch Versuchsflüge bis nach Wien gemacht hat. Meine Martha sah einmal so ein wegen der Perspektive ziemlich genau elliptisch aussehendes Ding, wobei ihr die ganz anders geartete Art des Fluges auffiel, nämlich auch ganz plötzliche Richtungsänderungen. Sie konnte gut sehen, da es nur wenig dämmerig war und noch sehr hell. Am Flugkörper war in der Mitte noch etwas dran. Sie hielt das Ding als etwas feindliches und lief ängstlich heim und hat dann nicht mehr sehr genau hin gesehn. Gleich nach dem schweren Bombenangriff auf die Flugzeugfabrik, den ich vom Berg bei Fischau aus sah, war mein Vetter der Medizinalrat OSKAR L. drinnen um Verletzten zu helfen. Dabei sah er ein solches arg beschädiges Modell und wusste aber damals nicht was es war. Die Astronomin WÄHNL war im Kriege auch als Konstruktionsberechnerin in dieser Flugzeugfabrik, da sie ja auch schon früher von ihrem Vater flugzeugtechïsche Kenntnisse hatte. Auch sie hat es bestätigt. Kürzlich sprach ich mit einem Ing. (Kühnelt) der als Flugtéchniker bei der Wehrmacht war und der mir von einem solchen Gerät mit 15 m Durchmesser, das er sah, erzählte. Schon vor vielen Jahren habe ich von einem mit 30 m Durchmesser erfahren. Einen Flugingeniur KLEIN habe ich, als ich bei der Flugerprobung (oberster Chef General UDET) tätig war, kennengelernt, der mit solchen Dingen zu tun hatte. Einmal ist er wenige Meter vor mir abgestürzt. Obwohl das Flugzeug zerbrach ist ihm nicht viel geschehen. Ich führte ihn damals gleich zum Flugchef.

Ein (oder mehrere) unbemannter ferngesteuerter Kreisel-Flugzeugkörper dieser Art, wurde in Würzburg (F.u.S. — Werke für Kugellager) dem damals dicht beieinander fliegenden Bombepulk zum Verhängnis (400 Bomber an einem Tag erlegt). Ich hörte dass Prof. RICHTER für den PERON in Argentinien den Bau solcher Geräte organisiert und konstruiert hat, wobei es weite Versuchsflüge bis USA gab. Ein USA-Flieger der sich feindlich entgegenstellte, wurde abgeschossen. Als RICHTER noch in Wien war, haben wir Vorlesungen bei Prof. SMEKAL besucht. SMEKAL hat Kernreaktionen an die Tafel geschrieben für Atombomben und Atommeiler, auch lange vor dem 2. Krieg und über die Tritium-Lithium-Atombombe, die erst jetzt die USA realisiert, wie ich erfahren habe. Wien war weit voraus wenigstens in der Theorie. Da man damals den Betrag der kritischen Masse nicht genau wusste, fand ich durch einen Konstruktionstrick einen Ausweg, der aber bald nicht mehr nötig war. LUSAR hat meine Angaben missverstanden, da ich mit meinen Angaben, ja keineswegs behauptete Atombombenerfinder zu sein. Die Grundidee hatte ja schon HASENOHRL 1904, wie mir Prof. MACHE mitteilte, bei dem ich Assistent war. Eine Abschrift dieser Angaben von mir (Physiker-Ing. F. LACHNER) können Sie mit Zitierung der Fachzeitschrift mitteilen. Was das LACHNER-Gerät zur Verbesserung des Auflösungsvermögens betrifft, dessen Priorität mir von Prof. R. entwendet wurde, da er mich als Urheber des Grundgedankens, samt Konstruktion und Theorie nicht zitiert hat, so kann ich Ihnen mitteilen, dass bereits einige Hochschulprofessoren erklärt haben für meine Priorität einzutreten. Auch Prof. THURING sollte davon erfahren. Er war im Kriege Leiter der Wiener Sternwarte, wo jetzt R. ist.

Mit freundlichem Grusse usw.

FRIEDRICH LACHNER

Zaprimijeno, decembar 1975.
Adresa autora: Prof. Phys.-Ing. Friedrich Lachner
A — 1140 Wien, Linzerstr. 415/1/6, Österreich.

Professor Lachner describes a sighting of a foo fighter by none other than his wife, Martha. Lachner mentions that he heard that Professor Richter built these devices for Juan Peron in Argentina. This, incidently, is the same Professor Richter involved in an ill-fated attempt to produce fusion generators for Peron.

"no record" response was uniformly generated by all facets of government.

A German researcher, Friedrich Georg, recognized a valuable entry in a microfilm roll, titled a 1944 U.S. Strategic Air Forces In Europe summary titled An Evaluation Of German Capabilities In 1945, which, somehow, had eluded the censors (5). In that summary report German devices called by American Intelligence "Phoo Bombs" are discussed. Sources for this summary were reports of pilots and testimony of prisoners of war. Phoo bombs were described as "radio-controlled, jet-propelled, still-nosed, short-range, high performance ramming weapons for use against bombing formations". Speed was estimated at 525 miles per hour.

Further demands were made using FOIA as to the raw data used to compile the summary evaluation. Of course, denials followed, but finally, after an Appeal, the government indicated that more information did exist concerning Phoo Bombs. Most of this was a repeat or re-statement of the summary document. One document was hand-written and may have served as the basic text of the report.

It seems the U.S. Air Force was never aware of a threat to aircraft engines coming from over ionization of the air around these devices. Likewise, the claim by Vesco that they possessed klyston tubes which pulsed at the same frequency of Allied radar and so jammed radar on board was not recognized. Vesco cites the aircraft radio research institute at Oberpfaffenhofen (F.F.O.) as having invented such devices (6).

The Combined Intelligence Objectives Sub-Committee report on this facility, Report 156, states that work there involved several types of klystron tubes and that one of this facilities principal functions was inventing technology to jam Allied radar. Unfortunately all the secret material held at this facility was burned in the face of the advancing Allies. Individual scientists later produces some copies of documents which represent what the Allied intelligence strike teams took away. Exactly how complete this sample was we will never know (7).

Other very exotic research did go on at the F.F.O. installation which might be mentioned. They not only did work on klystron tubes but on magnetrons also. They did work on generation of millimeter range radio wave through the use of crystal vibrations. They also experimented with silicon and germanium "crystals" (8). These two substances figure prominently in the making of what we call today semiconductors which form the basis of the transistor. Invention of the transistor is credited to William Shockley, for which he won the Nobel Prize, about two years after the Second World War.

This bit of research explodes an argument made by the late Col. Philip J. Corso in his book The Day After Roswell that transistors were, at least in part, based upon alien technology (9). The only questions which remain are: exactly how far the

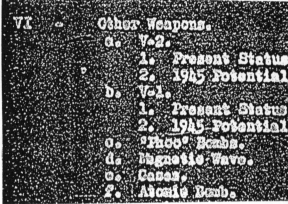

U.S. government's own documents prove they knew of the German origin of foo fighters. This table of contents of a "Intelligence Digest" document, with a February, 1945 date, addresses German military capacities. It lists "Phoo Bombs" as a weapon in the German arsenal (see VI- Other Weapons) Taken from microfilm negative image.

HEADQUARTERS

UNITED STATES STRATEGIC AIR FORCES IN EUROPE
OFFICE OF THE DIRECTOR OF INTELLIGENCE

AN EVALUATION OF GERMAN CAPABILITIES

IN 1945

This document, fascinating in its own right, serves as a
translation. "Foo fighters are "Phoo Bombs" in the
government's parlance. No more "no record" name-games from
the government.

A UFO Rosetta Stone

TOP SECRET

PART SIX – OTHER WEAPONS

1. In the following paragrpahs are listed the actual or potential weapons which the Germans may use against UsSTAF operations in 1945. For the most part they include the so-called V weapons. No consideration is given to those for which there is lacking evidence of possible us e for some time to come. Both V-1 and V-2 are considered in this analysis because, even though they are, in effect, long-range artillery, they do possess the ability to affect our operations by hitting airfields, and supplies enroute and in concentrations.

2. V-2:

 a. Present status. The V-2, or rocket projectile, with a warhead of approximately one ton, and a current range of 225 miles; is being fired at London at the rate of 180/250 per month, and against Continental ports at the rate of approximately 300 per month.

 Against London its accuracy is currently rated at 3.2/1,000 per square mile at the main point of impact. Against Continental ports it is estimated at the least 6.1/1,000 per square mile at the main point of impact. The best record was 75 in a twenty-four hour period within a four square mile area of the Antwerp Docks.

 b. 1945 Potential: The German plan calls for an increase in montly production from 600 to 1200. It is known, however, that any increase would be at the expense of the aircraft industry in radio equipment and certain essential components. An increase in accuracy would depend upon increased firings and increased use of already proved radio equipment, without which the majority of firings are conducted today. It is thought unlikely that range will be materially increased. Accuracy begins to f al l off somewhere between 165 and 190 miles, and becomes increasingly inaccurate to the maximum of 225 miles. Whether or not V-2 becomes an increased menace in 1945 must depend upon the position of the aircraft industry and its requirements. Its potential lies in stabilization of the expanding aircraft program.

 Larger rockets (68 feet in length as against 45 feet) are known to exist, and may appear in small quantities during the year. They would have a considerably larger warhead.

3. V-1:

 a. Present Status: The so-called Flying Bomb is being fired from launching ramps against Continental targets, ports and supply concentrations, at the rate of 600 per month, and against England by airborne launchings, at the rate of 250 per month. Accuracy against Continental targets is now between 11.0/1,000 per square mile at main point of impact, and against England at 3.3/1,000 per square mile at main point of impact.

 b. 1945 Potential: Here again, the German plan calls for an expansion in production, but, as in the case of V-2, this expansion must be at the expense of other vital industries. Authoritative estimates state that airborne launchings against England may reach 450 per month, and that a very substantial increase of launchings on the Continent will take place. On the other hand, the number of He-111s available for airborne launchings is distinctly limited, and the demands of other industries are such that the expanded production may not be carried out as planned.

4. "FROG" BOMBS: Occasionally reports by pilots and the testimony of prisoners of war and escapees describe this weapon as a radio-controlled, jet-propelled, still-nosed, short-range, high performance ramming weapon, for use against bombing formations. Its speed is estimated at 525 mph

TOP SECRET

T
H
I
S

P
A
G
E
—
I
S

U
N
C
L
A
S
S
I
F
I
E
D

A UFO Rosetta Stone

~~SECRET~~

and it is estimated to have an endurance of 25 minutes. These bombs are launched from local airfields, and are radio-controlled, either from the ground, or possibly by aircraft. The few incidents reported by pilots indicate no success. They have passed over formations, and performed various antics in the vicinity of formations. It is believed that in order to be effective some 100/200 would have to be launched against a formation, and it is also believed that they will not be produced in sufficient quantities to prove a real menace in 1945.

5. MAGNETIC WAVE: The best information available is from very secret and reliable sources, and forces the conclusion that this weapon exists as a possibility. It is designed to cause failure of various electrical apparatus in aircraft. Technically it does not appear to be a possible serious threat in 1945. At most it would be effective at a few locations for preventing ground strafing. Evidence to date indicates that it could have little effect against high level attack, since the apparatus would be too cumbersome to permit its use in aircraft.

6. GASES APPLICABLE TO AIRCRAFT: Two types of gases applicable to aircraft are known. One is designed to cause pre-ignition, blowing the heads off cylinders; and the other is designed to break down the viscosity of lubricating oils. Under laboratory conditions, free from operational considerations, these gases are a distinct possibility. It is doubtful, however, that with proper fighter escorts a sufficient concentration of either of these gases could be thrown against our formations to have any serious effect. Similarly, it is doubted whether sufficient anti-aircraft guns are available to produce an effective concentration, and it is probably that any possible concentration would be no more effective than a similar amount of well-directed flak.

7. ATOMIC BOMB: Close check of every report, and close surveillance of the area in which tests are alleged to have taken place lead to the conclusion that such bombs are not a likelihood in 1945.

~~SECRET~~

Obtained in a Freedom Of Information Act asking for more information after learning the government's code word for foo fighters ("Phoo Bombs").

Germans progressed in their work on semiconductors and should the scientists at the F.F.O. have been given credit for this discovery, the transistor, instead of Shockley? This example also illustrates exactly how far the military will go, or at least individuals in the military, to perpetuate the notion of high-technology derived from aliens. It also illustrates the willingness of large establishment publishing firms to assist in the propagation of these ideas.

Returning to the subject of foo fighters and the governments suppression of this information, it seems the government feels it has the right to deny FOIA requests, no matter how detailed the description may be, unless the requestor uses exactly the same name as the government uses. Was the name "foo fighters" as opposed to "Phoo Bombs" just not close enough to trigger a response under the law or was this just another example of the government's bad faith regarding FOIA? Probably it was the latter. Friedrich Georg's research work which produced the first document naming Phoo Bombs acted like a Rosetta Stone in that it was a translation of their terms into ours. This applied not only for foo fighters but for the other topics mentioned below which the government had previously denied.

With these documents as proof of American knowledge of foo fighters, the understanding with regard to foo fighters is quite different than the confusion generated heretofore. The fact is that Vesco has been vindicated. The fact is that foo fighters were German-built flying weapons of war. The fact is that they were the very first modern UFOs. And finally, the fact is the government of the United States has known this all along and kept these facts from us for almost sixty years.

It should be noted that the documents which are in my possession are all documents written during the Second World War. No mention is made of Phoo Bombs in any post-war documents I have seen. Examples or at least plans of these flying devices must have been recovered. It seems there are still secrets hidden away in government files. To keep these secrets the government is willing to violate its own Freedom Of Information Act laws.

It should be noted that the document uncovered by Mr. Georg describes several weapons systems previously not disclosed by the U.S. government. This includes German rockets larger than the V-2. The government document states:

"68 feet in length as against 45 feet"

The forty-five foot figure signifies the V-2, while the sixty-eight foot rocket is completely unknown.

In this same document is a description of a gas-weapon first described by Vesco and designed to down enemy aircraft (10). Actually, there are two such gas weapons. The first gas is designed to cause engine destruction through pre-ignition as

81

described by Vesco. The second gas is designed to cause engine seizure through the breakdown of the viscosity of the engine's lubricating oil. This is another vindication of Vesco. Therefore, when Vesco states that this very weapon was successfully used against Allied aircraft in a second-generation saucer, the Kugelblitz, perhaps he should be taken seriously (11).

Finally, this document describes something the Americans call the "Magnetic Wave" but which the Germans always described as "Motorstoppmittel", meaning literally, "means to stop motors". Motorstoppmittel and other German death rays were also the subject of repeated FOIA requests which were all denied. It was only with the code-word "Magnetic Wave" that the dam of information was finally broken concerning this device and other German ray-weapons. Not only did the Germans use ionization of the atmosphere to halt ignition based engines but they also experimented with x-ray weapons and an even more exotic method, possibly involving use of the laser (12).

Vesco places construction of the foo fighter at the Austrian site of Wiener-Neustadt (13). Indeed, the testimony supplied by Kadmon does indicate an Austrian home for the foo fighter. The most likely site for foo fighter development was the Rax Works. The Rax Works were an outgrowth of the combinations and growth of several firms, the Wiener-Neustaedter Flugzeugwerke GmbH, the Flugzeugbau der Hitenberger Patronenfabrik, the Flughafenbetriebsgesellschaft Wiener-Neustadt and the Wiener Neustaedter Lokomotiv-Fabrik which was acquired by Henschel after the unification of Austria and Germany (14).

All the sources cited place foo fighter production in Austria. It is often repeated that this was a purely SS project, built at Wiener-Neustadt, with the help of the F.F.O. It is possible that these craft had an independent origin, outside the scope and sphere of Peenemuende. At about this same time, early 1943, Professor Alexander Lippisch broke away from Messerschmitt to head the Vienna based Luftfahrtforschungsanstalt-Wien (LFW). This was a first-class facility and Professor Lippisch is a figure central to the understanding of German flying discs. Vesco links the foo fighter, his "Feuerball" with a further-developed manned saucer, the "Kugelblitz". It is possible that both these craft had an independent origin, that is outside the purview of officials at Peenemuende under the direction of Dr. Lippisch at the LFW. In this case their link to Peenemuende would have become stronger as the war progressed and on a higher order, that of the SS through Dr. Hans Kammler and the Kammler Group based near Prag. It is also possible that the research and controlling authority of the German disc program moved from Peenemuende to Wiener-Neustadt as researcher Klaus-Peter Rothkugel suggests.

Questions arise with the acknowledgement of "Phoo Bombs" by the government. The first is what is the agenda of those seeking to

Captured Foo Fighters In The USA?

Airborne Objects Watched

TWO SILVERY balls flashed across the Salt River valley north of Phoenix at 3:30 o'clock yesterday afternoon—and were watched for 25 to 30 seconds by a score or more persons in upper floors of the Heard Building.

All the witnesses were agreed on the main points:

FIRST ONE "ball" was sighted, then the other. At first glance the objects were thought to be bal-

FIRST ONE "ball" was sighted, then the other. At first glance the objects were thought to be bal-loons—until the extremely high speed of west-east flight was noticed.

Both objects appeared to be identical in size, were estimated to be at 5,000 feet altitude, and to be "about twice as large as an airplane."

THE OBJECTS were flying on two levels until near the end of the valley passage when the lower "ball" climbed sharply to the level of the upper.

The estimated distance traversed while they were under observation, and the endurance of the flight, indicated a speed well over 1,000 miles an hour.

SEVERAL OBSERVERS noted that at the time of the flight, the air was so still that smoke columns rose straight to high altitudes, and flags hung limp against their staffs. There was no noticeable air movement for an hour, when a rain storm began to approach the city from the northeast.

The Arizona Republic during the afternoon received a number of calls from persons who said they saw the "silvery balls". None reported the "flying saucers" which have been reported from so many parts of the country.

From "The Arizona Republic", July 8, 1947

83

deny this fact both in and out of government? Are these just extraterrestrial "true believers" gone amuck? There is no doubt that the government has known the truth about foo fighters and German saucers in general for almost sixty years, yet they have never been willing to publicly acknowledge these facts. Why is this? What issues of national security could possibly be compromised with such a disclosure over a half-century later?

Is this denial of foo fighters just of government inspiration? The sad truth is that the private "information" or disinformation sector is also guilty in of a cover-up. Why do they contribute to the denial of the German origin of this technology? What major New York publisher has ever published on German flying discs as opposed to the libraries of books pushing the extraterrestrial UFO hypothesis--a hypothesis totally lacking in proof? Let me pose the specific question: would Simon and Schuster ever publish a book on the German origins of flying saucers as they did for Col. Corso and his extraterrestrial hypothesis? If not why?

Another question arises from the confirmation of foo fighters by the government. This question concerns the veracity of Renato Vesco who originally placed the topic before us in his Italian edition as early as 1968. The question is this: If Vesco is right about foo fighters, what about the other claims he made about German saucers? Specifically, these are claims made about the further development of the foo fighter technology resulting in a manned saucer project he called "Kugelblitz" (ball-lightning). As well as claiming the Kugelblitz actually flew, Vesco gave us some tantalizing details of the development of German saucer technology by the Anglo-Americans after the war. In view of Vesco's track record, we can not simply dismiss these claims as has been done in the past. Vesco's assertions should be borne in mind as further facts become evident.

Finally, there is some small evidence that the Americans did acquire working examples of these foo fighters. If the Americans had captured complete examples of the foo fighter one would expect they would be taken to existing testing facilities in the Southwestern United States and tested as were other examples of captured German technology. This appears to be the case. The Arizona Republic reports a sighting dated July 8, 1947 involving two flying silvery balls which can only be foo fighters.

Foo Fighters

Sources and References

1. Vesco, Renato, 1976, page 82, <u>Intercept UFO</u>, Pinnacle Books, Inc., 275 Madison Ave, New York, NY. 10016, recently reissued as Man-Made UFOs 1944-1994 by Adventures Unlimited Press

2. Vesco, Renato, 1976, pages 85-86

3. ibid

4. Vesco, Renato, 1976, page 87

5. United States Air Force, 1944, "An Evaluation Of German
 Capabilities In 1945", Maxwell Air Force Base, Alabama, USA,
 this and other information related to Phoo Bombs can be found
 on microfilm rolls A-1007-1652, A-5729-2040

6. Vesco, Renato, 1976, pages 85-87

7. Combined Intelligence Objectives Sub-Committee Report Number
 156, "Report On Flugfunk Forschungsinstitut Oberpfaffenhofen
 F.F.O. Establishments"

8. ibid

9. Corso, Phillip J., Col., 1997, page 161, The Day After
 Roswell, Pocket Books, a division of Simon & Schuster Inc.,
 1230 Avenue of the Americans, New York, NY. 10020

10. Vesco, Renato, 1976, pages 136-138

11. Vesco, Renato, 1976, pages 145 and 156

12. German Research Project, 1999, "German Death Rays Part Two:
 The German And American Governmental Evidence", P.O. Box 7,
 Gorman, CA. 93243-0007 USA

13. Vesco, Renato, 1976, page 86

14. Rothkugel, Klaus-Peter, not yet published, page 31, Das
 Geheimnis der deutschen Flugscheiben

The Peenemuende Saucer Project

A report comes to us from Russian immigrant Paul Stonehill concerning the experience of a Russian POW in Northern Germany. The report was first published some time ago in UFO Magazine, volume 10, number 2 in 1995, but this witness describes a story so different from other German saucer reports that it is worth emphasis at this point. The witness is unnamed but the source of the original report is known to Paul Stonehill and he vouches for its authenticity. The unnamed witness is called mister "X".

Mister X was taken prisoner by the Germans in the Ukraine in 1941, early in the German offensive. From there he was housed in a concentration camp where he contracted typhus. X improved and even managed to escape but was re-captured and taken to Auschwitz concentration camp. There, he worked as a medical orderly before a typhus relapse made this work impossible. X was scheduled for a one-way trip to the crematorium but was saved from this fate by a woman German medical doctor who cured him of the typhus. Not only did she do this but, for some reason not made clear in the article, she supplied him with false identity papers stating that X was a mechanical engineer.

In August of 1943 X was moved to KZ (concentration camp) A4 at Trassenhedel in the vicinity of Peenemuende to work on project Hochdruckpumpe's removal from that area. Hochdruckpumpe, or high pressure pump in English, was a long distance cannon with fired in sequential states as the projectile moved by each charge and along an very long barrel. From here X was reassigned to work at Peenemuende itself.

In September of 1943, X and some other prisoners were engaged in demolition of a reinforced cement wall. At lunch time the other prisoners were driven away from this site but for some reason, possibly a dislocated foot, X was left behind.

After the others had gone, four workers appeared from a hangar and rolled out a strange looking craft onto the concrete landing strip nearby. It was round, had a teardrop-shaped cockpit in the center and was rolled out on small inflatable wheels, like an "upside down wash basin". After a signal was given, this silvery metal craft began making a hissing sound and took off, hovering at an altitude of about five meters directly over the landing strip. As it hovered, the device rocked back and forth. Then the edges began to blur. Suddenly the flying craft's edges seem to blur as it jumped up sharply and gained altitude in a snakelike trajectory. X concludes that because rocking was still exhibited, the craft was advancing erratically.

A gust of wind blew in from the Baltic. The flying craft was turned upside down and began to loose altitude. Mr. X was enveloped by hot air and the smell of ethyl alcohol as he heard the craft grinding into the earth. Without thinking, X ran for

the craft in an effort to assist the downed pilot. The pilot's body was hanging out of the broken cockpit and the craft was engulfed in blue flames of fire. X glimpsed the still hissing jet engine before everything was swallowed in flames.

What can be gleaned from this account? Mr. X certainly saw a German flying disc. But the "smell of ethyl alcohol" and the "blue fames of fire" set this engine apart from any so far described. German jet engines ran on jet fuel, a light oil something similar to kerosene. The Walter rocket engines ran of very exotic hypergolic fuels which burst into flames automatically once they made contact with each other. Ethyl alcohol is the alcohol of fermentation as, for instance, potatoes are fermented and distilled into vodka. Ethyl alcohol is not the best substance for aircraft fuel since it is low calories by weight and volume in comparison with the other fuels mentioned. The advantage of alcohol for the shortage plagued Germans was that it was available. Ethyl alcohol and liquid oxygen were exactly the fuels which powered the V-2 rocket developed at nearby Peenemuende.

Given this report, we have a reason to consider Peenemuende as a German site which produced flying discs. But before proceeding with our inquiry as before we must take a step back from our strictly detailed survey of German flying saucers in order to get better perspective of this overall body of information.

To this point any reader somewhat familiar with German flying discs might find the level of detail and proof enlightening but might feel that the basic story is known and has already been told. These readers will be pleasantly surprised by this chapter of our story. Not only is new evidence presented here but a new interpretation of existing evidence sheds a whole new light upon the study of German flying discs.

This new evidence and this new way of looking at things are primarily the result of the input of German aeronautical investigator Klaus-Peter Rothkugel. Within the last year or so he has proposed to me and to another investigator, Heiner Gehring, ideas which were previously overlooked. Mr. Rothkugel has investigated and documented his ideas to both of us and has convinced us of their merit. In turn, both Mr. Gehring and myself have spent some time and effort in advancing this research ourselves and sharing the results. These researchers have published their findings in Germany and have allowed me to make use of these ideas here.

The careful reader will note that mention has already been made of Mr. Rothkugel and his contributions. In this section some of the ideas which he first put forth will be examined as will his emphasis on the overall organization and understanding of the material.

It was Vesco who first gave us an explanation of foo fighters.

Vesco relied upon his own understanding of the subject which was gained during the war and documented them with facts gleaned from his research into British intelligence files. His explanation has been largely vindicated both by reports of sightings within Austria and through United States military documents obtained independently through the Freedom Of Information Act. Why then should not the other explanations given us by Vesco be worthy of further inquiry? While discussing German saucer development, Vesco described German research designed to overcome the drag limitations imposed upon aircraft by boundary layer effects.

Boundary layer effects refer to the flow of air across the wing of an aircraft in flight. The air forms sheets of air moving across the wing, the slowest moving sheet being closest to the wing. At high speeds these slower moving layers collide with oncoming air molecules of the atmosphere causing areas of turbulence with translate into atmospheric drag as a practical matter. Elimination of the boundary layer would mean that the aircraft could fly faster or expend less energy to fly at any given speed (1)(2).

Swept wings, a German innovation, represent an aircraft designer's response toward lessening the effects of drag on high speed aircraft wings. It was found that air passing over the wings at an angle retarded boundary layer formation. Therefore, turbulence was less apt to form. The swept back-wings of the Me-163 rocket interceptor may have been the result of this research. An advanced model of the Me-262 jet fighter was to incorporate fully swept-back wings. But German aircraft designers of those times wanted to go further. They wanted to eliminate the boundary layer completely.

They proposed to do this with suction wings (3). The literature on German efforts toward elimination of the boundary layer using suction wings is voluminous, as Vesco has pointed out. Beginning in the early 1940s German designers cut slots into experimental aircraft and auxiliary engines were employed to suck in the boundary layer through the wing itself and redirect this air into the fuselage and out the rear of the aircraft.(4). This proved to be more complicated than first anticipated. It was found that the area of turbulence, eddy currents caused by the boundary layer, moved across the wing from front to back as air speed increased. A slot at one position on the wing might work at one speed but not another. This meant that many, many slots covering the expanse of the wing would be needed to totally defeat this boundary layer problem. This proved impractical for a number of reasons.

One reason this was so was that multiple engines had to be used. The first engine had to provide power for flight as in any airplane. The second engine, mounted in the fuselage, was necessary to draw in air through the slotted wings and exhaust it towards the rear. Interestingly enough, it was found that the boundary layer could be eliminated by "sucking it in" or by

"blowing it off" using a strong flow of air to disrupt it (5).

Full scale suction wing aircraft were built for purposes of testing this concept. These were the Junkers "Absaugeflugzeug" (suction aircraft) AF-1 and the Fieseler "Absaugestorch" (suction-stork) AF-2.

Concurrent with these experiments, work was being done into the feasibility of circular wings. This work also began in the 1930s with the basic ideas being credited to Professor Ludwig Prandtl. Early scientific papers on circular winged aircraft were written beginning in 1936 by Wilhelm Kinner (6) and in 1938 by M. Hansen (7). Both of these scientists worked at the Aerodynamic Research Facility at Goettingen. By 1941 Dr. Alexander Lippisch was also engaged in experimentation on circular wings at the Messerschmitt firm. His design, designated J1253, was tested at the wind-tunnel at Goettingen (8). Dr. Lippisch was visited by Dr Giuseppe Belluzzo while at Messerschmitt in Augsburg and Lippisch worked together with Dr. F. Ringlib on a "Drehfluegel" or "rotating wing" which was tested at Peenemuende (9). As with suction wings, a body of scientific literature from those times documents this early circular-wing experimentation.

The genius of the German designers was to combine the ideas of suction and circular wings into a single aircraft. Housing a complete aircraft within its wing would eliminate the fuselage and so eliminate an unnecessary, drag-causing structure.

Prandtl and Lippisch were not comparably to Schiever and Habermohl. Prandtl and Lippisch are not even comparable to Dr. Richard Miethe. Pradtl and Lippisch were senior scientists who were well established in their worlds, either of whom would have been capable of heading a major project. In fact they did. In fact neither the Schriever-Habermohl or what we have called the Miethe-Bellonzo projects were major projects. This is another significance of what is being discussed here because what is being discussed here is a completely different organization and understanding of German flying discs than has been presented heretofore.

Remember that controlling authority for both the Schriever-Habermohl and the Miethe-Bellonzo projects came from officials in Peenemuende? J. Andreas Epp makes the point in his book that he originated the idea of the Schriever-Habermohl-type of flying disc and actually made a model of this flying craft. Setting aside for the moment the subject or originality, Epp sent his model to General Ernst Udet of the Luftwaffe whom he had met as a child. General Udet must have been impressed with this idea because he sent the plans and model to Peenemuende for evaluation. Peenemuende authorized the Schriever-Habermohl team to further develop the idea and as you might recall, Epp chided Schriever for straying from his original blade dimensions while crediting Habermohl for keeping them. The point is that Peenemuende set up Schriever and Habermohl to construct and

further develop this design as they set up Dr. Miethe to set up further develop the Leduc engine based design. The Germans even refer to the Schriever-Habermohl design as a "Flugkreisel" or flying top in English and the Miethe design as a "Flugdiskus". Our vernacular, "flying saucer" originally corresponded to the German folk-word "Flugschiebe" or flying disc. If the Flugkreisel, Flugdiscus and Flugschiebe are all different machines and we know who built the first two then who built the third, the Flugscheibe? The answer is that Peenemuende built the Flugscheibe. Officials at Peenemuende saved the best for themselves while controlling the other two.

Let's look at some evidence. The May, 1980 issue of Neue Presse featured an article about the German fluidics engineer Heinrich Fleissner (10). Fleissner was an engineer, designer and advisor to what he calls a "Flugscheibe" project based at Peenemuende during the war. It is interesting to note that Fliessner's area of expertise, fluidics, is exactly the specialty involved in investigating problems with boundary layer flow. Fleissner reports that the saucer with which he was involved would have been capable of speeds up to 3,000 kilometers per hour within the earth's atmosphere and up to 10,000 kilometers outside the earth's atmosphere. He states that the brains of the developmental people were found in Peenemuende under the tightest of secrecy (11). We will return to this article again, at a later point, but what is of most interest to us here are three facts. First, that Fleissner worked at Peenemuende on a flying saucer project. Second, that a hint of this design has survived to this day. Third, the surviving design can be linked to photographic evidence of a German saucer, circa World War Two.

Almost ten years after the war, on March 28, 1955, Heinrich Fleissner filed a patent application with the United States Patent Office for a flying saucer (Patent Number 2,939,648). Fleissner's saucer was unlike Schriever's, Habermohl's, or Miethe's. The engine employed by Fleissner rotated around the cabin on the outside of the saucer disc itself. It was set in motion by starter rockets as with Schriever and Habermohl. The difference is that this engine was really a form of ram-jet engine. It featured slots running around the periphery of the saucer into which air was scooped. The slots continued obliquely right through the saucer disc so that jet thrust was aimed slightly downward and backward from the direction of rotation. Within the slots, fuel injectors and a timed ignition insured a proper power curve which was in accordance with the speed and direction of the saucer much like an automobile's fuel injection is timed to match the firing of the spark plugs. Steering was accomplished by directing the airflow using internal channels containing a rudder and flaps which ran alongside of the central cabin. The cabin itself was held stationary or turned in the desired direction of flight using a system of electromagnets and servo-motors coupled with a gyroscope (12).

It is interesting to note that while the patent was filed on

90

The Post-War Saucer Patent Of Heinrich Fleissner

Fleissner was a technical advisor on the Peenemuende
saucer project. An eye witness, known by Fleissner, told
him this: "Shortly before the Capitulation, on April 24,
1945, a squadron of four flying discs took off-manned with
two pilots whose names are unknown-under heavy artillery
barrage from the German and Russian sides from the Berlin-
Lichterfelde Airport to a still-today unknown destination."
(Neue Press, 5/2/80, page 3)

March 28, 1955, it was not granted until June 7, 1960, over five years later! What could possibly have been the reason for the delay? The only possible reason concerns the American Silver Bug Project which was being developed at the same time. This was a project which was tasked with further development of the Miethe design or an outgrowth of it and simply referred to as a "radial jet engine". But we now know this Miethe project was not the equal of the Peenemuende project in terms of speed. The Americans must have realized this sometime after the filing of Fliessner's patent. There can be little doubt that the reason for the delay of the Fleissner patent was the evaluation and possibly the pirating of his design by the Americans. At about the same moment that Fleissner's patent was granted, it was announced that the joint Canadian-American saucer project, Silver Bug and its derivatives, had been abandoned by those governments. The only possible reason for this abandoning was that they had found something better and the better design, by far, was Fleissner's.

Fleissner's design was likened to a ram-jet earlier. It could function in this way but it was also much more than a ram-jet. Fleissner states in his patent that the saucer could be powered by any number of fuels: "liquid, dust, powder, gas or solid" (11). It could have used, for example, used the recently re-discovered fuel first made by Dr. Mario Zippermayr consisting of finely powered coal dust in a suspension of liquid air (13) or "Schwammkohle" ("foam coal") and liquid air (14). Different fuel mixtures and types could be accommodated simply by varying or adjusting the type of injectors and ignition used. We know that the Germans used hypergloic fuels during the war, that meaning fuels which ignited simply by coming in contact with one another. "C-Stoff" and "T-Stoff" were German designations for the hypergloic fuels used in the Messerschmitt Me-163 rocket interceptor, for instance. These fuels could also have been used in this engine as well. Fleissner further elaborated in his 1980 article stating that liquid hydrogen and liquid oxygen were suitable for this design (11). Liquid hydrogen and liquid oxygen are rocket fuels of the highest order. This means Fleissner's saucer could function as a rocket with the proper fuel.

Shall we assess the implications? In its simplest form, Fleissner's saucer could have operated as a ram-jet on jet fuel. At its highest level, Fleissner's saucer could have operated outside the atmosphere on liquid hydrogen and oxygen. Or it could have done both. Fleissner's saucer could have taken off as a ram-jet, gained speed and altitude but at some point, reached a limit of diminishing returns. At this point, the saucer would have been able to slowly bleed liquid oxygen into the ram-jets for further performance enhancement. Further, it could slowly have replaced jet fuel with liquid hydrogen. This would be accompanied by a closing of the air intake apparatus. At this point there is no reason this saucer can not become a space ship, that is, able to operate beyond the fringes of the earth's atmosphere. Is this performance enough to impress the U.S. Air

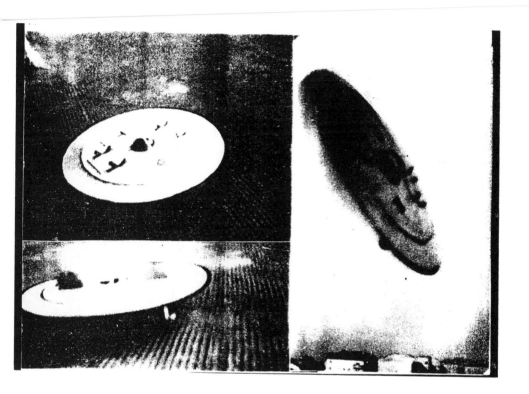

This is a blow-up of the picture attached to J. Andreas
Epp's "Still Alive" letter from Prag, March, 1944. Note
air intake ring and crest for steering on the roof of the
cabin. Diameter is about six meters. Is this the saucer
described in the Aftonbladet article? Possible location is
Stettin near Peenemuende.

Thinking Outside The Box

Hybrid Liquid-Solid Propellant Rocket

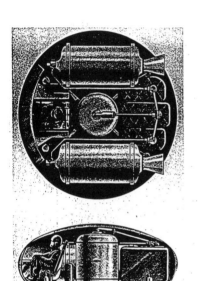

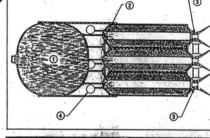

EIN BÜNDEL von Hybrid-Triebwerken läßt sich leicht zur Startstufe einer Großrakete zusammenbauen. Ein einziger Tank (1) genügt zur Aufnahme des Oxydators, der durch Düsen (2) in die mit festem Brennstoff (3) ausgekleideten Kammern eingespritzt wird. In den kleinen Kugeltanks (4) befindet sich ein Zündmittel, das die Verbrennung startet.

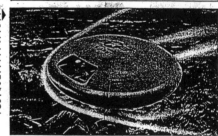

◄ FLUGSCHEIBEN nach den Vorschlägen der United Aircraft sollten auf dem Hubstrahl eines senkrecht stehenden Hybridtriebwerks 'reiten' und durch zwei Horizontaltriebwerke gleichen Typs Überschallgeschwindigkeit erreichen. Die Scheiben könnten einmal als Aufklärer für die US-Air-Force, aber auch bei Expeditionen (selbst auf dem Mond und dem Mars) eingesetzt werden.

Top Right: 1. Liquid Oxidizer 2. Injection Jets for Oxidizer 3. Combustion Chamber Constrictions 4. Ignition Mechanism Solid fuel shown running along sides of combustion chamber (dark color). "Schaumkohle" (porous compressed coal) are suitable as fuel as would a mixture of Aluminum power and polyurethan combined with liquid nitrogen tetroxide. Thrust controlled by amount of oxidizer injected. Hypergolic mixtures would require no ignition system. Alternately, oxydizers could be solid and fuel liquid. "Nichts ist unmoeglich" Nothing is impossible

Force and the civilian population of the late 1940s and early 1950's? The answer is certainly in the affirmative.

There are design elements in the Fleissner saucer which link it to the work of Prandtl and Lippisch. It should be noted that the slot air intakes mounted near the edge of the saucer would have sucked in the boundary layer before it got any real chance to form. Below, the jets would have blown off the boundary layer at a similar point. Further, because the entire wing, the saucer, is spinning, any further development of a boundary layer would have been moved at an angle and so almost nullified as happens with severely swept-back wings of a conventional high-speed jet aircraft. Therefore, at supersonic speeds, this saucer might not have even generated a sonic boom.

There is some proof that the Fleissner-type of saucer was actually built and flown at Peenemuende or a nearby test facility at Stettin. Fleissner's patent is likened to wartime reality by a photograph. Actually, it is three photographs. These photographs have appeared in a fragmentary, vintage Dutch article on German saucers and they are attached to a wartime letter from Prag sent to this writer by J. Andreas Epp and later published in Ahnstern (15). No specific mention of the photograph is made in the letter and so it could be that the late Mr. Epp included it as a general example rather than a specific reference. Epp never claimed the saucers in these photographs as his design. Epp himself claimed to have the only photographs of that device. There is reason to suspect, however, that this design does bare a relationship to the Fleissner design.

The pictures show a small saucer with some telling features. One point of correspondence with the Fleissner patent is that the air intake is located near the periphery of the saucer wing. This is seen as seen in the ring just inside the saucer's edge. The other is that the directional control is clearly viable in the rudder mounted on the top of the cockpit or central cabin. In the picture the control is external and not as sophisticated as the Fleissner patent but the idea behind both are the same. In the pictured saucer, turns would be made by turning the cabin as a whole, thus, turning the rudder just as the prehistoric flying reptile, the Pterodactyl, turned its flight direction using a rudder located on top of its head.

Further confirmation of a Peenemuende saucer project comes from a Stockholm evening newspaper, Aftonbladet, dated October 10, 1952. It reports that a flying saucer, a "space ship", was developed by the Germans during World War Two at Peenemuende by Dr. Wernher von Braun and his rocket team. A test-model of this craft lifted off in April of 1944. It was six meters in diameter. The ultimate craft to be built was a space ship of 42 meters in diameter, capable of flying an astonishing three hundred kilometers in altitude! Not stated in the article but interesting to note is that this 300 kilometers represents a higher altitude than the first American earth orbiting satellite.

95

Flygande tefat var Hitlers A 7-vapen

Genom det material som finns i Sverige kan det fastställas, att den s. k. flygande tefatet är en tysk konstruktion. Det konstruerades i robotanläggningen i Peenemünde med början omkring 1936 under ledning av professor WERNER VON BRAUN. I serien "robotvapen", den s. k. A-serien, hade det beteckningen A 7. Den flygande bomben V 2 hade här beteckningen A 4.

I april 1944 var man färdig med provflygningen, med ett tefat på 6 meters diameter och det provet blev lyckat. Sedan kom den tyska invasionen i vägen och man blev aldrig färdig med slutprodukten, ett rymdskepp med 42 meters diameter avsett för höjder upp till 300 km. Ryssarna äger kännedom om konstruktionen, men originalritningarna till A-serien samt professor von Braun i spetsen arbetar sedan 1945 i White Sands i New Mexico och har säkerligen kommit långt med sina konstruktioner.

Se dess art. på sid. 6.

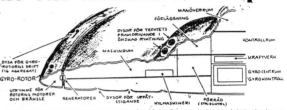

HALVA "TEFATET" (A 7:s slutliga gestalt i genom- och urskärning. Den roterande ringen per farkosten dess form av "tefat". Rotorn skall drivas av 16 raketaggregat av samma utförande som på V 2 med omkoppling för styre ur luften. Framdrivningsverket består av 8 parvis kopplade liknande aggregat.

BILLIGARE

Tyska tefatsbyggare i USA sedan 1945
Siktar på atomkraftdrivet rymdskepp

Det flygande tefatets såväl som de andra tyska fantomvapnens konstruktör är i första hand professor Werner von Braun och hans bror, men många andra deltog också, bl. a. den av Aftonbladet för några dagar sedan omnämnde ingenjör Georg Kiela. Bröderna von Braun började redan på 1920-talet, men fick med sed 1934 tog Hitler hand om saken och kort därpå började man anlägga Peenemünderverken, där man var färdig 1938 och där fantastiska saker skedde.

De hemliga vapnen blev till slut på underhållen. De sista ämnade tie, A 1 till A 16. Det flygande tefatet var A 7, men de kallades länge bara rymdskepp eller något dylikt. Först efter kriget har det efter iakttagelser på himlen döpts till tefat. A 10 skulle bli det förträffligaste av alla vapen, användbart vid bombardemang av amerikanska städer, men det blev aldrig färdigt. Det på papperet.

Rymdskepp på 200 ton

Bytdet med A 7, tefatet, var att banan så att i den intressanta rymden man så farkost, som kunde förflytta sig med enorm fart på höjder där ingen dragningskraft avtar och drivas med reaktionskraft. Men redan i atgmosfären kunde man i riktig användning för de mindre typer av farkosten.

Slutkonstruktionen skulle ha en diameter av 42 meter och 15 en vikt av 200 ton, varav trolligen halva bränsle, dvs syre och alkohol. Reaktionsaggregatens mynningar, de à k. dysorna, placeras runt om och...

Ideala drivmedlet

Detta är alltså något tim som A 7:s slutprodukt, som dock aldrig blev färdig i tysk upplaga. Det svåraste problemet att lösa är bränslefrågan. I Amerika har trot retiskt var bränsleförbrukning skulle ägå oerhört mycket bränsle innan farkosten kom upp i några tusende höjden rum. Även temperaturen för bestigningen är en svår fråga. Det ideala drivmedlet för ett flygande tefat vore atomkraften, och tormodligen inriktar man sig i Amerika på att lösa detta problem.

Så långt hade alltså tyskarna kommit och ännu sig ha läst problemen teoretiskt och laboratorimässigt. Sedan dess har de arbetat i Amerika i syfte att utröna av krig verkninga till samman väl med sina olika remrser. Man blir betänksam när det är tyska folk och omkring 1939 och 1945.

Det är inte nödvändigt att inrätta sig på rymdskeppet, utan konstruktörerna kan måhända vill också på tefat för användning inom atmosfären gränser och med mindre Faktor Ceder efterfrågas.

ligen inte ryska utan amerikanska. Sju års obehindrat arbete i USA har troligen inte blivit alldeles fruktlöst.

Fakta kända i Sverige

De militära och tekniska fackmännen i de flesta länder är naturligtvis underrättade om hemligheten kring A 7-konstruktioner och Tysklands sammanbrott. Även det svenska flygvapnet ställer sig efterträdande, men redan 1945 mottog det en luvekälorib rapport om hela A-serien från en svensk som vistats i den tyska konstruktionsrevirelse.

Såväl flygvapnet som robotavdenbyrån känner väl till saken och har givetvis kunnat identifiera "tefatet", när fakta om det på stationen länder har dragits fram. Utgångspunkten för spekulationerna om teknikens nuvarande ståndpunkt jul just de tyska konstruktionerna av 1944 och 1945.

Dyrbar dröm var nagellack

En stulen ring, som föregivits vara nagellack dyrbar, då den var besatt med diamanter och en exklusiv röd sten, har vid granskning på kriminalen visat sig vara ett falsarium. Den röda stenen betedd endast av — röt nagellack, som fyllts i den illa inställningen!

Det var i somras, som en amerikanska på hotell Malmen blev bestulen på sitt värdefulla smycke av detta har nu en värderarbetare häkten. Han gav smyckena till en kvinna, vid ett tillfälle blev de osams och råkade i grogräl. Under tumultet revs den riktiga röda stenen på "fingen ur sin infattning. Kvinnan, som tyckte det låg tomt — ut, fyllt i röt nagellack som länge byte och gällde för en dyr sten.

Om tefaten finns, så finns de i Amerika och Sovjet. De som snart vara iakttagna i Amerika är säker.

Möblerat rum önsk. hyra med intresse för affär erhåller anställning i AFTONBLADETS av 2 typografarlängar. Heist inom depeschkontor, Norrmalmstorg 1. Den kan också något språk, främst tullarna. Svar till telefon 22 20.00, engelska, har företräde. Roligt, omväxlande arbete, trevliga kunder och bra arbetskamrater. Sök anställning kl. 10—12, 3—16.

hans familj att nu inlägga sin sinnesundersökning säga just nu med frågan om vem som skall bygge höghusen vid Brovrägen. Ärendet berördes i går, kväll därför att man inte kunnat enas om honom, så att han inte skulle ha att han var Jesus, får nog tas med en nypa salt. Overdrifter i sådana här sammanhang hör ju till vanligheten, säger medicinalrådet.

Höghusen blir stridsäpple

Fastighetsnämndens styrelse just nu med frågan om vem som skall bygge höghusen vid Brovrägen. Den ena läkaren vill att Byggnadsentreprenörernas fastighetsaktiebolag .BEFA., HSB, Skånska cement eller Olle Engkvist skall få bygga dessa hus. Minoriteten håller på att stadens byggnadsbolag Svenska bostäder skall få uppdraget. Den ståndpunkten företräder ordföranden i fastighetsnämnden, borgarrådet Gösta Wennström.

Mot det förslaget hävdas att staden vinner mest på att den fria konkurrensen blottäller. För höghusen skulle staden hålla ett vil.t helag och derta i sin tur antite Svenska bostäder som entreprenörer. Sådan är situationen för dagen. Innan man beslutar vill fastighetsnämnden inväntu fastighetsdirektör Jarl Berga åtorkomst från lördagen den en konferens i Lissabon.

Pojkar tog checkhäfte

Tvs 15-åriga pojkar gjorde i går en kupp mot en affärsinnehavarinna på Bolinders plats på Kungsholmen. De jagas nu av polisen. De brukar köpa tuggummi i affären, i vilka de ränder ul och in på onsdagseftermiddagen, fick ett oberäknat ögonblick smet en av pojkarna in på kontoret bakom affären. Då innehavarinnan återvände skeppa dem, försvann de springande ur affären. Det var ett rov.

16—17-års FLICKA

The construction drawings for this device are in the USA, according to the article, and the drawings are also known to the Russians. The chief difficulty with the saucer, according to the report, is the tremendous fuel requirements during its assent. This problem, it goes on to say, could be solved through the utilization of atomic energy.

Let us look at the picture of the three saucers again. In the lower left picture two dark objects can be seen resting on its top. Mr. Rothkugel suggests these may be bombs or fuel. Let us assume the latter, that they are fuel drums for refueling the saucer. In the USA metal drums of this type commonly contain petroleum products. They measure about three feet in height. Two are shown but six lengths could be stretched across this saucer with perhaps inches to spare. A meter is slightly over a yard. This saucer roughly corresponds in size to the description given in the Aftonbladet article. The picture on the right, minus the fuel drums and poised above some buildings, clearly shows that this saucer actually flew.

A whole technical history and organizational hierarchy can be pieced together from this picture, the Fliessner patent, and the Aftonbladet article. The Fleissner design minimizes the effects of boundary layer resistance reflecting the outcome of work starting with Ludwig Prandtl. It is a circular aircraft and a linear descendant of the circular aircraft designed by Dr. Prandtl and Dr. Alexander Lippisch. Fleissner states that he worked at Peenemuende. Peenemuende functioned as the head of all German saucer research. A fact of life at Peenemuende was that all German scientists deferred to Dr. Wernher von Braun who was an expert, the only expert, at everything. Dr. von Braun did have an organizational supervisor, Dr. Walter Dornberger, later to work for Bell Aircraft in the USA. Above Dr. Dornberger was Dr. Hans Kammler, the SS chief of all jet aircraft and vengeance weaponry. All these named men and organizations were part of the German saucer program, their public denials not withstanding.

One more loose end is tied up relating to the Fleissner design. This is the relationship of Dr. Giuseppe Belluzzo to the German saucer projects as a whole. Remember, Dr. Belluzzo was a senior scientist and engineer who specialized in materials and **steam turbines**. The Fleissner saucer design is normally thought of as a sort of ram-jet. But this ram-jet spun due to thrust imparted to it by its exhaust. This exhaust-supplied motion scooped in and compressed the incoming air before ignition. Low speed flight would have been impossible without this feature just as it is with any ram-jet. So another way to look at this engine is that it was a turbine-ram-jet no matter how incongruous this may sound at first. It should also be noted that in the rocket mode, when the saucer is burning only liquid oxygen and liquid hydrogen, the products of this combustion are only heat and water. Another way to say heat and water is steam. To repeat, Dr. Giuseppe Belluzzo was a steam-turbine expert. As mentioned earlier, Mr. Rothkugel reports that Dr. Belluzzo visited and,

97

presumably consulted with, Dr. Alexander Lippisch at Augsberg. Dr. Belluzzo's involvement with the German saucer projects should not be assumed to be confined to the Miethe project.

Let's review the Peenemuende Project to this point. It is a wide ranging project with at least two spin-offs, the Schriever-Habermohl project and the Miethe project. The Schriever-Habermohl project(s) employ a whirling set of vane-blades and one or more rocket or jet engines in a kind of "spinning top" manner. It may have been capable of supersonic flight. The Miethe project differs in that it employs an internal spinning turbo-jet first invented by Rene Leduc. Depending of the saucer configuration, its thrust can be vented in any direction for steering purposes. It also may have been capable of supersonic flight.

This design was given further study and was probably developed after the war in the form of the John Frost "Manta". A design such as this may have been responsible for the sightings by Kenneth Arnold near Mt. Rainier in the State of Washington in June of 1947. It was probably responsible for the pictures taken by William Rhodes as seen and described in the July 9, 1947 edition of the newspaper, The Arizona Republic. This same design, described as a "Flying Shoe" may have figured in the Roswell crash. Ideas from this design may have been further developed by A.V. Roe, Limited company in Canada.

Besides retaining overall control of these two saucer projects, the officials at Peenemuende retained and developed their own saucer project. Using similarities between surviving pictures from the time and the patent filed by a former member of that project, Heinrich Fleissner, we can piece together something of its design. Its identifying characteristic is its engine which has been described earlier as a turbine-ram-jet. It could operate using a variety of fuels. It could function as a jet engine within the atmosphere or covert to a rocket engine using liquid oxygen and liquid hydrogen. Its speed and altitude limits would have been much greater than either the Schriever-Habermohl or the Miethe saucers, yet its construction would have been less complex than the advanced designs of the radial-jet engines being developed in the Canada as part of the Silver Bug Program. Recognition of these facts, especially after the 1955 patent application by Fleissner, probably lead to the abandonment of the A.V. Roe, Limited project(s). A cover project, the "Avrocar" was released to the public, discredited by its own designers, and put away to be forgotten.

In discussing the Aftonbladet article we have jumped ahead of our story slightly in order to connect the three saucers pictures with the Fleissner saucer patent in a proper context. The Aftonbladet article has other implication which will be discussed. Now, however, we must once again return to basics in order to illustrate the next stage of saucer development envisioned by the German scientists.

98

Vesco makes mention of liquified air or liquid propellants or explosives numerous times in discussing flying saucers (16)(17)(18)(19)(20). Vesco refers to saucers powered using "liquid air". On page 135-136 of <u>Intercept UFO</u> he says:

"After the German surrender in May 1945, when the British examined the secret papers of the technical departments of certain factories hidden in the forested area of the Schwarzwald-another region earmarked as an "island" for a last-ditch stand-they discovered that some of the documents miraculously spared from the retreating S.S. units' destruction of papers concerned "the important experiments conducted with liquid air as a power supply for certain new types of turbine engines capable of producing tremendous power outputs. At first the discovery led them to believe that a new system for powering submarines was under study, but ancillary information about the construction of powerful apparatuses working on principle of electromagnetic waves that would make it possible to exercise radio control at great distances, as well as photographs showing some parts of the new turbine, caused them to change their minds. Thus they got on the track of a preliminary preparatory stage for a new and very powerful type of armored, radio-controlled aircraft".

Mr. Rothkugel points out that the logical projection of Vesco's statements on liquid air would involve a saucer in with air would be drawn in through the skin or through slots in the upper wing (saucer), then rapidly cooled by special equipment into liquid air. The liquid air would be burnt in a combustion chamber and the hot air and steam would be exited through a turbine used to produce the electricity which this process would require.

The saucer would be drawn along through the atmosphere by the low pressure area to its front and top as well as by aerodynamic forces caused by its wing at low speed. With the addition of more liquid air into the combustion chamber, the expansive forces involving the conversion of a liquid to a gas would provide additional performance enhancement. This amazing and little-know method was invented and patented by the Austrian Karl Nowak in 1943 (21) and will work even with inert gasses. Of course, even nitrogen, sometimes considered an inert gas and which constitutes the major component of our atmosphere, can be burnt with sufficing electrical ignition as is witnessed in lightning.
The cooling needed to liquify the air would be generated using a cryostat, probably liquid helium. Liquid helium is the coldest of gasses, minus 452 degrees F, just above absolute zero. In addition to the cryostat, magnetic cooling machinery, such as is employed to produce liquid nitrogen would be employed (22). From the cooling power of liquid helium and evaporative techniques, liquid nitrogen and liquid oxygen can be made which are the major constituents of our atmosphere.

A saucer which could gather its fuel along the way has one obvious advantage. It could stay aloft for days if not weeks. More conventional chemical power could be employed for take-offs

and landings and for bursts of speed necessary for military applications. In fact, there is no reason that the propulsion systems of the Fleissner saucer and the liquid air saucer envisioned by Vesco could not be combined into one aircraft.

It is unknown at this time if actual steps were taken to realize a liquid air powered flying saucer by the Germans. Whether it was undertaken or not it certainly did lead thinking on to the next step in this process and for this step there is more than a little evidence. This step was mentioned in the Aftonbladet article. It involves atomic power. Yes, the Germans intended to build a nuclear powered flying saucer (23).

These are the conclusions first reached by Dr. Milos Jesensky and engineer Robert Lesniakiewicz in 1998. The former author is a Czech and the latter author is a Pole. Both belong to a large UFO organization which functions in both countries. After the Soviet pullout there were no restrictions on excavation of unused military sites belonging to the Germans during the Second World War. This organization got busy interviewing witnesses who had connections to those times as well as identifying German underground facilities. They opened up as many of these as they could find, and they were numerous. Most of the Polish sites were within the borders of Germany at that time since the borders, before and during the Second World War, extended into about 20% of Western Poland. Other sites were in the heavily German dominated areas of Moravia and Bohemia, now the Czech Republic.

Of course, the Germans had taken out what they wanted before retreating and then sealed up the entrances with explosives. As an example of how far this research group was willing to go, they not only opened up and explored the upper levels of Der Riese, mentioned earlier, but also explored the flooded lower levels, in the cold, silent darkness using scuba gear. Besides Der Riese, other very large sites were discovered and explored including "Robert 1", "Robert 11", and "Robert 111".

They found that the larger sites were really composed of a complex of sites. For instance, at Der Riese some of these sites within the larger facility were involved in mining uranium ore. Some were involved in refining the ore. Some other sites were involved in nuclear research (24).

Wartime German work in nuclear research was not confined to bomb building, as it was in the USA. The Germans were also interested in harnessing the atom as an energy source. Remember, Germany was dependent upon foreign sources of oil for energy. German planners long realized this was a weakness and had been trying to correct the problem since the early 1930s. Great plans were in the works, if not actually built, for atomic reactors used to generate electricity. These were sometimes called "uranium machines" by the Germans. Not only were these uranium machines to be used to generate electricity but they were also destined to

power submarines and aircraft.

Dr. Jesensky and Mr. Lesniakiewicz assembled and analyzed the great volume of evidence they had gathered over the years. They analyzed the physical evidence of the sites and interviewed as many people as possible. From the thousands of observations made and facts collected, they tried to draw conclusions. They found a close proximity and close association of the German nuclear program to the German flying saucer program. They concluded that one aim of the German nuclear program was to build a nuclear powered flying saucer (23).

There is some independent evidence supporting this conclusion. After the war, German physicist Werner Heisenberg wrote a paper concerning German interest in atomic energy. In that paper Heisenberg stated that in the summer of 1942 discussion had occurred among technical people specializing in issues of heat. This discussion concerning the handling of technical questions about the efficiency of conversion of heat from uranium to determined materials, for example, water or steam (25). It is hoped the reader would recall Dr. Giuseppe Belluzzo's specialties (materials and steam turbines) in connection to this discussion.

Further evidence can be gleaned from British Intelligence Objectives Sub-Committee Report. This report seems to follow a pattern we will see used again twice. The report does its best to discredit the informant in question, in this case a physicist and chemist, Josef Ernst, on one hand, while on the other hand the British thought it had enough merit to include this testimony concerning German research in some detail. Evidently, the intelligence agency in question is trying to cover all the bases in the event of any contingency. No matter if the scientist in question were to be cited or discredited, there would be language in the report substantiating both.

The report describes several areas of totally new German technology but what is of most importance to us here is Ernst's report of a new high speed fighter. The project designation is P-1073, and it was being developed by Messerschmitt. Three different engines were to be employed. The first was a B.M.W. 003 engine using petrol as fuel. The second engine was to use crude oil. The third aircraft was to use an atomic engine. This engine was described as 60 cms. long and 20 cms. in diameter. Ernst said it produced about 2,000 horse power! This aircraft was supposed to have a speed of 2,000 kilometers per hour (about 1250 m.p.h.) and a ceiling of 18,000 meters (over 54,000 feet). It was made at a Camp Mecklenburg. Only one model was ever made and it was destroyed, as was Camp Mecklenburg, by the SS before being taken by the Allies (26).

Establishment historians have all told us that the German atomic program was inept and disorganized. There may be some evidence for the charge that they did not share information between themselves due to strong rivalry (27) but the real facts are

British Intelligence Objectives Sub-Committee Report Number 142

C. Interrogation of Josef Ernst

In the course of interrogation it became clear, that Ernst was not at all reliable, and though there may in some cases be a factual basis for some of his claims, they are as a whole inaccurate and of doubtful value.

(a) Personal history of J. Ernst

Ernst's own account of his life did not agree with the details which were extracted from a file in his possession, and which are given below. He was born at Malsch, near Ettlingen in 1899, and claims to be a physicist and chemist. He became a teacher, but was removed from his position in 1923 for dishonesty and then tried to make a living by obtaining financial backing for various inventions which he claimed to be capable of developing. He was eventually charged with obtaining money by false pretences and imprisoned at Mannheim in 1944. Here he claimed that he had a process of obtaining petrol from oil, and was brought to Berlin by the S.S. Hauptamt under the charge of Kreutzfeld. After spending some time in hospital, he was ready to begin work, and in April 1945 was brought to Hinterstein, near Sonthofen, again under the charge of Kreutzfeld.

(e) High speed fighter aircraft

Ernst said that while he was in Camp Mecklenburg, he found out that there were three new types of high speed fighter aircraft. One of these was the P 1073, made by Messerschmidt with a B.M.W. 003 engine using petrol as fuel; the second was a similar aircraft using crude oil as a fuel. The third was alleged to be powered with an atomic engine. The fuselage, which was the same as the P 1073, was of wooden construction and was fitted with skid landing gear. The engine was 60 cms. long and 20 cms in diameter, and produced about 2,000 h.p. This aircraft was supposed to have a speed of 2,000 km./hr. and a ceiling of 18,000 m. The engines were made by the prisoners at Camp Mecklenburg. Only one model was ever in existence, and that was completely destroyed, as was the whole camp, by the S.S. during the Allied advance.

Top: British efforts to accredit and discredit their informant, Josef Ernst. This theme appears repeatedly in Allied documents in association with German informants. The intelligence people were merely covering themselves for all eventualities. Bottom: A German atomic airplane built at Mecklenburg. The Mecklenburg facility utilized some personnel which were considered to be a security risk.

quite different than heretofore publicly disclosed (28). The overwhelming fact is that until now establishment historians have not had enough information to reach final conclusions about the German atomic program. Many facts have been concealed and these facts are only now being brought into the open. One fact is that there were even more German atomic programs than previously known, and the fact is that one of these programs was run by the SS (28).

One establishment historian, Thomas Powers (29), perhaps unwittingly gives us some insight into the discussion at hand. Powers concentrates on the historical sequence of the German atomic program and with the people involved and their relationships with one another. He also follows the progress of the many organizations researching atomic physics for the purposes of energy production and bomb making. Powers documents six such groups.

One group concerns this discussion. It was run by the Heereswaffenamt or Army Weapons Department. Its Director of Research was Dr. Erich Schumann who was also the scientific advisor to Field Marshal Wilhelm Keitel. Schumann was a professor of military physics at the University of Berlin. He also held a commission in the army so with these credentials he was able to move comfortably in both academic and military circles. Schumann should be thought of as an administrator rather than a research scientist (30).

The field of research was left to Dr. Kurt Diebner (31). Diebner was a physicist for the Heereswaffenamt since 1934 and headed his own atomic research project. German physics during the war years was geared towards practical results. During the early phases of the war it was thought that nuclear weapons were unnecessary. The thinking at the time was that the war could be won without an atomic bomb using conventional weaponry. Therefore, work on atomic weapons was de-emphasized in the early years of the war. Work on atomic means of energy production was always a high priority, a priority which only got higher as the war drug to a conclusion.

Germany always felt more threatened by dependence upon foreign sources for energy. Therefore, harnessing the energy potential of the atom for an ongoing source of energy was always a concern for German atomic scientists, much more so than for the Americans. This aim is clearly mentioned in discussion among the scientists involved in the work.

In early 1942 the success of Diebner's reactor experiments lead him to propose a full-scale effort to develop both power-producing machines and atomic bombs. He continued to pressure Schumann who was more pessimistic about the possibilities of bringing this research to a practical result. Schumann finally became convinced and agreed to give a presentation to top Nazi officials of their findings. The text of Schumann's speech was

to stress the more conservative energy production aspect of atomic research rather than the building of a bomb. This was considered more feasible and so gives us an insight into the German atomic program and its thinking (32).

One example of their optimism was the participation of Diebner in plans for building an atomic power plant for Germany's submarine fleet. The year 1945 was mentioned as a target date for this to happen (33)(34).

Diebner's relationship to Schumann is made clear by Powers. Powers also introduces us to two additional players who were not officially involved with this project but who somehow interject themselves into things making their view heard.

The first is industrial physicist, Carl Ramsauer. Ramsauer was the head of the German Physical Society and a leading researcher for the electrical firm Allgemeine Elektrizitaetsgesellschaft. Ramsauer urged the German research establishment to rid itself of ethnic physics and get down to the business of using science to win a war (35).

A second scientist interjected himself into the fray in support of Ramsauer. This was none other than Ludwig Prandtl whom we have met earlier (36). Prandtl was familiar with the potential of fission's use in the war effort and insisted that the Nazis let scientists do science without reference to ethnic background or politics. Why was German atomic research so important to an a scientist involved in aeronautics? What aims did Prandtl have in common with these other individuals which linked them together? What was the urgency that compelled Ramsauer and Prandtl to intervene in a matter outside their areas of expertise and in opposition to the will of Nazi officials?

To answer those questions, let us look at each individual involved and his major area of interest. Professor Erich Schumann's interest was the military application of atomic energy. Dr. Kurt Diebner's interest was the development of atomic energy for nuclear weaponry as well as for a variety of other applications. As an industrialist, Karl Ramsauer's expertise was putting technology into large-scale, practical, production. In this time and place that meant military production. We already know that Professor Ludwig Prandl's interests were round-wing, suction aircraft. The interests of these four could only coincide if we were discussing the military-industrial production of a nuclear powered, round-wing, suction aircraft.

In addition, it is now known that Dr. Diebner, more than any other well known German scientist, was at the heart of the German atomic bomb development. It was Dr. Diebner who participated in the development of a German uranium bomb which was being prepared in one of the underground facilities at Jonastal, specifically at a facility "Burg". Not only did Dr. Diebner do this but he did

EIGHTH ARMY NEWS

NAZIS HAD 10,000 mph ATOM PLANE—IN THEORY

Gen. McCreery Arrives For Vienna Talks

MANY of Germany's inner secrets had been unlocked by the United States and Britain and were being adapted for the war in the Far East when the Japanese surrendered.

MORE THAN 300 BRITISH AND AMERICAN TECHNICAL EXPERTS FOLLOWED HARD ON THE HEELS OF THE INVADING ARMIES IN EUROPE TO TRACK DOWN SECRETS, HOWEVER WELL HIDDEN, BY THE GERMANS.

The thoroughness of the search in Germany foreshadows a similar probing for secrets now locked in Japan.

This is revealed in a statement issued on behalf of the Combined Intelligence Objectives Sub-Committee and the Technical Industrial Intelligence Committee — agencies authorized by the British and United States Chiefs of Staff — and published by the British Ministry of Information and United States Office of War Information.

Discoveries show that German invention was far ahead of her capacity to translate theory into industry.

Not only had the Germans made significant progress in the development of the atomic bomb and on the production of "heavy water," but they had contemplated a piloted missile with a possible range of 3,000 miles.

The designer envisaged commercial applications for trans-Atlantic passenger crossings in 17 minutes.

The Germans were working on a formula for new war gases which they hoped would prove more deadly than any chemical agent yet developed.

DETAILS FOR NEWER NAVAL VESSELS

They had specifications and construction details for naval vessels of advanced design, including submarines, with high underwater speeds and apparatus for sustained underwater operations.

They had developed a system of Radar camouflage, consisting of anti-Radar coverings and coatings to be employed on submarines and other weapons and had highly advanced jet engine, rocket-assisted take-off, and new dynamics designs.

New uses had been found for many staple food products. Out of the Germans were making synthetic butter as well as alcohol of both beverage and industrial types, be petrol, and they had designs for various secret types of guns and gunsights.

Other German war secrets ranged from records on the location of German capital in neutral countries and the status and composition of German cartels, specifications of long-range rocket developments which scientists described as "sensational."

The information gathered is not only valuable in the shaping of the policy for control of Germany but is expected to influence post-war scientific and industrial development.

BOMBER CHIEF RETIRING

Air Chief Marshal Sir Arthur T. Harris, Air Officer Commanding-in-Chief Bomber Command since February, 1942, will relinquish his appointment next month, and shortly afterwards retire from the Royal Air Force, announces the Air Ministry.

He will be succeeded by Air Marshal Sir Norman Bottomley, at present Deputy Chief of Air Staff.

999 Was His Unlucky Number

THE unluckiest crook in London is now serving six months in Wandsworth Jail and still finds it difficult to understand how he landed there.

When he left a Peckham house by the back window carrying a suitcase filled with silverware, jewellery and clocks, a police dog met him at the end of the drive.

His capture was a result of the new radio - telephony system — calling all cars — which is being introduced by Scotland Yard. In this case was caught during a "dummy" run in South London.

A housewife dialling 999 and found herself speaking to the information room at Scotland Yard. The quick - witted inspector switched a police car which was on the testing trip in the area to the road and the burglar was under arrest three minutes and twenty-five seconds later.

Scotland Yard hope for a big decrease in London crime through the introduction of the new system. Although all of London will not be covered at first, supplies of the necessary radio parts are now coming in, and Chief Inspector Bowman of the Yard's Communications Branch, can complete the work he began in 1938.

Every patrol car, flying-squad car and "Q" car—taxis and removal vans disguised—will soon be in radio-telephonic communication with the Yard's central information control room.

Poison Gas Bomb Panics VJ Crowd

Hundreds of people celebrating victory in Strabane, Northern Ireland, were affected when a poison gas bomb was released in the crowd.

Women and children panicked and—within a few moments of the explosion the street was littered with people lying ill.

Taxis and private cars drove the affected people to their homes and doctors were kept busy throughout the night attending to them.

The symptoms were those of a lung irritant gas containing chlorine.

Police believe that the bomb was let off by one of the celebrators who did not realise the seriousness of what he was doing.

MONTY STARTS SAVINGS DRIVE

Field-Marshal Sir Bernard Montgomery and Air Chief Marshal Sir Sholto Douglas, commanding the RAF in the British zone in Germany, are personally directing a drive against heavy spending by British occupation forces.

With nothing to buy locally,

The Allied Commanders in Austria met recently in Vienna. The BTA Commander, Lt.-Gen. Sir Richard McCreery, is seen, at the British airfield at Vienna, above, with (left to right) Wing Commander Kent (airfield Commander), Lt.-Gen. Betovsky (representing Marshal Koniev) and Air Commodore Sevicki (Commander of the Air Division, Vienna). Below, the BTA Commander steps in shot with one of the RAF Regt. guard of honour at the airfield.

The Russians Are To Quit Manchuria In 3 Months

UNDER the terms of the treaty between China and the Soviet, published simultaneously in Chungking and Moscow during the week-end, Russia is to render military and material assistance to the Chungking central government of China in a plan of collaboration to prevent a repetition of Japanese aggression.

Reaffirming respect for China's full sovereignty in her three eastern provinces, Stalin has given an assurance that after the Japanese capitulation the Russian forces will withdraw from Manchuria within three months.

In the case of Sinkiang, Russia reiterates that she has no intention of interfering in Chinese internal affairs while China is to recognize the independence of Outer Mongolia if the plebiscite proves that the people so desire.

The trunk line of the Chinese eastern and south Manchurian railways will be combined into one jointly-owned and operated line known as the Chinese Changchuan railway for a period of 30 years after which it is to revert to China.

Dairen has been declared a free port by the Chinese Government and for 30 years Port Arthur will be a joint Chinese-Russian naval base.

Although the Chinese Communists are not specifically mentioned, the treaty is regarded in Chungking as a political defeat for them at a particularly difficult time.

NO CIVIL WAR?

It is the impression at London political circles that the recent conversations between the Chinese Premier Minister, Dr. T. V. Soong, and Generalissimo Stalin have notably reduced the risk of civil war in China.

THREAT OF 'UNBEATEN JAP ARMY'

FEARS of a Japan still believing, in spite of defeat, in its glorious destiny and the invincibility of its army, with the Japanese "General Staff going to ground" as did the German staff in 1918, were expressed by The Times yesterday.

In the demilitarization of the Japanese people the paper urged the honest application to Southeast Asia of the principles of San Francisco.

The dismemberment of the Japanese surrender, the paper observes, imposes upon the Allies the necessity for extreme vigilance.

ARMY DEFEATED IN "REMOTE" AREAS

While the Japanese naval and air forces have been almost annihilated and the civil population has been shattering democratic observation, The Times adds, there is brave remorse from public observation.

Large bodies of Japanese troops will return home with so other experience than that of victory and many Japanese commanders of overseas territories will boast with truth that they surrendered not to Allied arms, but in deference to Imperial receipt.

The way is thus open for the propagation of the myth which proved so formidable a factor in the rise of the Third Reich—that the Army had never been conquered and that the war was lost by poor - civilian morale caused by the Allies employing "unfair weapons."

"The Allies can expect little aid from civil authorities in exposing this dangerous myth.

"The governing class from the Emperor downwards is engaged in persuading the nation that its imperial prerogative remains intact and the destiny of Japan glorious."

The Times claims that the task and to be aimed at is the demilitarization of the minds of the Japanese people.

"There are two main influences which may be expected to contribute powerfully to each conversion.

"First is 'honest application to South-east Asia of the principles of the San Francisco Charter and second a spectacle of unity upon their declared aim.

"One of the contributory motives of Japanese aggression has been a deep resentment at the disposition of the Western Powers to treat the Eastern peoples as their inferiors.

WISHED TO UNITE EAST 'AGAINST WEST

"Japan desired to unite the East against the West under her own leadership and led the Japanese invaders displayed even more...

Peace In Long Buckby, Too

People in the Northamptonshire village of Long Buckby are speaking to each other again now that Japan has surrendered.

Their war started on VE-Day when it was found that the parish council had not arranged any celebrations.

Jack Cooper, secretary of the local Comforts Fund, Frank Biddall, the village fishmonger and Home Guard, Bill Coleman, the chimney sweep and Bob Coleman, bootmaker, got together and with many more helpers arranged VE celebrations 25 days...

The 8th Army News, Triest, August 28, 1945, page three. For a short period of time, before the Cold War started heating up, censorship, both military and civilian was lax. It is from this time period from which we get much valuable information

105

this within a working association with the SS atomic research team mentioned above (37). This SS connection runs back to Prag, the Skoda Works and the Kammler Group who held knowledge and control of every truly innovative weapons system being developed by the Third Reich including those at Peenemuende. As we know, this included the development of flying discs. The association of the facilities in and around Prag, the Kammler Group, atomic energy and German flying discs has been made by other researchers using other evidence (38). This connection seems very strong.

The Germans were planning an nuclear powered flying saucer just as they were planning a nuclear powered submarine. The proof for both of these claims is the fact that the Americans discovered such plans, further developed them with captured German scientists, and built them in America after the war. We already know about the nuclear submarine and proof of American plans to build a nuclear flying saucer based upon German ideas has just been reveled.

Jim Wilson, writing in the November, 2000 edition of Popular Mechanics discloses something of major importance. Wilson tells of the days following the collapse of the 3rd Reich and a rumor which had begun circulating in Allied military intelligence circles. Interrogations of captured German aircraft engineers pointed to the development of a super-fast German rocket fighter at a secret base in Bavaria (the reader will recall the research aircraft 8-346 and P-073 mentioned earlier). This aircraft, according to Wilson's article, featured odd looking curved wings which blended into the fuselage.

Documents obtained by Wilson point to an American secret saucer project, separate and parallel to Project Silver Bug, of German inspiration and involving captured German personnel. This project, called the Lenticular Reentry Vehicle (LRV), was a flying saucer designed to carry four nuclear tipped missiles into earth orbit for a mission duration of six weeks at a time. The saucer had a four man crew, was forty feet in diameter and was powered by a combination of chemical rocket engines and nuclear power (39).

The chemical engines were the hypergolic rocket engines of the same type as employed by the Germans during the war in the Me-162 rocket interceptor and referred to earlier.

Besides the chemical rocket engine, two atomic engines were employed as atomic rockets. In this type of engine a liquid gas (perhaps liquid air as described above) which is very cold, is passed through the atomic reactor or passed through a radiator of molten metal heated by the reactor. The liquid gas turns to vapor instantly and is accelerated out the rear of the rocket at a greater velocity than can be obtained by burning two liquid gases, for instance, hydrogen and oxygen. Although a shielded nuclear reactor is certainly heavier than an air-cooled aero-engine, there might an overall weight savings as compared to a

Nuclear Gas Core Reactor

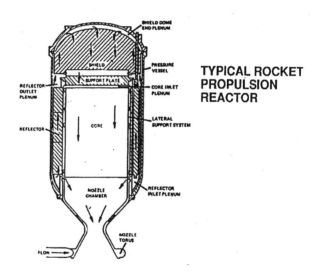

TYPICAL ROCKET PROPULSION REACTOR

Top: The simple story is that hydrogen is passed through or by an atomic reactor. The very cold liquid hydrogen in instantly heated and greatly expands, providing thrust for the rocket. No actual combustion occurs and no oxidizer is needed. Bottom: A detailed look at the reactor itself.

conventional liquid rocket system since a liquid oxidizer, such as liquid oxygen, need not be carried on the vehicle. The atomic engine would also produce electricity for the saucer using this expansive output coupled to a turbine generator.

Wilson cites some evidence that this saucer was built and actually flew (40). Orbiting at an altitude of 300 miles and with a six week mission, this saucer was in reality an orbiting space station capable of raining destruction down upon any country or countries deemed an enemy. One can extrapolate a rotation system by which such a dreadnought was always kept on station for such a contingency. Klaus-Peter Rothkugel has suggested that an orbiting doomsday space station such as this was to be called the "Gatland Space Station" and that it was part of a strategic military joint-effort between the United States, Britain, Canada and perhaps Australia. Before the Popular Mechanics revelation, this assertion might have been dismissed as lacking in proof but now this idea must be given a hearing.

Wilson states that project's general contractor was North American Aviation in California but the project was managed out of Wright-Patterson Air Force Base in Ohio where German engineers who worked on rocket plane and flying disc projects were housed under secret contract with the United States government (41).

The Popular Mechanics article is based upon information obtained from working on the American perspective and going back in time. The Freedom Of Information Act was very skillfully employed in obtaining this information. What Mr. Wilson did not know was what the reader knows now, that there is a trail of information leading to the American nuclear saucer project which started in Germany in the 1930s. One example which links both lines of evidence and bringing them full-circle back to the German origin is one report recently obtained via FOIA on a particular German scientist working at that Wright-Patterson facility.

This is a December, 1946 report written by one of those captured German scientists working under contract for the USA, Dr. Franz J. Neugebauer, titled "Effect Of Power-Plant Weight On Economy Of Flight (Project No. NFE-64). Dr. Neugebauer was, in fact, one of those "booty scientists" brought to the USA under the auspices of Operation Paperclip. The Biographical Note in the report, "Effects Of Power-Plant Weight On the Economy Of Flight", describes Dr. Neugebauer as:

"Dr. Franz J. Neugebauer is the foremost German authority on this subject. An Expert on internal-combustion engines and a specialist for Diesel compound aircraft engines, he held leading positions at Junkers in Dessau and Munich from 1924 to 1943, and was director of the engineering department of the Institute for Aeronautical Research at Munich from 1943 to 1945.

Dr. Neugebauer is employed at present in the Propulsion Section, Analysis Division, Intelligence (T-2), AMC, Wright

Field, Dayton, Ohio" (42).

Two comments are in order. The first is that Junkers-Dessau is associated with a possible German saucer project designated "Schildkroete" which will be discussed later. The second comment is that Dr. Neugebauer was not brought to the USA to build diesel-powered aircraft. Diesel engines are much heavier than piston type aero-engines of those times. Dr. Neugebauer's relevant expertise is, in reality, his knowledge of the effects of heavy engines on aircraft performance and economy.

Nowhere in this report are the words "atomic rocket" mentioned but the implications are clear. As touched upon above, an atomic rocket's weight distribution would be somewhat different from that of a conventional rocket or aircraft. The nuclear reactor would be weighty but the fuel load would be lighter because no oxidizer, such as liquid oxygen, would be necessary. Also, the power output would be somewhat greater than an ordinary liquid fuel chemical rocket. The three variables as opposed to the already known figures for piston, jet or chemical rocket engines are greater engine weight, lesser fuel weight, and greater power output. A new equation was necessary if atomic rockets were to be fitted into an aircraft design calling for a certain speed, payload or range. It was Dr. Neugebauer's job to do this computation.

The following is a paragraph from the introduction of this report (43). It seems to say nothing but state the obvious until one thinks "atomic engine":

"Power-plant weight is a factor which affects flight performance; the greater the weight, the greater is that portion of the airplane and the drag which is affected by the power plant. In contrast to the effect of fuel consumption, the effect of power-plant weight cannot be easily determined. For example, it cannot be easily determined whether a certain reduction of fuel consumption is still advantageous if it involves an increase in power plant weight. This report aims to facilitate insight into these and similar questions."

Without ever mentioning the word "atomic", Dr. Neugebauer did the mathematical computations necessary to establish the feasibility of an atomic powered aircraft. Thanks to the work of Mr. Wilson, we know that at least advanced planning was undertaken with the goal of building an atomic powered flying saucer. There is no doubt that the Americans would not have involved captured German scientists in this project unless it was absolutely necessary to do so. The reason it was necessary was the same reason which other German scientists were employed in America's ballistic missile program. It was because both groups of German scientists has previous experience. Both groups worked on very similar projects in Germany during the war. These scientists and their projects were far ahead of the Americans in both these areas. The input of these scientists was absolutely essential if these

109

projects were to succeed in a timely matter, meaning, ahead of the Soviets.

Two final points or comments should be added to this discussion. First, while the Peenemuende saucer project was run in and around Peenemuende, research and component work were probably also done in other facilities elsewhere within the Greater Reich. References to saucer research at some of these other sites by this or other writers may be, in fact, part of the overall Peenemuende project.

Second, historically speaking, the German atomic projects have always been minimized to say the least. For whatever reason, there seems to have been a concerted effort to deny German expertise in the field of atomic energy. Originally, this may have been government inspired. Now, however, it seems to be a mantra taken up as part of some agenda whose specifics remain clouded. "Nay-saying" regarding German atomic projects has become sheik and those who expound it imply knowledge and sophistication in their opinions. Anyone doubting the high degree of understanding possessed within the Third Reich concerning matters "atomic" should take a look at the evidence being put forth by on-site investigators and German language researchers which have arisen since the fall of the Berlin Wall. Much of this information is in book form available from Anum Verlag. Anyone with the interest and ability to read German language is urged to contact this publisher for a list of publications. After reviewing the evidence, German wartime expertise in atomic research sounds much less far-fetched than the nay-sayers would have you believe.

The Peenemuende Project

Sources and References

1. Goldstein, Sydney, 1948, pages 189 and 190, "Low-Drag and Suction Airfoils", Journal Of The Aeronautical Sciences, Volume 15, Number 4, University of Manchester, England

2. Pretsch, J., date unknown, "Umschlagbeginn und Absaugung Ein Breitrag zur Grenzschichttheorie", Report of the Aerodynamic Research Facility at Goettingen

3. Betz, A., 1961, page 1, in Boundary Layer And Flow Control edited by G.V. Lachmann, Pergamon Press, Oxford

4. Betz, A., 1961, page 6

5. Schlichting, H., 1942, "Die Grenzschicht and der ebenen Platte mit Absaugung and Ausblasen", Luftfahrt-Forschung

6. Kinner, Wilhelm, 1936, "Ueber Tragfluegel mit Kreisfoermigen

Grundriss", Vortraege der Hauptversammlung in Dresden, Band 16, Heft 6,

7. Hansen, M., 1938, "Messungen and Kreistragflaechen und Vergliech mit der Theorie der tragenden Flaeche", Vortraege der Hauptversammlung in Goettingen

8. Miranda, J. and P. Mercado, 1998, page 4, "Deutsche Kreisfluegelflugzeuge", Flugzug Profile

9. Rothkugel, Klaus-Peter, 2000, pages 1 and 2, "Dr. Alexander Lippisch der "Vater" der "fliegenden Untertassen", privately published information sheet

10. Sandner, Reinhardt, 1980, page 3, "Der Vater der fliegenden Untertasse ist ein alter Ausburger", Neu Presse, number 19/17

11. ibid

12. U.S. Patent, Number 2,939,648, Granted June 7, 1960 filed March 28,1955, United States of America granted to H. Fleissner,"Rotating Jet Aircraft With Lifting Disc Wing And Centrifuging Tanks"

13. British Objectives Sub-Committee Report Number 143, "Information Obtained From Targets Of Opportunity In The Sonthosen Area, pages 4 and 5, 32 Bryanston Square, London

14. Combined Intelligence Objectives Sub-Committee Evaluation Report Number 289, 1945, Interrogation of Drs. Julius Schmitt, Ludwig Schmitt, and Heinrich Schmitt, of Dr. Heinrich Schmitt-Werke, K.G. Berchtesgarden

15. Kadmon, 2000, Ahnstern lX "Andreas Epp", Aorta c/o Petak, Postfach 778, A-1011, Wien, Austria

16. Vesco, Renato, 1976, page 93, Intercept UFO, Pinnacle Books, New York

17. Vesco, Renato, 1976, pages 135-136

18. Vesco, Renato, 1976, page 164

19. Vesco, Renato, 1976, page 168

20. Vesco, Renato, 1976, page 163

21. German Patent, 1943, Karl Nowak, German Patent Number 905847, Class 12g, Group 101, Subsequently issued by the German Federal Republic on March 8, 1954. "Verfahren und Einrichtung zur Aenderung von Stoffeigenschaften oder Herstellung von stark expansionsfaehingen Stoffen" (English translation: Method and Arrangement to the change from material properties

111

or production of strong expansive capable matter)

22. Van Norstrand's Scientific Encyclopedia, 1954, pages 453-454 and 978-979.

23. Jesensky, Milos PhD. and Robert Lesniakiewicz, 1998, pages 51, 146, 151, "Wunderland" Mimozemske Technologie Treti Rise, Aos Publishing

24. Jesensky, Milos PhD. and Robert Lesniakiewicz, 1998, pages 41-43.

25. Heisenberg, Werner PhD., 1946, page 327, "Ueber die Arbeiten zur technichen Ausnutzung der Atomkernenergie in Deutschland" (In English: Concerning the Work Toward the Technical Exploitation of Nuclear Energy in Germany) courtesy of Mr. Klaus-Peter Rothkugel

26. British Intelligence Objectivers Sub-Committee Report Number 142, 1946, page 8, "Information Obtained From Targets Of Opportunity In The Sonthofen Area", London, courtesy of Friedrich Georg

27. Georg, Friedrich, 2000, page 222, Hitlers Siegeswaffen Band 1: Luftwaffe und Marine Geheim Nuklearwaffen des Dritten Reiches und ihre Traegersysteme, Anum Verlag, Schleusingen and Heinrich-Jung-Verlagsgesellschaft, mbH, Zella-Mehlis

28. Georg, Friedrich, 2000, pages 125, 154. ·

29. Powers, Thomas, 1993, Heisenberg's War The Secret History Of The German Bomb, Alfred A. Knopf, New York

30. Powers, Thomas, 1993, pages 130, 131, 132, 136, 137

31. Powers, Thomas, 1993, pages 131, 132, 135, 325

32. Powers, Thomas, 1993, pages 136, 138

33. Powers, Thomas, 1993, page 325

34. Georg, Friedrich, 2000, pages 188-190

35. Powers, Thomas, 1993, pages 131, 137, 143, 317

36. Powers, Thomas, 1993, pages 131, 137, 317, 416

37. Georg, Friedrich, 2000, page 125

38. Jesensky, Milos PhD., and Robert Lesniakiewicz, 1998, pages 146, 151,

39. Wilson, Jim, 2000, Popular Mechanics, "America's Nuclear Flying Saucer"

40. Wilson, Jim, 2000, page 71

41. Wilson, Jim, 2000, page 68

42. Neugebauer, Franz J. PhD., 1946, Technical Report: "Effect Of Power-Plant Weight On Economy Of Flight (Project No. NFE-64), Headquarters Air Material Command Wright Field, Dayton, Ohio

43. Neugebauer, Franz J. PhD., 1946, page 1

Section Summary

It can be said that the German flying disc program built upon itself, each innovation retaining something from a previous design yet incorporating a new innovation. This progressed through several steps until the original had seemingly nothing in common with final design. At each step a saucer project or at least a saucer design, seems to have been spun off. Each of these spin-offs was not an independent, stand-alone project but remained under the guidance and direction of an overall controlling authority. If viewed out-of-context, the multiplicity of designs and spin-offs have led to confusion concerning the whole. Proponents of each design or spin-off have championed the project with which they were familiar as "the" German saucer project. Let us try to keep idea in mind when discussing the next group of saucers which may or may not have had a relationship to those already discussed.

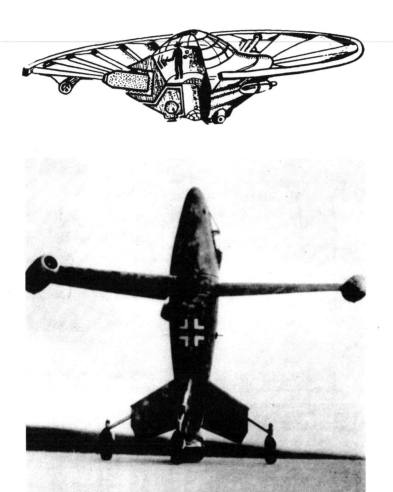

Top: Diagram of the Scriever-Habermohl flying disk. Bottom: The Focke-Wulf powered wing design with three Lorin ramjet engines. The required initial velocity was to be provided by rockets mounted in the engines.

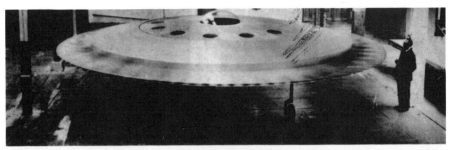

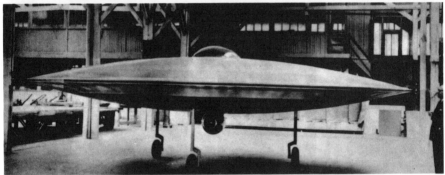

Top: These photos of French aerospace designer Rene Couzinet's flying saucer
with a diameter of 27 feet appeared in the Philadelphia Inquirer on July 5, 1955.
He died in a sudden auto accident shortly afterward. Left: The famous Darmstadt
Saucer, a photo taken in August 1953 near the German city of Darmstadt.

IGOR WITKOWSKI

SUPERTAJNE BRONIE
HITLERA
część 3

A Polish language book on Hitler's secret weapons, including saucer and cylindrical aircraft.

Pekka Lahtinen

Ufojen arvoitus ratkeaa

Tulevatko ne tosiaan ulkoavaruudesta vai voiko kyseessä olla ihmisen oma keksintö? Entä pienet vihreät miehet?

158-2-11

A Finnish language book on Hitler's secret weapons, including saucer and cylindrical aircraft.

CHAPTER FOUR:

THE GERMAN FIELD PROPULSION PROJECTS

THE VICTOR SCHAUBERGER MODELS

THE KM-2 ROCKET

FIELD PROPULSION SAUCERS
A German Eye Witness
A Combined Intelligence
Objectives Sub-Committee Report
The Smoking Gun: An F.B.I. Report
Discussion of German Field Propulsion Saucer
Atomic Saucers Again
The Karl Schappeller Device

German Field Propulsion Projects

This type of flying vehicle would lift and move itself powered by
an electric, magnetic. diamagnetic or ether field which repels
earth's magnetic field or overpowers the effects of gravity.

The Viktor Schauberger Models

An Austrian, Viktor Schauberger was first and foremost a
naturalist. His primary focus was water as found in naturally
occurring streams, rivers and lakes. In observing the movement
of water he formulated his own ideas about its movement and
energetic properties. They are applicable in air also. His
ideas are quite contrary to accepted ideas, both then and now and
are even now imperfectly understood and debated. These ideas
involved the vortex which was the way Schauberger believed that
water naturally flowed both in the earth and in streams.
Schauberger believed that energy naturally flowed in a vortex but
that this movement was only visible through another medium such
as water or air. This discussion will first focus on theories of
why and how the Schauberger saucer model flew and then recount
the sequence of events in Schauberger's involvement with flying
discs.

Viktor Schauberger's saucer models incorporated a vortex in which
air entered at the top and flowed right through the center of the
saucer. Schauberger's vortex was an open system. A whirlpool or
tornado or hurricane are examples of the kind of vortex upon
which Schauberger's ideas are based. There are two directions of
vortex movement, centripetal or inward moving vortex and
centrifugal or outward moving vortex. Centripetally moving, that
is inwardly moving spiraling air or water, takes up less space
and is cooled by this motion according to Schauberger (1). The
example we see in daily life is the motion of water in a toilet
after flushing. He called this centripetal movement "implosion".
Implosion was always accompanied by explosion as the fluid
expanded again in an outward, centrifugal spiral. The process is
first centripetal then centrifugal. The form this vortex took is
really dictated by function according to Schauberger. The
"function" is the energy flow. The spiral vortex is the shape
the energy flow takes in its movement (2). Energy flows in at
the top of the vortex in the characteristic double-spiral manner.
These air molecules are imploded, that is, they are made more
dense and they yield heat as they progress (3). Air molecules are
squeezed tighter and tighter together as they move down the
vortex until the sub-atomic particles themselves become unglued
transforming into new and unrecognized forms of energy (4). As
the vortex itself decreases in diameter implosion and speed are

121

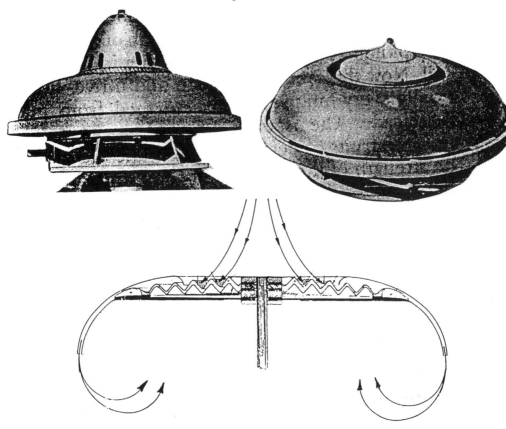

Viktor Schauberger's Saucer Models

Top: Schauberger models. Bottom: Sectional diagram. The zig-zag is the air passage. The passage is a hollow space between two plates. As the saucer spins on its axis, the air enters and moves away from the center toward the rim following the up and down flow of the zig-zag. The spin causes individual tornado-like vortices to form as the spin causes the air flow to fold over on itself as it moves outward. Vortices become smaller in diameter and more "densified" until they reach the rim where they are released into the atmosphere, rapidly expand, and yield energy. Model is multi-section, copper. Courtesy Klaus-Peter Rothkugel

122

increased until they reach the point within the vortex where centripetal forces stop and centrifugal forces take over.

Energy is radiated out from the center of the vortex (5). The Schauberger vortex may be visualized as a figure "8" according to Dr. Gordon Freeman, with the energy radiating out at the narrow mid-point between the upper and lower loops (6). This energy is produces levitation. It may be diamagnetic energy as Schauberger believed (7).

Viktor Schauberger first built new designs for flumes to transport logs. He then built water purification machines using the principle of the vortex. He then built electric generators, heaters and coolers using only air as fuel. The breakthrough using machines was Schauberger's claim to have found a way to make his vortex machines auto-rotate at rotational speeds between 10,000 and 20,000 revolutions per minute (8).

In some Schauberger machines, a small high-speed electric engine would spin the air around an axis using a paddle-like propeller. The motor would continue accelerating the rotating air until it reached the critical speed of auto-rotation. At this point, the process was self-sustaining with air being drawn in and expelled with no additional input of energy (9). Air could be drawn in on a continuous basis since it was being cooled and thus made more dense in the vortex spiral. Greater density is loss of volume. Loss of volume created lower pressure at the air inlet with drew in more and more air as the reaction continued. Greater air speed at the point of ejection also served to lower the pressure as explained in Bernouli's Law (the same process which makes an airplane wing lift the aircraft), thus helping to lowering pressure at the inlet.

So to review: air is drawn in one end of the machine by an electric-powered, paddle-like fan or by spinning the entire machine as was the case with the saucer model. Air is then spiraled into a vortex of special proportion and shape designed by Schauberger. The air is made more dense yet cooled as it funnels down to its smallest diameter. At this point, just before expansive forces take over, energy is liberated perhaps due to the un-gluing of sub-atomic forces which frees energy in some manner currently imperfectly understood. The air begins to expand in a centrifugal motion as it warms. It is at this midway point that the air exits the saucer model at its periphery or lip of the saucer to expand centrifugally in the open atmosphere. Once a speed of 10,000 to 20,000 revolutions per minute is attained, the machine auto-rotates without need of the small electric-powered starter motor.

The exact proportions for the Schauberger pipes are designed geometrically. This geometry is of a rather esoteric nature. For instance, the bend of the spiral pipe is calculated using the Golden Section. For some time a true engineering genius, Dr. Gordon Freeman, has been writing to some interested parties and

DAS HYPERBOLISCHE OFFENE SYSTEM.

Top Left : The Hyperbolic Open System. The movement could be centripetal or centrifugal. Top Right: Law of Natural Tones resulting from the hyperbolic spiral. Bottom: The egg-shape, built according to the non-Euclidian Law of Natural Tones, correct some of the planetary motion laws of Kepler according to Schauberger.

explaining how certain shapes or wave patterns can impact conventional physics. He believes one needs to understand known science as well as a more esoteric doctrine in order to appreciate the nature of free-energy and some types of field propulsion UFO craft. The work of Viktor Schauberger is an example of this. In this work there remains a world of knowledge imperfectly understood by most of us.

Returning to the mechanism by which these models flew, Schauberger himself always made the point of the fact that his saucer models were constructed of diamagnetic materials. Diamagnetic materials are those which are repel a magnetic field. Schauberger considered copper diamagnetic (10) and the surfaces of the saucer models coming in contact with air were made of copper.

As mentioned above, the very atomic structure of these atoms may have altered by this process. Coats tells us that electrons, protons and neutron may have been separated from one another (11). It has been suggested that the electrons and protons of these atoms were stripped from their nuclei. Their opposing charges were free and attracted one another resulting in their mutual annihilation of one another yielding a release of energy (12). This would occur exactly at the point where centripetal forces ceased and centrifugal forces began, these air particles reversed their spin and altered their rotation.

Further, Coats explains that the neutrons, which were left over in the process described above, and contrary to accepted views, are themselves magnetic (13). These neutrons were expelled from the saucer centrifugally along with water, water vapor and air which had not reacted as stated above. These "magnetic" neutrons, on the outside of the saucer body may serve to increase the diamagnetic reaction of the copper saucer which would be both pushing away from the earth and the cloud of surrounding "magnetically charged" neutrons. In other words, the Schauberger disc may have been repelling away from the magnetically charged atmosphere which it itself had just created.

Dr. Richard LeFors Clark proposes a more detailed description of similar ideas involving the mechanism of the Bloch Wall (14). This will be discussed in the section involving Karl Schappeller but it should be kept in mind while reading these ideas that Dr. Clark had Schauberger in mind. These ideas and others pertaining to both Schauberger and Karl Schappeller will be presented in the Schappeller section to follow.

The history of the Schauberger flying disc models is as follows. According to Alexandersson, Aloys Kokaly, a German, began work for Viktor Schauberger in the early days of the Second World War producing certain parts for a "flying object" which were hard to obtain in Austria. The parts were to be delivered to the Kertl Works in Vienna which was the site of this work at the time. The Kertl Works were operating "on higher authority" in association

with Schauberger. Kokaly was received at Kertl by its chief and told by this individual, somewhat bitterly, that one of these strange contraptions had already flown. As a matter of fact it had gone right through the roof of the Kertl plant (15). The year was 1940.

Coats tells us that the purpose of this device was twofold. First, it was to investigate free energy production. This could be done by running a shaft to the rapidly rotating wheel-like component which was auto-rotating at between 10,000 and 20,000 rpm. Using reduction gearing, some of that energy could be mechanically coupled to an electric generator producing electricity at no cost. The second purpose of these experiments was to test Schauberger's theories on levitation and flight (16).

Two prototypes were said to have been built at Kertl. The test flight was done without Schauberger's presence or even his permission to do the test. The model flew as described above but it did considerable destruction to the Kertl Works so there were mixed feels concerning the success of this flight. The force of levitation was so strong that it sheared six 1/4 inch diameter high-tensile steel anchor bolts on its way to the roof. Coats reports that according to Schauberger's calculations based upon previous tests, a 20 centimeter diameter device of this sort, with a rotational velocity of 20,000 rpm, would have lifted a weight of 228 tons (17).

A few years earlier in 1934 Schauberger had met with Hitler to discuss alternative energy ideas (18). Nothing come of this meeting immediately but after Germany annexed Austria in 1938, Schauberger became involved in research at Professor Kotschau's laboratory in Nuremberg. Assisted by his son, Walter, who had just completed engineering studies at a technical college in Dresden, Viktor Schauberger went to work with a Dr. Winter on a plan to extract electrical energy directly form a water flow. Some success was achieved. Alexandersson reports that a potential of 50,000 volts was achieved but that no practical results came from this at that time (19).

Probably based upon the fact that Viktor Schauberger was a veteran of the Great War, he was inducted into the Waffen-SS in 1943. This put him under the direct control of SS chief Heinrich Himmler. Schauberger was ordered to castle Schoenbrunn near the Mauthausen concentration camp in Austria. There he was to select qualified prisoners, twenty to thirty craftsmen, technicians and engineers, and begin work on a new, secret weapon. Schauberger arranged improved conditions for his team and produced another flying saucer model (20).

In May, 1945, because of the deteriorating circumstances of the war, Schauberger was re-located to Leonstein in Upper Austria by the SS. There, just after a successful test flight of his latest device, it was seized by an American intelligence unit which appeared to be well informed about it. Schauberger was de-

briefed by American intelligence, according to Coats, detained, and told not to participate in further research (21).

Coats was actually able to locate a surviving example of a Schauberger saucer model. Excellent photographs of this device are to be found in his book, <u>Living Energies</u>, as well as a dissection of it into its various components. It is unclear if this device was one of the earlier (1940) or later (1945) projects.

After the war, Schauberger worked on agricultural projects in Austria until one day in the late 1957 when he was contacted by two Americans. They promised Viktor almost unlimited resources if he and his son Walter would work for them in the United States (22). Discussion concerning the exact source and motives for this offer are beyond the scope of this discussion but suffice it to say that they were powerful interests. The Schaubergers were sent to Texas, near the Red River, where Viktor was asked to disclose everything he knew and Walter was asked to set Viktor's terminology into the standard language of physics and engineering. This whole episode proved extremely unsatisfactory for both Schaubergers and they returned to Austria after about three months. As a condition for their return, Viktor was asked to sign away his knowledge to this powerful concern. Viktor was given a contract in English, which he did not read. Nevertheless, the deal was done and the Schaubergers returned to Austria (23). Viktor, already in poor health, died five days later on September 25, 1958. Walter continued advancing his father's research in Austria until his death in 1997.

Coats provides us with pictures of one of the Schauberger saucers in question and an explanation of its workings (24). This saucer was composed of a number of copper plates bolted together. Air was drawn in at the to and into the rapidly spinning saucer which was set into motion by an electric motor. In this machine no paddles pushed upon the air to start it. Instead, a motor was used to spin the whole saucer model to the desired number of revolutions per minute. The air was thus spun rapid over channels formed by the upper and lower surfaces of two copper plates. On these plates alternate ridges and depressions on both plates kept the air moving in snake-like wave forms and it moved toward the periphery of the saucer. Because the saucer was rapidly spinning, the air was folded over upon itself as it moved laterally into many individual vortices. The air was rotating in these vortices and moving up and down between the ridged plates. It was also moving around as the saucer spun on its axis. This is a double-spiral motion which additionally duplicates the undulating motion seen on the Schauberger log flumes. The air was cooled and made more dense as it progressed towards the periphery. At and around the saucer the periphery, it was ejected into the atmosphere at great speed.

In this machine, centripetal air flow changes to centrifugal air flow at this periphery. The air, once outside the saucer,

spirals away in a centrifugal motion. It is at this periphery, at the midline of the saucer, where the change of motion takes place. It is here that energy is liberated. It is this energy which gives the saucer its quality of levitation.

Sometimes the Coanda Effect is cited as a reason this saucer flew (25). Coanda effects, if present at all, are only a secondary force if Viktor Schauberger's calculations are correct. Coanda effects alone could never be powerful enough to generate the lifting force equal to 228 tons which Schauberger estimated his small model produced.

The important factual points to keep in mind are these: First, this saucer-model, probably in more than one version, actually flew. Second, one model still exists today. Therefore this "flying saucer" is a physical reality which can be photographed, touched and studied. Third, explanations of the mysterious energetic forces causing lift in this device should not be forgotten. The German scientific leadership was interested in implosion and in what Schauberger had to teach them but they did not necessarily want to be limited by the use of air to achieve these results. Instead, they may have wanted to use Schauberger ideas but actuating these principles with electronic components. We will see some ideas relating to Schauberger in a future example.

The Viktor Schauberger Models

Sources and References

1. Coats, Callum, 1996, page 276, <u>Living Energies</u>, Gateway Books, Bath, U.K.

2. Coats, Callum, 1996, page 46

3. Coats, Callum, 1996, page 276

4. Coats, Callum, 1996, page 290

5. Freeman, Gordon PhD., 1999, personal correspondence

6. ibid

7. Coats, Callum, 1996, 290

8. Coats, Callum, 1996, 287

9. ibid

10. Coats, Callum, 1996, page 292

11. Coats, Callum, 1996, pages 290-292

12. Coats, Callum, 1996, page 292

13. ibid

14. Clark, Richard LeFors PhD., 1987, "The Earth Grid, Human Levitation And Gravity Anomalies" in Anti-Gravity And The World Grid, edited by David Hatcher Childress, Adventures Unlimited Press, Stelle, Illinois

15. Alexandersson, Olaf, 1990, page 87, Living Water, Gateway Books, The Hollies, Wellow Bath, U.K.

16. Coats, Callum, 1996, page 287

17. ibid

18. Kadmon, date unknown, pages 10, 23, Ahnstern 1, "Viktor Schauberger", Aorta c/o Petak, Postfach 788, A-1011, Wien, Austria

19. Alexandersson, Olaf, 1990, pages 89-91

20. Coats, Callum, 1996, page 11

21. ibid

22. Coats, Callum, 1996, page 15

23. Coats, Callum, 1996, page 27

24. Coats, Callum, 1996, pages 287-293

25. Reba, Imants, 1966, page 86, "Applications Of The Coanda Effect", Scientific American

The KM-2 Rocket

A shred of evidence comes down to us though the years in the form
of a newspaper article by Lionel Shapiro in the Denver Post,
dated November 9, 1947, and titled "Spies Bid for Franco's
Weapons". (Please refer to a copy of that article). It should
be noted that this was a few months after the summer of 1947, the
first and largest UFO flap in history, which included the Kenneth
Arnold sighting and the flying saucer activity of Roswell. It
should also be noted that the Denver Post was nor is not a
tabloid publication.

In doing research, this newspaper was contacted in an attempt to
learn the whereabouts of the author, Lionel Shapiro. Unlike so
many newspapers in the United States which have been purchased
and merged by conglomerates, this newspaper is still intact and
in existence. Unfortunately, no record could be found of Mr.
Shapiro in their personnel files although they did maintain files
going back that far. Also, no record could be found in their
sister publication, The Rocky Mountain News. It was suggested
that Mr. Shapiro was "a stringer", that is, a writer who did not
work directly for the newspaper and whose work was purchased on a
piece by piece basis. His work seems to have been channeled
through the North American Newspaper Alliance. More of Mr.
Shapiro's history and connections will unfold as the tale
progresses.

This article describes two devices. The first is an
"electromagnetic rocket", sometimes referred to later as the "KM-
2 rocket" in other literature. The second is a nuclear warhead
small enough to be fired by an artillery piece. The nuclear,
warhead which is affixed to a cannon projectile, is novel at this
time and is interesting since such devices were built and fired
shortly thereafter by the United States military. The article's
description of the nuclear cannon is correct. This was a German
invention and was under development in Germany during the latter
stages of the war. A prototype was even built and it carried the
German designation of DKM 44 (1). This very cannon was copied by
the Americans and became the T-131 which fired a nuclear warhead
(2).

The discussion of the nuclear cannon is really beyond the scope
of this book but what is important to bear in mind concerning
this discussion is that if fifty percent of this article has
proven to be accurate. The nuclear cannon was built and it
stemmed from a German prototype. Does this not at least raise
the possibility that the other fifty percent is accurate also?

Returning to the electromagnetic rocket itself, this device is
right on point for the discussion of field propulsion. Some
points are ascertained in reading this article. Its description
as a "rocket" would lead one to believe it was cylindrical in
shape rather than saucer-shaped. It is suggested that this

130

The KM-2 Rocket

Spies Bid for Franco's Weapons

Agents Ascribe 'Flying Saucers' to New Rocket

By LIONEL SHAPIRO.

GENEVA.—Three German scientists working under the personal sponsorship of Generalissimo Francisco Franco have developed two highly advanced weapons of war, according to specifications and blueprints smuggled out of Spain by the agent of an independent European spy organization.

The first weapon is an electromagnetic rocket which, it is claimed, is responsible for the "flying saucers" seen over the North American continent last summer and for at least one and perhaps two hitherto unexplained accidents to transport aircraft.

The second weapon is an artillery warhead employing the principle of nuclear energy and described as having a startling disintegrating power.

Blueprints of the weapons have been offered for sale to at least three of the great powers. The degree of credence placed in them by the military intelligence sections of these powers is indicated by the fact that two of them—of whom this correspondent has certain knowledge—have made strenuous and, indeed, dramatic efforts to acquire the blueprints.

Big Sums Offered

The disclosure that these plans were available has touched off the most intense activity among secret agents in European capitals since the end of the war. Huge sums of money and even threats of death have been involved in negotiations.

The nation which coupled a threat of death to its bid is Soviet Russia.

I came upon the story three weeks ago by accidental interception of a document cataloging the weapons. This was being circularized through Europe's intricate network of secret agents. Since then, careful checking among agents and military intelligence organizations in several countries has disclosed:

That the principal powers fully believe Franco has been developing new weapons.

That the weapons (particularly the electro-magnetic rocket) do actually exist and are now being manufactured in Spain.

According to the information available, the weapons were developed in secret laboratories located near Marbella on the south coast of Spain just east of Gibraltar. They were tested in Franco's presence early last summer. The rocket, known as KM2 after its inventors, Professors Knoh and Mueller—was tested off Malaga while Franco watched from the deck of his yacht.

The rocket is described as having a range of 16,000 kilometers (9,942 miles) traveling in a given direction. Its flight can be controlled by radio for at least the first 5,000 kilometers (3,107 miles) and when the control is removed the rocket is attracted by electric vibrations of flying planes or the magnetism of the nearest mass of metal. It explodes when it reaches the attracting element.

The agent who smuggled the blueprints out of Spain, and who presumably was present at the tests, claims that the rockets were directed over North America and that they were responsible for at least one and probably two transport-plane accidents which, for want of better explanation, were attributed to structural defects.

The nuclear-energy projectile is credited to a Professor Halkmann. It is described as twenty-two centimeters (8.7 inches) long and is used as a warhead for artillery shells. The agent claims that Franco is already mass-producing automatic guns to fire these new shells and that the first tests of the projectiles show them to have unprecedented explosive qualities.

Post-War German science for Generalissimo Francisco Franco. This is from the Denver Post, November 9, 1947, four months after flying saucers were seen all over the USA.

131

device was responsible for the flying saucer sightings over the USA that previous summer. This speaks for its operational range. It was said to have been tested off Malaga while Franco watched. The device was constructed in the town of Marbella, east of Gibraltar. Finally, it was said to have been of German origin, even naming the German scientists who built it.

Even Spain itself is of some interest here since this country's ruler, Generalissimo Francisco Franco, was openly sympathetic to the Nazis. The Nazis had assisted Franco militarily in the Spanish Civil War during the 1930s and were instrumental in his retention of power. During the final stages of the Second World War and afterward Spain was seen by the Germans as a safe haven for all those things they wished to keep out of Allied hands, including secret weapons. Many shipments of gold, secret blueprints, specialty steel, machine tools, scientists and high ranking Nazis were sent to Spain (3). Colonel Otto Skorzeny, head of several SS post-war, self-help organizations even set up his headquarters in Madrid (4). Spain served as a home-away-from-home for the SS after the war.

In analyzing the means by which the KM-2 device flew, it must be noted that gravitational force can be overcome through the use of a strong electrostatic charge as shown by the work of T. Townsend Brown beginning in the 1920s. This is sometimes referred to as the Biefield-Brown Effect. Imagine a torpedo-shaped model with a dielectric center section suspended by a string from the ceiling. If this model were charged with high voltage, one end would become positive and the other end would become negative. Movement would occur toward the positively charged direction if the voltage was sufficient and the charged ends remained separated by the dielectric (5).

This dielectric is an insulating material which can keep positive and negative charges from interacting with each other and so canceling each other out. They are commonly used in capacitors or condensers which have a positive charge on one side while retaining a negative charge on the other. If the charge can be contained by the non-conducting dielectric, a force is exerted in the direction of the positive side with the application of 75,000 to 300,000 volts. One way to conceive of this action is to imagine a gravity hill whose slope increases with the intensity of the ion charge. The craft being powered simply slides down the gravity gradient like a surfboard on a wave (6).

This concept is a new, non-conventional form of flight. It is non-aerodynamic method of flight. All previous conventional flight had either been through the use of lighter than air balloons, winged craft powered by propellers, jets or rockets or the brute force of rockets themselves. Using this method, Brown advocated defeating gravity by generating another form of energy over which gravity could be surfed. It is a form of field propulsion.

132

Force

100 k volts

Force

G - hill

G - well

Gravity Potential

T.T. Brown found that when strong electric charges are
separated by a dielectric, movement occurs towards the
positive charge as if gravity were reduced on the positive
side or as if the charged object were sliding down a hill.

133

T. Townsend Brown demonstrated this means of propulsion to the American military during the 1950s. He used a saucer-shaped model tethered only by a high voltage line supplying the charge to the model (7). During that decade Brown built increasingly larger, faster models using this method. Brown found that a saucer or a triangle was the best shape for this type of flying craft. A secret proposal, code-named Winterhaven, was to develop a Mach 3 antigravity saucer interceptor was put forth to the U.S. Air Force (8). This project was further developed through the 1960s but after this all traces of this concept seem to disappear.

But where Brown is overlooked is not only did he have a method of electrostatic propulsion but he also had a self-contained method to impart this charge to a flying craft. He invented a flame-jet generator or electrokenetic generator which supplied the necessary high voltage in a light weight, compact manner (9).

The flame-jet generator utilized a jet engine with an electrified needle mounted in the exhaust nozzle to inject negative ions in the jet's exhaust stream. A corresponding but positive charge is automatically built up upon the leading front edge of the craft. As long as there is no leakage through the dielectric or insulating material, in this case through the wings and body of the craft, propulsive force is generated in proportion to the strength of the charge attained. Brown estimated that such a flame-jet generator could produce potentials as high as 15 million volts of potential (10).

Ionized air molecules on the leading edge of the craft's surface had other positive benefits. The positive electrical field on the wing's leading edge reduced air friction so that drag caused by air molecules was reduced. This was because individual air molecules on the wing's leading edge were repelled from each other by their like charges (11). Frictional heating was reduced. The sonic boom of such a craft was softened (12). And finally, any returning radar signal was greatly reduced (13). Dr. Paul LaViolette has made the argument that all these characteristics are incorporated into the American B-2 bomber, concluding that the B-2 bomber is in reality an anti-gravity aircraft (14).

As Brown repeatedly points out in his Electrokinetic Generator patent, any fluid stream can be substituted for the jet engine's fuel and air (15). This means that hot water vapor or steam itself would be suitable for this purpose.

If T. Townsend Brown had been working on this form of flight since the 1920s, is it not conceivable that others were also? Remember that the KM-2 device is described as an "electromagnetic rocket". If a combination design is considered, one which combines the electrokinetic apparatus with the electrokinetic generator, a picture emerges which would seem to fulfill the description given to the KM-2 "electromagnetic rocket".

134

The real question may be if the flow of this knowledge went from Brown to the Germans or from the Germans to Brown as was the case with so much high technology in the post-war years. T. T. Brown's early collaborator and mentor was a Dr. Paul Biefield a Professor of Physics and Astronomy at Dennison University. Dr. Biefield was a German speaker who was a fellow student of Albert Einstein in Switzerland. Physicists share information across international boundaries. There is no reason for German scientists not to have followed developments in this Biefield-Brown Effect, as it is sometimes called, for the twenty years leading up to World War Two.

Before leaving the KM-2 discussion, perhaps we should return to the reporter who originally broke this story of the German "Electromagnetic Rocket" in 1947, Lionel Shapiro for a closer look at who he really was. It seems this reporter does have a history of breaking or leaking stories through the North American Newspaper Alliance. These stories which, prior to his involvement, could only be classified as "secret". The point in question is a 1946 report, brought to our attention though the extensive research of Dr. Milos Jesensky and Mr. Robert Lesniakiewicz and translated into English for me by Milos Vnenk. This account is of post-wartime intrigue can only be outlined here.

On October 13, 1945, over five months after the hostilities in Europe had ended, the French embassy in Prag notified the Czechoslovakian Foreign Ministry that an SS officer in a French detention camp had given them information that a cache of secret documents existed near Prag. This cache took the form of a tunnel in which 32 boxes of secret documents were hidden and were wired with explosives before being sealed at its opening. The French offered their services and the information given to them by the SS officer in question, Guenther Achenbach. But even after three months of waiting, no response was received by the French from the Czechoslovakian Foreign Ministry (16).

Somehow the Americans got wind of this information. Incredibly, the Americans on February 13, 1946 mounted an armed incursion into Czechoslovakia which was in the Soviet sphere of occupation, retrieved this hoard of information and escaped back into occupied Germany. Naturally the Czechoslovakians were furious and demanded and got an apology from the Americans. They also demanded the return of the German documents stolen from their sovereign territory. The Americans did return documents but probably not those sensitive documents for which the expedition was mounted (17).

Dr. Jesensky and Mr. Lesniakiewicz have made an extensive study of the German technical facilities surrounding Prag and the purposes for these facilities. It is their conclusion that the sensitive technical information recovered and which prompted this dangerous action was nothing other than plans of the German disc airplane, the "V-7" (18).

135

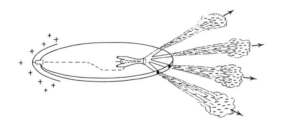

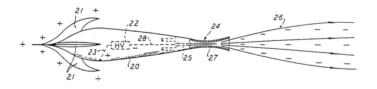

Top: T.T. Brown's flame-jet generator, capable of
supplying millions of volts. Middle: Brown's saucer design
which is definitely food for thought. Bottom: Brown's
electric rocket incorporating flame-jet generator. The
KM-2 rocket must have been a very similar device.

136

It was Lionel Shapiro, writing under the name Lionel S. B. Shapiro who broke this story for the North American Newspaper Alliance (19). As confirmation, it can be added that the story was also covered by Ms. Lux Taub in the Swedish publication "Expressen" with stories on 2/19/46, 2/22/46 and 2/24/46 (20).

In the immediate post-war world there seems to have been a relaxation on the release German technical information. Not the detailed analytic work done by the various Allied intelligence teams combing the carcass of the dead Reich, but the popular reporting by Shapiro and others who received the "o.k." to publish brief stories recounting Nazi technology which would be squelched later as the cold war got underway.

But even given this relaxation, what are the chances of one reporter stumbling upon both the stories of the electromagnetic rocket and the U.S. incursion into Czechoslovakia, first, and on his own? It is also noteworthy that both of these stories dealt with the topic of this book, or at least one which is related to that theme. Mr. Shapiro must have been a very well connected reporter indeed! He is also an excellent source of information.

A point of speculation should be made concerning the KM-2 device. As stated above, T. T. Brown believed that water vapor or steam was a suitable medium for his electrokenetic generator. Water vapor is present in the atmosphere, as we all know. A small atomic engine, such as was mentioned earlier in connection with the Messerschmitt P-1073, burning and being cooled by atmospheric gasses, might provide enough water vapor to enable the electrokenetic generator to produce the high voltage required. This would be an atomic powered field propulsion device. Further, Friedrich Georg gives us details on an atomic steam engine with the Germans were designing to power a propeller driven aircraft (21). An easy substitution of a device similar to the Brown electrokenetic generator for the propellers could have been made enabling a device with all the characteristics given for the KM-2 electromagnetic rocket to have been born. And of course Dr. Giuseppe Belluzzo would have been waiting and willing to do the plumbing.

The KM-2 Rocket

Sources and References

1. Georg, Friedrich, 2000, pages 171-173

2. ibid
3. Infield, Glenn B., 1981, pages 179, 192, <u>Skorzeny Hitler's Commando</u>, St. Martin's Press, New York

4. Infield, Glenn B., 1981, pages 173, 183

5. LaViolette, Paul A. Ph.D., 1993, pages 84-85, "The U.S. Antigravity Squadron" in <u>Electrogravitics Systems Reports On A New Propulsion Methodology</u> edited by Thomas Valone, M.A., P.E., 1994, Integrity Research Institute, Washington D.C.

6. ibid

7. ibid

8. LaViolette, Paul A. Ph.D., 1993, page 87

9. U.S. Patent Number 3,022,430, Granted: 2/20/62 to T.T. Brown, titled "Electrokinetic Generator"

10. ibid

11. LaViolette, Paul A. Ph.D., 1993, page 93

12. LaViolette, Paul A. Ph.D., 1993, page 87

13. LaViolette, Paul A. Ph.D., 1993, page 88

14. LaViolette, Paul A. Ph.D., 1993

15. U.S. Patent Number 3,022,430, Granted: 2/20/62 to T.T. Brown, titled "Electrokinetic Generator"

16. Jesensky, Milos Ph.D., and Robert Lesniakiewicz, 1998, pages 98-102, <u>"Wunderland" Memozemske Technologie Treiti Rise</u>, Aos Publishing

17. Jesensky, Milos Ph.D. and Robert Lesniakiewicz, 1998, page 100

18. Jesensky, Milos Ph.D. and Robert Lesniakiewicz, 1998, page 102

19. Jesensky, Milos Ph.D. and Robert Lesniakiewicz, 1998, page 100

20. Jesensky, Milos Ph.D. and Robert Lesniakiewicz, 1998, page 101

21. Georg, Friedrich, 2000, pages 87-89, <u>Hitlers Siegeswaffen Band 1: Luftwaffe Und Marine Geheime Nuklearwaffen des Dritten Reiches und ihre Traegersysteme</u>, Amun Verlag, Heinrich-Jung Verlagsgesellschaft mbH.

Field Propulsion Saucers

The existence of World War Two German field propulsion flying saucers is a topic which is denied by virtually every reputable authority in aviation history. It is also denied by many researchers studying German saucers. The problem is that in the years immediately following the Second World War the earth's skies suddenly began to be populated by flying craft which did some remarkable things. They flew at unheard of speeds. They made very sharp turns, seemingly non-aerodynamic turns, even at this extreme speed. They lacked the glowing tail of jets or rockets but they glowed or gave off light at night from their periphery or from the whole craft. They were silent or almost silent. Sometimes they gave off sounds that an electric generator or motor might make. Sometimes vehicles with electrically based ignition systems ceased to operate in the presence of these saucers. No government claimed these flying craft, yet they were seen all over the world.

The press and popular culture attributed these unusual craft to an extraterrestrial source. Yet, after over fifty years, no real proof for this assertion has ever come forth. Let's come back down to earth. By all accounts these saucer were solid and material in nature. Perhaps it is time to attribute their origin to a solid, material source.

It seems only proper to begin searching for an explanation for field propulsion saucers with the very sources which we now know built conventional flying saucers, the Germans of the Third Reich. The earliest reference to a field propulsion saucer being a German invention is from a 1960 book by Michael X in which it is described as a "flying egg" (1). Michael X., under the name Michael X. Barton, is also the author who, in 1968, wrote The German Saucer Story. In the second book returns to the theme again (2). This time he cites a source. His primary informant, Hermann Klaas, describes twelve secret weapons to Barton. They are:

1. The flying disc
2. A tank made entirely of one piece of metal
3. The sound wave weapon
4. A laser beam weapon
5. A flaming artificial cloud
6. A robot bomb
7. A charged cloud weapon
8. An armor piercing projectile
9. The electromagnetic KM-2 rocket
10. A paralyzing ray
11. Electronic ball lighting
12. The flying bottle, tube, sphere, etc.

Thirty-two years later we certainly know that some of these weapons did exist. It has been confirmed that the Germans were

working on weapons numbered 1, 2, 3, 6, and 8 for instance. It has been confirmed that the Germans were working on x-ray or gamma ray weapons as well as another type, possible laser weapons. It has been confirmed that the Germans were working on a gaseous cloud as a means of combating enemy bombers. So in view of this track record, his claim of research on a "flying bottle" should be given serious consideration.

But what is the specific evidence which would cause us to believe that the Germans were working on a field propulsion saucer? As one paws through the literature on German saucers, some evidence is encountered which could indicate field propulsion vehicles. There are the still pictures which will be discussed later on. Here, we will focus on just three pieces of evidence, that of an eyewitness, a German pilot, who saw such things on the ground, a Combined Intelligence Ojectives Sub-Committee report and an F.B.I. report. The F.B.I. report was taken years after the war but for reasons which will be discussed, there is reason to conclude this report has merit.

German Eye Witnesses

The first report comes to us courtesy of researcher Horst Schuppmann. A friend of Mr. Schuppmann's interviewed an eyewitness to German saucers during the Second World War. This report first appeared in the 1998 <u>Geheimtechnologien, Wunderwaffen Und Irdischen Facetten Des UFO-Phaenomens</u> by Karl-Heinz Zunneck (3).

The subject of this interview was a German pilot who flew many missions in a JU-52, taking off and touching down in rough, presumably outlying airfields. The Junkers JU-52 was an aircraft used by the Luftwaffe for many roles and could be described as a mainstay or a workhorse. It was a transport airplane, a troop carrier and even had been used as a bomber. It resembled and was used in a similar way to the American Douglas Dakota or DC-3. The main difference between the two aircraft was that the JU-52 had three engines as opposed to the Dakota's two and the JU-52 lacked a traditional airframe, instead deriving structural strength from a unique corrugated metal shell, which also made the appearance of the JU-52 distinctive.

The sighting in question was reported to the author, Mr. Zunneck, by Horst Schuppmann whose friend knew the pilot of the JU-52 in question. The date was July, 1944. Accompanying the pilot on this three and one-half hour flight was a co-pilot, a mechanic, and the radio man. The airplane took off from Brest-Deblin and flew on a westerly course to Lublin. The flight was unfolding smoothly which was somewhat abnormal for the particular time and stage of the war. Over Stettin Lagoon preparations were made to land. A large white cross was sighted which was the marker for their goal, a meadow landing strip. The aircraft descended,

landed normally and rolled toward a group of bushes which would hide the aircraft from view.

Then things took a decided turn to the abnormal. Harsh orders were received that the pilot, co-pilot and mechanic were not to exit the airplane. Suddenly, the radio man had vanished. The others waited an hour in vain for his return. Finally, the pilot decided to get out of the airplane and find his missing crewman, without orders, and on his own.

On the airfield itself nobody was to be seen. There was only one building visible which was a lonely hanger. The pilot, ever concerned with maintaining cover, headed straight for this hanger. Upon arrival he opened an narrow, high sliding door and entered, hoping to receive some information. No person was to be seen but what the pilot did see bewildered him so that the image was deeply ingrained in his mind.

There in the hanger stood three or four very large, round, dark dish shaped metal constructions on telescope-like leg stands. The objects were about 6 meters off the ground and the objects themselves were 12 to 15 meters in diameter. The pilot compared the shape of the objects to a giant soup dish or soup plate.

Suddenly, out of the half darkness a military guard emerged. The guard let the pilot know that he was in an area which was strictly off limits. In fact, the pilot was told, on no uncertain terms, to disappear immediately or this would be his last day on earth.

This day had started as a routine flight connecting two outlying airfields. This pilot had no expectations of seeing something so unusual that he barley had context in which to place it. Further, even as his mind was transfixed and in a process of trying to give understanding to what he was seeing, he was suddenly jolted out of this tableau by a guard threatening his very life and ordering him to leave.

Of course the question of what those objects in the hanger really were comes back to this pilot even after almost 55 years. The pilot personally attributes it to the so called "Magnetscheibe", literally, "magnet-disk". According to the pilot rumors of these objects circulated in pilot circles since the summer of 1944 (4).

Two things can definitely be said of this sighting. First, it can be said is that this sighting seems to be of the smaller type of German field propulsion saucer as opposed to a larger version. Second, these saucers can definitely be ascribed to belonging to and in the possession of German military forces during the Second World War. At no time in this report has the word "alien" or "extraterrestrial" ever been mentioned or even considered.

Beyond that it can be said that the pilot personally believed these to be of the "Magnetscheibe" type, that is to say not

141

powered by chemical combustion. There reasons to believe this is correct. These saucers were found on a remote and rather primitive airfield. They were in the only building present. This means that they did not need an extensive support system.

The chemically powered jet or rocket engines needed an extensive field support structure. They needed to be refueled after every flight. The two liquid fuels used by the Me-163 rocket-fighter, for instance, ignited immediately when they came into contact with each other with explosive intensity. The fuel tanks had to be washed out after each flight and separate ground crews were responsible for each type of liquid fuel. It is noteworthy that no such support ground support structure or personnel was in evidence on this occasion. All that was observed was a large structure filled with saucers and a guard. The ground support necessary for launch of these craft must have been minimal and argues for the field propulsion hypothesis.

Of course the weakness in this report is the lack of the name of the pilot. Even if this report is taken at a minimal level of credulity, it constitutes a rumor of German involvement with field propulsion vehicles.

The reader will recall that the research paradigm being followed is that once mention was made by a German source of a particular thing, then (and only then) corroborating information should be sought from U.S. governmental agencies using FOIA.

A Combined Intelligence Objectives Sub-Committee Report

Since we have a German claiming field propulsion saucers we can now follow our research paradigm and search governmental records for corroboration. The Combined Intelligence Objectives Sub-Committee reports are a series of reports compiled by agents of the United States and Great Britain. Most were written immediately after the field work was done. The agents targeted specific things such as sites, people. specific technology or other aspects of specific interest. The agents then wrote a summary report which is what is entered into the record.

As with almost all summary reports at this level, the implications of what is being described are lacking. These reports do not set the particular technology into any context. That is, these reports doe not say how a specific technology under study was to be applied in the future in some, if not most, cases. Behind these reports must be a body of information and at least a few individuals intimately familiar with the technology in question. They were familiar with the technology and the context to which it was useful. If another government operative was interested in that topic or its implications, and if his security clearance sufficed, he would be shown the underlying material and presumably be directed to the particular individual

DR. GEORG OTTO ERB
WHO HAS A 500 TON(?) OUTPUT
(Target No. C1/639, C2/135?)

Erb with his two assistants, Georg Buhler and Ullrich Lrewitz are available at the above address and are known to Mil Gov Detachment at DORKEN.

To be investigated as early as possible. Suggest C.I.A.R. and C.E.A.D. (Fuzes) will be interested.

This man was interviewed by two members of the staff of D.D.O.S., and the attached report is compiled from their notes and a statement by Dr. ERB.

Dr. ERB was born in 1912. He is a doctor of Physics. At the outbreak of war he opened a small laboratory and had made a few inventions. In 1940 he was called up, but after a few weeks was released for research work and returned to Berlin to work for Physikalische Reichsanstalt. At this time he worked on acoustic heads for torpedoes. In 1941 he was again working in his own laboratory - mainly on fuzes. He was arrested in Berlin by the Gestapo in Nov 1944 on a charge of "favouring the enemy and sabotage". Buhler was also jailed. They escaped on 22 Apr 45 as the Russians were advancing into Berlin.

It is felt that he is reliable and likely to be of value as a source of information about the lines on which German development was proceeding in the field of experiment in which he was concerned.

Statement of the work of Dr. Otto ERB

1. Before the war, Dr. Erb developed measuring instruments of all sorts. The following are examples of his work:

(i) Measuring apparatus for interference free determination of the hardness and temper of steel.
(ii) Electrical measuring apparatus for automatic control of storage temperature.
(iii) Apparatus for conversion of residual heat into electrical energy.
(iv) Electrical medical apparatus of various sorts.
(v) High tension apparatus.
(vi) Warning mechanisms for excessive temperatures.
(vii) Electric fire fighting apparatus.
(viii) Electric sources of energy of various kinds.
(ix) Apparatus for turning the energy of the sun's rays into electrical energy.
(x) Rearward impulse propulsion for vehs and aircraft.
(xi) Wood gas generator for high performance.

After outbreak of war he had to devote his research to armament work.

who was its residing expert. Only slowly, if at all, was this secret science leaked or given to American industry and then only with an appropriate cover-story, one which may even supply a pseudo-inventor of that technology. This is conspiracy at its finest. This deception is beyond the scope of this book but what is important for us now is that sometimes a mistake or slip-up was made in writing or censoring these reports and hints of things of stupendous technological worth actually surfaces. Such is the case with Combined Intelligence Objectives Sub-Committee Report number 146 regarding Dr. Georg Otto Erb and his work which is reproduced here.

Dr. Erb was on the cutting edge of several technologies according to this report. None of these technologies was especially exciting in 1946, however. Jets, rockets and atomic energy where the hot-ticket items of the time. Nobody cared about new sources of electrical energy. The USA had plenty of electricity and plenty of oil to generate more. It was also known by then that atomic power could be applied to generate even more electricity. Nobody cared about Dr. Erb's experiments listed under item (iii) "Apparatus for conversion of residual heat into electrical energy" or item (viii) "Electrical sources of energy of various kinds" or even item (ix) "Apparatus for turning the energy of the sun's rays into electrical energy". Since nobody cared about these things, there was really no reason not to list them in the summary report. Their significance would only be realized a generation later during the "energy crisis" of the mid-1970s and by then it was too late to censor the report. One can only wonder where this research would have led if it funding had continued over the next thirty years. Or did it continue in secret?

Of course by now many readers will have already read number and grasped the significance of number (x) "Rearward impulse propulsion for vehs and aircraft". Given the nature of Dr. Erb's other work, it is a safe bet that this "impulse propulsion" was not of the jet or rocket nature. In fact there remains little doubt that this propulsion was, in fact, field propulsion. Dr. Erb was experimenting on means to apply forward motion using rearward impulse propulsion to aircraft and "vehs" (vehicles). If this is not the smoking gun for German experiments in field propulsion saucers, it is at least a hint that there is a gun.

The Smoking Gun: An F.B.I. Report

That is right, Fox Mulder was not the first F.B.I. agent to believe in UFOs. The files in question are F.B.I. file numbers 62-83894-383, 62-838994-384 and 62-83894-385. Their date is 11/7/57 to 11/8/57. They deal with a Polish immigrant, then living in the United States, who reported his wartime experience to the Bureau hoping it might throw some light on UFO sightings seen in Texas at about this time.

144

F.B.I. Reports On A German Field Propulsion Saucer

FD-36 (Rev. 3- 3-54)

FBI

Date: 11/7/57

Transmit the following message via ___AIRTEL___

___NISD - id.___
(Priority or Method of Mailing)

TO: DIRECTOR, FBI

FROM: SAC, DETROIT (100-26505)

UNIDENTIFIED FLYING OBJECTS; IS - X.

Re Detroit Teletype to Bureau, 11/7/57, captioned "UNIDENTIFIED FLYING OBJECTS; IS - X."

Interview of ███████████, aka. ███████████, reported in blank memo, five copies of which are ████████ herewith for the Bureau, was conducted by SA ████████████

No indication of irrational or otherwise abnormal behavior by ███████ was observed during the interview.

███████ advised that his communication was directed to Mr. ROBERT CUTLER rather than to President EISENHOWER after seeing Mr. CUTLER's picture and identification with the President's Office in a local paper.

███████ resides with his wife, nee ████████ married in 1952 at Detroit, and four small children, in a single residence in an old Polish neighborhood at ████████ ████ Detroit. No previous record located in Detroit Indices identifiable with ███████ or his wife.

On 11/7/57, ████████████████ advised IC ████████ that records of the ████████████████████, reflect only ████████ enquiries concerning ████████ during 6/56 and 3/57 and 6/57, which confirm his local address and employment.

3 - Bureau (Encls.5)(RM)
1 - Detroit

Cn:JLK
(4)

INDEXED-18

RECORDED-18 12 - - - 4387

21 NOV 8 1957

ENCLOSURE

AIRTEL

7 6 NOV 25 1957

Approved: _____ Sent _____ M _Per_
 Special Agent in Charge

Mr. Tolson
Mr. Boardman
Mr. Belmont
Mr. Mohr
Mr. Nease
Mr. Parsons
Mr. Rosen
Mr. Tamm
Mr. Trotter
Mr. Clayton
Tele. Room
Mr. Holloman
Miss Gandy

UNITED STATES DEPARTMENT OF JUSTICE

FEDERAL BUREAU OF INVESTIGATION

Detroit 31, Michigan

November 7, 1957

In Reply, Please Refer to File No.

UNIDENTIFIED FLYING OBJECTS

In response to a letter directed by him to Mr. Robert Cutler, Special Assistant to President Dwight D. Eisenhower, reflecting that he "might have some information about the rocket in Texas," ▆▆▆▆▆ Detroit, was interviewed November 7, 1957, and furnished the following information:

Born February 19, 1926 in the State of Warsaw, Poland, ▆▆▆ was brought from Poland as a prisoner of war to Gut Alt Golssen, approximately 30 miles east of Berlin, Germany, in May, 1942, where he remained until a few weeks after the end of World War II. He spent the following years at Displaced Persons Camps at Kork, Strasburg, Offenburg, Milheim and Freiburg, Germany. He attended a radio technician school at Freiburg and for about a year was employed in a textile mill at Laurachbaden, Germany. He arrived in the United States at New York, May 2, 1951, via the "S.S. General Stewart" as a Displaced Person, destined to the Reverend ▆▆▆▆▆ ▆▆▆▆▆, Hamtramck, Michigan; his alien registration number ▆

Since May, 1951, he has been employed at the Gobel Brewery, Detroit.

News report of mysterious vehicle in Texas causing engines to stall prompted him to communicate with the United States Government concerning a similar phenomenon observed by him in 1944 in the area of Gut Alt Golssen.

According to ▆▆▆▆▆, during 1944, month not recalled, while enroute to work in a field a short distance north of Gut Alt Golssen, their tractor engine stalled on a road through a swamp area. No machinery or other vehicle was then visible although a noise was heard described as a high-pitched whine similar to that produced by a large electric generator.

"62-83894-254

An "SS" guard appeared and talked briefly with the German driver of the tractor, who waited five to ten minutes, after which the noise stopped and the tractor engine was started normally. Approximately 3 hours later in the same swamp area, but away from the road where the work crew was cutting "hay", he surreptitiously, because of the German in charge of the crew and "SS" guards in the otherwise deserted area, observed a circular enclosure approximately 100 to 150 yards in diameter protected from viewers by a tarpaulin-type wall approximately 50 feet high, from which a vehicle was observed to slowly rise vertically to a height sufficient to clear the wall and then to move slowly horizontally a short distance out of his view, which was obstructed by nearby trees.

This vehicle, observed from approximately 500 feet, was described as circular in shape, 75 to 100 yards in diameter, and about 14 feet high, consisting of dark gray stationary top and bottom sections, five to six feet high. The approximate three foot middle section appeared to be a rapidly moving component producing a continuous blur similar to an aeroplane propeller, but extending the circumference of the vehicle so far as could be observed. The noise emanating from the vehicle was similar but of somewhat lower pitch than the noise previously heard. The engine of the tractor again stalled on this occasion and no effort was made by the German driver to start the engine until the noise stopped, after which the engine started normally.

Uninsulated metal, possibly copper, cables one and one-half inch to two inches in diameter, on and under the surface of the ground, in some places covered by water, were observed on this and previous occasions, apparently running between the enclosure and a small concrete column-like structure between the road and enclosure.

This area was not visited by ▉▉▉ again until shortly after the end of World War II, when it was observed the cables had been removed and the previous locations of the concrete structure and the enclosure were covered by water. ▉▉▉ stated he has not been in communication since 1945 with any of the work crew of 16 or 18 men, consisting of Russian, French and Polish POWs, who had discussed this incident among themselves many times. Whoever, of these, ▉▉▉ was able to recall by name only ▉▉▉ no address known, described as then about 50 years of age and presumed by ▉▉▉ to have returned to Poland after 1945.

-2-

This report is loaned to you by the FBI,
and neither it nor its contents are to be distributed
outside your agency.

Mr. J. Patrick Coyne

You will be advised of any further information which may be received regarding ███████ and the information furnished by him.

Pursuant to your request, ██████████ letter is returned herewith.

Sincerely yours,

H. Edgar Hoover

Enclosure

1 - Office of Security
 Department of State

1 - Director
 Central Intelligence Agency

 Attention: Deputy Director, Plans

1 - Assistant Chief of Staff, Intelligence
 Department of the Army

 Attention: Chief, Security Division

1 - Director of Naval Intelligence

1 - Office of Special Investigations
 Air Force

1 - Immigration and Naturalization Service

- 2 -

ce Men ⁓ *?um* • UNITED ⁓ ⌐OVERNMENT

: DIRECTOR, FBI DATE: 11-14-57

FROM: SAC, Dallas (62-1311)

SUBJECT: FLYING DISCS
INFORMATION CONCERNING

Re Kansas City letter 11-8-57.

This matter is being referred to OSI without inves-
tigation and no other action is being taken in
accordance with existing instructions.

(2) Bureau
1 Kansas City (66-2995)
1 Dallas
MCC:FB
(4)

RECORDED - 9 62-83874-385

NOV 1957

EX-139

RECD ESPION.

7 2 NOV 27 1957

150

F.B.I. Reports On A German Field Propulsion Saucer

Mr. Tolson
Mr. Boardman
Mr. Belmont
Mr. Mohr
Mr. Nease
Mr. Parsons
Mr. Rosen
Mr. Tamm
Mr. Trotter
Mr. Clayton
Tele. Room
Mr. Holloman
Miss Gandy

URGENT 11-7-57 4-55 PM EST WHH

TO DIRECTOR FBI

FROM SAC, DETROIT 1P

UNIDENTIFIED FLYING OBJECTS, IS - X. REBUTEL NOV SIX LAST.

WARSAW, POLAND, WAS GERMAN POW

MAY, NINETEEN FORTY TWO, UNTIL SUMMER OF NINETEEN FOURTYFIVE.

ARRIVED NY MAY TWO, NINETEEN FIFTYONE, AS DP, AR NO.

UPON INTERVIEW

ADVISED THAT WHILE GERMAN POW DURING NINETEEN FORTYFOUR OBSERVED

A VEHICLE DESCRIBED AS CIRCULAR IN SHAPE, SEVENTY FIVE TO ONE

HUNDRED YARDS IN DIAMETER, APPROXIMATELY FOURTEEN FEET HIGH. THE

VEHICLE WAS OBSERVED TO SLOWLY RISE VERTICALLY TO HEIGHT

SUFFICIENT TO CLEAR FIFTY FOOT WALL AND TO MOVE SLOWLY

HORIZONTALLY A SHORT DISTANCE OUT OF VIEW OBSTRUCTED BY TREES.

ENGINE OF TRACTOR FAILED TO OPERATE DURING THIS PERIOD AND

ONE OTHER OCCASION WHEN HIGH PITCHED WHINNING NOISE HEARD

IN AREA. NO INDICATION OF MENTAL INSTABILITY DURING

INTERVIEW. FURTHER DETAILS FOLLOW AMSD.

E CORRECT LINE FOUR WORD WX FOUR SHLD BE "TWO"

END AND A K PLS 62- 53394- 343

X 4-58 PM OK FBI WA EW

TU DIC

RECORDED-84
INDEXED-84

Mr. Belmont NOV 13 1957

EX 101

b7c

1 ‡ Mr.
1 ‡ Mr. Belmont
1 - Mr.
1 - Liaison

BY COURIER SERVICE
November 8, 1957

Mr. J. Patrick Coyne
National Security Council
Executive Office Building
Washington 25, D. C.

ALL INFORMATION CONTAINED
HEREIN IS UNCLASSIFIED
DATE 5/20/15 BY
comp # 045994

62-3894-283

b7c

Dear Pat:

 Reference is made to the letter addressed
to "Mr. Robert Cutler, Washington 25, D. C.," by
Mr. Detroit 11, Michigan,
in which advised that he might have some
information "about the rocket in Texas." He desired
to know to whom he could speak in this regard.

b7c,d

 Mr. was interviewed on November 7, 1957,
at which time he advised that his name is that he was born
on February 19, 1926, in Warsaw, Poland, and that he was
a German prisoner of war from May, 1942, until the Summer
of 1945. advised that he arrived in New York on
May 2, 1951, as a displaced person, Alien Registration
 He advised that during 1944, while he was
a German prisoner of war, he observed a vehicle described
as circular in shape, seventy-five to one hundred yards in
diameter, and approximately fourteen feet high. He stated
the vehicle was observed to rise vertically to a height
sufficient to clear a fifty-foot wall and that it moved
slowly horizontally a short distance out of view which was
obstructed by trees. He stated that the engine of a
tractor failed to operate during this period and that the
engine failed on one other occasion when a high-pitched
whining noise was heard in the area. During the interview,
 spoke in a rational manner with no indication of
mental instability.

ESS:dmn
(13)

son
hols
rdman
mont
ir
sons
en
am
tter
ise
e. Room
loman
dy

6 8 NOV 21 1957

MAIL ROOM ☐

BY COURIER SVC.
03 NOV 12
COMM - FBI

EX 105

RECORDED-84
INDEXED 84

Mr. J. Patrick Coyne

You will be advised of any further information which may be received regarding ▮▮▮▮ *and the information furnished by him.*

Pursuant to your request, ▮▮▮▮ *letter is returned herewith.*

Sincerely yours,

E. Edgar Hooyer

Enclosure

1 - *Office of Security*
 Department of State

1 - *Director*
 Central Intelligence Agency

 Attention: Deputy Director, Plans

1 - *Assistant Chief of Staff, Intelligence*
 Department of the Army

 Attention: Chief, Security Division

1 - *Director of Naval Intelligence*

1 - *Office of Special Investigations*
 Air Force

1 - *Immigration and Naturalization Service*

- 2 -

153

The time of the sighting was in 1944, the place was Gut Alt
Golssen, approximately 30 miles east of Berlin. The informant,
whose name has been deleted, states that while he was a prisoner
of war working for the Germans, a flying object arose nearby from
behind an enclosure hidden from view by a 50 foot high tarpaulin-
type wall. It rose about 500 feet then moved away horizontally.
The only noise the object made was a high-pitched whine. The
object was described as being 75 to 100 feet in diameter and 14
feet high. It was composed of a dark grey stationary top and
bottom sections five to six feet high with a rapidly moving
center section producing only a blur and extending the
circumference of the vehicle. Notably, the engine of their farm
tractor stalled during this event and the SS guards told the
driver not to attempt a restart until the whine could no longer
be heard.

Because of what I believe is their importance, these files have
been reproduced here in their entirety. One of the most
compelling reasons for taking this report so seriously is that
the government of the United States of America took this report
so seriously. It is hard to believe that an agency such as the
F.B.I. would take and retain reports of flying saucers which had
no special meaning for them. Add to this the fact that this
report was over ten years old at the time it was taken and that
it concerns a report originating in another country.

The F.B.I. operates within the USA and usually does not concern
itself with foreign matters unless they have meaning for the
internal security of the United States. Could the reason that
this report was taken and retained for so many years be that it
did, in fact, have meaning for the internal security of the
United States? Did it have something to do with the flying
saucers seen over Texas at the time which also stopped motor
vehicles?

As an alternative to the security issues, could there have been
another reason that the F.B.I. was so interested in flying
saucers? Did the F.B.I. desperately want information on UFOs
which was held by the military and other branches of the
intelligence community which was not shared with the F.B.I.? It
has been rumored that J. Edgar Hoover, head of the F.B.I. at the
time, was very interested in learning these secrets but was held
"out of the loop". It could be that the F.B.I. was already aware
of German saucers through security clearances done on German
scientists coming to the USA under Operation Paperclip? The ego
of J. Edgar Hoover may have been a factor in the Bureau's quest
to learn more on this subject. Hoover may have wanted to be on
an equal footing with other intelligence chiefs.

For whatever reason, something in these reports resonated with
the F.B.I. The report was taken seriously, investigated and
kept. This fact alone speaks volumes for the existence of UFOs
in general and German saucers in particular.

154

Discussion of German Field Propulsion Saucers

Some explanation has been attempted regarding the Schauberger models and the KM-2 rocket. From this point on, the discussion of German field propulsion saucers will move away from the areas centering around observed evidence and into areas of interpretation. Some of the German flying craft described are flying saucers in the classic sense. The F.B.I. report describes something which moves by non-aerodynamic means and which remains the source of speculation.

At this point, mention should be made of the ideas of some prominent writers in this field. The first of these is Mr. William Lyne of Lamy, New Mexico. Mr. Lyne has written two books concerning German saucers and field propulsion, <u>Pentagon Aliens</u> and <u>Occult Ether Physics</u>. His ideas on the mechanisms of field propulsion remain the best thought out and the most detailed on the subject.

Mr. Lyne lives near the secret weapons testing facilities of Los Alamos and White Sands. These were the places where German weaponry was brought for testing after the war and where the United States tested its first atomic bomb. It is still an area of secret military research and secret military projects. Then as now, aspects of atomic energy figure in this setting. It is also an area which attracted much flying saucer activity in the late 1940s and 1950s. Mr. Lyne was a child during this period of time and personally witnessed flying saucers as did his family and friends. Later, as an adult, he went about trying to explain mechanisms for the type of flight he had witnessed.

Mr. Lyne worked within certain parameters. He rejected the alien hypothesis outright. He realized that flying saucers had to have been made by humans. Since he observed the saucers in the 1940s and 1950s, he knew that any explanation of their workings must be limited to the technology present in the 1940s or earlier. He connected UFO technology to other recently imported technology from Germany while believing both had their origins with Nikola Telsa (5).

Further, there is no mention of intangibles by Mr. Lyne. There are no unknown energies or mystical forces at work. Mr. Lyne stands with both feet on the ground. Things are concrete. Machinery is diagramed. Matter and energy function as they always have. In reading Mr. Lyne's work one can almost smell the machine oil and the ozone.

Mr. Lyne builds upon the work of Nikola Tesla who developed his unique ideas over many years of experimentation and invention. This basis built upon real world experimentation, testing and application separates Tesla's ether theory ideas from those which will be explored later. Mr. Lyne presents us with an ether theory in which ether is super-fine matter which exists everywhere. It is so fine that it will go through the holes left

155

in ordinary matter (6).

A few words about Mr. Lyne's ideas are necessary to set a context for this discussion. Just as an internal combustion engine can be described as a "heat pump" so can the flying saucer drive of Mr. Lyne be described as an "ether pump". Ether (very fine matter) is attracted to the saucer via an electric field, then pumped through the saucer and out again using the principle of magneto-hydro-dynamic pumping (7). This magneto-hydro-dynamic pumping is related to the Hall Effect. Edwin Hall placed a gold leaf strip in which an electric current was flowing into a gap in a magnetic field. An electromotive force was produced at right angles to the magnetic field and the electric current. This electromotive force was proportional to the product of the electric current and the magnetic field (8).

According to experimentation by Tesla, ether is made rigid with high voltage, high frequency electrical energy (9). The convex shape of the upper half of the saucer projects the electrical attractive force, generated by a specific electronic component, in an ever expanding arch over the saucer. Ether is made rigid and anchors the saucer. This is possible since the total mass of the ether caught in the electric field is far greater than the mass of the saucer. Near the surface of the saucer, the "rigified" ether is pulled into the saucer in what Mr. Lyne calls "tubes of force". These tubes of force would be pulled right through the opposite side of the saucer and out if it were not for the blocking force of a second apparatus which nullifies the tubes of force and prevents this from happening. This imbalance is the reason the saucer is able to move (10).

The electrical components necessary for this to take place are, according to Mr. Lyne, a Tesla turbine to supply electrical power and two types of Tesla pancake coils (11).

The Tesla turbine is a wheel-like device which is described in Mr. Lyne's book (12) and elsewhere (13). Mr. Lyne orients this turbine vertically in his drawings but oriented with its flat spinning surface horizontally, this might, perhaps, account for the spinning disc witnessed on some saucers.

The Tesla pancake coils are also described in both sources cited. Mr. Lyne goes further and gives instructions as to their manufacture. One type of pancake coil insures forth a negative discharge of DC energy, tuned to a one-fourth wave length, and is oriented in the desired direction of flight (14). The other type of pancake coil is mounted exactly opposite the first and emits a positive AC discharge which is used to dissolve the ether flow or tubes of force.

Dr. Gordon Freeman, a Fucannelli-like scientist who knows about such matters, has been curious about the abbreviated wave-cycle of the first pancake coil. His position is that one must not only understand conventional scientific theory in order to

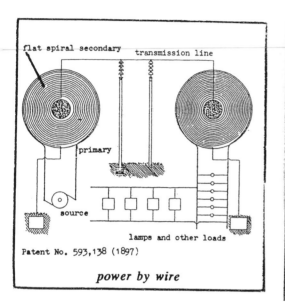

flat spiral secondary transmission line

primary

source

lamps and other loads

Patent No. 593,138 (1897)

power by wire

Top Left: Pancake Tesla coil with the secondary coil inside the primary. Top Right: The smaller of the Hans Coler free-energy machines. Bottom: Cut away showing Vril power plant. Was this related to the Schappeller device?

understand the way a field propulsion saucer flies but one must also understand some concepts which are sometimes labeled "occult". Dr. Freeman has worked out a "common denominator" for some field propulsion vehicles the essence of which he has shared (15). Dr. Freeman's ability to analyze, explain and interrelate physics, engineering and "occult" geometry is only matched by his ability to explain it all on a level we can all understand.

Some individuals see hidden, esoteric or occult knowledge as the inspiration for the breakthroughs the Germans made in field propulsion flying vehicles. Usually coupled with an exotic theory of UFO origin, it is an equally exotic local from which this exotic theory is said to have originated. We have been presented with this line of reasoning for years in the "UFOs are of extraterrestrial origin" theory. Indeed, some writers see an extraterrestrial origin for German UFOs also as we shall see. But just stating that UFOs are of occult or alien origin is not an explanation in itself. It still begs the question of how they operate. Their method of operation, their technology, must be explained regardless of where they came from in order for the explanation to be a satisfying one.

Returning to earth, another theory is that the German scientists were influenced by some ideas originating in Asia. Tibet and India are the suspects in question. UFOs have been reported over Mongolia, Tibet and India for centuries. The ancient Indians even claimed to have constructed aircraft which resemble flying saucers. These saucers are called Vimanas. Ancient Indian texts in Sanskrit speak of the flight and manufacture of these saucers. The German "Ahnenerbe", an organization whose purpose is associated with researching Germanic ancestry, sent out expeditions to the East with the express purpose of acquiring ancient, hidden knowledge. This is precisely what Heinrich Haarer was doing, whose book served as the basis for the film "Seven Years in Tibet". This link between flying saucers of the East and the West is suspected as an influence on German field propulsion vehicles (16). The exact connection, though, has never been demonstrated.

A connection which is more certain involves Viktor Schauberger's use of Pythagorean geometry. There is no doubt that Schauberger incorporated this mathematics into his work but what is intriguing is what is said about this body of mathematical knowledge. The story goes that it was the Knights Templar who stumbled upon this knowledge in the Holy Land during the Crusades and it was they who kept and incorporated this knowledge through the use of "sacred geometry".

Both the above mentioned schools of thought lead far beyond the parameters of this book but the reader should be aware of what is said about them and their relationship to German flying discs.

Whether it is called "occult technology" or "conventional technology", in the end, it is just simply technology. And in

the end, as Dr. Freeman says, "all machines can be reduced to numbers". What is called by some "occult" might be better called "arcane". This is because this technology, which seems to be the basis of field propulsion, is taught only to certain individuals, technological initiates, who use and need this knowledge for their work on government sponsored black projects. These scientist utilize a technology and understanding which are reserved for their use alone. This knowledge is not taught and not made available to the rest of us. We, the great unwashed masses, are given Einstein and the Theory of Relativity and told that this is the pinnacle of learning. As with all secret information, this arcane knowledge is held on a "need to know" basis. Our government believes that we simply don't need to know. It takes a true genius like Dr. Freeman to recognize this knowledge and set it before us in language that we can understand. It is hoped that Dr. Freeman will publish a book sooner rather than later.

Mention of the "occult" brings us to another line of evidence concerning field propulsion, that put forth by Norbert Juergen-Ratthofer and Ralf Ettl. Mr. Ettl became involved while doing research for a film project on Dr. Wernher von Braun. A film company was paying for this research. A package or several packages of information were obtained by the production company which had more to do with UFOs than rocketry. This information was laid aside by Mr. Ettl but he returned to it after enlisting the help of Norbert Juergen-Ratthofer who had a special interest in that subject (17).

The packages contained breathtakingly clear photographs of German saucers in flight. Some of these pictures may be just models but some look authentic and are posed against a landscape. Nowadays, pictures can be generated via computer and these pictures surfaced within modern times. At least one negative from these pictures which was given to Mr. Vladimir Terziski by Mr. Juergen-Ratthofer and seen by this writer, so at least not all of these pictures were computer generated. The pictures have been seen in public and through video film presentation, for about ten years. To the best of my knowledge these pictures have never been debunked using modern technical photo-analysis. Therefore, they have never been shown to be anything less than legitimate. Until they are shown to be less than legitimate, we must accept them as they are represented to us.

Besides the pictures, these writers provide an entire historical and cultural context for these saucers within the Third Reich. This contest involves secret organizations within the SS. Further, the context provided by these writers involving the occult, channeling, and extraterrestrials. This is the weak point of their presentation since the case for these latter connections is really not strong enough to be "in evidence".

Besides the books of Mr. Ettl and Mr. Juergen-Ratthofer, several other German language writers contribute books on a similar or

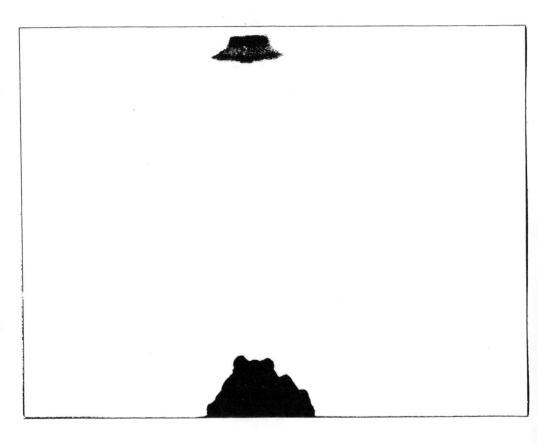

Ghostly image of a saucer, said to be a Haunebu 2, on a
test flight. Photograph originally from collection of
Norbert-Juergen Ratthofer, courtesy of Vladimir Terziski

160

related theme. The more notable are D.H. Haarmann (18) and O.
Bergmann (19). Mr. Ettl and Mr. Juergen-Ratthofer themselves
have written several books which are all in German language and
available through their publisher (20). Mr. Ettl and Mr.
Juergen-Ratthofer have also done two video films, "UFOs Das
Dritte Reich Schlaege Zurueck?" and a second film, whose English
title is "UFO Secrets of the 3rd Reich". This second film is
very well done and contains the pictures mentioned earlier.
These films should be seen by anyone seriously interested in
German field propulsion saucers (21) (22).

Mr. Juergen-Ratthofer, Mr. Ettl and allied writers offer two
different systems for field propulsion. The smaller saucer-type,
which they designate "Vril" was powered by three moving magnetic
fields (23). The larger type, designated "Haunebu" was powered
by a series of devices according to these writers. In this
arrangement, the output of smaller of the Hans Coler "free
energy" devices (24), the "Magnetapparat", was used to supply
input for the larger Coler device, the "Stromerzeuger". The
output of this second device was used to turn a Van de Graaf
generator. This energy was directed into something called a
Marconi ball dynamo with supplied lift to the saucer (25)(26).

All that seems to have been said about the latter device is that
it is mentioned in the same sentence with special saucer
condensers developed by T.T. Brown and Professor Paul Biefield in
the nineteen twenties and that "such" ("solche") with a rotor
system was done by Professor Marconi, in Italy, in the nineteen
thirties. Mr. Juergen-Ratthofer goes on to say that this device
is to be considered, in principle, a forerunner to the Searl
system (27).

The Haunebu pictures strongly resemble the Adamski saucer
pictures of the early 1950s. These saucers were seen and
pictures of them taken world-wide. There were many different
sources for both sighting of Adamski saucers and pictures of
them. There were so many in the early 1950s that it is hard to
believe that all of them are fakes. Mr. Ettl and Mr. Juergen-
Ratthofer maintain that these "Adamski saucers" are really the
German-designed Haunebu type saucers (28). Since they were flown
after the war, certain questions as to their origin arise. These
questions will be treated in an upcoming section of this book.

Besides the Vril and Haunebu designs mention is made by Mr.
Juergen-Ratthofer of another type of field propulsion vehicle.
This saucer uses a chemical engine to drive a field propulsion
generator (29). The type of chemical engine involved is similar
to the famous Walter (Walther) engine, which were to be installed
on some types of German submarines.

The Walter process involved a closed circuit system activated by
the thermal energy produced by the decomposition of a high
concentration of hydrogen peroxide. This reaction occurred in
the presence of a catalyst, potassium permanganate, in a

161

Chemical/Field Propulsion Saucer (N. Juergen-Ratthofer). 1. Plexiglass pilot's cabin. 2. Crew rooms. 3. Intake air slots (hermetically sealed in space). 4. Vacuum ring retainers with high-performance vacuum pumps. 5. Lifting and steering jets connected to the Walter turbine system. 6. Walter turbines and electric generators with connected machine maintenance rooms. 7. Disc rotor wheel, rotating clockwise. 8. Electromagnet outer ring rotating counter-clockwise. 9. Disc wheel, inner part of the electromagnet outer ring. 10. Segmented disc-rotor and wing screw with adjustable flight blades. 11. Axis of saucer with (a) two electric motors to drive the counter rotating disc motors: electro-gravitation plant, (b) various electrical connections, (c) fuel and water tanks. 12. Connection shaft between pilot's cabin and machine room.

162

decomposition chamber. This resulted in a 600 to 700 degree gas composed of steam and oxygen, under natural pressure sufficient to drive a turbine. After the gas had done its work if was fed into a reclamation chamber which recycled at least part of the gas back into the engine. Additional fuel, Juergen-Ratthofer mentions methanol, could be fed into the system for more heat. The system without additional fuel is called the "cold" system while with added fuel it is called the "hot" system. In fact, the cold system was used on the V-2 rocket to drive the turbo-fuel pumps since known pumps could not handle the volume of liquid necessary to feed this new type of rocket.

In the hybrid saucer Mr. Juergen-Ratthofer describes, the cold system drives a rotor-stator arrangement which doubles as a blade lifting wing similar to that of a helicopter. The rotor-stator-blade is internally housed in the cowling of the saucer. The output of the rotor-stator is a strong magnetic field which presumably frees the saucer of the constraints of gravity as claimed for the other field propulsion saucers (30). In addition, spaces within the saucer have all air removed by special vacuum pumps with increase the buoyancy of the craft within the atmosphere. Further, some of the hot oxygen-steam mixture is jetted out at the periphery of the saucer while being mixed with methanal for additional heat and therefore thrust. Again, we are reminded of Dr. Belluzzo. We are also reminded of Vesco since he hints at a similar engine (31) which he even vaguely links with "electromagnetic waves" (32). Have we come full-circle?

In the same vane, would be negligent not to mention that an atomic engine might easily be substituted for the Walter engine. The atomic engine might be one of three types. It might be the type which burned the atmosphere itself. This burning would produce hot air and steam from the water contained in the atmosphere. It might be one which produced steam using water carried in tanks. It might be one which super-heats and ejects a gas such as hydrogen or helium. Any of these mediums could be ejected through the rotor blades yielding the desired result. A device of this type would tie together many of the German saucers-plans so far discussed.

Dr. Freeman points out that Marconi "stole" Tesla's inventions. Tesla also built a power-plant of spherical construction which contained vacuum tubes and so may have been superior to the device of Schappeller which we shall look at next. Surprisingly, some detail exists about this Tesla free energy device (33). Tesla used his engine to successfully power a Pierce Arrow automobile. This means that a spherical, working field propulsion device existed in the USA powering, not a flying saucer but an automobile. Dr. Freeman warns not to be confused by many spherical devices, all of which seem different. The fact is that they all work on the same principles (34).

German Field Propulsion Flying Saucers

Sources and References

1. X, Michael, 1960, pages 17, 33, <u>We Want You Is Hitler
 Alive?</u>, Futura Press, reprinted 1969 by Saucerian Books,
 Clarksburg, WV.

2. Barton, Michael X., 1968, pages 26-36, <u>The German Saucer
 Story</u>, Futura Press, Los Angeles

3. Zunneck, Karl-Heinz, 1998, pages 120-122, <u>Geheimtechnologien,
 Wunderwaffen Und Irdischen Facetten Des UFO-Phaaenomens 50
 Jahre Desinformaton und die Folgen</u>, CTT-Verlag, Suhl

4. Zunneck, Karl-Heinz, 1998, page 122

5. Lyne, William R., 1999, page 48, <u>Pentagon Aliens</u>, Creatopia
 Productions, Lamy, New Mexico 87540

6. Lyne, William R., 1999, page 28

7. Lyne, Willaim R., 1999, page 38

8. Lyne, William R., 1999, page 21

9. Lyne, William R., 1999, pages 20, 41

10. Lyne, William R., 1999, page 42

11. Lyne, William R., 1999, pages 197-200

12. ibid

13. Trinkaus, George, 1988, pages 3-4, <u>Tesla The Lost Inventions</u>,
 High Voltage Press, Portland, OR.

14. Lyne, William R., 1999, page 215

15. Freeman, Gordon Dr., 3/18/01, personal letter to author

16. Stoll, Axel Ph.D., 2001, pages 15-20, <u>Hochtechnologie im
 Dritten Reich Reichsdeutsche Entwicklungen und die vermutlich
 wahre Herkunft der "UFOs"</u>, Amun-Verlag, Schleusesiedlung 2,
 D-98553 Schleusingen

17. Ettl, Ralf, 1999, page 11, "Notes To The Vril-Project"
 Ursprung und Quellen

18. Haarmann, D.H., 1983, <u>Geheime Wunderwaffen</u>, <u>ll Geheime
 Wunderwaffen</u>, <u>lll Geheime Wunderwaffen</u>, Hugin Gesellschaft
 Fuer Politisch-Philosophische Studien E.V., Postfach 23, D-
 48472, Hoerstel 3, Germany

19. Bergmann, O., 1988 and 1989, <u>1 Deutsche Flugscheiben und U-Boote Ueberwachen Die Weltmeere</u>, <u>11 Deutsche Flugscheiben und U-Boote Ueberwachen Die Wletmeere</u>, Hugin Gesellschaft Fuer Politisch-Philosophische Studien E.V., Postfach 23, D-484772, Hoerstel 3, Germany

20. Dr. Michael Daemboeck Verlag, Markt 86, A-3321 Ardaggr, Austria

21. Video Film "UFOs Das Dritte Reich Schlaegt Zurueck?, available through Dr. Michael Daemboeck Verlag, see reference (18)

22. Video Film "UFO Secrets of the 3rd Reich" available through Total Solutions International, Las Vegas, NV.

23. van Helsing, Jan, 1993, page 129, <u>Geheim Gesellschaften und ihre Macht im 20. Jahrhundret</u>, Ewertverlag, Meppen, Germany

24. British Intelligence Objectives Sub-Committee Final Report No. 1043 Item No. 31,"The Invention Of Hans Coler, Relating To An Alleged New Source Of Power"

25. Video Film "UFOs Das Dritte Reich Schlaegt Zurueck?, available through Dr. Michael Daemboeck Verlag, see reference (18)

26. Juergen-Ratthofer, Norbert and Ralf Ettl, 1992, page 51, <u>Das Vril-Porjekt</u>, Dr. Michael Daemboeck Verlag, Ardaggr, Austria

27. Juergen-Ratthofer, Norbert, date unknown, page 16, "Geheime UFO, 1. Folge: Flugscheibenprojekte aus verschiedenen Staaten der Erde", this article was courtesy of Theo Paymans, Holland

28. Juergen-Ratthofer, Norbert, date unknown, pages 84,85, <u>Flugscheiben und andere deutsche und japanische Geheim- und Wunderwaffen im Zweiten Weltkrieg</u>, self-published, available through reference (18)

29. Juergen-Ratthofer, Norbert, date unknown, pages 1 and 16, "Geheime UFO, 2. Folge So baut man fliegende Untertassen--und so funktioniernen sie", this article was courtesy of Theo Paymans, Holland

30. ibid

31. Vesco, Renato, 1976, pages 163 and 164, <u>Intercept UFO</u>, Pinnacle Books, New York

32. Vesco, Renato, 1976, pages 135-136

33. Nieper, Hans A., 1985, pages 188-189, Conversion of Gravity Field Energy Revolution in Technology, Medicine and Society, MIT Verlag, Oldenburg

165

34. Freeman, Gordon Dr., 3/18/01, personal letter

Atomic Saucers Again?

It is possible that all of the options for the field propulsion
of German flying discs have not been presented or had a fair
hearing. Two of these other possibilities are reviewed below.
The first is the possibility that a world-shattering breakthrough
in field propulsion occurred during the Third Reich involving
atomic energy. This is plausible given the extensive and mostly
still-secret atomic research done by the Germans coupled with the
government's attempt to down play UFO sightings immediately
following the war. The second possibility is that a field
propulsion device was developed out of the early work of the
Austrian inventor, Karl Schappeller. This possibility is
strengthened by the fact that individuals and organizations
involved in this research openly acknowledged that one of their
aims was to build an "ether ship".

The German conventional saucer program culminating with atomic
propulsion has been discussed. Evidence of German field
propulsion saucers has been reviewed. We already know that each
step in the conventional German saucer program was a logical
development of the previous saucer design. The question is: did
the power utilized in the German field propulsion saucers arise
from nuclear power? Was there a breakthrough which has been kept
secret for almost sixty years?

We have discussed the link between nuclear facilities and flying
saucers. Is this evidence, in itself, that an association
exists? The association could be for one of two reasons. First,
these areas may simply have been the most secure facilities
available. The two projects may not have been connected at all.
For security reasons, both projects were simply run out of the
same area.

The second possibility is that the two projects were run out of
the same facility because they are connected somehow. If there
is a connection between nuclear energy and field propulsion, what
type of connection is this? The connection under discussion is a
direct conversion from nuclear energy to field energy. This
connection is on the order of the connection between electricity
and magnetism or heat and electricity or nuclear energy and heat.
Does such a connection exist?

The answer I got from everyone asked was a resounding "no". The
consensus seemed to be that the closest we could come to this was
to convert nuclear energy to heat energy and then to electrical
energy though the medium of a steam turbine. This is how nuclear
power plants and atomic submarines work. This method seemed to
have nothing to do with flight since the hardware involved is
much too bulky and heavy.

166

We have already reviewed some other options for nuclear powered saucers. Klaus-Peter Rothkugel suggests that the atmosphere itself could be burnt using liquid air as a fuel and a nuclear reactor as a heat source. Friedrich Georg has documented some aircraft engine designs, apparently left on the drawing board, involving a propeller engine driven by steam heated by nuclear power. We have seen the enigmatic Messerschmitt design involving a small nuclear engine on a high-speed aircraft. We have also discussed the atomic rocket approach which involves heating and ejecting of liquid hydrogen using a nuclear reactor in the Lenticular Reentry Vehicle.

While there is no known direct connection between nuclear energy and field propulsion, Dr. Gordon Freeman has made me aware of an alternate method of production of electrical energy through the use of nuclear decay. This is important because with enough electrical energy both electrostatic and electromagnetic field propulsion are possible. Let me relate to you what Dr. Freeman told me as to how this process works. It is amazingly simple.

The simplest method involves the use of two solar cells which are the same size. A piece of paper, the thickness of a business card is cut to the same size as the solar cells. Radium chloride is painted onto both sides of the paper. The paper is then fitted between the solar cells. The radium chloride emits alpha and beta particles which activate the solar cell. The reader might ask, if this method works, why has it not been patented? The answer is, that in a slightly more efficient configuration, it has been patented (1).

There are other forms of this simple example. Imagine a simple circuit used for purposes of generating electromagnetic waves. This circuit would consist of a wire connecting a capacitor and then to a coil. An electrical input is given to this circuit whereby the capacitor is sufficiently charged in order for it to discharge. The electrical energy is carried by the wire to the coil where it is charged. Electrical energy is then carried back from the coil to the capacitor by another wire completing the circuit. Alternately, the capacitor (electrical field) and the coil (magnetic field) are charged and discharged. The output of this circuit are electromagnetic waves, such as fill the electromagnetic spectrum. The system works until electrical resistance in the three components converts enough electrical energy into heat to sufficiently degrade its output.

What is done using the new atomic decay system is to paint the capacitors with radium chloride. This unstable compound emits alpha and beta particles when magnetically or electrostatically pulsed. These particles are absorbed by the capacitors (as well as the other components), the end result of which is an increase in electrical energy in the circuit. If enough capacitors can be wired into the circuit in series to produce enough energy to offset the ohmic degradation, then the output can be maintained for a long time. Radium chloride has a half-life of 800 years.

Of course, if an extra capacitor were wired in to the circuit, an excess of energy would result. Even if this excess energy is small, it can be very important. Devices using a similar method have also been patented (2) (3).

In the next step, the circuit described above is given an antenna and a tesla coil. The radium chloride doped capacitors are turned to one of the resonant frequencies for the tesla coil.
An antenna is used which is suitable for receiving this same frequency output. A feed back loop is set up whereby energy is being pulsed into the system in these resonant frequencies. It is estimated that an output of three thousand watts can be obtained from this "lifetime battery" with an input of only fifty watts (4). A transformer and other devices can be used to tailor the electrical output produced by this device according to the need. Details for construction and tuning of this "battery" are available commercially (4).

This whole device can be held in one's hand. Imagine the power of one hundred or one thousand such units. Certainly a U-boat or a field propulsion saucer could be powered using this system.

Dr. Freeman believes this nuclear doping might be the missing link in several free energy devices. Dr. Freeman has evidence that both the Hubbard and Hendershot generators were doped with nuclear material. He has evidence that Hubbard actually worked for the Radium Company of America. Further, he has found evidence that it was radioactive material which was used to dope Moray's germanium valve (5).

Even further, he has suggested that the initial starting energy necessary for the operation of the Schappeller device, which will be discussed shortly, was supplied by a radioactively doped electret (5). Bolstering Dr. Freeman's claim is a U.S. patent using such a radioactive electret to maintain its charge (6). This is not the approach favored in this book, but the use of something like the "lifetime battery" to start the Schappeller device is not beyond the real of reason. In fact, there is some evidence that a very strange battery was being produced in wartime Germany.

During the war years, at least until 1943, none other than Professor. W. O. Schumann was engaged in building something called a "battery" at the Technical Institute at Munich. This battery was a project to itself and funded by the Deutschen Forschungsgemeinschaft, forerunner of the Reichsforschungrates, the Reich Research Council (7). The Reich Research Council coordinated high-priority war research between academic, industrial and military facilities.

This is the same Dr. Schumann who was brought to the United States after the war as part of Project Paperclip (8). This is also the same Dr. Schumann noted for the discovery of the Schumann Resonance. Dr. Schumann was no stranger to free energy

devices since it was he who evaluated a working Hans Coler device in 1926 and could find no fault, hoax or bad faith, on the part of its inventor (9).

Rumor has it that Dr. Schumann's specialty was antennas and that he was responsible for building or improving American submarine communication after the war. It is said this was done by employing extra low frequency radio equipment and mile-long antennae which were towed behind the submarines themselves. The radio waves employed for this communication were said to go directly through the earth's center. Dr. Schumann also discovered something called the Schumann Resonance which deals with the resonant frequency of the planet earth itself.

Returning to wartime Munich, why would a full professor and world-class scientist be devoting years of research and government sponsorship to a battery while Germany was in the middle of a war? The answer is that this battery was something special. Was this similar to the "lifetime battery"? Could this type of energy production have been the promised means of freeing Germany from dependence of foreign oil? Was this battery an energy producing device, capable of powering or starting a field propulsion saucer?

The old problem arises. The question is not **could** this be the way it was done. The question is **was** this the way it was done. What proof is there that nuclear decay was used by the Germans to produce energy by any other means than is in practice today? Dr. Freeman provides one hint.

This scrap of evidence involves a religious sect. It is the Methernita Society of Switzerland. This is a self-contained, Christian brotherhood who own large areas of land in Switzerland. Among their accomplishments is a free energy device they call the Testatika. One desk top machine can yield an output of 3000 watts. This machine or machines have been in existence since the late 1970s and have been demonstrated for outsiders, including scientists and engineers. No fraud has ever been detected.

High voltage is produced by electrostatic means using a Wimhurst generator as in integral part of the Testatika device. The counter-rotating wheels of the Wimhurst generator are not allowed to spin freely, but are purposefully restricted to lower revolutions per minute. Capacitors are used to hold the electric charge which is generated. Dr. Freeman believes that these capacitors are doped with radium chloride. The electric field of the capacitors increases the output of alpha and beta particles derived from the radium chloride. This electron flow is absorbed by the capacitors and other components and fed back into the system.

The Methernita Society has never been forthcoming concerning the workings of this device. The machine itself seems to be the brainchild of one person, Paul Baumann, who is described as a

Der Testatika-Generator

Der erste wissenschaftliche Konverter zur Umwandlung elektrostatischer
Energie in elektrodynamische Energie

Grundprinzip:
Wimhurst-Maschine mit
2 gegenläufigen Scheiben

Treibstoff: Radiumchlorid

Hauptspeicher: Elektrosta-
tische Wimhurst-Kapazität

Leyden-Speicher: DC-Spei-
cher mit 2 Farad für 300 Vdc

Drehzahl: 50 oder 60 U/sec

Dr. Freeman's drawing of the Testatika.

"technician". Even in the old films of the Testatika, Mr. Baumann does not look like a young man. Germany is Switzerland's neighbor and what better place to utilize secret wartime technology than in a closed religious order. Dr. Freeman informs me that one of the builder's assistants talks of radioactive and non-radioactive forces in conjunction with this machine. Dr. Freeman has put these scraps of evidence together and made a drawing which is reproduced here.

Let's try reversing an equation. What if the T. T. Brown relationship between a highly charged capacitor, gravity and movement were altered? What if the highly charged capacitor were fixed and unable to move in a gravitational field? Would not the energy evidenced in the movement of the capacitor in T.T. Brown's work be translated into electrical energy and contained in this fixed machine? Would this not be a generator?

Let's flip it around again. Could not a flying version of T. T. Brown's charged capacitor have gotten charged via decay of radioactive material with accompanying hardware similar to what has been described above?

One more point should be made concerning the possible relationship between atomic energy and field propulsion. We do know that electromagnetic radiation can be generated by atomic fission or fusion. This is done whenever nuclear weapons are detonated. It is called an electromagnetic pulse. This is a well-recognized phenomena and the military's communications and sensitive electronics have to be "hardened" against this electromagnetic pulse as a battlefield necessity. So the relationship between electromagnetic and atomic energy does exist. The question still remains as to a technological breakthrough in the application of this phenomena and to whether the Germans pioneered this effort involving flying craft.

Atomic/Field Propulsion Sources

1. United States Patent, Patent Number 5,443,857, August 22, 1995, granted to Howard C. Rivenburg, "Power Source Using A Photovoltaic Array And Self-Luminous Microspheres".

2. United States Patent, Patent Number 5,642,014, June 24, 1997, granted to Steven J. Hillinlus, assigned to Lucent Technologies, Inc., "Self-Powered Device".

3. United States Patent, Patent Number 4,835,433, May 30, 1989, granted to Paul M. Brown, assigned to Nucll, Inc., "Apparatus For Direct Conversion Of Radioactive Decay Energy To Electrical Energy".

4. Lifetime Batteries, 13A and 13B, contained in catalog of Energy Research Company, P.O. Box 1514, Jackson, CA. 95642

5. Freeman, Gordon Dr., personal letter to author dated 3/7/02

6. United States Patent, Patent Number 3,949,178, April 6, 1976, granted to Sten Hellstroem and Rolf Bertil Goeran Joenson, assigned to Telefonaktiebolaget L M Ericsson

7. Bundersarkiv, Postfach 450569, 12175 Berlin, file on Dr. W. O. Schumann, courtesy of Mark D. Kneipp.

8. Foreign Scientists Case Files, 1945-58 "Winfreid Otto Schumann", Location Box 151,631/26/01/07, The National Archives, 8601 Adelphi Rd., College Park, Maryland 20740, Courtesy of Mark Kneipp

9. British Intelligence Objectives Sub-Committee Final Report Number 1043, item number 31, "The Invention of Hans Coler, Relating To an Alleged New Source of Power", Bryanston Square, London

The Karl Schappeller Device

Was the Schappeller device an engine used in German field propulsion saucers? This is a possibility. Because so little has been reported about this device in the English language, the following is a report describing Karl Schappeller and his device in some detail.

Karl Schappeller (1875-1947) literally went from being born in poor house to owning a castle during his lifetime. His economic success was mirrored in his experiments in energy as a lay-scientist, culminating in the invention of a free-energy device which attracted considerable attention around 1930. Schappeller made no secret of his invention and actively sought private financing to manufacture and distribute the results of his research. He was in touch with financial concerns and even spoke with a representative of the British Admiralty concerning the utilization of his device to power the Royal Navy's ships (1).

At this time, 1930, the device was somehow appropriated and further worked upon by a governmental organization of the German Weimar Republic, the Reichsarbeitsgemeinschaft or Reich Works Association (RAG). At least one aim of the RAG was to make Germany self-sufficient in energy production. Specifically, they published their intentions to utilize many Schappeller devices in a system of broadcast energy distribution throughout Germany which would result in the entire elimination of the electrical grid (2). As we know, Adolf Hitler assumed power three years later and was also very interested in making Germany independent of foreign sources of energy for strategic reasons. It is known that political and scientific structure was set up to work on the energy problem as evidenced later by the synthesizing of gasoline and oil products from coal by the 3rd Reich. One of these

172

Left: Inventor Karl Schappeller Right: Karl Schappeller's
Device. A. Steel outer casing. B. Special ceramic lining in
which tubes are embedded. C. Hollow center, filled by
glowing magnetism when in operation. D. Tubes, circuit and
earthling.

political and scientific structures was contained within the SS and it is known that Karl Schappeller actually met with SS Reichsfueher Heinrich Himmler in Vienna in 1933 (3).

Fortunately, there are good descriptions of the Schappeller device in both German and English languages upon which to draw. Der Vril-Mythos is a complete discussion of Schappeller, his device, the history and the controversy surrounding it. "Vril" Die Kosmische Urkraft Wiedergeburt von Atlantis and Weltdynamisus Streifzuege durch technisches Neuland an Hand von biologischen Symbolen represent an attempt by the RAG to popularize their ideas in booklet form. Finally, British electrical and mechanical engineer, Cyril W. Davson, visited Karl Schappeller in Austria and spent three years learning of his device and his theory before the Second World War. Davson's descriptive book, The Physics of the Primary State of Matter, was written in 1955, after the war and the death of Schappeller.

Before describing the device itself it should be understood that Schappeller and all writing about his device do so believing that the energy-source being tapped is ether energy, sometimes called "Raumkraft" or "Raumenergie", that is space energy (4)(5)(6). This device was also said capable, perhaps with some tuning, of emitting ether as a radiant energy (7). The physics of ether energy is described by Davson as a primary physics as opposed to conventional physics which he believed could only be considered a secondary, derivative understanding.

<div align="center">Ether Theory</div>

For readers who have never heard of "ether", perhaps the simplest explanation for ether physics is that of the late Dr. Hans A. Nieper (7) titled Revolution in Technology, Medicine and Society. Ether could be thought of as an energy source emanating from everywhere equally at once. The universe could be considered, as often said, "a sea of energy". It forms a background of energy everywhere, and since it is everywhere all the time, it is difficult make independent measurement of it. This ether energy is in constant motion. All energy is radiant energy, according to this theory. This can easily be appreciated as to electromagnetic radiation but it is also true of that very elusive thing called gravity. Newton described the effects of gravity but he never told us exactly what it was. Dr. Nieper tells us that gravity is really a push, not a pull. Gravity is acceleration and is caused by the ether field. Again, all energy is radiant energy whose fundamental basis is ether radiation.

From the aforementioned book by Dr. Nieper:

"In addition, Nieper established the axiom that all natural accelerations can be attributed to a single unified basic principle, namely, the interception (or braking) of a field energy penetrating from the outside (gravity acceleration, magnetic, electromagnetic, electrostatic and radiesthesic

<div align="center">174</div>

acceleration)."

In trying to explain ether, it might be thought of as an all pervasive liquid occupying all of space. This liquid concept is useful because a liquid can not be compressed but can only transfer the energy attempting to compress it from one location to another. This is how an automobile's brakes work. The driver pushes in the break pedal when he wants to stop. The plunger of the break pedal attempts to compress fluid in the master cylinder. The master cylinder is connected by metal tubes full of fluid to each wheel. When force is put on the master cylinder by the driver it is transmitted to each of the four wheel cylinders full of the same fluid which transmit the force, moving the break shoes or stopping the disc which stops the wheels of the car.

Likewise, ether serves to transmit energy through this "non-compressibility" quality. In a primary electric coil and secondary electric coil, for instance, induction in the secondary does not take place directly from the primary as is now held by physics, but though and between the two via the ether field. This concept, that of the stimulation of the ether field as means of energy transport, is also expressed by Davson.

Using this perspective, that all energy is radiation, the braking of ether radiation, that is the slowing down or stopping of this radiation, can cause or generate other forms of energy. This word "energy" means the entire electromagnetic spectrum. This means electric, magnetic and electrostatic fields. This means heat. This also means gravity. Again, gravity is the primary radiation of the ether field. It radiates from every point in the universe equally.

This concept seems ridiculous until it is given some thought. One might ask: How can gravity be a push when we know better? After all, things fall to earth don't they? The answer is that the effects we feel and call gravity are due to gravity shielding. Ether radiation can be braked, that is slowed down and absorbed by mass. It is then re-radiated or turned into mass. It is re-emitted as slower ether radiation or even as heat. Some of it can be converted into mass inside a planet. If there is a loss of ether radiation, then there is shielding. Thus, a planet would shield from this radiation in one direction. That direction is always toward its center which is the direction of greatest mass and that is what we describe as "down". This is simply the area which contains the maximum amount of shielding. In all other directions the ether radiation continues to exert its push on us. The area of minimum shielding is directly opposite the area of maximum shielding, so things fall (or more correctly are accelerated or "pushed") to earth.

Think about this for a minute. Being in deep space is a little like being underwater. Underwater, all pressure from all points are so similar that we feel weightless. We are weightless in

deep space because the ether field exerts a push on us from all directions equally. In space, the nearer one gets to a large body the stronger the push is from the opposite direction since the body shields or converts the ether radiation. The result of this thinking is a mechanism totally different from "gravity" as we know it but appearing as exactly the same observed phenomena.

The beauty of this ether theory of gravity is that gravity functions like every other form of radiation. Its underlying cause, ether radiation, can be converted to mass or, in certain circumstances, re-radiated or converted to other forms of energy. No Unified Field Theory is necessary. The ether field is the unified field. Further, there is no need to look for something separate called "anti-gravity". If gravity is a push then it is all anti-gravity. All we have to do to make a UFO is to find this particular gravity frequency and find out how to generate it.

Ether physics was a lost physics. Physics was hijacked early in the 20th Century by alleged results of the Michelson-Morley experiment. The Michelson-Morley experiment assumed "ether" was matter. There is some confusion here. We know now that particles moving near the speed of light are measured as waves, that is energy, rather than as matter. Nevertheless, ether theory has been discredited among physicists who, in turn, discredit others who raise the subject. It is only through the efforts of "free energy devices" and free energy researchers that this knowledge is being returned to us. Without this ether theory, the reason these devices work cannot be explained at all. Rejection of ether theory allows these devices to be dismissed as "theoretically impossible" and so fraudulent by simple deduction. They are marginalized and dismissed as "perpetual motion devices". According to established physics, perpetual motion devices violate physical laws of conservation of energy. Without an ether theory as an explanation, they do violate laws of conservation of energy and so their detractors are able to simply dismiss them out of hand. The simple fact that some of these free energy devices actually work does not seem to bother these scientists in the least. Rather than change the theory to accommodate the observed facts, the facts are ignored and substituted by dogma. Whether we like it or not, we are living in an energy Dark Age.

Instead of ether theory, we have all been led to focus upon Einstein and his Theories of Relativity. Two or three generations of scientists have wasted themselves on "trying to prove Einstein right". This misguided thinking has resulted in stagnation. One need go no further than the many "free energy" devices which have arisen to the level of notice in spite of accepted scientific theory to see that this statement is true.

Needless to say, German scientists of the Nazi period labored under no such illusions. They never abandoned ether physics. This was the fundamental reason why field propulsion UFOs were

first developed in Germany. After the Second World War two different sciences developed called "Physics". One was the relativism taught in schools. The second more esoteric type was utilized only secretly, by the secret government, for deep black projects.

Structure of the Schappeller Device

According to Davson's description upon which we will rely, the Schappeller device is really composed of two separate units, the rotor and the stator. The stator is constructed as follows: Its surface is round or ball-shaped, being composed of two half-shells of steel. These half-shells contain the internal structure and are air tight. Attached at each "pole" of each half-shell is an iron bar magnet, most of whose structure is internal. This means that the bulk of the magnet is inside the steel ball, one opposite the other. There is a space between the two bar magnets at the very center of the sphere.

Insulation, a ceramic material, is placed on the inside of the steel ball leaving a hollow central area. Within this hollow area and around the space between the magnets are wound two internal coils. These originate at the bar magnet poles and each terminates at the center of the sphere with a connection leading out of the sphere to the rotor. These coils are composed of a hollow copper tube filled with a special and secret substance called the "electret". Upon leaving the sphere the electret filled copper tubes are replaced by conventional copper wire. An electrical connection is made from the outside surface of one pole to one pole of a special type of battery which is grounded at the other pole or, as an alternative, to a special device called an "Ur-machine" which will be discussed.

This electret is a permanent magnet within the sphere. This type of magnetism is not identical with ferro-magnetism or electromagnetism, it is much stronger (8). The actual composition of Schappeller's electret remains a secret but another electret has been made by Professor Mototaro Eguchi. It consists of carnauba wax and resin, perhaps also containing some beeswax. It was kept in a strong electric field while baking slowly until it solidified. For purposes of production of Schappeller spheres, a complete electret manufacturing plant would have to be set up which had no parallel in present science (9).

Before being set into operation, all the air is pumped from the hollow core of the sphere. This whole ball is mounted on a swivel mechanism so that the poles can be moved from the vertical to the horizontal. The stator is completely unattached from the rotor. The stator can function without the rotor and the stator is capable of producing electrical energy without the rotor. The rotor could also be used to generate additional electrical energy.

The rotor consists of: A steel wheel of special design fixed on

the shaft to be driven and surrounded on its outer surface by magnets which are attracted and repelled by the force of the stator. The copper wire attached to the internal copper tubing filled with electret runs through this wheel and supplies electric power to the magnets. The magnets are hollow and filled with the same electret. There are always an odd number of magnets.

A variant of this rotor comes to us from Taeufer, who refers to this further development as the "Ur-Machine". This machine is composed of six sphere units as described above, five revolving around a sixth set above or below the plane of the other revolving spheres. A seventh unit would be employed to rotate the rotating five spheres and so would be offset, and not attached to the others. The five rotating spheres would charge the sixth stationary sphere. The sixth and seventh spheres would function as an anode and cathode and so ground the unit. The Ur-machine could be used to activate other spheres instead of a battery-earthing procedure (10).

As a prime mover, an engine, the rotor would be employed turning a driven shaft. The stator would be offset, that is, moved off center in relation to the rotor. Schappeller worked out various angles of efficiency (11). The driven shaft could be used to power any number of machine applications such as, for instance, the propellers of a ship.

Means of Operation

The device is started through totally unique battery and a connection to the earth (12). A specific excitation impulse must be given to the device (13). This electric impulse was conducted through the iron magnet and jumped the gap in the center of the sphere to the other iron magnet.

What occurred then sets this device apart from all others. In the vacuum of the sphere, in the center space between the two bar magnets a field of "glowing magnetism" was set up. This glowing magnetism was something entirely unique. It is recognized as a magnetic field but much more powerful and unlike any magnetic field of an iron bar or an electric coil. Once the initial input had been made to start the device, the battery and ground could be disconnected. The device would continue of operate on its own (14).

For an understanding of what is really happening here we have to consider the bar magnet. We think of a bar of iron with two poles, one positive and one negative or perhaps one north and one south pole. But there are really three components to the bar magnet. There are the two poles and the neutral zone between the poles If we cut the magnet in half we get two new poles. For the Schappeller this neutral area is very important. Imagine a bar magnet running through the vertical axis of the ball. Then imagine the center section cut out. We now have a north pole at

178

the top of the ball, a south pole at the bottom of the ball just as we do with the planet Earth. In the center we have a missing section with a south pole, opposing the north pole at the top of the ball and, likewise, a north pole opposite the south pole at the bottom of the ball. We have now four poles and a split bar magnet with a gap in its center section.

It is this gap in the center where Schappeller's "glowing magnetism" is generated by grounding, that is, charging the device via a special battery and an earth connection. This glowing magnetism is the mystery. Davson cites Schappeller's calculations and gives this form of magnetism as being one thousand times more powerful than that produced by present magnetism (15). He also states that in this form of magnetism the electricity is stationary while the magnetism is radiated (16).

To repeat again, Davson contends throughout his book that this glowing magnetism is not found in secondary physics, that is, in modern physics, and that this glowing magnetism is a manifestation of primary physics. As a phenomenon of primary physics, it is responsible for and can generate heat, electricity and magnetism.

After initial stimulation and in a state of glowing magnetism, no further input of energy is needed from the battery. The device is able to draw in energy to it directly from the surrounding ether, bind this energy though its magnetic electret material, that is the filling in the hollow copper coils of the internal coil, and then re-radiate energy producing heat, electricity, magnetism or mechanical work depending upon the application.

Stated another way, this is an implosion device and it is described as such (17) (18). Unlike the Schauberger device which is associated with the word implosion, the Schappeller device operates purely at the energetic level. Energy is drawn towards the center, through the magnets, into the field of glowing magnetism, and then radiated outward.

My first explanation for this output of radiant energy involves the concept of the Block Wall. A Bloch Wall is defined by Van Norstrand's Scientific Encyclopedia, 1958 edition, pages 201 and 202, as follows:

"This is a transition layer between adjacent ferromagnetic domains magnetized in different directions. The wall has a finite thickness of a few hundred lattice constants, as it is energetically preferable for the spin directions to change slowly from one orientation to another, going through the wall rather than to have an abrupt discontinuity" (18).

In electromagnetics the Bloch Wall is external to the hardware itself. It is the point of division of the circling vortex, or spin, of the electronic magnetic energies of the north and south

Bloch Wall And Oscillating Circuit

Top: Bloch Wall, a gravity wave source as a function of the electromagnetic spectrum? (Dr. Richard LeFors Clark) Bottom: Oscillating circuit. Charged capacitor (electric field) discharges, current carried through insulated wire to charge coil (magnetic field) which discharges, charging capacitor. Oscillating electric and magnetic fields yield electromagnetic waves.

poles. The negative north pole magnetism spins to the left while the positive south pole spins to the right. Energy is being conducted into the Schappeller device through the un-insulated poles and being conducted and spun on its way to the center of the unit. The point of zero magnetism, no spin and magnetic reversal, where the two spin fields join, is the Bloch Wall (19).

The Block Wall radiates energy. Remember, if energy is coming in then it must be going out. The Bloch Wall may generate radio, radar and other electromagnet frequencies but what is most interesting is that it is actually able to radiate gravity as according to Dr. Richard Lefores Clark. According to this interpretation, the conjunction of two dipolar generated force field vectors, a quadropole force field or gravity is generated according to Dr. Clark. Gravity being a quadropole source, radiates in a circular, 360 degree, pattern of two cycles. Dr. Clark has fixed the point of emission as below that of radar and above infrared at 10 to the twelfth power Hertz (20). Dr. Richard Lefors Clark believes gravity is a radiation (21) and so a "push".

Another Opinion

In late 2001, I wrote a magazine article on the Schappeller device (22) which contained most of the material described above. In that article a request for alternative explanations for the Schappeller device was made. I received a letter from Mr. Michael Watson, BSc, Charted Physicist and Member of the Institute of Physics in the United Kingdom. But there was something in Mr. Watson's background even more impressive than his professional credentials. Cyril W. Davson was a family friend whom Mr. Watson knew well in his youth and with whom he had discussed Schappeller and his ideas at length, many times. In Mr. Watson's letter was a brief summary of Schappeller's theory in which he cut through most of the confusing terminology.

This summary is important for a couple of reasons. Mr. Watson's summary of Schappeller's ether theory as described by Davson dovetails nicely into the ideas of Schauberger yet seems to allow for Tesla's experimental results on ether as explained by Bill Lyne. The following is what I learned from Mr. Watson's letter:

Most of us have heard of the two Thermodynamic Laws. These are laws of heat. The First Law of Thermodynamics states that energy is conserved, meaning that the total amount of energy in the universe always remains the same. This is no surprise for most of us and it is not the real concern here.

What is of concern is the Second Law of Thermodynamics which discusses heat and entropy. The word entropy might be thought of as a state of randomness or chaos. Negative entropy would then mean movement toward the less random or the more ordered in any particular thing. If we apply this to a system, then entropy tends to increase until the system breaks down in utter chaos

This will occur unless the system is re-charged with additional outside energy. A concrete example is less confusing.

Imagine a new automobile just coming off the assembly line. It has taken a great deal of energy to find, refine, forge, weld, and paint the metal parts of this car alone. This same concept also applies to all the other components of the car. This energy and organization constitute a highly organized state, or, said another way, a state of negative entropy.

What happens next illustrates entropy. The car is purchased. Whether it is driven hard or just sits in the garage does not matter in the long run because what happens to the car is that it starts to fall apart. This change may be small at first and may only occur at the molecular level, but it occurs nevertheless. The engine, transmission, paint, rubber, electronics, etc. all will fail with time. Even it the car just sits in the garage, in a thousand years the metal will eventually oxidize. Finally, the car rusts away forming a reddish brown heap. This is exactly the opposite of the organization and energy used to put the car together. This disorganization is entropy. The only thing which will reverse this, as we all know, are additional inputs of energy by the owner in the form of maintenance and repairs.

All things in a relative state of relative order move toward a state of disorder. In terms of heat, heat will always flow into a colder place from a warmer place. When something is heated there is a rise in its entropy. With increasing heat its molecules move faster and faster in random chaos as a bomb does when it explodes. Increasing heat means increasing randomness and chaos which is entropy. Cold, then, can be seen in terms of negative entropy. Any cold object is simply more organized and less random than the same object once it is heated.

Schappeller had something to say about the Second Law of Thermodynamics. He said there was another and unknown thermodynamic cycle which runs opposite the Second Law. To name this idea we will call it "Reverse Thermodynamics". It is the reverse of the Second Law of Thermodynamics in that it leads to an increase in entropy. Not only is there an increase in order but there is an increase in cold! Schappeller, according to Mr. Watson's letter, built his spherical device primarily to demonstrate the principles behind this Reverse Thermodynamics. It was not designed as a practical machine.

To demonstrate the difference between the Second Law of Thermodynamics and Reverse Thermodynamics two theoretical machines shall be examined. Actually, a machine running according to the Second Law of Thermodynamics is not theoretical at all. Combustion machines are of this type. For simplicity sake we will use a wood burning stove such as the type invented by Benjamin Franklin for the heating of a house.

Wood is put in a hollow iron vessel with an adjustable hole at

182

one end. The adjustable hole admits atmospheric oxygen. An initial small input of heat is added to the wood and oxygen until burning occurs. A great deal of heat is produced once the wood begins to burn. We know heat expands. Carbon, carbon dioxide and water vapor are also produced as byproducts of the combustion. Entropy is increased. Since entropy is increased, so is pollution so perhaps we all can agree that this is a good example of the destructive technology so characteristic of the world in which we live.

In our example of a theoretical Reverse Thermodynamic machine the byproducts of the previous example can be used as fuel. But Schappeller's machine has the additional property of being creative, that is, negatively entropic. Schappeller believed this creative process to be individualistic, so we need a specific template to use as a pattern for this creation. Heat, water, and carbon dioxide are imputed into this machine. Quite amazingly, oxygen is yielded as a byproduct of this reaction! The heat is also absorbed in Schappeller's Reverse Thermodynamic machine! This absorption of heat is another way of saying that the machine is implosive in nature rather than expansive or explosive as was the heat producing machine. What is most amazing, however, is that entropy is actually reduced yielding, something which has been created - wood!

Actually, this machine is not theoretical either. It exists and works as we speak. These machines are all around us. We call these machine "life". In this case our machine is a tree. In the tree, energy, sunlight, is absorbed and combined in a cold process with water and carbon dioxide to form wood. The template used as a pattern for this seemingly intelligent, creative, process is simply a seed. In this type of reaction the "cold" force is something other than the absence of heat. This cold is an active cold. It is a "densifying", implosive cold. It is a life-giving cold. This is a cold, life giving force. To quote Watson:

"This process is life force and the reverse of the second law of thermodynamics; it is the vital force: Vril."

This is one huge difference between the physics of Schappeller and Schauberger and the physics of the Nineteenth Century. The physics of the Nineteenth Century explain everything in terms of the inanimate. Laws of physics are written using inanimate examples. Chemical reactions are described which stem from inanimate models. Animate models are simply made to conform with the inanimate assuming that life is just a special case which eventually will be shown to be nothing but chemistry and so subject to the same Second Thermodynamic Law as the inanimate. Schappeller and Schauberger both say in their own ways that this is not so. They say, each in their own ways, that a new and different law of thermodynamics applies to living forces. They say that this more akin to a life process than previous theories allow. They say this force is creative. Those that subscribed

to these new ideas claim it was not only a new physical law but a new science and that Germany would lead the way to this new science. Let us take a closer look at what is claimed to be the physics behind this new science.

The first concept to be considered is cold. Cold in this sense does not mean the mere absence of heat. This is interstellar cold, the cold found in the vacuum of space. In this relative vacuum, matter is not found in sufficient quantity to use to measure this cold. Think about how we measure cold. We measure matter which is cold. We measure the heat in air or water for instance. In the absence of matter how would cold be measured? There is no doubt that if we could, for instance, place a thermometer in a glass of water in deep space, the temperature recorded would be at or very near absolute zero, 0 Kelvin or -273 degrees Centigrade or -460 degrees Fahrenheit.

The presence or absence of matter in deep space may be the subject of conjecture. The presence or absence of energy in deep space is something universally accepted. For instance, we all know that light passes through interstellar space. We see the proof when we look up at the stars, planets or the moon. Besides visible light, other electromagnetic radiations freely pass through space. These include x-ray, gamma and cosmic rays. Yet besides electromagnetic radiation many people now believe that in the depths of space there resides another form of energy with is found there as well as everywhere else all around us. This energy sometime goes by the name of "zero point energy" but for our purposes we can simply call it "ether energy". It is sometimes argued that this energy is really the result of ether rather than ether itself and that ether really is matter. For a moment, let us postpone this discussion and focus on the vast, stretches of interstellar space which are filled with ether energy, near or at absolute zero.

Mr. Watson points out Dawson's words on page 83 of <u>The Physics Of The Primary State Of Matter</u> where he says:

> "Cold is not therefore the absence of heat, primary heat and cold having nothing to do with molecular action (in the cosmos) there are no molecules available".

The reader may recall that something strange happens to electrical energy at absolute zero. For instance, if a disc of conducting material is held at absolute zero and the disc is given an electric charge, the electric current will circulate around and around the disc forever, never loosing its energy as it would if the disc were sitting on an office desk at room temperature. This property ·of cold is instrumental in the storage of at least one form of energy. The vast stretches of cold interstellar vacuum must be seen as a vast energy storage sea in a state of heightened negative entropy. Schappeller called this undirected matter-energy reserve potential "latent magnetism.

184

Out of this latent magnetism, both energy and matter could be
produced with the corresponding stimulation. The non-excited
electromagnetic field was viewed by Schappeller as simply latent
magnetism. Matter is a condensation out of bipolar ether.
Therefore, electromagnetism is a product of matter and is nothing
more than bipolar ether in a different condition. Latent
magnetism could be, then, excited into matter. Latent magnetism
could be influenced by either of the thermodynamic principles
discussed, the Second Law of Thermodynamics or by Reverse
Thermodynamics. This vast ether field, whose most notable
characteristic is the property of cold, latent and awaiting
stimulus, is the progenitor of both energy, as we know it, and of
matter.

Since primary cold, this vast reserve of negative entropy
potential, is responsible for both matter and energy and since
all energy eventually degenerates into heat, it follows that, as
Davson puts it, again on page 83:

"Primary heat, as may now be understood, is composed of cold
energy".

This is seems like a surprising play on words, especially from a
man of science, but this statement follows perfectly from
Schappeller's reasoning nevertheless.

We turn now to Schappeller's concept of "stress". Both heat
stress and cold stress can be applied to an electromagnetic
field. Heat stress is the usual type of stress applied to
electromagnetic fields in secondary physics. Secondary physics
is the physics of our everyday world according to Schappeller.
Primary physics is the physics dealing with the cold force and
ether yielding matter and energy, which constitute the secondary
reactions and so Schappeller uses the term "secondary physics" to
describe our world as we know it.

An example of heat stressing of the electromagnetic field is the
condenser and the coil. A charged condenser results in an
electric field and a charged coil results in a magnetic field. A
charged condenser and coil, connected by a wire circuit
alternately charge and discharge each other, producing
electromagnetic radiation unit the heat caused by the resistance
of the wire degrades the whole process into heat. Heat stress on
the electromagnetism is +/-.

Cold stress on the electromagnetic field is something totally new
to our science and technology. It is also seen in terms of +/-
but the machines used to produce it are not known in our world.
Mr. Watson did not say this but if we return to our examples of
heat stressed machines, the condemnor and the coil, the
corresponding cold stressed machines might be the Schappeller
sphere and the Schappeller coil electret. The sphere collects
the charge through the magnets, holds and condenses it in its
glowing center corresponding to the electric field of the

condenser. The internal coils filled with electret produce a magnetic field in the presence of the intense and pulsing electric field. According to my interpretation, the whole Schappeller sphere is a combined condenser/coil combined into one machine made possible through an initial input of cold stress.

As in our example of the condenser/coil interaction producing an electromagnetic wave, so an attraction exists between a machine obeying the Second Law of Thermodynamics and one obeying the law of Reverse Thermodynamics. This attraction can lead to interaction. For instance, an imploding or centripetal vortex can couple with an exploding or centrifugal vortex. The centripetal vortex is an example of a system following the law of Reverse Thermodynamics while the centrifugal vortex represents a system following the Second Law of Thermodynamics. We have all seen these two systems working together in everyday life. The common toilet is such a machine although the centrifugal side forms inside the drain pipe which is out of sight.

Perhaps there is another example which is more germane to our discussion. It is the diagram of the Vril power plant. (This engine diagram is used here as an example for discussion and is not a blind endorsement of the diagram's existence or accuracy.) In this interpretation of this diagram, we are really dealing with two separate devices. First, is the central spherical device which may be a refined version of the Schappeller sphere. An initial charge would be imputed into the sphere to start it after which the unit would continue to gather up the surrounding energy. This is a Reverse Thermodynamic machine. The sphere generates a magnetic field which could be offset by rotating as in the Schappeller device. The offset field would feed and so rotate the arms of the electric generator surrounding the sphere. The electric generator would gather electric energy, feeding the four large broadcasting fixtures on the walls of the saucer. These fixtures might be, for instance, Tesla pancake coils. The electric generator is an example of a machine complying with the Second Thermodynamic Law.

Both components of the power plant are bonded together in a single system since the output energy of the broadcasting fixtures on the walls of the saucer constitute additional input energy for the sphere. The two components attract one another and use and depend upon one another as they circulate and recirculate energy. As the energy level of one component increases so does the energy level of the other. Indeed, the biggest problem facing the use of such an engine may be employing a means to stop it.

The actual levitation might be the particular electromagnetic radiation coming out of the sphere. In this interpretation, the broadcast fixtures are used to steer the saucer. Davson gives output frequencies for the sphere as 10 to the sixth power (22).

Mr. Watson points out in his letter that one reason machines

utilizing the Reverse Thermodynamic principle have not been
recognized is that a cold stressed magnetic field is a cold
machine. Even a centripetal vortex cools rather than heats. All
our devices of measurement ultimately measure heat in some form.
Measurement of cold is more difficult. The example already
given, the problem of measuring temperature in interstellar space
in the absence of matter is an example of this problem.

Finally, the reader will recall that Mr. Watson points out that
electromagnetism manifests itself bipolarity, yielding four
components in all. These are +/- hot electromagnetism and +/-
cold electromagnetism. The reader will recall that two hot
electromagnetic components can be joined (the condenser and the
coil) and set into a cycle producing an electromagnetic wave. Is
it possible that two complementary hot electromagnetic and cold
electromagnetic machines could be set into cycle producing not a
bi-polar but a quadropolar, 360 degree radiation, such as the one
described by Dr. Richard Lefores Clark, to produce gravity?

Planned Uses For The Schappeller Device

If the above discussion has any meaning at all in the quest for
an answer to the UFO question, one use for which the Schappeller
device must have been destined was that of a power plant for a
flying machine. Was this so? The Schappeller device had many
planned uses. In 1930 this device was planned as a source of
broadcast energy, reminiscent of Tesla, for both German homes and
industry. The device could also be used as a generator, battery,
transformer, or antenna (23). It is reported that toward the end
of the war the SS researched the possibility of using this device
in the form of a death ray (24). But additionally, and in answer
to our question, the Schappeller device was envisioned as a
levitation device for a flying machine. Here is some of that
discussion from our sources:

"The new dynamic technology will, in the future, be able to
drive electric locomotives and automobiles without the
manufacture of costly armatures and everywhere through connection
to the atmospheric voltage network. Hypothetically, is certainly
the installation of a sufficient number of central amplification
facilities which transports from the Ur-Machine the specific
magnetic impulse from the dynamic spherical element. New types
of aircraft with magneto-static power devices and steering, which
are completely crash and collision proof, could be built for a
fraction of the cost of today's aircraft--and without the lengthy
training of everyone who will be servicing these aircraft".

From "Vril" Die Kosmische Urkraft Wiedergeburt von Atlantis
by Johannes Taeufer, page 48.

"Our problem must be to drive toward the space ship problem
to new understanding of a realization! Here a definite postulate
can be established: "Spherical space ship with its own
atmosphere--also technical creation of small planets with world-

187

dynamic propulsion and buoyancy!".

Will this be possible?----

Major powers in the world prepare themselves in any case presently, especially in Germany."

The above from Weltdynamismus Streifzuege durch technisches Neuland an Hand von biologischen Symbolen, pages 11 and 12. Please note the use of the words "spherical space ship" (Kugelraumschiff).

From Davson in The Physics Of The Primary State Of Matter, page 240:

"The Rotor is laminated to prevent eddying and the magnets do not project; the Rotor periphery is thus entirely equiradial. The Rotor is fixed to the shaft to be driven and the Stator is fixed about a metre above the earth's surface. The latter is, of course, flexible because the earth can include the sea or even the floor of an ether-ship."

From Davson, page 199:

"As has already been explained, the new Technique will not concern itself with the air as a supporting medium, but directly with the ether. Therefore, the body may be a vertical sealed cylinder with conic ends or any other suitable form. Such a body is obviously rigid and inelastic, and it must contain an ether stress of sufficient intensity to support its mass against the ether stress of the earth's stressfield, which means that the glowing magnetism core in the Stator, provided in the body to be lifted, must be able to vary its intensity according to the height at which the ether-ship is to be raised and supported whilst in transit, as the ether stress or field, itself, varies inversely as the square of the distance from the earth's surface. The actual design and solution of all the various problems in the production of such ships, the choice of methods of propulsion, whether independent or directional, belong to the new Technique, whereas here we are only interested in the principle as applied to the problem of Gravitation."

Finally, from Davson, page 177:

"Now the reason that an unsupported body falls to the ground is primarily because it has "no hold" on the medium. It was previously explained that any inert mass or body has only a latent stressfield which functions merely as the force of cohesion and has no mobility and thus only a latent internal stressfield and no external stressfield. This means that it has no "hold" on any elastic medium such as the ether or the air, therefore it must fall, and it falls towards the greater inductive energy.

188

If the inductive energy, through some exterior cause, could be made suddenly to increase enormously, there would come a point when the body would be supported, or rather suspended, before it reached the earth's surface.

The new Technique could accomplish this by placing a Schappeller Stator in the body in question, where the body is suitably constructed, thus setting up a glowing magnetic stressfield which would hold or keep the weight or mass of the unit body suspended, not in the air--the stressfield would have no reaction on the air--but only on the earth's magnetic stressfield.

This is the basis of the new principle for "ether ships""

Employing the Schappeller mechanism is only half the total explanation. In a field propulsion saucer there are possible two types of "drive" needed. The first is the "Auftrieb" or levitation. Employment of levitation makes the craft buoyant. It weighs nothing. If it weighs nothing it can be moved very easily. "Antrieb", impulse or motive power is the second drive involved. It moves the craft directionally. Levitation only would be supplied by the Schappeller system. Directional movement is so far best explained, in my mind, using the Tesla pancake coils as explained by Bill Lyne.

Concluding Thoughts on the Schappeller Device

In the end, what can be said of the Schappeller device? Certainly, it did exist. It drew attention and funding from people within the German government of the time. It was studied by a qualified outsider, a British engineer, for a period of three years and was judged to be genuine.

There are some obvious problems, however. Exotic energies have been evoked which have not been explained satisfactorily. Therefore, the facts are not in evidence yet. Certainly more proof is required before the claims made for this device or the energies involved can be wholly accepted. For the time being we must put this discussion aside, awaiting further correlations.

There are some solutions connected with this device also. If we accept the idea that both the Schauberger and the Schappeller devices worked on the theory of implosion, then one explanation will serve to explain them both. It also allows for an ether-as-matter explanation. This may fit into the evidence gathered by Nickola Tesla. The commonality of these devices could then be sought and perhaps a more efficient device built as a result. We will pick up this theme again in the discussion section of this book.

It should be pointed out that the quest for this "new science" is not specific to Schappeller or Schauberger. Mr. Watson passed on

189

these words from Ehrenfried Pfeiffer, a scientist who collaborated with Dr. Rudolf Steiner around 1920. Although he is not happy with the translation he sent it as he found it which is as it is presented here:

"...the method of science, in a materialistic sense, is based on analysis splitting apart, disintegration, separation, dissecting and all the procedures which have to destroy and take apart, to work on the corpse rather than to grow, to develop, to synthesize. That the human mind was captured by these methods of braking apart: in that I saw the source of our present situation. My question therefore was: (to Rudolf Steiner) is it possible to find another force or energy in nature, with does not have in itself the ductus of atomizing and analysis but builds up, synthesizes. Would we discover that constructive force, which makes things alive and grow, develop adequate building up of methods investigation, eventually use this force for another type of technic, applied to drive machines, than because of the inner nature of this force or energy we might be able to create another technology, social structure, constructive thinking of man rather than destructive thinking. This force must have the impulse of life, of organization within itself as the so-called physical energies have the splitting, separating trend within themselves.

My question to Rudolf Steiner October 1920 and spring 1921 therefore was: does such a force or source of energy exist? Can it be demonstrated? Could an altruistic technic be build upon it?".

My questions were answered as follows: "Yes, such a force exists, but is not yet discovered. It is what is generally known the aether (not the physical ether) but the force which makes things grow, lives for instance in the seed as Samenkraft. Before you can work with this force you must demonstrate its presence. As we have reagents in chemistry, so you must find a reagent for the aetheric force. It is also called formative aetheric force because it is the force which relates the form, shape, pattern of a living thing, growth. You might try crystallization processes to which organic substrata are added. It is possible then to develop machines, which react upon and are driven by this force. Rudolf Steiner than outlined the principles of the application of this force as source of a new energy..."

Since this quest for a new science with the accompanying new machines had a relatively long history in Germany, certainly pre-dating the 3rd Reich, it is almost certain that the Schappeller device or others built along a similar understanding were further developed during the Nazi period. What became of it after the war is unknown. It can be assumed that this device did not escape the scrutiny of the numerous Allied intelligence units tasked with combing Germany for examples of German science. Perhaps someday a government report will be de-classified explaining all this as it was in the case of another free-energy machine, that being the Hans Coler device, which was declassified

190

by the British in 1978 (25) and which worked, according to Mr.
Watson, using the same principles of cold magnetism. Until that
final reckoning comes aspects of the Schappeller device will
still remain a mystery. And until a more final reckoning comes,
the question of if the Schappeller device was used as a source of
field propulsion in German flying saucers must be deferred.

The Karl Schappeller Device

Sources and References

1. Bahn, Peter, Ph.D. and Heiner Gehring, 1997, pages 120-131,
 Der Vril-Mythos Eine geheimnisvolle Energieform in Esoterik,
 Technik und Therapie, Omega Verlag, Duesseldorf

2. Taeufer, Johannes, 1930, page 31,"Vril" Die Kosmische Urkraft
 Wiedergeburt von Atlantis, commissioned and
 distributed by the Reichsarbeitsgemeinschaft "Das kommendende
 Deutschland", Astrologischer Verlag Wilhelm Becker, Berlin-
 Steglitz

3. Bahn/Gehring, 1997, page 131

4. ibid, pages 120-124, 130

5. Weltdynamismus Streifzuege durch technisches Neuland an Hand
 von biologischen Symbolen,1930, pages 14-15, commissioned and
 distributed by the Reichsarbeitsgemeinschaft "Das kommendende
 Deutschland", Otto Wilhelm Barth Verlag, Berlin

6. Davson, Cyril W., 1955, pages 50-59, The Physics Of The
 Primary State Of Matter And Application Through the Primary
 Technique, Elverton Books, London

7. Nieper, Hans A., Ph.D., 1985, Conversion of Gravity Field
 Energy/Revolution in Technology, Medicine and Society, M.I.T.
 Management Interessengemeinschaft fuer Tachyonen-Geld-Energy
 GmbH, Friedrich-Rueder-Strasse 1, 2900 Oldenbuurg, Germany
 (available in German and English language versions)

7. Davson, Cyril W., 1955, pages 212-213

8. ibid, page 231

9. ibid, pages 217, 223

10. Taeufer, 1930, pages 30-32

11. Davson, 1955, page 230

12. ibid, page 226

13. Taeufer, 130, page 30

14. ibid, page 32

15. Davson, 1955, page 231

16. ibid, page 231

17. ibid, page 57

18. Taeufer, 1930, pages 38-40

19. Clark, Richard LeFors, Ph.D., 1987, page 64, "The Earth Grid, Human Levitation And Gravity Anomalies", contained in <u>Anti-Gravity And The World Grid</u> edited by David Hatcher Childress, Adventures Unlimited Press, Stelle, Illinois

20. ibid

21. ibid

22. Stevens, Henry, 2001, "Infinite Energy", pages 9-13, Volume 7, Issue 40

23. Davson, 1955, page 244

24. Bahn/Gehring, 1997, page 115

25. British Intelligence Objectives Sub-Committee Final Report Number 1043, item number 31, "The Invention Of Hans Coler, Relating To An Alleged New Source Of Power, Bryanston Square, London

<div align="center">Chapter Summary</div>

There is ample evidence that the Schauberger saucer model flew. The fact that the Schaubergers were brought to the United States to continue the work leads to the assessment that they worked on something of value to the government of the United States. The U.S. government was neither interested in his water research nor was it interested in his work on agriculture. We are left to conclude that it was his work on a new form of levitation, his saucer work, which brought Viktor Schauberger and his son Walter Schauberger to the United States. After learning all they could, the government of the United States dismissed the Schaubergers rather badly, foreshadowing the treatment of the German rocket scientists two decades later.

Lionel Shapiro was a credible and incredibly well connected reporter of the war and post-war years. The fact that he was able to break stories relating to secret weaponry in Czechoslovakia indicates that he had some connections within the U.S. military. With the war won, the years of 1946 and 1947 seem

to have been a period when the guard of censorship was relaxed. This noose would be re-tightened as the cold war got underway. No fault can be found with Mr. Shapiro's article or its content. The article on the KM-2 electromagnetic rocket and Mr. Shapiro's other stories appeared in a respect newspapers, not a tabloids. His post-war report of the KM-2 electromagnetic rocket must be taken on face value as legitimate.

The German eyewitness account of "Magnetscheibe" prompted investigation into U.S. governmental sources for corroboration. The CIOS report and the F.B.I. report provided corroboration. In the CIOS report we find a U.S. governmental admission of experiments in field propulsion for aircraft undertaken in wartime Germany by Dr. Erb. The F.B.I. report on a field propulsion German saucer must be taken seriously because the F.B.I took it seriously. The F.B.I. carefully took the report and investigated the veracity of their subject. The F.B.I. then sent copies of this report to other intelligence agencies within the U.S. government which is indicated on the F.B.I. report itself. The Bureau saved the report all these years. The fact that this report deals with German technology but was taken by a domestic law enforcement agency, one whose "spy" activities are geographically restricted to within the USA, is noteworthy. It may indicate that the F.B.I.'s Director, J. Edgar Hoover, was kept "in the dark" about the real nature of flying saucers and may have wanted to show the other intelligence agencies that he was not so easily cut out of the information loop.

If you do not believe this F.B.I. report does not constitute something special, ask yourself, if you had walked into an F.B.I. office and described a UFO sighting you had made over ten years previously, what do you suppose the Bureau's reaction would be? Would you be taken seriously? Would your background be investigated and would your story be the subject of such extensive treatment? Would your report be kept for forty years? Or, on the other hand, would you be politely shown the door by a condescending uniformed security officer. Something in this report really struck a nerve at the F.B.I.

There is some suggestion that the Germans worked on a chemical engine which produced levitation. There is a possibility that electricity was produced by the Germans directly from atomic energy. There is some evidence, from both German and English language sources, that the Karl Schappeller device was being developed within Germany during the period of time in question. There is evidence that both the Schauberger and the Schappeller devices can be explained in terms of implosion and that implosion may have yielded the levitation force behind field propulsion vehicles. There is ample evidence that the Germans had access to the ideas of Nikola Tesla. The work of Tesla may be seen as an alternative method of propulsion or as a method of moving a field propulsion vehicle after it was made weightless by another method. There are wartime pictures along with many very similar

193

post-war pictures which indicate that the development of field propulsion vehicles took place at this time.

Concerning these pictures and related reports of flying saucers one is thrust up against the intelligence services of the government of the United States of America who see fit to involve themselves. As we will see, it is the latter's rather clumsy attempt to suppress and discredit the flying saucer phenomena which actually speaks volumes for its existence.

The exact methods pertaining to the propulsion of these saucers may be plausible but they can only be taken as provisional at this time. There may be hundreds of ways to power a field propulsion saucer. The question is not "how could it have been done" but "how was it done".

The brilliant Austrian scientist Victor Schauberger.

Victor Schauberger's vortex saucer models. Left: Victor Schauberger with a model of a home generator.

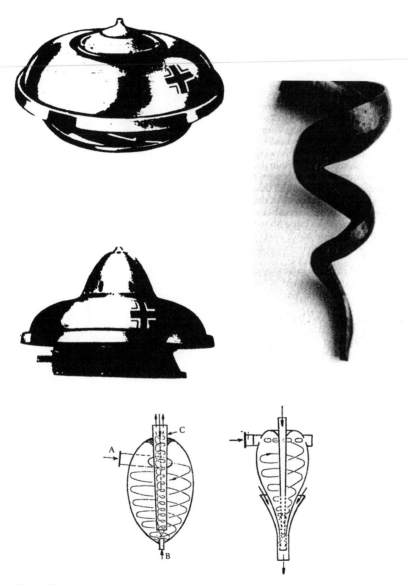

Above: Victor Schauberger's vortex saucer models, inspired by a kudu horn from Southern Africa. Below: Schauberger's two variations of an accelerator for nuclear fusion.

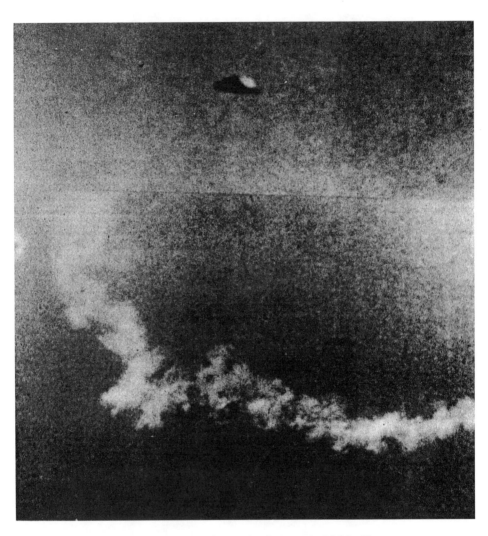

Above: One of a series of three photos taken by postman M. Muyldermans near Namur, Belgium, at about 7:30 PM on June 5, 1955. Project Blue Book showed little interest in these clear, daylight photos, despite the fame that they achieved.

Above: A cylindrical-appearing UFO photographed over Torrance, California in 1967. Possibly part of the southern California testing of US military modifications of German designs?

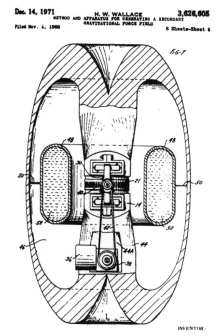

Above: A 1968 patent granted to H. W. Wallace for a "method and appartus for generating a secondary gravitational force field," exactly the kind of engine that the Germans were allegedly developing during WWII.

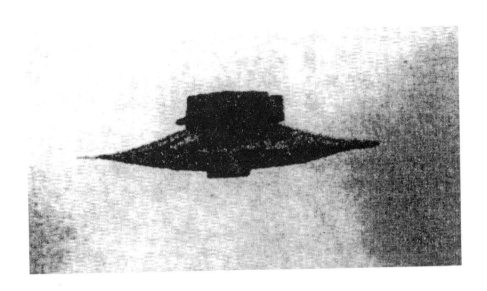

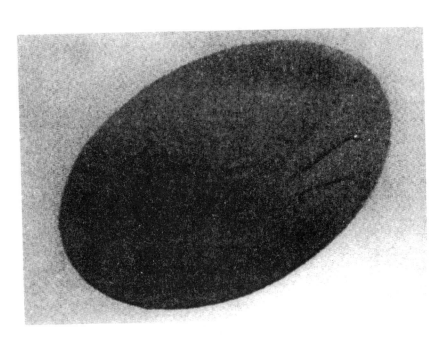

Above: Two photos of a "Vril-7" saucer in flight, according to Polish historian Igor Witkowski.

CHAPTER FIVE:

LORE AND LOOSE ENDS:
A DISCUSSION OF GERMAN SAUCERS

CHAPTER FIVE

Lore And Loose Ends: A Discussion Of German Saucers

Some of the historical context for German flying discs has been
discussed in the preliminary section of this presentation, "The
Situation Within Nazi Germany". German saucers were not designed
to generate the flying saucer mystery in the second half of the
Twentieth Century. They were designed as a weapons system to do
a specific job. The fast-moving wartime mind-set was a time when
new aircraft designs and new propulsion technologies were coming
on line with increasing frequency. The insertion of these
saucer-craft into the wartime fabric did not seem as culture
altering as the disclosure of these same craft might be to us
today. But a simple recitation of the facts is not enough. Some
things need to be said about the ideas on German saucers in order
to put their study in a better context. Also, some strings have
been left untied and some ideas need to be mentioned in order to
round out the discussion on this topic.

No better place to start exists than with Renato Vesco. Vesco's
insights for the reasons for German saucers were right on the
money as were his descriptions of cultural conditions within
wartime Germany with prompted this response. Vesco elucidated
the foo fighter mystery as nobody else did. But he went on to
describe another mystery craft which he called the "Kugleblitz"
or "ball lightning" in English (1). This craft is not the same
as the Schriever, Habermohl, Miethe or any other saucer design so
far disclosed. Indeed, Vesco seems to know nothing of these
other projects. His only descriptions were of the Feuerball (foo
fighter) and the Kugelblitz.

Vesco described Kugelblitz as the big brother of the Feuerball,
meaning that it was a further development of the Feuerball or foo
fighter. A central cupola or cabin was surrounded by a free-
spinning body or saucer which was turbine driven. Further
stabilization was probably provided by a small but rapidly
spinning centrally positioned flywheel, a gyroscope, set at
ninety degrees from the axis of the saucer. The Kugelblitz was
able to take-off vertically. Its method of destroying enemy
aircraft was probably that described by Vesco (2) and confirmed
in new U.S. government documents which included the description
of the "Phoo Bomb" (3) under item six, "Gases Applicable To

Aircraft". In this system the Kugelblitz approached an enemy bomber formation and ejected one of two types of gas ahead of that formation. The engines of the bombers inhaled the gas and were either destroy by pre-ignition or engine seizure caused by loss of motor oil viscosity. It is not know if one or both methods were used.

The Kugelblitz was guided to the bomber formation by a homing device whose name may have caused Vesco and later UFO researchers some confusion. This is because there existed a homing device whose name was "Kuglelblitz". This may have caused Vesco to assume the entire project bore its name. This device was manufactured by the Patent Verwertungs Gesellschaft of Salzburg and we know quite a bit about it through a Freedom Of Information Act response (4).

Curiously enough, and for a second time, the file comes to us from the Federal Bureau of Investigation, a domestic spy agency which theoretically had no business investigating foreign technology in foreign lands.

The Kugelblitz homing device was a proximity fuse which measured radio frequency waves bounced back from the target, reconciling the Doppler shift with measurement of standing waves to find the exact distance to the target. This homing device was the best of any produced by the Germans, according to the report, as was to be used on all varieties of flak rockets including the Schmettlerling and the Rheintochter. Examples were built at the Patent Verwertungs Gesellschaft plant but it never reached full assembly line production.

There are two interesting asides to this story. The first is that on May 1, 1945, one day after Hitler shot himself in the bunker and six days before Germany surrendered, two officers of the Reichsministerium fuer Rustungs und Kriegsproduktion (Albert Speer's ministry) arrived at the plant and took all existing examples of the Kugelbitz devices and the plans. Neither the two officers, the devices, nor the plans were ever seen again (5). Why was this done? Realistically, these officers must have had some post-war aspirations for this device. It must be added that at this point in the war, Speer's ministry, the Reichs Ministry for Armament and War Production referred to above was in fact being administered and run by the SS.

The second aside is another device in the conceptual stages at the Patent Verwertungs Gesellschaft called "Phantoscope". Phantoscope was to employ high frequency waves beamed to the ground then reflected and picked up on board a moving aircraft to image, in three dimensions, the contours of the earth's surface using a glass case filled with gas and tiny vertical wires. This could be done in any weather, day or night (6). One wonders if the German officers plucked this jewel also? If so, was this to be used on a manned saucer?

204

Vesco says the Kugelblitz saucer was flown once against enemy aircraft (7). It was destroyed by technical detachments of the SS after "a single lucky wartime mission" (8) in late March or April of 1945 (9).

Another mystery is the post-war activities of Dr. Richard Miethe. Most all sources state that Dr. Miethe went to Canada after the war and worked on a joint Canadian-American saucer project at an aircraft facility near Toronto, Ontario. Unfortunately, all Freedom Of Information Act inquiries concerning Dr. Miethe run into the solid wall of "no record". Only one researcher ever claimed to have a document naming Dr. Miethe in association with this Avro Aircraft, Limited project, (also known as A.V. Roe, Limited), and that one researcher later admitted to being "a government asset" which throws a cloud of doubt on all his work (10).

There is no doubt, however, that by early 1955, work was commenced by Avro to build a mach 3 flying saucer which is reminiscent of some of the designs attributed to Dr. Miethe. Two designs were proposed, the difference being the engine used to power the saucer. One proposal was to use several axial-flow jet engines. The second and preferred proposal was to use one large radial-flow jet engine. The axial type is the type most commonly used in jet aircraft today. The radial type was similar to the first jet engine flown by the Germans in 1937. In fact, the radial engine actually under study in Canada may have had some similarities with the Rene Leduc engine used by Dr. Miethe.

Work continued until the early 1960s under various names including Project Silver Bug and Project 1794. Finally, a small hover-craft was unveiled by Avro as the final outcome of their saucer experimentation. This "Avrocar" had nothing to do with either Dr. Miethe's work or a mach three interceptor. The Avrocar was probably a cover project for something else. This "something else" was more advanced.

The Avro Aircraft, Limited experimentation with saucer-craft was always an open secret which was at times exploited by the government. Information regarding this project has been obtained via Freedom Of Information Act using their American partner, the United States Air Force at Wright-Patterson Air Force Base, by this researcher as well as other researchers.

There exists a sub-story to the Canadian involvement which should be mentioned. In an article in a British UFO magazine, writer Palmiro Campagna revealed a previously unknown connection between the Canadian government and the history of German saucers (11). It seems that an SS technical liaison officer, Count Rudolf von Meerscheidt-Huellessem, (erroneously spelled "Hullessem" in the article), contacted the Canadian government in March of 1952, offering technical information about a German saucer which could attain speeds "limited only by the strength of the metals used in the saucer's construction". According to the article, von

Avro Flying Saucer

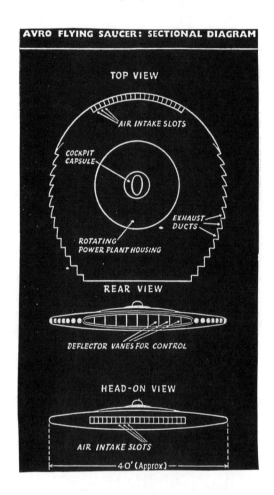

AVRO FLYING SAUCER: SECTIONAL DIAGRAM

TOP VIEW

AIR INTAKE SLOTS

COCKPIT
CAPSULE

EXHAUST
DUCTS

ROTATING
POWER PLANT HOUSING

REAR VIEW

DEFLECTOR VANES FOR CONTROL

HEAD-ON VIEW

AIR INTAKE SLOTS

4-0' (Approx)

This is a general diagram of the exterior of an Avro
saucer. It is representative of how the Avro radial engine
saucers worked. Within this outer hull an inner, flat
radial-type engine of was situated. This is exactly the
scheme designed by Dr. Richard Miethe it and has been
copied from his designs. Dr. Frost and his engine designs
were overblown, heavy, complicated frauds.

Meerscheidt-Huellessem wanted a large sum of money as down payment, a monthly salary and Canadian citizenship and police protection in exchange. Support for this claim comes in the form of copies of Canadian government documents describing this offer. Mr. Campagna states in the article that the Canadian government ultimately declined the offer but that the American government may have taken over negotiations and accepted.

Contact was made by this researcher with a daughter of Count Rudolf von Meerscheidt-Huellessem's who verified that her father was a technical liaison officer. She had little contact with her father since she was two years old since he had remarried and moved to Canada. She was able, however, to provide the address of another relative, Countess von Huellessem, who was Count Rudolf von Meerscheidt-Huellessem's widow.

Contact was made with Countess von Huellessem. Count von Meerscheidt-Huellessem died in 1988. But the Countess did know a little something about the story in question. Her late husband did discuss the flying saucer with her but only once. He told her that the "drawings" had been given to a representative of the Canadian government in 1952. After review of the drawings, the only comment from the representative was that they were "outdated". The drawings were never returned. The Canadians had succeeded in obtaining hard information concerning a real flying saucer and in paying for it with an insult. Count von Meerscheidt-Huellessem was somewhat despondent over the rejection. He never mentioned the subject to his wife again. At the time they were both making new lives for themselves in Canada and the subject never resurfaced.

In discussing these events with the Countess over the telephone, she told me that she herself had seen these drawings. She was asked if these were drawings or technical plans. She said they were technical drawings on rolls of paper. I said the word "blueprint" and she said "yes". She stated again that these drawings were given only to the Canadians and not to the Americans.

Countess von Huellessem was sent a copy of the aforementioned article. Her only comment was that her husband would not have asked for a large sum of money in exchange for this information. They already had means. He might have asked for a position, she said, since her husband would have enjoyed working on this project.

Returning to the Avro Aircraft, Limited - U. S. Air Force saucer project, we have to ask ourselves some questions. First, was this information, these plans, the real basis of the Avro saucer project? This would certainly explain the reason for the partnership between the two governments involved since the Americans would have needed the Canadians at that point and the Canadians would have insisted upon control of the project on their home soil. Second, did the technology brought to the

Canadians by von Meerscheidt-Huellessem have anything to do with the jet technology obtained the under Freedom Of Information Act? It certainly had nothing to do with a hover-craft which was the outcome of this project according to the government. How could a floppy hover-craft barely capable of 300 miles per hour under the best of estimates have had anything to do with a saucer whose speed was "only limited by the strength of metals used in the saucer's construction"? Could Project Silver Bug, Project 1794, and some of the other patents of John Frost attributed to this collaboration all be nothing more than an elaborate cover story?

Another point is that until recently, the only connection linking the German saucer projects to the Avro Project and to the Americans was the involvement of Dr. Richard Miethe. With the new evidence of the Peenemuende Project's connection to the American saucer projects run out of Wright Field, Ohio and the Count von Meerscheidt-Huellessem connections to the Canadians, the weak linkage of Dr. Miethe to these projects is superfluous. There is now more than enough evidence to make these connections with or without Dr. Miethe. Further, considering the Count von Meerscheidt-Huellessem evidence, there is now a direct link between German saucer technology and the Canadian government's saucer project at A.V., Roe Limited. That link turns out to be the SS in the form of an SS technical liaison officer.

There are differing opinions as to how known saucer-types were actually powered. Every researcher seems to have his own ideas about this subject. Could the answer to this dilemma be that there are more types of German saucers than we know about? For instance a device is depicted in a 1975 issue of Luftfahrt International, a well respected German aeronautical magazine, which shows a drawing of a "Flakmine" (12). Depicted are several rotor blades, some powered by ram-jets, making it essentially a jet-powered helicopter. This device may have been derived from design work done in Italy in which the propellant and the explosive were the same substance. This device was called the "Turboproietto" meaning in English, "turbine projectile" (13). It would have been able to carry large quantities of explosive to the altitude of a bomber formation. The device would have rotored up, vertically, to the level of a formation of bombers and then detonated, using the remaining fuel as a bomb, presumably inflicting heavy losses. Klaus-Peter Rothkugel refers to this very device as a "Drehfluegel" and will detail its development in his upcoming book.

In another instance of a possible saucer type, saucers shown to Bill Lyne in a movie clip while he was in Air Force Intelligence were described by him as "flying turtles" (14). This film was taken by B-17 flight personnel during World War Two as the two German saucers attacked a squadron of bombers. Other writers including Michael X. Barton and Norbert Juergen-Ratthofer used these same descriptive words. Vesco describes the "Feuerball", the foo fighter, as "circular and armored, more or less resembling the shell of a tortoise". This description also

applies to his Kugelblitz (15). Turtle or tortoise is "Schildkroete" in German. Sometimes this device is referred to as a "flying turtle" in both languages. With so many writers using this term for flying craft which are apparently not all similar, there exists a certain amount of confusion about this name, "Schildkroete". Therefore, this saucer does not seem to fit neatly into any previously described saucer type. Perhaps this flying turtle is only another name for the Fireball or foofighter which seems to be the consensus among German writers. Other writers seem to associate this word with a larger craft so perhaps this type of saucer is closer to what Vesco described as the Kugelblitz. "Schildkroete" seemed so nebulous that for many years this writer refused to accept the term at all.

This all changed when it was uncovered that the Germans were actually developing a flying weapon code-named Schildkroete. This researcher as well as another researchers have found references to an offensive air weapon, called by the Germans, "Schildkroete", and known to American intelligence. The exact nature of this device is, however, still kept secret. The government is uncooperative, even when presented with their own words on the subject and copies of their own reports. For instance in a Combined Intelligence Objectives Sub-Committee interrogation of Albert Speer, Reichminister of Armaments And War Production, report 53(b), Speer is specifically asked about "Schildkroete". Only Speer's reply is retained in the record, not the actual question. Line number 20 of that interrogation quoted here as the document from microfilm is difficult to read:

" 20. Schildkroete he was not sure about, but he thought is
 might, conceivably be a jet fighter. "

By the time Schildkroete had come about, Speer had lost much of his standing and duties to officials of the SS. In this same set of interrogations Speer deferred a question concerning V-weapons to Dr. Hans Kammler as the one the Allies should seek as the expert. Speer was the only one raising Kammler's name. There was no follow-up questioning by the Allied interrogators. It was almost as if Speer had uttered an obscenity, invoking the "K" word, which was a word simply too hot to be touched in that setting.

The next Allied reference to Schildkroete comes from the Combined Intelligence Objectives Sub-Committee, Evaluation Report 40, titled "Sonderausschus A-4". Sonderausschus was an organization whose job it was to prioritize resources toward projects most needed to defend the Reich. These high priority programs were the Vierjahresplan, Vulkanprogramm, Jaegerprogramm, Lokprogramm, and the Notprogramm. Each had projects within these headings. Even though under pressure of law in the form of a request under the auspices of the Freedom Of Information Act, the Federal Government of the United States of America has responded with a "No Record" when asked for their files on some of these programs. This is true even when confronted with their own documents naming

209

U.S. Government Documents Mentioning "Schildkroete"

<u>Production and Layout</u>

The Mittelwerk and Nordwerk tunnel system had been in reasonab.
full production up to the cessation of hostilities, the main
production being:-

> V1 and V2 components and assembly
> Taifun - flak rocket components
> Schildhrote - flak rocket components
> Junkers Engines - Jumo 004 components and assembly
> Jumo 213 components and assembly

SECRET KO-13489

5. Arbeitsausschuss Kontingents under Dir. Russo was charged
with cooperating with the various plants throughout Germany to
insure that required raw materials were received at the proper
times and places. Interrogation of Russo revealed that he had
been instrumental in and/or had certain knowledge regarding
the following programs:

Name or Designation -	Remarks
Vierjahresplan	4 years plan
Vulkanprogramm	
Jägerprogramm	
Lokprogramm	
Notprogramm	Necessity program
8-103	V-1. Also known under code name "Kirschkern" or "cherry pit" and as "Vu I". Sometimes known also as "Libelle". Was manufactured or was to be manufactured by Henschel, Schönefeld/Berlin. Final assembly in Mittelwerke at Neidersachsverfen.
8-117	Also known as Hs. 117 and "Schmetterlin" or "Butterfly".
8-152	
8-162	Also known as "Schildkröte" and "Salamander". Manufactured by Heinkel in Rostock, Junkers in Dessau; motors from Mittelwerke in Neidersachsverfen, Bayrische Motorenwerke in Eisenach; Berlin-Spandau and Zuhlsdorf-Wandlitz/Mark, Klöckner in Brünn and Walter-Motoren in Prag.
8-246	

19. Mistel, he had explained yesterday as being pick-a-back aircraft.

20. Schildkröte he was not sure about, but he thought it might conceivably
be a jet fighter.

21. Taiphun and Eber he had not heard of.

Top: Combined Intelligence Objectives Subcommittee (CIOS)
Report items 21, 22, 31, File# XXXlll-38 Underground
Factories In Germany, page 19. Middle: CIOS Report 40,
Sonderausschus A-4, page 5. Bottom: CIOS Report 59(b)
Interrogation Of Albert Speer Reich Minister Of Armaments
And War, Page 3

these programs. One project, project 8-162, clearly names Schildkroete as the code-name of this project. It is listed in association with a known project, the "Salamander" project, which resulted in the He 162A Salamander or Volksjaeger jet fighter.

The last reference to Schildkroete was found by Heiner Gehring in the Combined Intelligence Objectives Sub-Committee Party 536 report on Underground Factories in Germany. This was classified as "Secret" and was a G-2 Division, S.H.A.E.F. report! In describing the large underground facility at Nordhausen, where the bulk of the V-2 production took place, tunnel divisions Mittelwerk and Nordwerk were said in this secret report to be producing "Schildhroete - flak rocket components". Although spelled incorrectly in the report, the intended word is very apparent.

Clearly something is going on under the heading Schildkroete. A possibly is the connection of Schildkroete to the Italian "Turboproietti" mentioned by Vesco. In an information sheet, Klaus-Peter Rothkugel depicts a diagram for the Turboproietti. This design is remarkably similar that found in Swiss newspaper from the mid-1950s (16). This article credits the successful German saucer program and Georg Klein and goes on to describe another related design which is reproduced here. One can immediately see the relationship with the Turboproietti design. In this design the center of gravity is below the saucer surface adding stability. The pilot's cabin is also below the wing surface. This is curiously similar to a turtle's bony structure in which the head and neck emerge from under the turtle's shell. Could this have been the Schildkroete design?

This design calls for the use of ram-jets but turbojets could have also been used. Fuel tanks are located in the rotating wing and so fuel is fed to the jet engines by centrifugal force. The two small wings have adjustable angles as do the jet engines themselves. Thus, the method of vertical flight is similar to the Schriever-Habermohl saucers.

The horizontal maneuvering is unique and warrants discussion. We have all heard reports of flying saucers in flight making seemingly non-aerodynamic turns instantaneously. In this article, Mr. Zollikofer proposes a simple method to accomplish this. It involves angular momentum. We all remember seeing a child's top spinning on a smooth floor. Perhaps the reader will recall that when the top nears a piece of furniture and hits it, the top shoots off instantly in the opposite direction. This happens because contact with the furniture caused a change in the top's angular momentum. The top's momentum was braked on one side. A sudden slow down on one side caused an imbalance whose force drove the top to the opposite direction.

In this same way the intentional slowing of one engine (on one side) on this saucer design would cause the rapidly spinning saucer to instantaneously change course, shooting to the other

"Turbopriette" And A Possible Successor

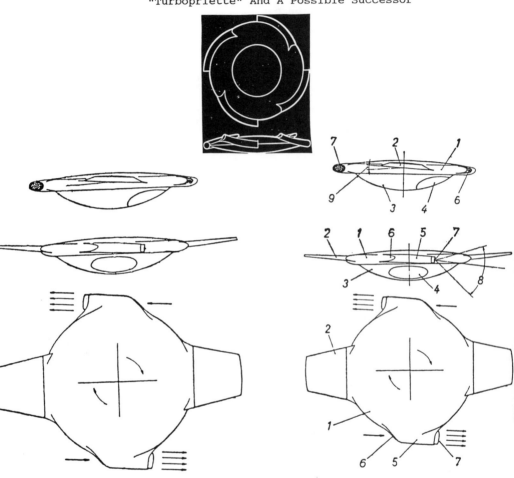

Top: Italian designed "Turboproietti" an anti-aircraft design which used left-over fuel as its warhead. Bottom: Saucer design, 2/3/55, "Neue Zuercher Zeitung". 1. Hub of the rotating winged-wheel. 2. Adjustable wings 3. Non-rotating cabin. 4. Lookout for the pilots. 5. Ram-jets 6. Air intake. 7. Exhaust, direction changeable. 8. Angle of variation of the exhaust rudder. 9. Variable adjustment angle of the wings. Was this a Schildkroete? Kugelblitz?

side. Several of these course changes would resemble insect-like flight to the observer. The rapidity of the course changes is tied to the degree of slow-down or breaking of the saucer's angular momentum and to the degree (revolutions per minute) of that momentum. Even when stationary, increased spinning would serve as a "bank" of angular momentum to be drawn upon at a moment's notice.

Through out Vecso's _Intercept UFO_ the words "circular wing" are mentioned. Looking at this design yields a possible new understanding to that term. It is possible that this basic design is to be found in the foo fighter, (Feuerball, Phoo Bomb), as well as the mysterious Kugelblitz. It was hinted above that this design may be the basis of the Schildkroete but it could also be the basis for other German saucer projects.

Many writer attribute field propulsion to the foo fighter. This is because of its luminosity, its flight pattern and its alleged disruption of ignition based aircraft engines. Another possibility is that it was a jet propelled flying machine but with one addition. It is possible that a T.T. Brown-type of flame-jet generator was attached to its exhaust nozzles and the appropriate insulation added on the surface of the craft. With this addition, the exhaust gasses would become enriched with negative ions. So would the air in the surrounding vicinity. This would have resulted in the short-circuiting of the target aircraft's engines should such variables as the wind have been just right. The fact that it apparently did not always work argues for the variables being in operation. More variables would have accompanied this means of disruption than a purely electromagnetic one since the electromagnetic field would have been present regardless of atmospheric conditions. It other words, the field propulsion vehicle should have always disrupted the bomber's engines.

Another item is submitted for your consideration under the heading of "loose ends". This is another F.B.I. report, Number 62-0-11328, which is reproduced here in total. A unique feature of this report is that it contains two "xerox" copies of a German saucer. These pictures were given to the F.B.I. but the negatives were retained by the informant whose name has been deleted. Also deleted is the last name of the German saucer designer. It is a remotely controlled device but the circular glass cockpit indicates a design ultimately intended for human pilots. Undulations on the saucer periphery resembling jet engines are noticeable in the picture. This report dates from July 8, 1967 but describes events from November, 1944. As with the other F.B.I. report, the fact that it was taken and kept so long attests to its worth.

There are some similarities between this report and Vesco's description of the Kugelblitz. The encounter described in the F.B.I. report resulting in the "downing" of a B-26. Vesco describes the same or a similar incident involving the Kugelblitz

213

A Second F.B.I. Report on German Flying Discs
(Three pages and best possible picture)

Memorandum

TO : DIRECTOR, FBI

DATE: 6/8/67

FROM : SAC, MIAMI (62-0-11328)

SUBJECT: ▓▓▓▓▓▓▓▓▓

INFORMATION CONCERNING

A review of the Miami indices revealed information reflecting subject appeared at the Miami Office on July 24, 1959, and volunteered to return to Austria as an intelligence agent. His expressed motivation was to do something to repay the debt he felt he owed the United States. He was afforded the Washington, D. C. Headquarters address of the Central Intelligence Agency and told his inquiry should be directed here.

Also, on July 4, 1961, he appeared at the Miami Office and gave an incoherent story of recently meeting an individual who asked him to kill his mother. ▓▓▓▓▓ appeared to be somewhat bewildered and continuously gazed away from the interviewing Agent.

During his most recent visit to the Miami Office, ▓▓▓▓▓ seemed genuinely concerned about the existence of the object he allegedly photographed during November, 1944. He exhibited no emotional nor mental disorder and appeared to be rational.

In view of recent publicity afforded UFO sightings, some apparently by responsible sources, this information is submitted to the Bureau for consideration of transmittal to the U. S. Air Force.

Bureau (Bnc. 4)
1 - Miami
LB/bab
(3)

UNITED STATES DEPARTMENT OF JUSTICE

FEDERAL BUREAU OF INVESTIGATION

In Reply, Please Refer to
File No. 62-0-11328

Miami, Florida
June 8, 1967

RE: ▮▮▮▮▮▮▮▮▮▮▮

INFORMATION CONCERNING

Read copy 3,234 of 1st ed.

On April 26, 1967, ▮▮▮▮▮▮▮▮▮▮▮▮▮▮▮▮▮
▮▮▮▮▮▮▮ Miami, Florida, appeared at the Miami Office and
furnished the following information relating to an object,
presently referred to as an unidentified flying object, he
allegedly photographed during November, 1944:

Sometime during 1943, he graduated from the
German Air Academy and was assigned as a member of the
Luftwaffe on the Russian Front. Near the end of 1944, he
was released from this duty and was assigned as a test
pilot to a top secret project in the Black Forest of Austria.
During this period he observed the aircraft described above.
It was saucer shaped, about twenty-one feet in diameter,
radio controlled, and mounted several jet engines around the
exterior portion of the craft. He further described the
exterior portion as revolving around the dome in the center
which remained stationary. It was ▮▮▮▮▮▮ responsibility
to photograph the object while in flight. He asserted he
was able to retain a negative of a photograph he made at 7,000
meters (20,000 feet). A Xerox copy of the negative, as furnished
by ▮▮▮▮▮, appears on the last page of this communication.
Also, a still photograph he allegedly made "at the risk of my
life", illustrating the object parked in a hanger, appears on
the last page.

According to ▮▮▮▮▮ the above aircraft was designed
and engineered by (First Name Unknown) ▮▮▮▮, a German engineer
whose present whereabouts is unknown to him. He assumed ▮▮▮▮▮
was taken into custody by Allied Forces upon the termination
of hostilities. ▮▮▮▮▮ stated ▮▮▮▮ unsuccessfully attempted
to avoid the German draft, but was apprehended by the Gestapo

RE: ███████████

INFORMATION CONCERNING

in Vienna, Austria, sometime during late 1943 or early 1944.
████████ also assumed the secrets pertaining to this aircraft
were captured by Allied Forces. He said this type of aircraft
was responsible for the downing of at least one American B-26
airplane. He furnished the following fuel and engine data:

"....Fuel mixture of N_2H_4O in Methyl Alcohol
(CH_3OH) rather than 'oxygen-holding' mixture of
hydrogen peroxide H_2O_2 in water. 7m 1,3m high two
rocket motors; smooth flow, rotary drive over 2,000
meters per second...."

████████ said he copied this data from a board
located in the hanger area.

████████ asserted he was shot down by the British
on March 14, 1945, after having been reassigned to the
Western Front. He was held prisoner by the British in
London and later in Brussels until his release in 1946.
He departed for the United States from Bremerhaven, Germany,
on December 26, 1951; entering the United States in New
Jersey on January 7, 1952, and was subsequently naturalized
in Miami during 1958. He is presently employed as a
mechanic at Eastern Airlines, Miami, Florida. He related
he was born May 3, 1924, in Austria.

████████ stated he has withheld this information
because he assumed the United States possessed it. He has
become increasingly concerned because of the unconfirmed
reports concerning a similar object and denials the United
States has such an aircraft. He feels such a weapon would
be beneficial in Vietnam and would prevent the further loss
of American lives which was his paramount purpose in contacting
the Federal Bureau of Investigation (FBI).

████████ reiterated he has the original negatives
of both photographs. He said the shots were taken at a thirty
second time exposure.

This document contains neither recommendations nor
conclusions of the FBI. It is the property of the FBI and is
loaned to your agency; it and its contents are not to be
distributed outside your agency.

2

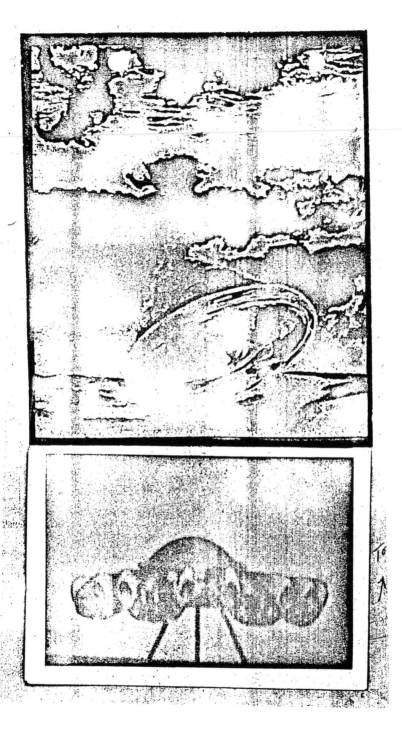

and an American "Liberator" (17). Both saucers are surprisingly identical in description. In the F.B.I. report this secret project was set in the "Black Forest of Austria". The Schwarzwald, the Black Forest, is in Southern Germany. Vesco says that toward the end of the war the Germans dispersed their remaining aircraft to improved air field hidden in thick pine forests (18).

Vesco specifically mentions the Schwaebischerwald and the Bubesheimerwald (19). Vesco goes on to say:

"It was from one of these improved fields that the first Kugelblitz fighter took off on its fantastic flight" (20).

The general description of the airfield hidden in a forest does seem to correspond with what Vesco described. Finally, the fuel used on this saucer was unlike that of the Me-163 or any other fuel known. Is this a variant of the exotic fuels Vesco says were considered for German saucers? (21).

Is this report confirmation of Vesco? Is the informant in the F.B.I. report describing a Kugelblitz? Is this fuzzy "xerox" copy really a picture of the Kugelblitz? It is not proof positive, but it is intriguing.

A request was made to the F.B.I. for a clear picture. The Bureau responded on March 22, 2001 saying that the Miami Field Office may have had a clearer picture but that the file was destroyed.

Here we have a real X-File, yet nobody saved the picture? Fox Mulder, where are you when we need you most? The F.B.I. did provide a somewhat clearer picture which is reproduced here.

Sometimes blind luck in needed when dealing with the government. This has proven to be the case regarding a very special compass developed by the Germans to use in their flying disc program. Actually, there may have been more than one type of compass for this purpose. The first inkling of this compass comes to us from the writings of Wilhelm Landig wherein he describes a "Himmelskompass" or heavenly compass (22). This device was mounted upon a flying disc and could orient itself using the position of the sun even in twilight or if the sun was below the horizon. The method given for its operation is that sunlight striking the earth is polarized and that this direction has a stronger electromagnetic field which can be detected with instruments (ibid). The magnetic fields emanating from the north and south poles are a similar situation.

William Lyne discloses, pictures and describes a German compass which he states was used on. a German flying disc in his book Pentagon Aliens, the first edition which circa 1990. He bought the device as junk from a New Mexican junk dealer who got it on an Air Force base after it had apparently slipped though a security check.

(e) Artificial horizon

A self regulating artificial horizon for use in aircraft was invented by Dr. Knappstein, who had a factory in Berlin-Schoneberg. He worked in collaboration with Henschel, Berlin-Konigswusterhausen. The horizon was not affected by any aerobatic manoeuvres.

PAGE NO. 2

NO.	TO	FROM	DATE	
				1174 - RESTRICTED - 9 June 1945
				Subject: "Mother Horizon"

Request received from Technical Data for one (1) "Mother Horizon", as the Germans called it. It's a remote indicating gyro horizon device. Equipment Lab seems to be the interested agency.

W. J. Putt

D. L. PUTT,
Colonel, A.C.
Director of Technical Services.

"Mother Horizon" was possibly a device used on a German flying disc. Top: "Information Obtain From Targets Of Opportunity In The Sonthofen Area" BIOS Report # 142. Bottom: Entry in microfilm obtained via FOIA.

Recently, mention of a German compass was encountered while searching for something else in a Freedom Of Information Act response. Called a "Mother Horizon", the device recalls and may confirm the device first described by Landig. On the other hand, it may simply be a device showing the pilot the attitude of the aircraft in relation to that of the horizon. Whether or not this is the same device in the possession of William Lyne is not known at this time.

Turning to field propulsion saucers and pictures of them, it should be pointed out that the saucer pictures of Ralf Ettl and Norbert Juergen-Ratthofer are unique to them, that is, no pictures of saucers specifically identified as "Haunebu", "Vril" exist outside of their presentation to my knowledge. As if preempting criticism, these writers counter with the proposal that all Adamski saucers are really German field propulsion saucers or originated from German wartime designs. Adamski saucers were photographed and witnessed world-wide in the early 1950s. In fairness, it should be pointed out that there also exists at least one source of confirmation of their thesis.

Confirmation of sorts comes from a new book by a conspiracy writer, George Piccard, who cites similar information to that of Ettl and Juergen-Ratthofer as coming from his informant, a man calling himself "Kilder" (24). Piccard states that he believed the name "Kilder" to be an alias. Kilder was a clerk working in British intelligence and allegedly came to Piccard through a mutual contact shortly before Kilder died of lung cancer. During his years of service, Kilder had allegedly filed away many classified documents which he committed to memory. This book is interesting reading, of that there is no doubt. It is too bad, though, that Piccard could not elicit the real name of the dying Kilder, because, as has already been pointed out, there is nothing reliable about an unnamed, secret government source and, hence, there is no reason to spill much ink in discussing the matter.

More evidence that the Germans produced something truly strange comes from the Polish researcher Igor Witkowski. Mr. Witkowski is considered by the Eastern European sources already cited, the engineer Mr. Robert Leiakiewicz and Dr. Milos Jesensky, to be the foremost authority on German saucers in Poland. This is no small title considering the mountains of research through which they have tunneled, both figuratively and in reality. According to his interviewer, Nick Cook, the Aviation Editor of "Janes Defense Weekly", Mr. Witkowski was shown classified Russian documents through an unnamed contact. In them it described German research on a device called "die Glocke" (the bell). This device was tested underground, at Der Riese, at the Wenceslas mine near Ludwigsdorf(25) under the German code-names of "Laternentraeger" ("lantern carrier") and "Chronos" which obviously refers to time. This was done under the auspices of a heretofore unknown SS organization, the Forschungen, Entwicklungen and Patente (Research, Development and Patents) or FEP. This was Kammler's

220

group according to Mr. Witkowski (26). Could this be the true name of what has been referred to up until now simply as the "Kammler Group"? Mr. Witkowski maintains that this group was independent of the Reichsforschungsrat, the Reich Research Council, which is significant. Heading the research on the Bell was none other than Professor Walther Gerlach (27) who was among the very top tier of German nuclear scientists. A metallic liquid, violet in color and resembling mercury, was stored within the bell in two cylinders. These cylinders were spun in opposite directions for test lasting for a minute. The effects included.a pale blue light emitted from the bell, electrical equipment failures, as well as deleterious effects on animals and people (28). To his credit, Mr. Witkowski did not try make more out of this than is in evidence. He is of the opinion, however, that the bell was a very powerful engine (29). Of course, we all can jump ahead of the facts slightly and wonder if this engine was not to be used on a very large German atomic saucer or field propulsion saucer, the very kind described by Mr. Norbert Juergen-Ratthofer.

Weighing into the German field propulsion controversy is Dr. Axel Stoll. Dr. Stoll is a Geophysicist, that is, a real scientist. Dr. Stoll names no sources in his book but states that they exist and must be protected for the common need as opposed to that of serving an individual purpose as a citation (25). Dr. Stoll supports the assertion that field propulsion vehicles were being developed during the Third Reich. But unlike what has transpired before, Dr. Stoll gives us the theory and the mathematics behind the theory, citing and translating Maxwell and Bearden. Besides the mathematical support for his thesis that the Germans built field propulsion vehicles, he states something about his suspicion concerning a spin-off of this technology which may have been further developed by the Germans (26). It is what was stated by Mr. Juergen-Ratthofer over ten years ago in his video films. It is what was indicated by circumstantial evidence at Jonastal and recognized as such for at least five years by some of the researchers there. It is that the Germans were interested in the manipulation space and time itself. It is said that time and space can be manipulated or time and space can be created or obliterated through the use of am electromagnetic longitudinal wave (32). Normal electromagnetic waves, such as light waves, are transverse. This brings us right back to the production of quadropolar waves (transverse and longitudinal waves in cycle) as discussed in connection with the Schappeller device. Could this lost technology provide us with a window into time or into another dimension? Would our scientists of today be able to unlock this technology given their restricted scientific outlook? Has the reconstruction and piecing together of this puzzle occupied our scientists since the end of the Second World War?

Turning aside for a moment, as stated, this book was written as a guide to German flying discs. As such, the reader should be cautioned about at least one pitfall. This pitfall consists of a series of technical diagrams of alleged German field propulsion

221

saucers, prominently displaying a date of November, 1944. In some of these drawings mention is made of a "Thule-Tachyonator". This word "Tachyonator" obviously has its origins in the word tachyon. This word bothered me for years but I loved those "old" drawings so much that my nagging doubts were put aside. What bothered me was the fact that this word never arose in my introductory physics course in the 1960s. This ate at me until I called the Physics Department at the University of California at Los Angeles for their opinion as to the origin of this word. An old physicist said from his memory the word was not even coined until the mid-1960s, thus casting doubt on the technical drawings. He gave me a reference and his memory proved correct. The word "tachyon" was coined by Dr. Gerald Feinberg in 1966 (33). This means that there was no word "Tachyonator" in 1944. Unless better evidence surfaces, the veracity of these documents must be questioned. It hurts to admit that I count myself as one of the people taken in by this deception.

CHAPTER FIVE

Lore And Loose Ends: A Discussion of German Saucers Sources

Sources and References

1. Vesco, Renato, 1976, page 158

2. Vesco, Renato, 1976, pages 137, 156-157

3. United states Strategic Air Forces In Europe, Office Of The Director Of Intelligence, 1944, "An Evaluation Of German Capabilities In 1945"

4. Federal Bureau of Investigation, United States Department of Justice File Number 65-57183, "Patent Verwertungs Gesellschaft Espionage", American Embassy, London

5. Hogg, I. V., 1970, page 48, German Secret Weapons Of World War 2, Arco Publishing Company, Inc., New York

6. Federal Bureau of Investigation, United States Department of Justice, File Number 65-57193, "Patent Verwertungs Gesellschaft Espionage", American Embassy, London

7. Vesco, Renato, 1976, pages 156-157

8. Vesco, Renato, 1976, pages 134-135

9. ibid

10. Moore, W. L., date unknown, page number not specified in publication, " #4510 Research File Project "y" and the 'Avro' Flying Disc", W. L. Moore Publications, Burbank, California

11. Campagna, Palmiro, 2000, pages 74 and 75, "Nazi UFO? Released documents increase speculation that Nazis did research disc technology", Article from UFO Magazine, United Kingdom

12. Luftfahrt International, 1975, page 1366, "Deutsche Flugkreisel Gab's die?

13. Vesco, Renato, 1976, page 145

14. Lyne, William R., 1999, pages 206-207, Space Aliens, Creatopia Productions, Lamy, New Mexico

15. Vesco, Renato, 1976, page 157

16. Zollikofer, Otto, February 3, 1955,"Die Fliegenden Teller Ein Deutungsversuch", an article appearing in the Neue Zuercher Zeitung

17. Vesco, Renato, 1976, page 134

18. Vesco, Renato, 1976, page 158

19. ibid

20. ibid

21. Vesco, Renato, 1976, page 145

22. Landig, Wilhelm, 1971, page 27, Goetzen Gegen Thule, Volksturm Wilhelm Landig, Vienna, Austria

23. ibid

24. Piccard, George, 1999, Liquid Conspiracy JFK, LSD, The CIA, Area 51, And UFOs, Adventures Unlimited Press, Kempton, Illinois

25. Cook, Nick, 2001, page 188, The Hunt For Zero Point One Man's Journey To Discover The Biggest Secret Since The Invention Of The Atom Bomb, The Random House Group Limited, 20 Vauxhall Bridge Road, London, SW1V 2SA

26. Cook, Nick, 2001, page 195

27. Cook, Nick, 2001, page 194

28. Cook, Nick, 2001, page 192

29. Cook, Nick, 2001, page 198

30. Stoll, Axel Ph.D., 2001, page 12, Hochtechnologie Im Dritten Reich Reichsdeutsche Entwicklungen und die vermutlich wahre Herkunft der "UFOs", Amun-Verlag, Schleusesiedlung 2, D-98553

31. Stoll, Axe., Ph.D., 2001, pages 106 and 107.

32. ibid

33. Feinberg, Gerald, 1977, <u>What Is The World Made Of?</u>, Anchor Press/Doubleday, Garden City, New York

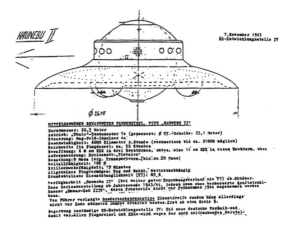

Alleged photocopy of SS plans for a Haunebu II being designed in 1943. From the German book *Die Dunkle Seite Des Mondes (The Dark Side of the Moon)* by Brad Harris (1996, Pandora Books, Germany).

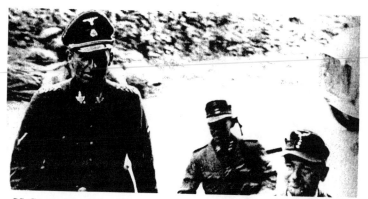

SS-Grupenfuhrer Hans Kammler circa 1944. He was alledgedly in charge of the Polish saucer bases.

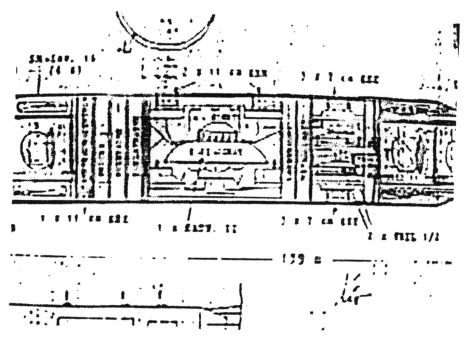

Internal plans for a "mothership" craft called "Andromeda," according to Polish historian Igor Witkowski.

One of the books on "Hitler's Super Weapons" by Polish military historian Igor Witkowski.

German plans for an underground saucer base, according to Polish historian Igor Witkowski.

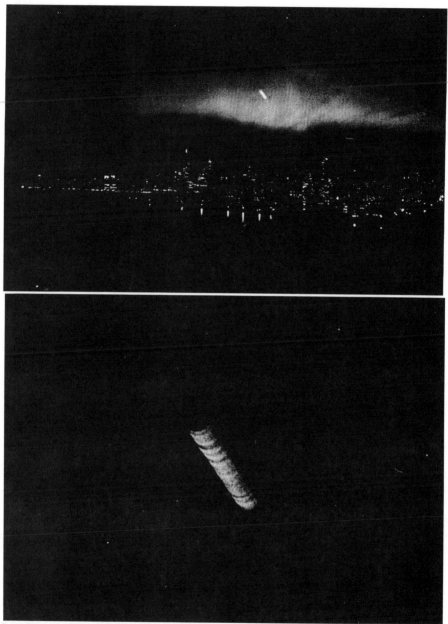

Above: Photos from the Project Blue Book files of a cylindrical UFO that hovered over New York City on March 20, 1950. The military suggested that it was possibly "the Moon." The photographer's name was deleted from the Project's files, as were most of the names when the material was finally declassified and released. These are some of the best photographs of a cylindrical UFO, thought to be a "Mothership" that would launch flying saucers.

Above: Project Blue Book examined this gun-camera film footage from Victorville, California taken on February 2, 1953. It apparently shows a cylindrical "Mothership" in flight.

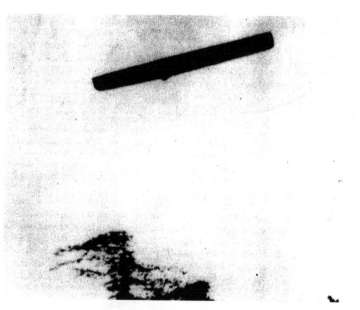

A classic cigar-shaped UFO allegedly seen by Joe Ferriere near Woonsocket, Rhode Island in the early 1950s. Ferriere claimed that a dome-shaped object, which he also photographed, emerged from the creaft. Observers have pointed out that craft is remarkable for its ability to absorb light, being almost completely non-reflective.

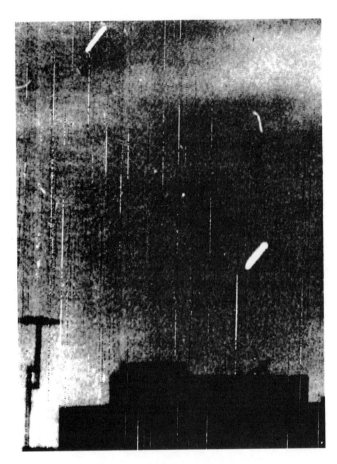

Above: Two cylindrical objects were photographed in a one-minute exposure hovering over Buenos Aires, Argentina in 1965. They remained stationary over the city for 10 minutes and then departed at very high speed according to witnesses.

CHAPTER SIX:

"SONDERBUERO"

CHAPTER SIX

"Sonderbuero"

A topic worthy of discussion is the alleged German agency called "Sonderbuero" or Special Bureau. Sonderbuero is sometimes also referenced by a sub-bureau working within it called "Operation Uranus" or "U-13". In the past, debate has centered around the reality of Sonderbuero. Discussion of Sonderbuero or Sonderbuero-13 have been made recently by Juergen-Ratthofer (1), and Zunneck (2).

There is no real record of Sonderbuero in official sources. Searches have been made in Germany as well as in the U.S.A. under provisions of the Freedom Of Information Act. All inquiries came back with negative results. This, however, may not be the final word on the subject. German sources may be classified or buried within another designation. The American Freedom Of Information Act is something less than advertised as anyone ever attempting to use these provisions knows full well.

Rather than get "official" about Sonderbuero, please let me relate what is said about it, its relation to this story and to the history of UFOs as a whole. With this information the reader can make up his or her own mind about the subject.

It is said that in Germany during the war there was a quest to make Germany independent of outside energy sources. An organization was formed to investigate things we would now call "alternative energy". This included, among other things, the making of synthetic fuel and lubricants out of coal using a special process which was perfected by the Germans during the war. But it may have, and probably did, included other, more exotic, research encompassing into such topics as nuclear energy and possibly even "free energy" or "new energy".

A spin off of this research was said by Juergen-Ratthofer to have yielded field propulsion. Research toward this end was said to have been conducted by Sonderbuero. About this time strange things were taking to the skies in Germany. To keep a lid on publicity, the following scenario is cited by Juergen-Ratthofer to have been employed (3).

233

Germany was surrounded by enemies and their agents permeated much of the German war effort. The Germans needed to get control over what was accidently seen by spies. To do this they enlisted the help of an unwitting German civilian population. An attempt was consciously made by Sonderbuero to "spin" reports of these sightings as they came in from civilian sources. A sub-department was set up within Special Bureau which sent out orders, countrywide, that all sightings of unusual flying craft be reported directly to that office and not discussed or publicized.

So while a German governmental agency is doing research and testing on unconventional aircraft, at this same time the same agency is gathering reports from the citizenry on sightings of unconventional aircraft. In order to confuse and disguise real testing from the Allies or their agents in Germany, a spin could be put on those sightings describing them as something other than what they were. Of course, all this time, the German civilians are believing the point is to observe and report Allied secret spy aircraft or other Allied secret weaponry. The Allied intelligence agencies may have even bought into this ruse. Remember, this was a German operation to fool its own people and so envelope Allied intelligence gathering organizations in this deception. This was done very subtly and very cleverly.

But what evidence do we really have that this actually occurred? After all, there is no official mention on Sonderbuero. Perhaps there is an overall picture. Let us see if we can find a pattern. After cessation of hostilities the Allies, especially the Americans, seized every piece of German technology they could lay their hands on. They also seized every scientist, manager, and technician having anything to do with the German scientific community, military, or intelligence service. The hardware was analyzed and the personnel interviewed. In some cases both were taken to America for further study.

The technology was reconstructed and further developed. In America the latest German jet technology made its appearance five years later in the Korean War. America got its hands on the V-1 which was further developed into the cruise missile. America got the V-2 which was further developed into intercontinental ballistic missiles and into our space program culminating in our landing on the moon. America got the V-3, the high pressure cannon, further developed by Dr. Gerald Bull into Iraq's super cannon, which, after being pointed at Israel was the real trigger for the Gulf War. And America got at least part of the German saucer program, the outcome of which was the Silver Bug Program, the Lenticular Reentry Vehicle project recently disclosed under pressure of the Freedom Of Information Act, and the UFO activity reported at Area 51. There are probably other examples which are, as of yet, undisclosed. Many other examples of technology transfer exist but the point need not be belabored.

America received more than just technical assistance from the

234

Germans. For example, they received the services of General
Reinhard Gehlen, former intelligence chief of the German Army
General Staff on the eastern front. Gehlen turned over to the
Americans his entire spy apparatus, giving a then blinded America
an eye into Soviet military objectives. Further, he set up and
modernized our intelligence apparatus, culminating in the C.I.A.,
as a means to counter the Soviet threat. This spy effort was
massive but please keep it in mind as we turn our attention to
something smaller and seemingly less significant.

As mentioned, in the 1950s the United States Air Force was busy
developing and testing flying saucers derived from captured
German technology. Of course, the Air Force wanted it to remain
a secret project, after all, we were involved in a Cold War.
Given this problem might the Americans have asked the question as
they always did: How did the Germans do this? If they did they
would have formed, as an adjunct to the secret saucer programs, a
program to gather material on all civilian sightings of strange
unidentified flying objects, under the cover of national
security, as if an external threat existed. This agency would
have then been in a position to "explain" or spin the data so as
not to alarm the populace while still maintaining secrecy
concerning its own projects.

As the reader may have surmised by now, this is exactly what the
United States Air Force did so successfully in the form of
Project Blue Book and its predecessors. The Air Force
experimented on flying saucers on one hand while gathering
reported sightings from civilians on the other hand, spinning and
manipulating the information according to dictates of their
agenda.

When viewed in this perspective, the similarity between
Sonderbuero and Project Blue Book is striking. Is not the
greatest evidence for the existence of Sonderbuero the American
pattern of imitation which infiltrated all post-war intelligence
work? The only real question is whether the Germans originated
the term "swamp gas" or if this was an American embellishment.

Although not central to our discussion, one might ask why, if it
was successful, why was Project Blue Book suspended? Remember
that the Americans tried to further develop German ideas. In
this case the solution was so imaginative and uniquely American
that the Pentagon must have resounded with the reverberation of
back-slapping and belly laughs at its implementation.

Remember Mark Twain's tale of Tom Sawyer whitewashing the picket
fence? Instead of being compelled to an afternoon of drudgery,
Tom pretended to his friends that this work was play. Not only
did he enlist them to do the painting, but his friends were so
eager to help paint that they paid Tom to do this work.

The United States Air Force followed this paradigm. They
infiltrated an existing civilian intelligence gathering

235

organization researching UFOs. They did this at no cost to the United States Air Force or any other governmental intelligence service. There were no official records, and no accounting trail. And best of all those doing the work and volunteering the intelligence would pay for the privilege in the form of dues to maintain the organization. If there is any question in the reader's mind as to whether MUFON (Mutual UFO Network) has been co-opted, ask yourself this question: would the intelligence services of the United States government allow the largest civilian intelligence gathering agency in the world to operate within its purview without at least monitoring it? Of course the answer is a resounding "no". This is one reason why MUFON is allowed to remain in operation within the USA without attempts to discredit it.

Given this sophisticated government intervention, would it not be a simple matter not only to manipulate the incoming sightings data, but to spin and confuse the debate concerning the origins of UFOs, even setting the agenda for the entire inquiry? Perhaps this is the reason MUFON has taken such a negative view of terrestrially originating UFOs and of the German origin of UFOs in particular. In the early 1990s, this writer was told via telephone from his home in Texas by the head man of MUFON himself that: "We investigated that a long time ago and found nothing to it". The "that" referred to was German saucers.

As an aside, he further went on to say that the idea of a German origin would for UFOs would not even be on the table for discussion if it were not for one, Vladimir Terziski, who, "is the guy pushing it", to directly quote this individual. Mr. Terziski has formed his own ideas about German saucers which he has never been afraid to share, and, to his undying credit, he stood up and lectured on this topic to the faces of MUFON in the very temples of the alien world, UFO conferences, worldwide. Mr. Terziski, almost alone, forced these facts into those conferences and subsequently forced all those UFO magazines to deal with the subject of German flying discs. And although he never got credit for it, he also supplied the technical assistance for a world famous Japanese television producer to bring an hour of this German saucer story to Japan in prime-time. Mr. Terziski, almost single-handedly, opened up two continents to this UFO reality.

MUFON's successful existence is tied to their implicit and explicit assumptions of UFOs as alien machines. The greatest appeal the extraterrestrial hypothesis has for the government is that this hypothesis is simply not testable. MUFON does not even try to test anything. Instead, they chase sightings. They train their followers to take meaningless celestial measurements accompanying these sightings and then analyze this "data" into gibberish. MUFON then lends itself to endless rambling speculation involving increasingly more exotic alien scenarios.

It is not MUFON's rank and file membership which is to blame. The individuals I have met are honest and sincere as are 99% of

all the participants in the quest to understand these mysterious flying objects. Their methods may stimulate UFO interest and UFO enthusiasts but it utterly fails to advance our quest for knowledge about these devices. This is perfectly alright with the behind the scenes government manipulators, however, since this result is their real goal. It is unknown to what extent the Americans have succeeded in improving and further developing the original German saucers. The extent to which they have succeeded in further developing Sonderbuero, however, should be apparent to all.

CHAPTER SIX

"Sonderbuero"

Sources and References

1. Juergen-Ratthofer, Norbert, 1993, page 63, <u>Das Vril Projekt</u>, Dr. Michael Daemboeck Verlag, Ardaggr, Austria

2. Zunneck, Karl-Heinz, 1998, page 125, <u>Geheimtechnologien, Wunderwaffen Und Irdischen Facetten Des UFO-Phaenomens</u>, CTT-Verlag, Suhl, Germany

3. Juergen-Ratthofer, Norbert, 1993, page 63

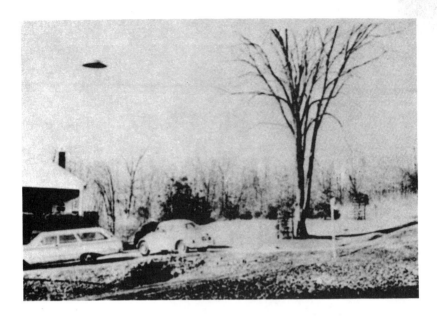

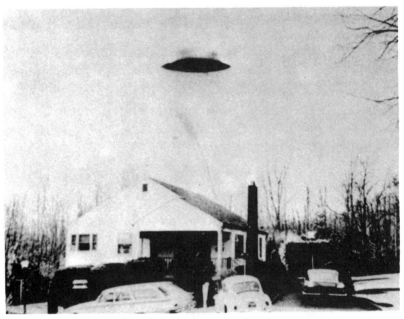

Two photos taken by a barber named Ralph Ditter, in Zanesville, Ohio on November 13, 1966. Ditter was leaving home with his camera when he chanced to look back and saw the UFO over his house. He took two exposures within a short period of time of the helmet-like craft, with an apparent "canon" on the underside of the craft. Ditter did not seek publicity but put them in his shop window to stimulate business. Eventually a news service bought them and they were widely published. The object is similar to the "Heflin UFO" and is said to be an original German design with a Panzer Tank canon mounted beneath it. Such a craft at such a late date would tend to indicate that this was not a captured test craft but rather a "renegade craft" possibly operating from South America as late as 1966.

Above: Aerospace expert Stuart Nixon, executive director of the National Investigations Committee on Aerial Phenomena (NICAP), which was founded in Washington, DC, in 1956 to conduct a civilian study of UFOs. Note the apparent "cannon barrel" beneath the craft.

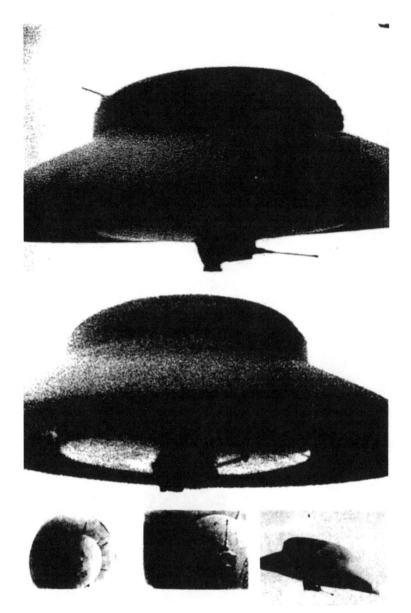

Alleged photos from SS files of a Haunebu II in flight circa 1944. Note the Panzer tank canon mounted underneath the craft. From the German book *Die Dunkle Seite Des Mondes (The Dark Side of the Moon)* by Brad Harris (1996, Pandora Books, Germany).

CHAPTER SEVEN:

DISPOSITION OF GERMAN SAUCER TECHNOLOGY AFTER THE WAR

CHAPTER SEVEN

Disposition of German Saucer Technology After the War

The question arises as to what ever became of the saucer designs and saucer designers referred to in this discussion? For some there are easy answers. For others, there whereabouts after the war is more clouded.

Dr. Richard Miethe, for instance, has been rumored to have gone to work in Canada on the joint Canadian-U.S. Air Force saucer project. Dr. Miethe is not the only German scientist very willing to start construction on a post-war flying disc. All the scientists involved, with the exception of Rudolf Schriever, seem to have been eager to begin at once.

Heinreich Fleissner, who claimed to have been a technical advisor on a German flying disc project at Peenemuende, filed an American patent for a flying disc on March 28, 1955. This was patent number 2,939,648 which can be obtained from the United States Department of Commerce, U.S. Patent Office for a small fee. The patent was not granted until June 7, 1960, a delay of over five years. One can not help but wonder if the delay Fleissner experienced had anything to do with the work going on at the same time at the A.V. Roe, Limited organization or the black project to develop the Lenticular Reentry Vehicle or even on some black project which is still undisclosed.

Another German saucer designer eager to get things rolling after the war was Georg Klein. When asked about future plans in the Tages-Anzeiger fuer Stadt und Kanton Zuerich on September 18, 1954, Klein replied that he had already demonstrated a flying saucer model utilizing electric propulsion.

But probably the most anxious to begin work, no matter the obstacles, was Joseph Andreas Epp. This is said because according to government files, which were first located by researcher Mark Kneipp, Epp went so far as to enlist in the Soviet flying saucer project which began immediately after the war in East Germany using former German scientists (1).

Post-War Soviet "German" Saucer

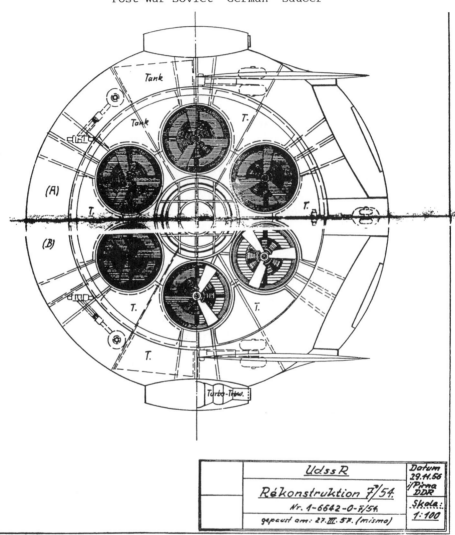

	UdssR	Datum 29.11.56
	Rékonstruktion 7/54.	i/Pirna DDR
	Nr. 1-6642-0-7/54.	Skala:
	gepaust am: 27.III.57. (mismo)	1:100

After the war J. Andreas Epp worked briefly for the Soviets
along with other German experts on a flying saucer. This
is a drawing he made of the Soviet saucer. It was to be
used in the polar regions.

According to this F.B.I. file which was secluded by the National
Archives, Epp became disenchanted with the Soviets after working
for them for about a year. He then defected to the West. Epp
re-drew their designs from his seemingly photographic memory. He
provided detailed test and technical specifications, including
his apparent area of specialty, the steering linkage system. His
comments were that the type of flying craft being built for the
Soviets was especially designed for polar conditions.

After settling in Bavaria, Epp continued design work on flying
discs himself. He designed the "Omega Disc" which is remarkably
similar to the Soviet design. Epp was very interested in working
for Bell Aircraft, builders of the X-1 which broke the sound
barrier in 1947. Epp sent me copies of correspondence with Dr.
Walter Dornberger, at this time executive of Bell Aircraft, who,
at one time was Dr. Wernher von Braun's boss at Peenemuende. Epp
did mention the flying saucer in this correspondence. Nothing
came of it, however. To his death in 1997, Andreas Epp was still
trying to realize this dream of building a flying saucer.

These are the stories of saucer designers of which we know
something. There were others of which we have completely lost
track. Otto Habermohl is one of these. Habermohl was presumed
captured by the Soviets. This presumption seems to be solely
based on the fact that he disappeared after the capture of Prag.

What about the post-war disposition of the flying saucers
themselves? We know, for instance, that examples were destroyed
by the Germans so the advancing Allies would not benefit from
them. This very thing happened to saucers designed by the
Schriever-Habermohl team at Prag. The scorched earth policy was
a standing solution and ruthlessly imposed by the SS, especially
concerning German high technology. Yet we all know flying
saucers did not disappear after the collapse of Germany, as a
matter of fact quite the contrary. Michael X. Barton tells us
that their earliest appearance was not over the State of
Washington in 1947 as usually given but in South America. In
fact, there were many sightings of UFOs in South America during
this post-war time frame. Latin American sightings continue to
this day.

South America is a long way from the USA. Even if the Americans
were experimenting with captured German technology at that time,
the sightings from other parts of the world can not be explained
as originating from the USA. There must be more at work here.

Could die-hard Nazis have exported this technology to a
stronghold in the Antarctic or Andes as some often claim? Or did
these craft appear from "Beaver Dam", a secret German base on the
east coast of Greenland as disclosed by Dr. Jesensky and Mr.
Lesniakiewicz (2). Was part of this technology appropriated by
the British and further developed in Canada as stated by Renato
Vesco? Or was this technology completely absorbed by the USA in
a secret deal with Admiral Karl Doenitz after Hitler's death as

245

stated by Bill Lyne (3)?

In the first of the aforementioned possibilities, these die-hard Nazis and their technology, including saucers, are sometimes called the "Third Power" by German writers on the subject. The Third Power is meant to signify a power besides the West (the First Power) or the East (the Second Power). The Third Power allegedly operates in secret as regards the general population of this planet but is very well known to the First and Second Powers. The sole reason the Third Power has survived is their high technology and high finance both of with resulted from picking clean the bones of the Third Reich. The story is as follows and at least some of it is factual.

It is known that the Germans made contingency plans for the war's loss. On August 10, 1944, nine months before the war in Europe ended, a meeting was called at the hotel Rotes Haus in Strassbourg. In attendance were representatives of all the major German industrial concerns including I.G. Farben, Thyssen, Siemens, Krupp, Daimler-Benz, Rheinmetall-Borsig, as well as representatives of the major German banks. Meeting with them were members of the SS. They were planning measures which would insure their survival after the coming German defeat (4).

Scientists, scientific plans, strategic materials, and money were to be taken from Germany and secured in secret hiding places. Long range cargo aircraft were to fly from Germany to Spain carrying the goods. From here items were to be loaded on to U-boats bound for South America. It is possible that other destinations were also planned such as Japan and the Antarctic base original established in 1938-1939 by the Ritcher Antarctic Expedition.

Surprisingly, the Ritcher Antarctic Expedition (1037-38) was set up and funded by Hermann Goering, head of the German Air Force. The ship Schwabenland, equipped with amphibious aircraft which could be launched via catapult explored, mapped and claimed a large portion of the Antarctic Continent for Germany during this expedition. Weighted metal flags were dropped from these aircraft clearly delineating the territory in which Germany was claiming. The territory included ice-free lakes which were naturally heated from below by geothermal means (5). Along the line of these lakes a huge fault line bisects "Neuschwabenland", as it was called, so presumably a permanent heat source was built into this new territory. One German writer has perused reports of Neuschwabenland and states that during the war repeated trips were made to this vicinity at which time a permanent base was established there (6). Another writer, Wilhelm Landig, in novel form, describes this and other secret post-war German bases in Antarctica, the Andes as well as a secret polar base near the North Pole (7). Mr. Landig recently died and it is now known that he was a Third Reich insider and knew of which he wrote. As mentioned earlier, it is now known that Landig was a member of the Waffen SS and at one time was responsible for security for

the development of German saucers (8). He knew that of which he spoke. His books each bore the sub-title "Ein Roman voller Wirklichkeiten" or "a novel filled with realities" as this novel treatment was an easy avenue in avoiding post-war legal entanglements.

Through the descriptions of the writers mentioned and other records it is possible to pinpoint the location of these secret German bases in Antarctica as well as a large Andean base in Chile. Bill Lyne as well as Mr. Robert Lesniakiewicz and Dr. Milos Jesensky state that a mysterious polar base existed in Greenland (9) (10). The latter writers cite the coast of eastern Greenland and cite a code-name which translates into "Beaver Dam", complete with underwater U-boat entrances.

The Antarctic base was first attacked by forces of many nations, led by the United States, in a 1946 military action code-named "Operation High Jump". This operation involved a fleet of ships, including an aircraft carrier, submarines and support craft. It also involved aircraft and four thousand armed troops under the command of Admiral Richard Byrd. Immediately four aircraft were mysteriously lost and the whole operation, scheduled for six months duration, was canceled after less than six weeks (11) (12).

The Antarctic base, Landig's Point 211 (13), was in operation until the late 1950s when it became the subject of an American nuclear "test". In this test three bombs were detonated under cover of the International Geophysical Year 1957-58 (14). Landig claims the type of rockets used in the "test" to attack Point 211 were prototypes of the American Polaris missile, a solid-fuel rocket which was used later operationally, the final design being fired from submarines underwater (15). Detonation of these atomic weapons over the base generated electromagnetic shock waves which, it was hoped, would destroy apparatus in the base used for defensive purposes (16). Landig claims this tactic failed. The electromagnetic pulse attack was insufficient to destroy the improved apparatus (17). Both "High Jump" and this 1957-58 attack turned out not only to be a fiasco, but to be superfluous. The greater part of the German forces had already abandon the Antarctic base in favor of a base in the South American Andes.

Landig claims that the reason for its abandonment was the purity of the atmosphere in the Antarctic which is almost germ-free (18). It seems that the human immune system needs constant challenge to remain healthy even if this challenge does not always result in illness. Without a constant influx of visitors supplying this challenge, the staff on-hand lost almost all immunity to infection after a few years. The common cold became a serious matter.

As mentioned earlier, writers Dr. Milos Jesensky and Robert Lesniakiewicz see the origin of flying saucers over the USA

247

during the late 1950s as coming from a forgotten German facility called "Beaver Dam" in Eastern Greenland. According to these writers, this base did not surrender with the fall of Germany but continued to function. It was from this base that flying saucers were directed to the USA on spy missions, especially toward our nuclear facilities in New Mexico. Additionally, one wonders if this base was the real origin of the ghost rockets seen moving south from Northwestern Europe immediately after the war. The status of this base today is unknown.

There is no doubt that the Germans had bases in the Arctic. German bases were located on Soviet soil, as well as the soil of Greenland which belonged to Denmark. Denmark had been overrun by the Germans early in the war. What is most surprising is that Landig's claim that the Germans maintained a base in the high Canadian arctic right under the noses of Canada and the USA (19).

Is this all fantasy? Is there any hard evidence for secret post-war German bases? Has a post-war German base ever been discovered? Yes, one has. New evidence for this exodus theory comes to us from the discovery of a German U-boat way-station in the Atlantic which had a hand in moving this clandestine cargo from Europe to the austral world well after the war, right into the 1950s. This information is revealed in an article in the July, 1984 issue of Nugget magazine titled "Der U-Boot Bunker von Fuerteventura" (20). Fuerteventura is the eastern most island of the Canary Island chain and lies just out of sight off the west coast of North Africa.

Geologically, the base was formed by an huge, ancient volcanic bubble around which the molten rock solidified in the center of the island. According to the article, the Germans brought in excavation equipment and bored out three tunnels for underwater access by U-boats. On top of the island, directly over the bubble and the military facility rested a villa with a stairway leading down to the base from the cellar. The villa was owed by a respectable German family, named Winter. This base functioned during the war as a secret U-boat base for the Germans. It continued this function after the war as a way-station for transport U-boats.

In our modern world of science and academic history this claim of lost islands and hidden bases sounds like something out of a Jules Verne fantasy. If such a base really existed, would we all not be aware of its existence above and beyond an obscure reference in a publication which mainly deals with treasure hunting?

Actually, most readers are already quite familiar with this particular base. This base was the truth behind the visual images of the German U-boat base situated in the volcanic island off the coast of Africa in the movie "Raiders of the Lost Ark". In fact, this aspect of the story was the only part of the movie which was factual.

248

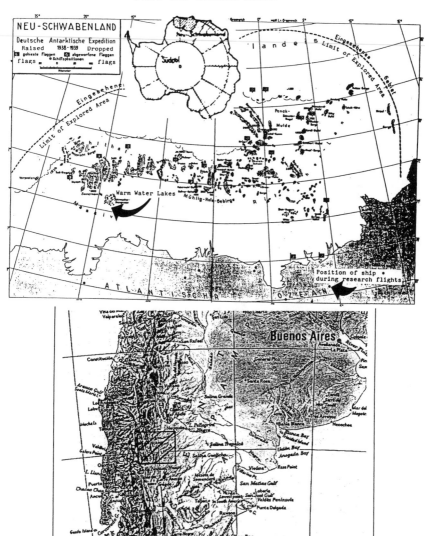

Top: Neuschwabenland (Antarctica). Bottom: "Colonia
Dignedad" in Argentina near Chilean border comprising
25,000 quadrakilometers (over half as large asSwitzerland).

The subterranean island base was actually visited by two eyewitnesses, according to the Nugget report. There, two derelict U-boats were discovered which had remained undetected for over thirty years. One of these U-boats was entered by the two adventurers. Inside they found detailed nautical maps of South America. To add to the mystery, the assertion is made that these U-boats and this base functioned with the full knowledge of the U.S. government right into the 1950s.

This base would have formed a physical link between the ports of Spain and destinations in South America. Perhaps even bridging bases in Greenland with Antarctica, if certain reports are true. It is also fuel for the argument that a technological transfer actually took place between the Third Reich and entities in the Southern Hemisphere. As surely as die-hard Nazis spread into the Southern Hemisphere sightings of flying saucers followed. Further, if the government of the United States knew of this transfer and these U-boat bases then there then there may have been some actual political link or understanding between the government of the United States and the post-war Nazis, the "Third Power".

If his words are read carefully, Landig's Point 211, the Antarctic base, can be located on the maps he supplies (21). Until, however, this base is visited and excavated and the evidence made public, this base along with the ones in Canada and Greenland constitute more speculation than fact. This is not true, however, in the South American situation.

In the immediate post-war world South America was a haven for Germans who could not stomach Occupied Germany for one reason or another. The political climate in these countries was favorable toward these refugees. Nazi gold and money was transferred to South America, particularly Argentina. Hunted Nazis found a market for their services in a variety of occupations. SS organizations set up shop as they had in Franco's Spain. These facts are hardly in dispute. They are covered in detail by Infield (22) as well as by Farago (23) a whole genre of "Nazi Hunter" writers. What is less often mentioned is that German technical people infused these countries with expertise gained during the Second World War. For instance, Argentina and Brazil had state-of-the- art jet fighters in the 1950s thanks to the efforts of German immigrant scientists and technicians.

Along with this monetary and technical transfer, large land holdings were purchased, secured and set aside with the full knowledge of the South American governments in power. From these vast secure areas members of these German organizations simply did as they pleased. It is not out of the question to think that the flying saucers seen in the late 1940s and 1950, both conventional and field propulsion, were built and flown from these bases. One of these Andean bases, referred to as "Colonia Dignidad" consisted a land area half the size of Switzerland (24). This is certainly more than enough room to develop hide

anything.

The South American industrial base during these times was more than adequate to make these saucers. But even if this were not true, this is no argument against construction of flying saucers in South America. Parts could have been ordered from suppliers in other countries as are done by major aircraft firms today. Each major aircraft firm has a host of sub-contractors who manufacture everything from individual screws to complete sub-assemblies. Many if not most of these sub-contractors are accustomed to filling these orders without ever knowing what the final assembled product will be. This is part of the security system and unquestioned. Germans working in South America would have no trouble using this system. They could have even ordered parts and sub-assemblies from companies in Europe and the USA.

This is exactly what Dr. Gerald Bull did in Iraq when he built the largest of his high-pressure cannons for that country. This nearly mile long fixed gun was built resting on the slope of a hill pointed at Tel Aviv. It would have been able to shoot projectiles weighing about 1800 pounds. Parts were built by sub-contractors all over the world and sent to Iraq for assembly where it was nearly completed. The sub-contractors were lied to or otherwise kept in the dark as to the purpose of their components. It was only by chance that word of this project reached the hands of opposing intelligence services. The result was near panic in the intelligence services of these countries. What followed was the assassination of Dr. Gerald Bull and a diplomatic ruse which bated Saddam Hussein into an invasion of Kuwait. This invasion facilitated the entry of the Americans into the conflict. The high pressure cannon was destroyed immediately, even though it was pointed in the opposite direction from Kuwait. If this risky, bulky weapon's system could be almost completed using a system of unwitting sub-contractors world-wide, imagine how easily a one-off flying vehicle could be built using the same system.

Richard Ross, a UFO researcher based in Austin, Texas, reports to me that even today vast tracts of land in South America are avoided by airline pilots there because of UFO activity in these areas. He obtained this information by interviewing the South American airline pilots themselves. He goes on to make the point that Latin America is a hotbed of UFO activity. Reports of this activity for some reason never find their way into the main stream American news media.

There still remains one possible hiding place on European soil. There remains the possibility that German flying discs were flown to Switzerland during the last moments of the 3rd Reich and hidden there in the vast system of caves built there for defensive purposes by the Swiss. This would imply a limited partnership with the Swiss concerning a technology that neither country wanted to loose. In modern times we have witnessed something similar when Iraq flew its jet aircraft to Iran for

251

safe keeping during the Gulf War. Iraq and Iran had been bitter
enemies only a few years before but put these differences aside
in order to save technology. If they could do it certainly the
Germans and Swiss could do it also. One eye witness claims that
he saw an experimental aircraft crossing the German border into
Switzerland on the morning of May 9, 1945, the day after the
surrender of the 3rd Reich (25). This same procedure could have
taken place with even more exotic flying craft.

One of our most trusted sources, Renato Vesco believes that
Canada was strongly involved in further developing captured
German saucer technology. Vesco's belief seems to be that the
British kept this information to themselves. That is, they did
not share it with the United States. They did this in response
to the latter's refusal to share atomic secrets with Great
Britain. The British hid this research in the Canadian forests
where they spent time and money developing it into the flying
saucers of the 1950s. Somewhat related to this idea, the German
researcher Klaus-Peter Rothkugel also believes post-war saucer
research was the product of a massive and still-secret Anglo-
American effort. Jim Wilson adds fuel to this fire in that there
was apparently joint British-American-Australian involvement in
the Lenticular Reentry Vehicle project (26).

Bill Lyne has another opinion. He believes all German saucer
data was transferred to the government of the United States in a
deal done with Admiral Karl Doenitz who was acting head of
Germany for the week or so between the time Hitler shot himself
in the bunker and Germany surrendered. Recently, Mark Kneipp has
found some very interesting evidence which seems to support Mr.
Lyne's sequence of events in this deal with Admiral Doenitz.
This is one surprise I do not want to spoil so it will be left to
Mr. Kneipp to reveal his research.

One real mystery remains absolutely untouched. This concerns the
man who did know everything about Germany's saucer development
and all its V-weaponry and other high technology for that matter.
This was SS General and Doctor of Engineering Hans Kammler.
Kammler first came to prominence because of his expertise in
building extensive underground installations. Soon his high
intelligence and "can do" attitude were recognized, resulting in
a meteoric rise in rank and influence within the Third Reich.
Kammler assembled the best of the best as far as weaponry was
concerned and kept it close to him in the form of the Kammler
Group, based at the Skoda industrial complexes near Prag. By
war's end he was among the top five most powerful people in
Germany. He had the entire SS technical organization to do his
bidding. He was in charge of Peenemuende, "Der Riese" in modern
Poland, Nordhausen, Kahla, the many facilities at the Jonas
Valley in Thuringia, as well as the huge underground facility he
built for himself in Austria. The Kammler Group was everywhere
on the cutting edge of the cutting edge of applied technology.
For instance it was the Kammler Group which was in the process of
applying nuclear energy toward missile and aircraft propulsion

252

(27).

What happened to Kammler? This was the most knowledgeable of all the German technical people. Even Albert Speer, German Minister of Munitions, admitted under Allied interrogation, that Kammler was the expert in the area of V-weapons development. This was no small admission for Speer. With the cessation of hostilities in Europe, Kammler simply waltzed off the pages of history, never to be seen or heard from again. Why, then, was there no post-war manhunt for Kammler? What are we missing here?

Tom Agoston recounts the stories of Kammler's death (28). There are five in all. They all read like pulp fiction. None are even remotely believable. As proof of this, no serious investigation was ever done into any of these stories by any of the Allied Powers. But equally shocking is the fact that Kammler was ignored by the "Nazi Hunter" aficionados. A quick call to the Simon Wiesenthal Center in Los Angeles revealed that they were not looking for Kammler and have never looked for Kammler even though they fully agreed that the stories of his death stretched credulity. This, in spite of the fact that it was Kammler who was responsible for the many slave-labor camps, including Dora and S-3, where many inmates died working for the SS.

There is a sixth possible story for Kammler's demise.
Could not the answer to this enigma be found in a practice commonly given to criminals in the USA, that of the "witness protection program"? Was Kammler given a new identity in exchange for his knowledge and knowledge of where the treasure-trove of SS technical information was stored? Actually, any country in the world at the time would have made Kammler this deal in a second. He was simply too technologically valuable to loose or to involve in a showcase criminal trial. A new identity was the best way out of his problems.

One thing is striking concerning the technological history of the Twentieth Century. The preponderance of that century's technology has its roots in the 1940s. The technology we use and take for granted today was invented or developed to the utilitarian degree during this time frame. These technological roots sink most deeply into Nazi Germany. In support of this argument, there is a laundry list too long to fully recount. It ranges from synthetic materials such as plastics and artificial rubber to metallurgy. It included the host of technologies which gave us the jet engine, rockets and so access to space travel. It includes atomic power. It also includes early semi-conductor research upon which our modern computer-based research, economy and communications are built. Technically speaking, we are still living off the caracas of the Third Reich. Yet, still, to this day, much of that German technology remains veiled. Counted among this still-veiled technology are the German flying discs.

Disposition of German Saucer Technology After The War

Sources and References

1. Dossier/Joseph Andreas Epp, U.S. Army Intelligence, Record Group 319, The National Archives at College Park, College Park, Maryland.

2. Jesensky, Milos, Ph.D. and Robert Lesniakiewicz, 1998, page 143, "Wunderland" Mimozemske Technologie Treti Rise, Aos Publishing

3. Lyne, William R., 1999, page 48, Pentagon Aliens, Creatopia Publishing, Lamy, New Mexico

4. Infield, Brian, 1981, page 179, Skorzeny Hitler's Commando, St. Martin's Press, New York

5. Mattern, W., date unknown, page 79, UFO's Unbekanntes Flugobjekt? Letzte Geheimwaffe des Dritten Reiches?, Samisdat Publishing, Toronto, Canada

6. Bergmann, O., 1988, page 14, 1 Deutsche Flugscheiben und U-Boote Ueberwachen Die Weltmeere, Hugin Gesellschaft Fuer Politisch-Philosophische Studiern E.V., Wetter/Ruhr

7. Landig, Wilhelm, 1971, Goetzen Gegen Thule Ein Roman voller Wirklichkeiten, Hans Pfeiffer Verlag GmbH. Hannover

8. Informationsdienst gegen Rechtexremismus, URL address: http://www.idgr.de/texte-1/esoterik/landig.htr

9. Lyne, William R., 1999, page 97

10. Jesensky, Milos, Ph.D. and Robert Lesniakiewicz, 1998, page 143

11. Buechner, Howard A. Col. and Bernhart, Wilhelm Capt., 1989, Hitler's Ashes, pages 229-232, Thunderbird Press, Inc., Metarie, Louisiana

12. Landig, Wilhelm, 1991, page 571, Rebellen Fuer Thule Das Erbe Von Atlantis, Voldstum-Verlag, Wien

13. ibid

14. ibid

15. Landig, Wilhelm, 1991, page 572

16. ibid

17. ibid

254

18. ibid

19. Landig, Wilhelm, 1971, pages 109-142

20. Nugget, July and August editions 1984, "Der U-Boot Bunker von Fuerteventura"

21. Landig, Wilhelm, 1980, pages 486-489, Wolfzeit Um Thule, Volksturm-Verlag Wilhelm Alndig, Wein

22. Infield, Glenn B., 1981, Skorzeny Hitler's Commando, St. Martin's Press, New York

23. Farago, Ladislas, 1974, Aftermath Martin Bormann and the Fourth Reich, Simon and Schuster, New York

24. Wilson, Harvey, 1994, "Hitlers Fluchtweg nach Argentinen", in Zeiten Schrift, Sept-Nov. 1994, Number 4, Berneck, Switzerland

25. Heppner, Siegfried, 1997, page 11, "Geheimnisse...dem Deutschen Volke", self-published, A-9142, Globasnich-Podjuna, Austria

26. Wilson, Jim, November 2000, page 71, "America's Nuclear Flying Saucer", Popular Mechanics

27. Agoston, Tom, 1985, pages 13, 83-84, 87, 129, Blunder How the U.S. Gave Away Nazi Supersecrets to Russia, Dodd Mead Company, Inc., New York

28. Agoston, Tom, 1985, pages 102-109

255

COPY ONE OF ONE.

SUBJECT: OPERATION MAJESTIC-12 PRELIMINARY BRIEFING FOR
PRESIDENT-ELECT EISENHOWER.

DOCUMENT PREPARED 18 NOVEMBER, 1952.

BRIEFING OFFICER: ADM. ROSCOE H. HILLENKOETTER (MJ-1)

NOTE: This document has been prepared as a preliminary briefing
only. It should be regarded as introductory to a full operations
briefing intended to follow.

• • • • • •

OPERATION MAJESTIC-12 is a TOP SECRET Research and Development/
Intelligence operation responsible directly and only to the
President of the United States. Operations of the project are
carried out under control of the Majestic-12 (Majic-12) Group
which was established by special classified executive order of
President Truman on 24 September, 1947, upon recommendation by
Dr. Vannevar Bush and Secretary James Forrestal. (See Attachment
"A".) Members of the Majestic-12 Group were designated as follows:

> Adm. Roscoe H. Hillenkoetter
> Dr. Vannevar Bush
> Secy. James V. Forrestal•
> Gen. Nathan F. Twining
> Gen. Hoyt S. Vandenberg
> Dr. Detlev Bronk
> Dr. Jerome Hunsaker
> Mr. Sidney W. Souers
> Mr. Gordon Gray
> Dr. Donald Menzel
> Gen. Robert M. Montague
> Dr. Lloyd V. Berkner

The death of Secretary Forrestal on 22 May, 1949, created
a vacancy which remained unfilled until 01 August, 1950, upon
which date Gen. Walter B. Smith was designated as permanent
replacement.

On 24 June, 1947, a civilian pilot flying over the Cascade
Mountains in the State of Washington observed nine flying
disc-shaped aircraft traveling in formation at a high rate
of speed. Although this was not the first known sighting
of such objects, it was the first to gain widespread attention
in the public media. Hundreds of reports of sightings of
similar objects followed. Many of these came from highly
credible military and civilian sources. These reports res-
ulted in independent efforts by several different elements
of the military to ascertain the nature and purpose of these
objects in the interests of national defense. A number of
witnesses were interviewed and there were several unsuccessful
attempts to utilize aircraft in efforts to pursue reported
discs in flight. Public reaction bordered on near hysteria
at times.

In spite of these efforts, little of substance was learned
about the objects until a local rancher reported that one
had crashed in a remote region of New Mexico located approx-
imately seventy-five miles northwest of Roswell Army Air
Base (now Walker Field).

On 07 July, 1947, a secret operation was begun to assure
recovery of the wreckage of this object for scientific study.
During the course of this operation, aerial reconnaissance
discovered that four small human-like beings had apparently
ejected from the craft at some point before it exploded.
These had fallen to earth about two miles east of the wreckage
site. All four were dead and badly decomposed due to action
by predators and exposure to the elements during the approx-
imately one week time period which had elapsed before their
discovery. A special scientific team took charge of removing
these bodies for study. (See Attachment "C".) The wreckage
of the craft was also removed to several different locations.
(See Attachment "B".) Civilian and military witnesses in
the area were debriefed, and news reporters were given the
effective cover story that the object had been a misguided
weather research balloon.

c. There is a possibility that some of the incidents may be caused by natural phenomena, such as meteors.

d. The reported operating characteristics such as extreme rates of climb, maneuverability (particularly in roll), and action which must be considered evasive when sighted or contacted by friendly aircraft and radar, lend belief to the possibility that some of the objects are controlled either manually, automatically or remotely.

e. The apparent common description of the objects is as follows:-

(1) Metallic or light reflecting surface.

U-39552

Basic Ltr fr CG, AMC, WF to CG, AAF, Wash. D. C. subj "AMC Opinion Concerning "Flying Discs".

(2) Absence of trail, except in a few instances when the object apparently was operating under high performance conditions.

(3) Circular or elliptical in shape, flat on bottom and domed on top.

(4) Several reports of well kept formation flights varying from three to nine objects.

(5) Normally no associated sound, except in three instances a substantial rumbling roar was noted.

(6) Level flight speeds normally above 300 knots are estimated.

f. It is possible within the present U. S. knowledge — provided extensive detailed development is undertaken — to construct a piloted aircraft which has the general description of the object in subparagraph (e) above which would be capable of an approximate range of 7000 miles at subsonic speeds.

g. Any developments in this country along the lines indicated would be extremely expensive, time consuming and at the considerable expense of current projects and therefore, if directed, should be set up independently of existing projects.

h. Due consideration must be given the following:-

(1) The possibility that these objects are of domestic origin - the product of some high security project not known to AC/AS-2 or this Command.

(2) The lack of physical evidence in the shape of crash recovered exhibits which would undeniably prove the existence of these objects.

(3) The possibility that some foreign nation has a form of propulsion possibly nuclear, which is outside of our domestic knowledge.

3. It is recommended that:

a. Headquarters, Army Air Forces issue a directive assigning a priority, security classification and Code Name for a detailed study of this matter to include the preparation of complete sets of all available and pertinent data which will then be made available to the Army, Navy, Atomic Energy Commission, JRDB, the Air Force Scientific Advisory Group, NACA, and the RAND and NEPA projects for comments and recommendations, with a preliminary report to be forwarded within 15 days of receipt of the data and a detailed report thereafter every 30 days as the investi-

-2- U-39552

Basic Ltr fr CG, AMC, WF to CG, AAF, Wash. D.C. subj "AMC Opinion Concerning "Flying Discs"

gation develops. A complete interchange of data should be effected.

4. Awaiting a specific directive AMC will continue the investigation within its current resources in order to more closely define the nature of the phenomenon. Detailed Essential Elements of Information will be formulated immediately for transmittal thru channels.

N. F. TWINING
Lieutenant General, U.S.A.
Commanding

-3- U-39552

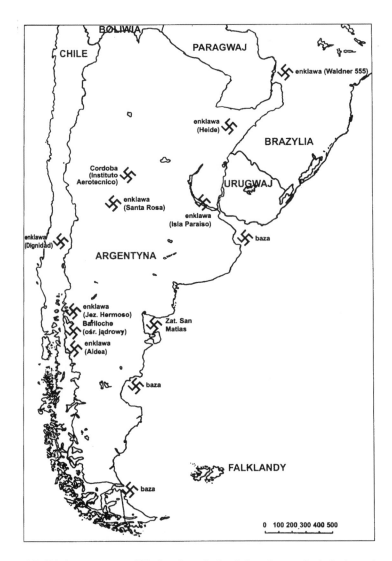

The map contains the following labels:

BOLIWIA

CHILE

PARAGWAJ

enklawa (Waldner 555)

enklawa (Heide)

BRAZYLIA

Cordoba (Instituto Aerotecnico)

enklawa (Santa Rosa)

URUGWAJ

enklawa (Isla Paraiso)

enklawa (Dignidad)

baza

ARGENTYNA

enklawa (Jez. Hermoso)
Bariloche (ośr. jądrowy)
enklawa (Aldea)

Zat. San Matias

baza

FALKLANDY

baza

0 100 200 300 400 500

A Polish-language map of Nazi enclaves in South America, particularly Argentina. It is thought that some of the UFO activity in South America came from German saucers relocated to remote parts of that continent.

CHAPTER EIGHT:

CONCLUDING THOUGHTS

CHAPTER EIGHT

Concluding Thoughts

What can be concluded from this glimpse into the world of German flying discs? Certainly, it can be said that some of these projects were realized. This being true, it can be said that these were the first "flying saucers". It is also certainly true that German flying discs were re-created and perhaps further developed by countries comprising the former Allied Powers. It can be said that in all probability, Germans immigrated to places outside Europe after the war and also built these flying craft. It is also a certainty that the exact nature and real history of these flying devices has remained a closely guarded secret in all these countries. Not only has a secret been kept but an active effort, a conspiracy, has been made to keep it that way. This means that their exists an effort to keep the exact knowledge of these devices from the general populace for the foreseeable future. This effort extends back into time, into the origins of these projects in Germany and extends into the present. The victors wrote history. The victors omitted German flying discs and the victors are keeping quite now.

The exact methods of propulsion of the exotic versions of these discs still remains a mystery. Jet and rocket engines were used but there is still debate as to which models used which engine at what time. There is no doubt in my mind that field propulsion techniques were at least experimented upon during the 3rd Reich. This is established in my mind, if for no other reason, by the series of F.B.I. reports dealing with the witness who saw such a device while a prisoner of war near Gut Alte Gossen. The F.B.I. took these reports seriously enough to take them and save them all these years. Maybe we should also.

One overriding question concerning UFOs is why are they so, so secret? Dr. Milos Jesensky and engineer Robert Lesniakiewicz propose an atomic saucer in their book "Wunderland" Mimozemske Technologie Treti Rise. This conclusion is seconded by Klaus-Peter Rothkugel and Jim Wilson. This assertion should be taken very seriously.

The UFO-atomic connection fits the historical facts concerning both atomic energy and UFOs. UFOs have always been and are today

261

associated with atomic energy facilities. Los Alamos, Hanford and Area 51 are examples of nuclear facilities at which or very near to which UFOs are or were regularly seen. If we suppose atomic energy as a power source it might explain this association. But that can not be all there is to this matter. Methods of propulsion involving atomic energy seem to be known to us. Indeed, some were reviewed in this book. Why the extreme secrecy then? Might it be that there is some other arrangement involving nuclear energy of which we know nothing? Might the Germans have stumbled on to something really exciting during those war years, perhaps coupling field propulsion with atomic energy ? If this is so then not only would the association of UFO activity over and near nuclear facilities be explained but some of the extreme secrecy and conspiracy to cover-up the matter might also be explained.

At this point the reader may smiling and shaking his or her head in disbelief, perhaps even making comments involving the words "fantasy" or "science fiction". The German watch-word of those times was "nothing is impossible" and it is clear that within the Reich scientists took this saying to heart. Those scientists were not surprised by breakthroughs, they expected them. Please let me remind the reader that the alternative explanation is the real science fiction or fantasy. In this origin of UFOs a multitude of alien beings seemingly travel to earth from intergalactic space not to exchange ideas, exploit earth's resources or conquer the planet, but to abduct and inseminate our females. And above all, if we buy into this reasoning, these aliens seem particularly attracted to American women.

The story goes on from here to describe genetic experiments, mixing the DNA of humans and aliens to produce a hybrid human-alien. Anybody who entertains such nonsense has absolutely no understanding of the species concept in biology. Unfortunately, many individuals subscribing to the alien hypothesis fall into this category, even some with advanced degrees. Only one of two possibilities are within reason. The first is that these hominids are manifiested in the minds of the witnesses as the result of some black mind control project sponsored by the government. The second possibility is that they are the result of experimentation by the government involving human, hominoid or hominid genes. Either option is possible but both options are beyond the scope of this book. Both discussions are superfluous, however, since the topic of this book is UFOs, not aliens. "Aliens" have been used by the media and the government long enough to misdirect the inquiry into UFOs. Aliens are the ultimate "red herring".

In trying to crystallize these thoughts on the origin of UFOs, we are presented with two mutually exclusive hypotheses for the origin of flying saucers. The first is that they are a man-made technology. The second is that they are a non-man-made technology. In view of the fact that we now know the first senecio is true, why are we even considering holding on to the

262

second hypothesis? There is no reason for a duplicity of theory. If a failure to explain the facts is ever encountered in the "UFOs are man-made theory", then and only then are we justified in moving to another hypothesis.

Before signing off it is felt that an obligation exists to discuss another reason for the suppression of the German connection in the history of UFOs. English speakers sometimes recognize this as an unuttered truth once it is out in the open but many German speakers and others are usually well ahead of the curve on this one. Unfortunately, this is not going to be pleasant.

In some circles, the flying discs built by the Germans during the war are called "Nazi UFOs". Some may do this as a way to quickly name a concept but some others do this for an entirely different reason. The point that is being made is that technology usually does not adopt a political name. The atomic bomb dropped on the Japanese by the Americans was not called the "Democrat Bomb", for example, even though a Democrat was in power in the United States at the time. The Nazis are a special case, however, and this is a central problem and roadblock we encounter in researching their innovations.

The Nazis were defeated militarily by the Allies. Yet some in the media elite continue to fight this war. Of course, the Allies always win but that is not the purpose of their fight. The purpose is the nature of the Nazis themselves. The Nazis were not just a military machine. Hitler and his supporters brought other ideas with them into power. These ideas were historical, social, artistic, economic and scientific. In other words, the Nazis brought a completely new culture into prominence almost overnight and with at least the passive acceptance of most of the general populace.

It is sometimes said by these media people in question that America defines itself as what the Nazis were not. The fascination that the mass media, especially in Hollywood, has for the Nazis is evidenced in their ongoing campaign to insure that these cultural ideas are as thoroughly defeated as the Nazi military. In defeating the Nazis militarily on the silver screen they believe they also defeat the cultural ideas associated with the Nazis. They take every opportunity to do this. The media fight this propaganda war over and over again, as if the war was still going on, while attempting to link the military defeat of the Nazis with the cultural defeat of their ideas.

For a moment I want to digress in order to illustrate an example of exactly what I am talking about. This example is both germane to our discussion of UFOs as well as cutting to the very heart of this cultural conflict. It has to do with Hitler's myrmidons, the SS.

Historians tell us that the abbreviation "SS" stands for

263

"Schutzstaffel". "Schutzstaffel" could be thought of as "bodyguard" and in the early days of the Nazi movement members of this order dressed in black and were Hitler's personal bodyguard. As it developed, this order changed into many things.

Portrayal of the SS in the media has degenerated simply into a negative caricature to which we are all supposed to respond immediately with a politically correct, knee-jerk type of condemnation formula. As far as the media is concerned, this is all the SS was. Their point is that we now know enough about the SS and are supposed to drop further inquiry. This first unwritten law has already been violated in this book. In this discussion we have focussed on the SS as the organizational and in some cases the research and development framework behind German super-weapon's technology. But the SS was more than this. To insiders, initiates within the 3rd Reich, the abbreviation "SS" did not stand for "Schutzstaffel" at all but for the words "Schwarze Sonne".

"Schwarze Sonne" means "Black Sun" in English. The Black Sun to these initiated individuals was a physical body like our visible sun except that the Black Sun was not visible to the naked eye. This Black Sun radiated light which was invisible to the human eye. The concept of the Black Sun seems to have bordered upon the religious. It was said to be located at the center of our galaxy. The earth along with every other cellestial body in the gallaxy rotate around this Black Sun.

The Black Sun is sometimes represented symbolically as a black sphere out of which eight arms extend. Such is its most famous rendition on the mosaic floor at Wewelsburg Castle which served as the spiritual home of the SS. The number of arms are unimportant. There could be eight or six or only four. The more astute reader will recognize at this point that the swastika, the very icon of the Nazi Party, was itself is a Black Sun symbol.

The point is that concept of the Black Sun is not just Nazi mumbo-jumbo. The Black Sun is in reality a cold, collapsing implosive vortex as described by Viktor Schauberger or Karl Schappeller. It gathers and densities yet is as cold as interstellar space. It does generate unseen radiation in the form of cosmic, gamma and x-ray radiation. This is possible because in spite of what was said about those crazy "Nazi madmen", the Black Sun is very real. In fact, the Black Sun is the most powerful force yet observed in our universe.

Forty or so years after the demise of the SS, scientists, in this case astronomers, have located the Black Sun at the very center of our galaxy. In fact, we are all familiar with it by another name. Today, we call it a "black hole". It is the center of a great spiral vortex of stars which draws in matter and energy and generates the aforementioned radiations near it periphery. The Black Sun is, in reality, a huge system or perhaps it could even be called a huge machine. We and our entire galaxy are all part

264

of this machine whirling through space. All the matter it contains, the stars, planets, asteroids, comets, meteors and so forth, are all bound in a context of energy. Our galaxy, with the Black Sun as its heart, operates as a vast machine using all the matter and energy contained therein and using every law of physics at once in its operation. Its counterpart, the centrifugal vortex which remains unseen, may even be a doorway into another dimension into which this matter and energy from our dimension spew forth like a fountain. It is the same kind of implosive vortex from which the Germans were about to build a "new science" based upon creative, living energy as we have discussed. It may have been the same force which was to propel their flying discs.

Yet who in the media would dare give credit to those associated with the 3rd Reich for making these connections so long ago? In fact, who in the media would even point out this connection today? None. As far as they are concerned, one is politically incorrect to ever say or imply that the Nazis thought of or developed anything of value. To do so would be to commit professional suicide. To do so would mean the end of one's carrier whether in the business or the academic world. Even if one wanted to make this connection in print or film form, no politically correct publisher or producer would touch it, at least in English.

Not only does the media fail to give credit where credit is due, or to even mention or explain this concept, but anyone seeking to look into such concepts runs the real risk of being branded a neo-Nazi. This threat clearly extends into the UFO world. As a result, this threat has had a chilling effect on real UFO inquiry for over fifty years.

How should the media be treated in this case? How are we going to handle institutions within our culture which actively seek to stymie knowledge? Regardless of one's personal opinion of the Nazis, should we and are we going to allow these " open-minded champions of truth" the right to omit the history of UFOs, let alone the new science of this force of nature, simply because "they" find its origin politically offensive?

Returning from this example to our broader discussion of the media, in American culture it is sometimes said that the media's power rivals or exceeds that of the three branches of American government. With power such as this, the media believes itself up to any propaganda challenge. They are correct in this belief. As any thoughtful person realizes, the mass media's power has been used frequently in the last forty years to radically alter the course of those three branches of government.

In addition to the above referenced dilemma regarding media bias, we face a second obstacle in any effort to arrive at the truth. It is a culture of secrecy within the government itself. Vesco recognized this immediately. According to this "Vesco Doctrine"

265

no German secret was acknowledged publicly unless that secret fell into the hands of more than one of the four occupying powers, (USA, Soviet Union, Great Britain, France). He says:

"In fact, of the numerous revolutionary "new weapons" that the Germans developed in that period, we know only those-fortunately, they comprise the majority-that fell into the hands of all, or at least more than one, of the four occupying powers"(1).

These governments seem to keep secrets for the sake of keeping secrets. In any event, they operate on a "need to know" basis in dispensing these secrets. We simply have no need to know in their eyes.

The differences between the media and the government itself are becoming more and more blurred. Politicians rely of instant polls, conducted the night before by the media, to plot today's public policy. The results of these polls are whatever the media says they are. In the meantime, the media itself is doing everything it can through "news", through entertainment and through movies to influence the results of those polls. The media and the government are so closely intertwined that for all practical purposes they can be considered as one. The C.I.A. spends a large portion of its budget in an effort to frame public discussion on issues it deems sensitive. The point here is that "truth" is not the goal of the government and in accomplishing their ends they use the methods of the mass media if they are not in partnership with the mass media itself.

For almost sixty years this government/media has been telling us through their propaganda machine, "Hollywood", that all the ideas of the Nazis were meritless, if not dangerous. "The Nazis never had a good idea" seems to be their simplistic mantra. Of course government, at some level, know what you now know about the origins of UFOs. In fact, they know that there is much more to this still-secret high technology than just UFOs. In the past, they have no trouble using captured German scientists when it is in their interest to do so, but they hate to admit it. The problem they face is that they have boxed themselves in a corner. They can not admit the origins of UFO technology without a re-appraisal of other ideas which they have succeeded in putting to bed. If they were to admit one good "Nazi" idea, the question might arise as to if there is another good idea. The elite media has already preempted this question rhetorically, calling any re-appraisal of the Second World War "Revisionism". They use this word disparagingly. Using a sort of "new-speak" they have kept the genie bottled up for almost sixty years.

What does this all mean to the researcher or truth seeker? With enough evidence could this information ever be acknowledged officially? With what level of proof could this elite media/government power axis acknowledge the fact that Germans working for Hitler built experimental flying craft that we could

266

not even touch? The simple answer is that they can not do so,
period. Not with "all the proof in the world". Why should they?
What is the upside for them? There are no good Nazi ideas.
There is no need to know. There is perhaps a technological
breakthrough behind the mystery. This is a loose-loose-loose
situation for them by any reckoning.

Perhaps we can crystalize this nightmare for the power elite in
an image. Suppose that tomorrow a highly technically advanced
flying saucer landed on the White House steps in front of full,
live, media coverage. Their nightmare would not be a little grey
alien emerging from the saucer saying: "Take me to your leader".
Their nightmare would be a former SS scientist emerging from the
flying saucer saying: "I have an appointment".

The implications are obvious. For over forty years the UFO
community has been saying that we are on the verge of full
government UFO disclosure. For the reasons outlined above, we
are not now nor will we ever be on the verge of full UFO
disclosure by the government.

This means that it is up to us to do the "disclosure". Anyone
interested in doing research along these lines will be encouraged
to know that there is plenty of room in this field. It is not
necessary to be a scientist. It is not necessary to live in
Europe. It is not necessary to read German. The most important
ingredient in this research is interest. If you are interested,
there are mountains of government files which remain unexplored.
The censors did not edit-out everything. They made mistakes
which can be caught and pieced together. If each researcher
could contribute just one fact to this growing body of knowledge,
our trouble would be over quickly. In short, "Disclosure" isn't
going to happen unless we make it happen.

These scientists and technicians who built these early flying
sauces may have been the very best and brightest of their time
but they got up each morning and put their pants on just like the
rest of us. In fact, they are us. Now that we know that we
earthlings are capable of manufacturing objects we call UFOs,
should we not use these facts we possess in explaining this
phenomena rather than ignoring this information altogether?
Should we not cease creating a new and superfluous mythology, if
not an outright religion, to explain this phenomena which is
completely devoid of a factual basis? Real truth is usually
quite simple. In this case the real truth is that the origin of
UFOs and many more technological secrets are resting in the grave
of Nazi Germany, simply awaiting our re-discovery.

This has not been "The Complete Book of UFOs" or even "The
Complete Book of German Flying Discs". Within each topic touched
upon in this book lie worlds within worlds of details and

additional information. It is for the reader to use the references cited as a starting point to root out what is of interest. This book was designed to get you started. It was only a guide.

Concluding Thoughts-References

Vesco, Renato, 1976, Intercept UFO, page 96, Pinnacle Books, New York, NY.

THANKS

Most everyone who has ever looked in to the matter of German flying discs has come to the conclusion that there is at least some truth to it. Still, opinions and interpretations within this group differ with the individual doing the research. Nobody can know or find everything. This certainly is true of the study of German flying discs. Many researchers in this field have set up a circle of correspondence or exchange with others interested in this topic. Even the brightest, most hard working individuals have benefitted from an exchange of information.

I have written up this book by doing some research and receiving a great deal of help, input and information sent to me by my friends. My deepest thanks and appreciation' go out to those individuals who have shared their findings with me, explained their research to me and/or shared the counsel of their wisdom. This is true even in cases of disagreement or in cases of differing interpretations. In all cases, they have gone much beyond their published material. These include: Michael Blaeser, Rainer Daehnhardt, the late Joseph Andreas Epp, Dr. Gordon Freeman, Heiner Gehring, Friedrich Georg, Dr. Milos Jesensky, Kadmon, Mark Kneipp, Robert Lesniakiewicz, William Lyne, Thomas Mehner, Theo Paymans, Richard Ross, Klaus-Peter Rothkugel, Horst Schuppmann, Vladimir Terziski, Milos Vnenk and Michael Watson. I would also like to thank my daughter, Lisa Stevens, for her work in proof reading and editing this text.

DECLASSIFIED PER EXECUTIVE ORDER 12356, Section 3.3. NND 871508
By W/G Lewis MARS, Date Jan 29, 1985 SECRET

SECRET

DEPARTMENT OF THE AIR FORCE
HEADQUARTERS UNITED STATES AIR FORCE
WASHINGTON 25, D. C.

3 JAN 1952

AFOIN-4

MEMORANDUM FOR GENERAL SAMFORD

SUBJECT: (SECRET) Contemplated Action to Determine the Nature and
Origin of the Phenomena Connected with the Reports of Un-
usual Flying Objects

1. The continued reports of unusual flying objects requires
positive action to determine the nature and origin of this phenomena.
The action taken thus far can seem designed to track down and evaluate
reports from casual observers throughout the country. Thus far, this
action has produced results of doubtful value and the inconsistencies
inherent in the nature of the reports has given neither positive nor
negative proof of the claims.

2. It is logical to relate the reported sightings to the
known development of aircraft, jet propulsion, rockets and range
extension capabilities in Germany and the U.S.S.R. In this connec-
tion, it is to be noted that certain developments by the Germans,
particularly the Horton wing, jet propulsion, and refueling, com-
bined with their extensive employment of V-1 and V-2 weapons during
World War II, lend credence to the possibility that the flying objects
may be of German and Russian origin. The developments mentioned
above were completed and operational between 1941 and 1944 and sub-
sequently fell into the hands of the Soviets at the end of the war.
There is evidence that the Germans were working on these projects
as far back as 1931 to 1938. Therefore, it may be assumed that the
Germans had at least a 7 to 10 year lead over the United States in
the development of rockets, jet engines, and aircraft of the Horton-
wing design. The Air Corps developed refueling experimentally as
early as 1928, but did not develop operational capability until 1948.

3. In view of the above facts and the persistent reports of
unusual flying objects over parts of the United States, particularly
the east and west coast and in the vicinity of the atomic energy pro-
duction and testing facilities, it is apparent that positive action
must be taken to determine the nature of the objects and, if possible,
their origin. Since it is known fact that the Soviets did not detonate
an atomic bomb prior to 1949, it is believed possible that the Soviets
may have developed German aircraft designs at an accelerated rate
in order to have a suitable carrier for the delivery of weapons of mass
destruction. In other words, the Soviets may have a carrier without the
weapons required while we have relatively superior weapons with relatively
inferior carriers available. If the Soviets should get the carrier
and the weapon, combined with adequate defensive aircraft, they might
surpass us technologically for a sufficient period of time to permit
them to execute a decisive air campaign against the United States and
her allies. The basic philosophy of the Soviets has been to surpass
the western powers technologically and the Germans have given them
the opportunity.

4. In view of the facts outlined above, it is considered
mandatory that the Air Force take positive action at once to definitely
determine the nature and, if possible, the origin of the reported
unusual flying objects. The following action is now contemplated:

a. to require ATIC to provide at least three teams to
be matched up with an equal number of teams from ADC for the purpose
of taking radar scope photographs and visual photographs of the
phenomena;

b. to select sites for these teams, based on the concen-
trations of already reported sightings over the United States; (these
areas are, generally, the Seattle area, the Albuquerque area, and the
New York-Philadelphia area) and

c. to take the initial steps in this project during
early January 1952.

W. M. Garland
W. M. Garland
Brigadier General, USAF
Assistant for Production
Directorate of Intelligence

1 Incl
Tech. Rept #76-45

2. It is logical to relate the reported sightings to the
known development of aircraft, jet propulsion, rockets and range
extension capabilities in Germany and the U.S.S.R. In this connec-
tion, it is to be noted that certain developments by the Germans,
particularly the Horton wing, jet propulsion, and refueling, con-
bined with their extensive employment of V-1 and V-2 weapons during
World War II, lend credence to the possibility that the flying object
may be of German and Russian origin. The developments mentioned
above were completed and operational between 1941 and 1944 and sub-
sequently fell into the hands of the Soviets at the end of the war.
There is evidence that the Germans were working on these projects
as far back as 1931 to 1938. Therefore, it may be assumed that the
Germans had at least a 7 to 10 year lead over the United States in
the development of rockets, jet engines, and aircraft of the Horton-
wing design. The Air Corps developed refueling experimentally as
early as 1928, but did not develop operational capability until 1948.

Left, U.S. Air Force document, Jan. 3, 1952
Right, blowup of the second paragraph

The Adventures Unlimited
Catalog

Visit us online at:
www.adventuresunlimitedpress.com

CONSPIRACY & HISTORY

HITLER'S FLYING SAUCERS
A Guide to German Flying Discs of the Second World War
by Henry Stevens

Learn why the Schriever-Habermohl project was actually two projects and read the written statement of a German test pilot who actually flew one of the saucers; about the Leduc engine, the key to Dr. Miethe's saucer designs; how U.S. government officials kept the truth about foo fighters hidden for almost s years and how they were finally forced to "come clean" about the foo fighter's German origin. Learn of the Peenemuende saucer project and how it was sl to "go atomic." Read the testimony of a German eyewitness who saw "magnetic discs." Read the U.S. government's own reports on German field propuls saucers. Read how the post-war German KM-2 field propulsion "rocket" worked. Learn details of the work of Karl Schappeller and Viktor Schauber Learn how their ideas figure in the quest to build field propulsion flying discs. Find out what happened to this technology after the war. Find out how Canadians got saucer technology directly from the SS. Find out about the surviving "Third Power" of former Nazis. Learn of the U.S. government's meth of UFO deception and how they used the German "Sonderbueroll" as the model for Project Blue Book.
388 PAGES. 6x9 PAPERBACK. ILLUSTRATED. INDEX. $18.95. CODE: HFS

POPULAR PARANOIA
The Best of Steamshovel Press
edited by Kenn Thomas

This anthology exposes the biologocal warfare origins of AIDS; the Nation of Islam/Nazi link; the cult of Elizabeth Clare Prophet; the conspirato mind of John Judge; Marion Pettie and the shadowy Finders group in Washington, DC; demonic iconography; spies among the Rajneeshis; and m other parapolitical topics. Articles include: the Oklahoma City bombing writings of the late Jim Keith, as well as an article on Keith's own strange de a treatment of the death of Princess Diana, its connection to the Octopus and the Saudi aerospace contracts; and scholarship on the historic Illumi The book also includes the Steamshovel's last-ever interviews with the great Beat writers Allen Ginsberg and William S. Burroughs, and neuro Timothy Leary, and new views of the master Beat—Neal Cassady and Jack Kerouac's science fiction. August Publication.
308 PAGES. 8X10 PAPERBACK. ILLUSTRATED. $19.95. CODE: POPA

THE HISTORY OF THE KNIGHTS TEMPLARS
by Charles G. Addison, introduction by David Hatcher Childress

Chapters on the origin of the Templars, their popularity in Europe and their rivalry with the Knights of St. John, later to be known as the Knights Malta. Detailed information on the activities of the Templars in the Holy Land, and the 1312 AD suppression of the Templars in France and o countries, which culminated in the execution of Jacques de Molay and the continuation of the Knights Templars in England and Scotland; the forma of the society of Knights Templars in London; and the rebuilding of the Temple in 1816. Plus a lengthy intro about the lost Templar fleet and connections to the ancient North American sea routes.
395 PAGES. 6x9 PAPERBACK. ILLUSTRATED. $16.95. CODE: HKT

SAUNIER'S MODEL AND THE SECRET OF RENNES-LE-CHATEAU
The Priest's Final Legacy
by André Douzet

Berenger Saunière, the enigmatic priest of the French village of Rennes-le-Château, is rumored to have found the legendary treasure of the Cathars. But what became of it? In 1916, Saunière created his ultimate clue: he went to great expense to create a model of a region said to be the Calvary Mount, indicating the "Tomb of Jesus." But the region on the model does not resemble the region of Jerusalem. Did Saunière leave a clue as to the true location of his treasure? And what is that treasure? After years of research, André Douzet discovered this model—the only real clue Saunière left behind as to the nature and location of his treasure—and the possible tomb of Jesus.
116 PAGES. 6x9 PAPERBACK. ILLUSTRATED. BIBLIOGRAPHY. $12.00. CODE: SMOD

THE STONE PUZZLE OF ROSSLYN CHAPEL
by Philip Coppens

Rosslyn Chapel has fueled controversy and debate in past centuries, and also recently because of several world-bestselling books. Revered by Freemasons as a vital part of their history, believed by some to hold evidence of pre-Columbian voyages to America, assumed by others to hold important relics, from the Holy Grail to the Head of Christ, the Scottish chapel is a place full of mystery. The history of the chapel, its relationship to freemasonry and the family behind the scenes, the Sinclairs, is brought to life, incorporating new, previously forgo and heretofore unknown evidence. Significantly, the story is placed in the equally enigmatic landscape surrounding the chapel, which includes features f Templar commanderies to prehistoric markings, from an ancient kingly site to the South to Arthur's Seat directly north of the chapel. The true significance and meaning of the chapel is finally unveiled: it is a medieval stone book of esoteric knowledge "written" by the Sinclair family, one of the most powerful and wealthy families in Scotland, chosen patrons of Freemasonry.
124 PAGES. 6x9 PAPERBACK. ILLUSTRATED. $12.00. CODE: SPRC

THE SHADOW GOVERNMENT
Drugs, Guns, Oil and the Bush Dynasty
by Kenn Thomas

Thomas goes on the trail of a multi-armed hydra of oil interests, the CIA, organized crime and a huge team of hit men known as the Octopus. He explores the connection to the Bush family, its oil company, the development of the aerospace industry and secret technology. Inside: Prescott Bush sold aviation fuel to the Nazis during WWII; George Herbert Walker Bush's alleged early CIA years and his involvement in the Bay of Pigs fiasco which was called "Operation Zapata"; Was George H.W. Bush in Dallas on the day of JFK's assassination, and did he have any connection with other assassinations, including those of Martin Luther King and Robert F. Kennedy?; Why was Ronald Reagan nearly assassinated in Washington DC by a known Bush family associate?; What was the "deal" made to hold the Iran hostages unti inauguration of Reagan?; What was George H.W. Bush's real association with Iraq before the Gulf War?; What did current President George W. Bush know to the events of 9/11?; How do the family ties with Saudi Arabia affect the hunt for Osama bin Laden?; Dick Cheney's ties with Enron and Halliburton; mor
288 PAGES. 6x9 PAPERBACK. ILLUSTRATED. $16.00. CODE: SGOV

ARKTOS
The Myth of the Pole in Science, Symbolism, and Nazi Survival
by Joscelyn Godwin

A scholarly treatment of catastrophes, ancient myths and the Nazi Occult beliefs. Explored are the many tales of an ancient race sa have lived in the Arctic regions, such as Thule and Hyperborea. Progressing onward, the book looks at modern polar legends inclue the survival of Hitler, German bases in Antarctica, UFOs, the hollow earth, Agartha and Shambala, more.
220 PAGES. 6x9 PAPERBACK. ILLUSTRATED. $16.95. CODE: ARK

THE A.T. FACTOR
A Scientists Encounter with UFOs: Piece For A Jigsaw Part 3
by Leonard Cramp
British aerospace engineer Cramp began much of the scientific anti-gravity and UFO propulsion analysis back in 1955 with his landmark book *Space, Gravity & the Flying Saucer* (out-of-print and rare). His next books (available from Adventures Unlimited) *UFOs & Anti-Gravity: Piece for a Jig-Saw* and *The Cosmic Matrix: Piece for a Jig-Saw Part 2* began Cramp's in depth look into gravity control, free-energy, and the interlocking web of energy that pervades the universe. In this final book, Cramp brings to a close his detailed and controversial study of UFOs and Anti-Gravity.
324 PAGES. 6X9 PAPERBACK. ILLUSTRATED. BIBLIOGRAPHY. INDEX. $16.95. CODE: ATF

COSMIC MATRIX
Piece for a Jig-Saw, Part Two
by Leonard G. Cramp

Cosmic Matrix is the long-awaited sequel to his 1966 book *UFOs & Anti-Gravity: Piece for a Jig-Saw.* Cramp has had a long history of examining UFO phenomena and has concluded that UFOs use the highest possible aeronautic science to move in the way they do. Cramp examines anti-gravity effects and theorizes that this super-science used by the craft—described in detail in the book—can lift mankind into a new level of technology, transportation and understanding of the universe. The book takes a close look at gravity control, time travel, and the interlocking web of energy between all planets in our solar system with Leonard's unique technical diagrams. A fantastic voyage into the present and future!
364 PAGES. 6X9 PAPERBACK. ILLUSTRATED. BIBLIOGRAPHY. $16.00. CODE: CMX

UFOS AND ANTI-GRAVITY
Piece For A Jig-Saw
by Leonard G. Cramp
Leonard G. Cramp's 1966 classic book on flying saucer propulsion and suppressed technology is a highly technical look at the UFO phenomena by a trained scientist. Cramp first introduces the idea of 'anti-gravity' and introduces us to the various theories of gravitation. He then examines the technology necessary to build a flying saucer and examines in great detail the technical aspects of such a craft. Cramp's book is a wealth of material and diagrams on flying saucers, anti-gravity, suppressed technology, G-fields and UFOs. Chapters include Crossroads of Aerodymanics, Aerodynamic Saucers, Limitations of Rocketry, Gravitation and the Ether, Gravitational Spaceships, G-Field Lift Effects, The Bi-Field Theory, VTOL and Hovercraft, Analysis of UFO photos, more.
388 PAGES. 6X9 PAPERBACK. ILLUSTRATED. $16.95. CODE: UAG

THE ENERGY GRID
Harmonic 695, The Pulse of the Universe
by Captain Bruce Cathie.
This is the breakthrough book that explores the incredible potential of the Energy Grid and the Earth's Unified Field all around us. Cathie's first book, *Harmonic 33,* was published in 1968 when he was a commercial pilot in New Zealand. Since then, Captain Bruce Cathie has been the premier investigator into the amazing potential of the infinite energy that surrounds our planet every microsecond. Cathie investigates the Harmonics of Light and how the Energy Grid is created. In this amazing book are chapters on UFO Propulsion, Nikola Tesla, Unified Equations, the Mysterious Aerials, Pythagoras & the Grid, Nuclear Detonation and the Grid, Maps of the Ancients, an Australian Stonehenge examined, more.
255 PAGES. 6X9 TRADEPAPER. ILLUSTRATED. $15.95. CODE: TEG

THE BRIDGE TO INFINITY
Harmonic 371244
by Captain Bruce Cathie

Cathie has popularized the concept that the earth is crisscrossed by an electromagnetic grid system that can be used for anti-gravity, free energy, levitation and more. The book includes a new analysis of the harmonic nature of reality, acoustic levitation, pyramid power, harmonic receiver towers and UFO propulsion. It concludes that today's scientists have at their command a fantastic store of knowledge with which to advance the welfare of the human race.
204 PAGES. 6X9 TRADEPAPER. ILLUSTRATED. $14.95. CODE: BTF

THE HARMONIC CONQUEST OF SPACE
by Captain Bruce Cathie
Chapters include: Mathematics of the World Grid; the Harmonics of Hiroshima and Nagasaki; Harmonic Transmission and Receiving; the Link Between Human Brain Waves; the Cavity Resonance between the Earth; the Ionosphere and Gravity; Edgar Cayce—the Harmonics of the Subconscious; Stonehenge; the Harmonics of the Moon; the Pyramids of Mars; Nikola Tesla's Electric Car; the Robert Adams Pulsed Electric Motor Generator; Harmonic Clues to the Unified Field; and more. Also included are tables showing the harmonic relations between the earth's magnetic field, the speed of light, and anti-gravity/gravity acceleration at different points on the earth's surface. New chapters in this edition on the giant stone spheres of Costa Rica, Atomic Tests and Volcanic Activity, and a chapter on Ayers Rock analysed with Stone Mountain, Georgia.
248 PAGES. 6X9. PAPERBACK. ILLUSTRATED. BIBLIOGRAPHY. $16.95. CODE: HCS

MAN-MADE UFOS 1944—1994
Fifty Years of Suppression
by Renato Vesco & David Hatcher Childress

A comprehensive look at the early "flying saucer" technology of Nazi Germany and the genesis of man-made UFOs. This book takes us from the work of captured German scientists to escaped battalions of Germans, secret communities in South America and Antarctica to todays state-of-the-art "Dreamland" flying machines. Heavily illustrated, this astonishing book blows the lid off the "government UFO conspiracy" and explains with technical diagrams the technology involved. Examined in detail are secret underground airfields and factories; German secret weapons; "suction" aircraft; the origin of NASA; gyroscopic stabilizers and engines; the secret Marconi aircraft factory in South America; and more. Introduction by W.A. Harbinson, author of the Dell novels *GENESIS* and *REVELATION.*
318 PAGES. 6X9 PAPERBACK. ILLUSTRATED. INDEX & FOOTNOTES. $18.95. CODE: MMU

24 hour credit card orders—call: 815-253-6390 fax: 815-253-6300
email: auphq@frontiernet.net www.adventuresunlimitedpress.com www.wexclub.com

FREE ENERGY SYSTEMS

LOST SCIENCE
by Gerry Vassilatos

Rediscover the legendary names of suppressed scientific revolution—remarkable lives, astounding discoveries, and incredible inventions which would ha produced a world of wonder. How did the aura research of Baron Karl von Reichenbach prove the vitalistic theory and frighten the greatest minds of German How did the physiophone and wireless of Antonio Meucci predate both Bell and Marconi by decades? How does the earth battery technology of Nath Stubblefield portend an unsuspected energy revolution? How did the geoaetheric engines of Nikola Tesla threaten the establishment of a fuel-dependa America? The microscopes and virus-destroying ray machines of Dr. Royal Rife provided the solution for every world-threatening disease. Why did the FDA a AMA together condemn this great man to Federal Prison? The static crashes on telephone lines enabled Dr. T. Henry Moray to discover the reality of radiant sp energy. Was the mysterious "Swedish stone," the powerful mineral which Dr. Moray discovered, the very first historical instance in which stellar power v recognized and secured on earth? Why did the Air Force initially fund the gravitational warp research and warp-cloaking devices of T. Townsend Brown and th reject it? When the controlled fusion devices of Philo Farnsworth achieved the "break-even" point in 1967 the FUSOR project was abruptly cancelled by I'l

304 PAGES. 6x9 PAPERBACK. ILLUSTRATED. BIBLIOGRAPHY. $16.95. CODE: LOS

SECRETS OF COLD WAR TECHNOLOGY
Project HAARP and Beyond
by Gerry Vassilatos

Vassilatos reveals that "Death Ray" technology has been secretly researched and developed since the turn of the century. Included are chapters o such inventors and their devices as H.C. Vion, the developer of auroral energy receivers; Dr. Selim Lemström's pre-Tesla experiments; the ear beam weapons of Grindell-Mathews, Ulivi, Turpain and others; John Hettenger and his early beam power systems. Learn about Project Argu Project Teak and Project Orange; EMP experiments in the 60s; why the Air Force directed the construction of a huge Ionospheric "backscatter telemetry system across the Pacific just after WWII; why Raytheon has collected every patent relevant to HAARP over the past few years; more

250 PAGES. 6x9 PAPERBACK. ILLUSTRATED. $15.95. CODE: SCWT

QUEST FOR ZERO-POINT ENERGY
Engineering Principles for "Free Energy"
by Moray B. King

King expands, with diagrams, on how free energy and anti-gravity are possible. The theories of zero point energy maintain there are tremendous fluctuations of electrical field energy embedded within the fabric of space. King explains the following topics: Tapping the Zero-Point Energy as an Energy Source; Fundamentals of a Zero-Point Energy Technology; Vacuum Energy Vortices; The Super Tube; Charge Clusters: The Basis of Zero-Point Energy Inventions; Vortex Filaments, Torsion Fields and the Zero-Point Energy; Transforming the Planet with a Zero-Point Energy Experiment; Dual Vortex Forms: The Key to a Large Zero-Point Energy Coherence. Packed with diagrams, patents and photos. With power shortages now a daily reality in many parts of the world, this book offers a fresh approach very rarely mentioned in the mainstream media.

224 PAGES. 6x9 PAPERBACK. ILLUSTRATED. $14.95. CODE: QZPE

Quest For
Zero Point
Energy

Engineering Principles
For "Free Energy"

Moray B. King

THE TIME TRAVEL HANDBOOK
A Manual of Practical Teleportation & Time Travel
edited by David Hatcher Childress

In the tradition of *The Anti-Gravity Handbook* and *The Free-Energy Device Handbook*, science and UFO author David Hatcher Childress takes us into the wei world of time travel and teleportation. Not just a whacked-out look at science fiction, this book is an authoritative chronicling of real-life time travel experimen teleportation devices and more. *The Time Travel Handbook* takes the reader beyond the government experiments and deep into the uncharted territory of ea time travellers such as Nikola Tesla and Guglielmo Marconi and their alleged time travel experiments, as well as the Wilson Brothers of EMI and their connectic to the Philadelphia Experiment—the U.S. Navy's forays into invisibility, time travel, and teleportation. Childress looks into the claims of time travelli individuals, and investigates the unusual claim that the pyramids on Mars were built in the future and sent back in time. A highly visual, large format book, w patents, photos and schematics. Be the first on your block to build your own time travel device!

316 PAGES. 7x10 PAPERBACK. ILLUSTRATED. $16.95. CODE: TTH

THE TESLA PAPERS
Nikola Tesla on Free Energy & Wireless Transmission of Power
by Nikola Tesla, edited by David Hatcher Childress

David Hatcher Childress takes us into the incredible world of Nikola Tesla and his amazing inventions. Tesla's rare article "The Problem of Increas Human Energy with Special Reference to the Harnessing of the Sun's Energy" is included. This lengthy article was originally published in the June 1 issue of *The Century Illustrated Monthly Magazine* and it was the outline for Tesla's master blueprint for the world. Tesla's fantastic vision of the futu including wireless power, anti-gravity, free energy and highly advanced solar power. Also included are some of the papers, patents and material collec on Tesla at the Colorado Springs Tesla Symposiums, including papers on: •The Secret History of Wireless Transmission •Tesla and the Magnify Transmitter •Design and Construction of a Half-Wave Tesla Coil •Electrostatics: A Key to Free Energy •Progress in Zero-Point Energy Resea •Electromagnetic Energy from Antennas to Atoms •Tesla's Particle Beam Technology •Fundamental Excitatory Modes of the Earth-Ionosphere Ca

325 PAGES. 8x10 PAPERBACK. ILLUSTRATED. $16.95. CODE: TTP

THE FANTASTIC INVENTIONS OF NIKOLA TESLA
by Nikola Tesla with additional material by David Hatcher Childress

This book is a readable compendium of patents, diagrams, photos and explanations of the many incredible inventions of the originator of the mode era of electrification. In Tesla's own words are such topics as wireless transmission of power, death rays, and radio-controlled airships. In additio rare material on German bases in Antarctica and South America, and a secret city built at a remote jungle site in South America by one of Tesl students, Guglielmo Marconi. Marconi's secret group claims to have built flying saucers in the 1940s and to have gone to Mars in the early 195 Incredible photos of these Tesla craft are included. The Ancient Atlantean system of broadcasting energy through a grid system of obelisks a pyramids is discussed, and a fascinating concept comes out of one chapter: that Egyptian engineers had to wear protective metal head-shields wh in these power plants, hence the Egyptian Pharoah's head covering as well as the Face on Mars! •His plan to transmit free electricity into atmosphere. •How electrical devices would work using only small antennas. •Why unlimited power could be utilized anywhere on earth. •He radio and radar technology can be used as death-ray weapons in Star Wars.

342 PAGES. 6x9 PAPERBACK. ILLUSTRATED. $16.95. CODE: FINT

ANTI-GRAVITY

THE FREE-ENERGY DEVICE HANDBOOK
A Compilation of Patents and Reports
by David Hatcher Childress

A large-format compilation of various patents, papers, descriptions and diagrams concerning free-energy devices and systems. *The Free-Energy Device Handbook* is a visual tool for experimenters and researchers into magnetic motors and other "overunity" devices. With chapters on the Adams Motor, the Hans Coler Generator, cold fusion, superconductors, "N" machines, space-energy generators, Nikola Tesla, T. Townsend Brown, and the latest in free-energy devices. Packed with photos, technical diagrams, patents and fascinating information, this book belongs on every science shelf. With energy and profit being a major political reason for fighting various wars, free-energy devices, if ever allowed to be mass distributed to consumers, could change the world! Get your copy now before the Department of Energy bans this book!
292 PAGES. 8x10 PAPERBACK. ILLUSTRATED. BIBLIOGRAPHY. $16.95. CODE: FEH

THE ANTI-GRAVITY HANDBOOK
edited by David Hatcher Childress, with Nikola Tesla, T.B. Paulicki,
Bruce Cathie, Albert Einstein and others

The new expanded compilation of material on Anti-Gravity, Free Energy, Flying Saucer Propulsion, UFOs, Suppressed Technology, NASA Cover-ups and more. Highly illustrated with patents, technical illustrations and photos. This revised and expanded edition has more material, including photos of Area 51, Nevada, the government's secret testing facility. This classic on weird science is back in a 90s format!
• How to build a flying saucer.
•Arthur C. Clarke on Anti-Gravity.
• Crystals and their role in levitation.
• Secret government research and development.
• Nikola Tesla on how anti-gravity airships could
 draw power from the atmosphere.
• Bruce Cathie's Anti-Gravity Equation.
• NASA, the Moon and Anti-Gravity.
230 PAGES. 7x10 PAPERBACK. BIBLIOGRAPHY/INDEX/APPENDIX. HIGHLY ILLUSTRATED. $14.95. CODE: AGH

ANTI–GRAVITY & THE WORLD GRID

Is the earth surrounded by an intricate electromagnetic grid network offering free energy? This compilation of material on ley lines and world power points contains chapters on the geography, mathematics, and light harmonics of the earth grid. Learn the purpose of ley lines and ancient megalithic structures located on the grid. Discover how the grid made the Philadelphia Experiment possible. Explore the Coral Castle and many other mysteries, including acoustic levitation, Tesla Shields and scalar wave weaponry. Browse through the section on anti-gravity patents, and research resources.
274 PAGES. 7x10 PAPERBACK. ILLUSTRATED. $14.95. CODE: AGW

ANTI–GRAVITY & THE UNIFIED FIELD
edited by David Hatcher Childress

Is Einstein's Unified Field Theory the answer to all of our energy problems? Explored in this compilation of material is how gravity, electricity and magnetism manifest from a unified field around us. Why artificial gravity is possible; secrets of UFO propulsion; free energy; Nikola Tesla and anti-gravity airships of the 20s and 30s; flying saucers as superconducting whirls of plasma; anti-mass generators; vortex propulsion; suppressed technology; government cover-ups; gravitational pulse drive; spacecraft & more.
240 PAGES. 7x10 PAPERBACK. ILLUSTRATED. $14.95. CODE: AGU

ETHER TECHNOLOGY
A Rational Approach to Gravity Control
by Rho Sigma

This classic book on anti-gravity and free energy is back in print and back in stock. Written by a well-known American scientist under the pseudonym of "Rho Sigma," this book delves into international efforts at gravity control and discoid craft propulsion. Before the Quantum Field, there was "Ether." This small, but informative books has chapters on John Searle and "Searle discs;" T. Townsend Brown and his work on anti-gravity and ether-vortex turbines. Includes a forward by former NASA astronaut Edgar Mitchell.
108 PAGES. 6x9 PAPERBACK. ILLUSTRATED. $12.95. CODE: ETT

TAPPING THE ZERO POINT ENERGY
Free Energy & Anti-Gravity in Today's Physics
by Moray B. King

King explains how free energy and anti-gravity are possible. The theories of the zero point energy maintain there are tremendous fluctuations of electrical field energy imbedded within the fabric of space. This book tells how, in the 1930s, inventor T. Henry Moray could produce a fifty kilowatt "free energy" machine; how an electrified plasma vortex creates anti-gravity; how the Pons/Fleischmann "cold fusion" experiment could produce tremendous heat without fusion; and how certain experiments might produce a gravitational anomaly.

190 PAGES. 5x8 PAPERBACK. ILLUSTRATED. $12.95. CODE: TAP

CONSPIRACY & HISTORY

LIQUID CONSPIRACY
JFK, LSD, the CIA, Area 51 & UFOs
by George Piccard
Underground author George Piccard on the politics of LSD, mind control, and Kennedy's involvement with Area 51 and UFOs. Reveals JFK's L experiences with Mary Pinchot-Meyer. The plot thickens with an ever expanding web of CIA involvement, from underground bases with UFOs se by JFK and Marilyn Monroe (among others) to a vaster conspiracy that affects every government agency from NASA to the Justice Department. T may have been the reason that Marilyn Monroe and actress-columnist Dorothy Kilgallen were both murdered. Focusing on the bizarre side of histo *Liquid Conspiracy* takes the reader on a psychedelic tour de force. This is your government on drugs!
264 PAGES. 6x9 PAPERBACK. ILLUSTRATED. $14.95. CODE: LIQC

INSIDE THE GEMSTONE FILE
Howard Hughes, Onassis & JFK
by Kenn Thomas & David Hatcher Childress
Steamshovel Press editor Thomas takes on the Gemstone File in this run-up and run-down of the most famous underground document ever circulat Photocopied and distributed for over 20 years, the Gemstone File is the story of Bruce Roberts, the inventor of the synthetic ruby widely used in la technology today, and his relationship with the Howard Hughes Company and ultimately with Aristotle Onassis, the Mafia, and the CIA. Hug kidnapped and held a drugged-up prisoner for 10 years; Onassis and his role in the Kennedy Assassination; how the Mafia ran corporate America the 1960s; the death of Onassis's son in the crash of a small private plane in Greece; Onassis as Ian Fleming's archvillain Ernst Stavro Blofeld; mo 320 PAGES. 6x9 PAPERBACK. ILLUSTRATED. $16.00. CODE: IGF

WHO KILLED DIANA?
by Peter Hounam and Derek McAdam
Hounam and McAdam take the reader through a land of unofficial branches of secret services, professional assassins, Psy-Ops, "Feather Men," remote-controlled cars, and ancient clandestine societies protecting the British establishment. They sort through a web of traceless drugs and poisons, inexplicable caches of money, fuzzy photographs, phantom cars of changing color, a large mysterious dog, and rivals in class and ethnic combat to answer the question, Who Killed Diana?! After this book was published, Mohammed El Fayed held an international news conference to announce that evidence showed that a blinding flash of light had contributed to the crash.
218 PAGES. 6x9 PAPERBACK. ILLUSTRATED. $12.95. CODE: WKD

Who Killed Diana?

Peter Hounam and Derek McAdam

THE ARCH CONSPIRATOR
Essays and Actions
by Len Bracken
Veteran conspiracy author Len Bracken's witty essays and articles lead us down the dark corridors of conspiracy, politics, murder and mayhem. In 12 chapters Brac takes us through a maze of interwoven tales from the Russian Conspiracy to his interview with Costa Rican novelist Joaquin Gutierrez and his Psychogeographic Map the Third Millennium. Other chapters in the book are A General Theory of Civil War; The New-Catiline Conspiracy for the Cancellation of Debt; Anti-Labor Day; t with selected Aphorisms Against Work; Solar Economics; and more. Bracken's work has appeared in such pop-conspiracy publications as *Paranoia*, *Steamshovel P* and the *Village Voice*. Len Bracken lives in Arlington, Virginia and haunts the back alleys of Washington D.C., keeping an eye on the predators who run our country 256 PAGES. 6x9 PAPERBACK. ILLUSTRATED. BIBLIOGRAPHY. $14.95. CODE: ACON.

MIND CONTROL, WORLD CONTROL
by Jim Keith
Veteran author and investigator Jim Keith uncovers a surprising amount of information on the technology, experimentation implementation of mind control. Various chapters in this shocking book are on early CIA experiments such as Project Artichoke Project R.H.I.C.-EDOM, the methodology and technology of implants, mind control assassins and couriers, various famous M Control victims such as Sirhan Sirhan and Candy Jones. Also featured in this book are chapters on how mind control technology r be linked to some UFO activity and "UFO abductions."
256 PAGES. 6x9 PAPERBACK. ILLUSTRATED. FOOTNOTES. $14.95. CODE: MCWC

NASA, NAZIS & JFK:
The Torbitt Document & the JFK Assassination
introduction by Kenn Thomas
This book emphasizes the links between "Operation Paper Clip" Nazi scientists working for NASA, the assassination of JFK, and the secret Nevada air base Area 51. The Torbitt Document also talks about the roles played in the assassination by Division Five of the FBI, the Defense Industrial Security Command (DISC), the Las Vegas mob, and the shadow corporate entities Permindex and Centro-Mondiale Commerciale. The Torbitt Document claims that the same players planned the 1962 assassination attempt on Charles de Gaul, who ultimately pulled out of NATO because he traced the "Assassination Cabal" to Permindex in Switzerland and to NATO headquarters in Brussels. The Torbitt Document paints a dark picture of NASA, the military industrial complex, and the connections to Mercury, Nevada which headquarters the "secret space program."
258 PAGES. 5x8. PAPERBACK. ILLUSTRATED. $16.00. CODE: NNJ

MIND CONTROL, OSWALD & JFK:
Were We Controlled?
introduction by Kenn Thomas
Steamshovel Press editor Kenn Thomas examines the little-known book *Were We Controlled?*, first published in 1968. The book's author, the myst ous Lincoln Lawrence, maintained that Lee Harvey Oswald was a special agent who was a mind control subject, having received an implant in 196C a Russian hospital. Thomas examines the evidence for implant technology and the role it could have played in the Kennedy Assassination. Thomas a looks at the mind control aspects of the RFK assassination and details the history of implant technology. A growing number of people are interested CIA experiments and its "Silent Weapons for Quiet Wars." Looks at the case that the reporter Damon Runyon, Jr. was murdered because of this bo 256 PAGES. 6x9 PAPERBACK. ILLUSTRATED. NOTES. $16.00. CODE: MCOJ

24 hour credit card orders—call: 815-253-6390 fax: 815-253-6300
email: auphq@frontiernet.net www.adventuresunlimitedpress.com www.wexclub.com

CONSPIRACY & HISTORY

REICH OF THE BLACK SUN
Nazi Secret Weapons and the Cold War Allied Legend
by Joseph P. Farrell

Why were the Allies worried about an atom bomb attack by the Germans in 1944? Why did the Soviets threaten to use poison gas against the Germans? Why did Hitler in 1945 insist that holding Prague could win the war for the Third Reich? Why did US General George Patton's Third Army race for the Skoda works at Pilsen in Czechoslovakia instead of Berlin? Why did the US Army not test the uranium atom bomb it dropped on Hiroshima? Why did the Luftwaffe fly a non-stop round trip mission to within twenty miles of New York City in 1944? *Reich of the Black Sun* takes the reader on a scientific-historical journey in order to answer these questions. Arguing that Nazi Germany actually won the race for the atom bomb in late 1944, and then goes on to explore the even more secretive research the Nazis were conducting into the occult, alternative physics and new energy sources.
352 PAGES. 6X9 PAPERBACK. ILLUSTRATED. BIBLIOGRAPHY. $16.95. CODE: ROBS

SAUCERS OF THE ILLUMINATI
by Jim Keith, Foreword by Kenn Thomas

Seeking the truth behind stories of alien invasion, secret underground bases, and the secret plans of the New World Order, *Saucers of the Illuminati* offers ground breaking research, uncovering clues to the nature of UFOs and to forces even more sinister: the secret cabal behind planetary control! Includes mind control, saucer abductions, the MJ-12 documents, cattle mutilations, government anti-gravity testing, the Sirius Connection, science fiction author Philip K. Dick and his efforts to expose the Illuminati, plus more from veteran conspiracy and UFO author Keith. Conspiracy expert Keith's final book on UFOs and the highly secret group that manufactures them and uses them for their own purposes: the control and manipulation of the population of planet Earth.
148 PAGES. 6X9 PAPERBACK. ILLUSTRATED. $12.95. CODE: SOIL

TECHNOLOGY OF THE GODS
The Incredible Sciences of the Ancients
by David Hatcher Childress

Popular *Lost Cities* author David Hatcher Childress takes us into the amazing world of ancient technology, from computers in antiquity to the "flying machines of the gods." Childress looks at the technology that was allegedly used in Atlantis and the theory that the Great Pyramid of Egypt was originally a gigantic power station. He examines tales of ancient flight and the technology that it involved; how the ancients used electricity; megalithic building techniques; the use of crystal lenses and the fire from the gods; evidence of various high tech weapons in the past, including atomic weapons; ancient metallurgy and heavy machinery; the role of modern inventors such as Nikola Tesla in bringing ancient technology back into modern use; impossible artifacts; and more.
356 PAGES. 6X9 PAPERBACK. ILLUSTRATED. BIBLIOGRAPHY. $16.95. CODE: TGOD.

THE ORION PROPHECY
Egyptian & Mayan Prophecies on the Cataclysm of 2012
by Patrick Geryl and Gino Ratinckx

In the year 2012 the Earth awaits a super catastrophe: its magnetic field reverse in one go. Phenomenal earthquakes and tidal waves will completely destroy our civilization. Europe and North America will shift thousands of kilometers northwards into polar climes. Nearly everyone will perish in the apocalyptic happenings. These dire predictions stem from the Mayans and Egyptians—descendants of the legendary Atlantis. The Atlanteans had highly evolved astronomical knowledge and were able to exactly predict the previous world-wide flood in 9792 BC. Orion and several others stars will take the same 'code-positions' as in 9792 BC! For thousands of years historical sources have told of a forgotten time capsule of ancient wisdom located in a mythical labyrinth of secret chambers filled with artifacts and documents from the previous flood.
324 PAGES. 6X9 PAPERBACK. ILLUSTRATED. BIBLIOGRAPHY. $16.95. CODE: ORP

DARK MOON
Apollo and the Whistleblowers
by Mary Bennett and David Percy

•Did you know that 'live' color TV from the Moon was not actually live at all?
•Did you know that the Lunar Surface Camera had no viewfinder?
•Do you know that lighting was used in the Apollo photographs—yet no lighting equipment was taken to the Moon?
All these questions, and more, are discussed in great detail by British researchers Bennett and Percy in *Dark Moon*, the definitive book (nearly 600 pages) on the possible faking of the Apollo Moon missions. Bennett and Percy delve into every possible aspect of this beguiling theory, one that rocks the very foundation of our beliefs concerning NASA and the space program. Tons of NASA photos analyzed for possible deceptions.
568 PAGES. 6X9 PAPERBACK. ILLUSTRATED. BIBLIOGRAPHY. INDEX. $25.00. CODE: DMO

WAKE UP DOWN THERE!
The Excluded Middle Anthology
by Greg Bishop

The great American tradition of dropout culture makes it over the millennium mark with a collection of the best from *The Excluded Middle*, the critically acclaimed underground zine of UFOs, the paranormal, conspiracies, psychedelia, and spirit. Contributions from Robert Anton Wilson, Ivan Stang, Martin Kottmeyer, John Shirley, Scott Corrales, Adam Gorightly and Robert Sterling; and interviews with James Moseley, Karla Turner, Bill Moore, Kenn Thomas, Richard Boylan, Dean Radin, Joe McMoneagle, and the mysterious Ira Einhorn (an *Excluded Middle* exclusive). Includes full versions of interviews and extra material not found in the newsstand versions.
420 PAGES. 8X11 PAPERBACK. ILLUSTRATED. $25.00. CODE: WUDT

ARKTOS
The Myth of the Pole in Science, Symbolism, and Nazi Survival
by Joscelyn Godwin

A scholarly treatment of catastrophes, ancient myths and the Nazi Occult beliefs. Explored are the many tales of an ancient race said to have lived in the Arctic regions, such as Thule and Hyperborea. Progressing onward, the book looks at modern polar legends including the survival of Hitler, German bases in Antarctica, UFOs, the hollow earth, Agartha and Shambala, more.
220 PAGES. 6X9 PAPERBACK. ILLUSTRATED. $16.95. CODE: ARK

24 hour credit card orders—call: 815-253-6390 fax: 815-253-6300
email: auphq@frontiernet.net www.adventuresunlimitedpress.com www.wexclub.com

PIRATES & THE LOST TEMPLAR FLEET
The Secret Naval War Between the Templars & the Vatican
by David Hatcher Childress

Childress takes us into the fascinating world of maverick sea captains who were Knights Templar (and later Scottish Rite Free Masons) who battled the Vatican and the Spanish and Italian ships that sailed for the Pope. The lost Templar fleet was originally based at La Rochelle in southern France, but fled to the deep fiords of Scotland upon the dissolution of the Order by King Phillip. This banned fleet of ships was later commanded by the St. Clair family of Rosslyn Chapel (birthplace of Free Masonry). St. Clair and his Templars made a voyage to Canada in the year 1298 AD, nearly 100 years before Columbus! Later, this fleet of ships and new ones to come, flew the Skull and Crossbones, the symbol of the Knights Templar. They preyed on the ships of the Vatican coming from the rich ports of the Americas and were ultimately known as the Pirates of the Caribbean. Chapters include: 10,000 Years of Seafaring; The Knights Templar & the Crusades; The Templars and the Assassins; The Lost Templar Fleet and the Jolly Roger; Maps of the Ancient Sea Kings; Pirates, Templars and the New World; Christopher Columbus—Secret Templar Pirate?; Later Day Pirates and the War with the Vatican; Pirate Utopias and the New Jerusalem; more.

320 PAGES. 6x9 PAPERBACK. ILLUSTRATED. BIBLIOGRAPHY. $16.95. CODE: PLTF

CLOAK OF THE ILLUMINATI
Secrets, Transformations, Crossing the Star Gate
by William Henry

Thousands of years ago the stargate technology of the gods was lost. Mayan Prophecy says it will return by 2012, along with our alignment with the center of our galaxy. In this book: Find examples of stargates and wormholes in the ancient world; Examine myths and scripture with hidden references to a stargate cloak worn by Mari, Nimrod, Elijah, and Jesus; See rare images of gods and goddesses wearing the Cloak of the illuminati; Learn about Saddam Hussein and the secret missing library of Jesus; Uncover the secret Roman-era eugenics experiments at the Temple of Hathor in Denderah, Egypt; Explore the duplicate of the Stargate Pillar of the Gods in the Illuminists' secret garden in Nashville; Discover the secrets of manna, the food of the angels, Jesus and the Illuminati; more. Chapters include: Seven Stars Under Three Stars; The Long Walk; Squaring the Circle; The Mill of the Host; The Miracle Garment; The Fig; Nimrod: The Mighty Man; Nebuchadnezzar's Gate; The New Mighty Man; more.

238 PAGES. 6x9 PAPERBACK. ILLUSTRATED. BIBLIOGRAPHY. INDEX. $16.95. CODE: COIL

GUARDIANS OF THE HOLY GRAIL
by Mark Amaru Pinkham

Although the Templar Knights had been schooled in the legend of Jesus Christ and his famous chalice while in their homeland of France, during their one hundred years in the Holy Land they discovered that Jesus's Holy Grail was but one of a long line of Holy Grail manifestations, and that a lineage of Guardians of the Holy Grail had existed in Asia for thousands of years prior to the birth of the Messiah. This book presents this extremely ancient Holy Grail lineage from Asia and how the Knights Templar were initiated into it. It also reveals how the ancient Asian wisdom regarding the Holy Grail became the foundation for the Holy Grail legends of the west while also serving as the bedrock of the European Secret Societies, which included the Freemasons, Rosicrucians, and the Illuminati. Also: The Fisher Kings; The Middle Eastern mystery schools, such as the Assassins and Yezidhi; The ancient Holy Grail lineage from Sri Lanka and the Templar Knights' initiation into it; The head of John the Baptist and its importance to the Templars; The secret Templar initiation with grotesque Baphomet, the infamous Head of Wisdom; more.

248 PAGES. 6x9 PAPERBACK. ILLUSTRATED. BIBLIOGRAPHY. $16.95. CODE: GOHG

RETURN OF THE SERPENTS OF WISDOM
by Mark Amaru Pinkham

According to ancient records, the patriarchs and founders of the early civilizations in Egypt, India, China, Peru, Mesopotamia, Britain, and the Americas were the Serpents of Wisdom—spiritual masters associated with the serpent—who arrived in these lands after abandoning their beloved homelands and crossing great seas. While bearing names denoting snake or dragon (such as Naga, Lung, Djedhi, Amaru, Quetzalcoatl, Adder, etc.), these Serpents of Wisdom oversaw the construction of magnificent civilizations within which they and their descendants served as the priest kings and as the enlightened heads of mystery school traditions. Pinkham recounts the history of these "Serpents"—where they came from, why they came, the secret wisdom they disseminated, and why they are returning now.

400 PAGES. 6x9 PAPERBACK. ILLUSTRATED. REFERENCES. $16.95. CODE: RSW

THE STONE PUZZLE OF ROSSLYN CHAPEL
by Philip Coppens

Rosslyn Chapel is revered by Freemasons as a vital part of their history, believed by some to hold evidence of pre-Columbian voyages to America, assumed by others to hold important relics, from the Holy Grail to the Head of Christ, the Scottish chapel is a place full of mystery. The history of the chapel, its relationship to freemasonry and the family behind the scenes, the Sinclairs, is brought to life, incorporating new, previously forgotten and heretofore unknown evidence. Significantly, the story is placed in the equally enigmatic landscape surrounding the chapel, which includes features from Templar commanderies to prehistoric markings from an ancient kingly site to the South to Arthur's Seat directly north of the chapel. The true significance and meaning of the chapel is finally unveiled: it is a medieval stone book of esoteric knowledge "written" by the Sinclair family, one of the most powerful and wealthy families in Scotland, chosen patrons of Freemasonry.

124 PAGES. 6x9 PAPERBACK. ILLUSTRATED. $12.00. CODE: SPRC

THE HISTORY OF THE KNIGHTS TEMPLARS
by Charles G. Addison, introduction by David Hatcher Childress

Chapters on the origin of the Templars, their popularity in Europe and their rivalry with the Knights of St. John, later to be known as the Knights of Malta. Detailed information on the activities of the Templars in the Holy Land, and the 1312 AD suppression of the Templars in France and other countries, which culminated in the execution of Jacques de Molay and the continuation of the Knights Templars in England and Scotland; the formation of the society of Knights Templars in London; and the rebuilding of the Temple in 1816. Plus a lengthy intro about the lost Templar fleet and its North American sea routes.

395 PAGES. 6x9 PAPERBACK. ILLUSTRATED. $16.95. CODE: HKT

SAUNIER'S MODEL AND THE SECRET OF RENNES-LE-CHATEAU
The Priest's Final Legacy
by André Douzet

Berenger Saunière, the enigmatic priest of the French village of Rennes-le-Château, is rumored to have found the legendary treasure of the Cathars. But what became of it? In 1916, Sauniere created his ultimate clue: he went to great expense to create a model of a region said to be the Calvary Mount, indicating the "Tomb of Jesus." But the region on the model does not resemble the region of Jerusalem. Did Saunière leave a clue as to the true location of his treasure? And what is that treasure? After years of research, André Douzet discovered this model—the only real clue Saunière left behind as to the nature and location of his treasure—and the possible tomb of Jesus.

116 PAGES. 6x9 PAPERBACK. ILLUSTRATED. BIBLIOGRAPHY. $12.00. CODE: SMOD

24 hour credit card orders—call: 815-253-6390 fax: 815-253-6300
email: auphq@frontiernet.net www.adventuresunlimitedpress.com www.wexclub.com

LOST CITIES

LOST CITIES OF ATLANTIS, ANCIENT EUROPE & THE MEDITERRANEAN
by David Hatcher Childress

Atlantis! The legendary lost continent comes under the close scrutiny of maverick archaeologist David Hatcher Childress in this sixth book in the internationally popular *Lost Cities* series. Childress takes the reader in search of sunken cities in the Mediterranean; across the Atlas Mountains in search of Atlantean ruins; to remote islands in search of megalithic ruins; to meet living legends and secret societies. From Ireland to Turkey, Morocco to Eastern Europe, and around the remote islands of the Mediterranean and Atlantic, Childress takes the reader on an astonishing quest for mankind's past. Ancient technology, cataclysms, megalithic construction, lost civilizations and devastating wars of the past are all explored in this book. Childress challenges the skeptics and proves that great civilizations not only existed in the past, but the modern world and its problems are reflections of the ancient world of Atlantis.

524 PAGES. 6x9 PAPERBACK. ILLUSTRATED. BIBLIOGRAPHY & INDEX. $16.95. CODE: MED

LOST CITIES OF CHINA, CENTRAL INDIA & ASIA
by David Hatcher Childress

Like a real life "Indiana Jones," maverick archaeologist David Childress takes the reader on an incredible adventure across some of the world's oldest and most remote countries in search of lost cities and ancient mysteries. Discover ancient cities in the Gobi Desert; hear fantastic tales of lost continents, vanished civilizations and secret societies bent on ruling the world; visit forgotten monasteries in forbidding snow-capped mountains with strange tunnels to mysterious subterranean cities! A unique combination of far-out exploration and practical travel advice, it will astound and delight the experienced traveler or the armchair voyager.

429 PAGES. 6x9 PAPERBACK. ILLUSTRATED. FOOTNOTES & BIBLIOGRAPHY. $14.95. CODE: CHI

LOST CITIES OF ANCIENT LEMURIA & THE PACIFIC
by David Hatcher Childress

Was there once a continent in the Pacific? Called Lemuria or Pacifica by geologists, Mu or Pan by the mystics, there is now ample mythological, geological and archaeological evidence to "prove" that an advanced and ancient civilization once lived in the central Pacific. Maverick archaeologist and explorer David Hatcher Childress combs the Indian Ocean, Australia and the Pacific in search of the surprising truth about mankind's past. Contains photos of the underwater city on Pohnpei; explanations on how the statues were levitated around Easter Island in a clockwise vortex movement; tales of disappearing islands; Egyptians in Australia; and more.

379 PAGES. 6x9 PAPERBACK. ILLUSTRATED. FOOTNOTES & BIBLIOGRAPHY. $14.95. CODE: LEM

LOST CITIES OF NORTH & CENTRAL AMERICA
by David Hatcher Childress

Down the back roads from coast to coast, maverick archaeologist and adventurer David Hatcher Childress goes deep into unknown America. With this incredible book, you will search for lost Mayan cities and books of gold, discover an ancient canal system in Arizona, climb gigantic pyramids in the Midwest, explore megalithic monuments in New England, and join the astonishing quest for lost cities throughout North America. From the war-torn jungles of Guatemala, Nicaragua and Honduras to the deserts, mountains and fields of Mexico, Canada, and the U.S.A., Childress takes the reader in search of sunken ruins, Viking forts, strange tunnel systems, living dinosaurs, early Chinese explorers, and fantastic lost treasure. Packed with both early and current maps, photos and illustrations.

590 PAGES. 6x9 PAPERBACK. ILLUSTRATED. FOOTNOTES. BIBLIOGRAPHY. INDEX. $16.95. CODE: NCA

LOST CITIES & ANCIENT MYSTERIES OF SOUTH AMERICA
by David Hatcher Childress

Rogue adventurer and maverick archaeologist David Hatcher Childress takes the reader on unforgettable journeys deep into deadly jungles, high up on windswept mountains and across scorching deserts in search of lost civilizations and ancient mysteries. Travel with David and explore stone cities high in mountain forests and hear fantastic tales of Inca treasure, living dinosaurs, and a mysterious tunnel system. Whether he is hopping freight trains, searching for secret cities, or just dealing with the daily problems of food, money, and romance, the author keeps the reader spellbound. Includes both early and current maps, photos, and illustrations, and plenty of advice for the explorer planning his or her own journey of discovery.

381 PAGES. 6x9 PAPERBACK. ILLUSTRATED. FOOTNOTES. BIBLIOGRAPHY. INDEX. $16.95. CODE: SAM

LOST CITIES & ANCIENT MYSTERIES OF AFRICA & ARABIA
by David Hatcher Childress

Across ancient deserts, dusty plains and steaming jungles, maverick archaeologist David Childress continues his world-wide quest for lost cities and ancient mysteries. Join him as he discovers forbidden cities in the Empty Quarter of Arabia; "Atlantean" ruins in Egypt and the Kalahari desert; a mysterious, ancient empire in the Sahara; and more. This is the tale of an extraordinary life on the road: across war-torn countries, Childress searches for King Solomon's Mines, living dinosaurs, the Ark of the Covenant and the solutions to some of the fantastic mysteries of the past.

423 PAGES. 6x9 PAPERBACK. ILLUSTRATED. FOOTNOTES & BIBLIOGRAPHY. $14.95. CODE: AFA

24 hour credit card orders—call: 815-253-6390 fax: 815-253-6300

email: auphq@frontiernet.net www.adventuresunlimitedpress.com www.wexclub.com

MYSTIC TRAVELLER SERIES

THE MYSTERY OF EASTER ISLAND
by Katherine Routledge
The reprint of Katherine Routledge's classic archaeology book which was first published in London in 1919. The book de
her journey by yacht from England to South America, around Patagonia to Chile and on to Easter
Island. Routledge explored the amazing island and produced one of the first-ever accounts of the
life, history and legends of this strange and remote place. Routledge discusses the statues, pyra-
mid-platforms, Rongo Rongo script, the Bird Cult, the war between the Short Ears and the Long
Ears, the secret caves, ancient roads on the island, and more. This rare book serves as a sourcebook
on the early discoveries and theories on Easter Island.
432 PAGES. 6x9 PAPERBACK. ILLUSTRATED. $16.95. CODE: MEI

This Rare Archaeology book on Easter Island is back in print!

MYSTERY CITIES OF THE MAYA
Exploration and Adventure in Lubaantun & Belize
by Thomas Gann
First published in 1925, *Mystery Cities of the Maya* is a classic in Central American archaeology-
adventure. Gann was close friends with Mike Mitchell-Hedges, the British adventurer who dis-
covered the famous crystal skull with his adopted daughter Sammy and Lady Richmond Brown,
their benefactress. Gann battles pirates along Belize's coast and goes upriver with Mitchell-Hedges
to the site of Lubaantun where they excavate a strange lost city where the crystal skull was dis-
covered. Lubaantun is a unique city in the Mayan world as it is built out of precisely carved
blocks of stone without the usual plaster-cement facing. Lubaantun contained several large pyra-
mids partially destroyed by earthquakes and a large amount of artifacts. Gann shared Mitchell-Hedges belief in Atlantis and
civilizations (pre-Mayan) in Central America and the Caribbean. Lots of good photos, maps and diagrams.
252 PAGES. 6x9 PAPERBACK. ILLUSTRATED. $16.95. CODE: MCOM

IN SECRET TIBET
by Theodore Illion
Reprint of a rare 30s adventure travel book. Illion was a German wayfarer who not only spoke fluent Tibetan, but travelle
disguise as a native through forbidden Tibet when it was off-limits to all outsiders. His incredible adventures make this one o
most exciting travel books ever published. Includes illustrations of Tibetan monks levitating stones by acoustics.
210 PAGES. 6x9 PAPERBACK. ILLUSTRATED. $15.95. CODE: IST

DARKNESS OVER TIBET
by Theodore Illion
In this second reprint of Illion's rare books, the German traveller continues his journey through Tibet and
is given directions to a strange underground city. As the original publisher's remarks said, "this is a rare
account of an underground city in Tibet by the only Westerner ever to enter it and escape alive! "
210 PAGES. 6x9 PAPERBACK. ILLUSTRATED. $15.95. CODE: DOT

DANGER MY ALLY
The Amazing Life Story of the Discoverer of the Crystal Skull
by "Mike" Mitchell-Hedges
The incredible life story of "Mike" Mitchell-Hedges, the British adventurer who discovered the Crystal
Skull in the lost Mayan city of Lubaantun in Belize. Mitchell-Hedges has lived an exciting life: gam-
bling everything on a trip to the Americas as a young man, riding with Pancho Villa, questing for
Atlantis, fighting bandits in the Caribbean and discovering the famous Crystal Skull.
374 PAGES. 6x9 PAPERBACK. ILLUSTRATED. BIBLIOGRAPHY & INDEX. $16.95. CODE: DMA

The true life adventure of F.A. Mitchell-Hedges

IN SECRET MONGOLIA
by Henning Haslund
First published by Kegan Paul of London in 1934, Haslund takes us into the barely known world of Mongolia of 1921, a lan
god-kings, bandits, vast mountain wilderness and a Russian army running amok. Starting in Peking, Haslund journeys to Mong
as part of the Krebs Expedition—a mission to establish a Danish butter farm in a remote corner of northern Mongolia. Along
way, he smuggles guns and nitroglycerin, is thrown into a prison by the new Communist regime, battles the Robber Princess
more. With Haslund we meet the "Mad Baron" Ungern-Sternberg and his renegade Russian army, the many characters of U
fledgling foreign community, and the last god-king of Mongolia, Seng Chen Gegen, the fifth reincarnation of the Tiger god anc
"ruler of all Torguts." Aside from the esoteric and mystical material, there is plenty of just plain adventure: Haslund encounte
Mongolian werewolf; is ambushed along the trail; escapes from prison and fights terrifying blizzards; more.
374 PAGES. 6x9 PAPERBACK. ILLUSTRATED. BIBLIOGRAPHY & INDEX. $16.95. CODE: ISM

MEN & GODS IN MONGOLIA
by Henning Haslund
First published in 1935 by Kegan Paul of London, Haslund takes us to the lost city of Karakota in the Gobi desert. We meet
Bodgo Gegen, a god-king in Mongolia similar to the Dalai Lama of Tibet. We meet Dambin Jansang, the dreaded warlord of
"Black Gobi." There is even material in this incredible book on the Hi-mori, an "airhorse" that flies through the sky (simil
a Vimana) and carries with it the sacred stone of Chintamani. Aside from the esoteric and mystical material, there is plenty of
plain adventure: Haslund and companions journey across the Gobi desert by camel caravan; are kidnapped and held for rans
witness initiation into Shamanic societies; meet reincarnated warlords; and experience the violent birth of "modern" Mong
358 PAGES. 6X9 PAPERBACK. ILLUSTRATED. INDEX. $15.95. CODE: MGM

This rare 1935 book is back in print! Mystic Traveller Series

24 hour credit card orders—call: 815-253-6390 fax: 815-253-6300
email: auphq@frontiernet.net www.adventuresunlimitedpress.com www.wexclub.com